Abstract Art since 1945

Abstract Art since 1945

Foreword by Jean Leymarie

with contributions by

WERNER HAFTMANN

IRVING H. SANDLER

MICHEL RAGON

FRANCINE C. LEGRAND

GILLO DORFLES

HANS L. C. JAFFÉ

UMBRO APOLLONIO

LUCY R. LIPPARD

OTO BIHALJI-MERIN

304 plates, 33 in colour

Thames and Hudson · London

Translated by Carill J. Hay-Shaw (Leymarie, Ragon),
Caroline Lincoln (Haftmann), Heinz Norden (Bihalji-Merin),
John Mathews (Dorfles, Apollonio), R. R. Symonds (Jaffé).

Printed and bound in Belgium.

ISBN 0 500 23144 3

Contents

Preface

JEAN LEYMARIE

Ten years of existence, twenty consecutive volumes; these are limits beyond which a review of living art, conscious of its destiny, cannot go today without either trying to renew itself or inviting its own demise.

In the spring of 1956, a substantial publication appeared, the title of which was itself an indication of the scope envisaged and which, under the pen of the greatly lamented Paul Fierens – whose competence and whose broad human sympathy had led to his election as first president of the Association Internationale des Critiques d'Art – thus defined its programme: '*Quadrum* aims to be everywhere; everywhere that new and worthwhile forms are being created, where experiments are in progress, where aesthetic doctrines and works of art deserving of close and impassioned attention are found in confrontation, where the adventure of our epoch lies.' Directed by Ernest Goldschmidt, founder of the Brussels publishing house Éditions de la Connaissance, it was administered by Pierre Janlet and by Robert Giron, the brilliant and indefatigable organizer of exhibitions at the Palais des Beaux-Arts in Brussels. It was in his ever-hospitable office – up to the time of his recent and sudden death, and whenever the exigencies of his profession had not called him to some part of the globe where an important event was taking place – that the working-parties most frequently met. My last encounter with him was in Cuba, during the summer of 1967, where the Havana government had invited the leading artists of the Paris Salon de Mai and allowed them, in the open street and mingling with the writers and poets, to create a vast collective panel, under the excited gaze of the crowd, and in the exhilaration of creative and revolutionary liberty.

The Editorial Committee was a truly international body; and I must finally pay tribute to the memory of a number of other eminent personalities, now dead, who, by their advice, their prestige and their effective contributions, gave to the review both its impetus and its orientation: Georg Schmidt, possessor of an acute and rigorous analytical brain, heroic assembler of the exemplary modern section of the Kunstmuseum in Basle; Georges Salles, a connoisseur of supreme distinction and universality; Herbert Read and Will Grohmann, whose importance on the theoretical level, and whose consistent clearsightedness and courage in the advocacy of contemporary art, are equally well known. Each of them carried on the battle in his own country, but in the breadth of their vision and their contacts they knew no frontiers. We used to meet periodically at the great art events in Venice, in Kassel and in São Paulo; on the sites of great architectural projects in Berlin, Brasilia and New York, or on extended excursions in Ireland, Sicily, Greece and Macedonia, and at Istanbul, where, with a contemporary eye, we examined the monuments of the past. I take this opportunity to express my gratitude and my admiration for these great men of an earlier generation.

In the autumn of 1966, at the very moment of celebrating the eighty-fifth birthday of Picasso – that supreme embodiment of this century's impulse towards exploratory conquest, and of its need to recollect our total heritage from the past – *Quadrum* declared in its last editorial: 'The experience gained in the course of these past ten years, the confidence of an informed public and the faithful collaboration of authors – all these factors have made it possible for us to announce, as from now, the publication of a great work which will present

the balance-sheet of the absorbing and impassioned adventure of the art of our time.'

This work now sees the light, comprising broadly-based critical essays, methodologically correlated and complemented by the manifestos, the writings and the pronouncements of the most representative creative artists – as individuals or in groups.

In order to grasp and to impose some order on so complex and mobile a field, to articulate the precipitate succession of tendencies, while singling out certain significant contributions, it has been necessary to attempt a type of classification at once chronological and stylistic; one sufficiently clear to be expository and sufficiently flexible to allow for overlapping. For it is a basic property of the genuine artist to be able to escape from those currents in which he thinks to engage himself, and to resist even the most cogent theories which seek to define him. In dealing with a period so close and so ambiguous, we still lack the necessary 'distance' to distinguish clearly between what belongs to history and what to fashion; the imitative variants which find their way into the broad picture so often make an impression much more quickly than do the original forms from which they spring.

These reserves aside, art since 1945, its flight governed by a sort of inherent polarity, passes first through a phase during which abstraction, expressionist or geometric, becomes universal, with primacy given to the gesture, to matter and to the sign, then to space, movement and light, only to return after a few years to a new figuration, to a new realism, basing itself on the proliferation of the image and the recognition of the object.

Following the Second World War, after the killings, the concentration camps, the bombing of Hiroshima, confidence in the machine age and the technological society had been rudely sapped. Then arose, under an entirely original and intensely dramatic aspect, an art which was not merely international but worldwide: a type of organic non-figuration radically opposed to the pre-Bauhaus geometric constructivism. Variously described, in Paris as lyrical abstraction and tachism, in New York as abstract expressionism and action painting, it came to rest under the generic names of gestural abstraction and *art informel*. Are we to conclude from this last somewhat surprising term

that the incessant metamorphoses to which contemporary art has been subject had suddenly cancelled themselves out in non-form? But non-form would be incommunicable and consequently non-existent. *Art informel* has created its own forms beyond the accepted ones by enlarging the concept of form. It belongs in the category of the 'open work', of which Umberto Eco has shown the diffusion and resonance at the present time. The *informel* artist suppresses all distance between the creative act and the substance acted upon, penetrating to the heart of the work, with which he identifies himself existentially.

Each style is a complete system of exclusive and limited values. The accidental and subjective values banished by the constructivists have become the favoured values of the *informel* aesthetic: the gesture, the sign, writing, chance, speed, everything which reveals a trace of the hand, biological pulsation, time-weathering. In *art informel*, the signs are an integral part of the ground, which absorbs without regulating or orientating them, and it is this infinite fluid field which gives the work its substance and its meaning. The 'informal' gesture, whose vital tension is the opposite of a mechanical movement, records psychic energy directly in the material. Finally, in contrast with commonly accepted procedures, which are valid for all the arts and transmissible by instruction, gestural abstraction is the recourse of the individual in his isolation, of the completely self-taught, who accepts no part of reality except what he experiences through his own action.

'Informal' art has considerably enriched our conception of matter in painting, and of its textures, and our understanding of life and its internal rhythms. It is the first historically complex style of which no single element is predetermined, in which the sudden emergence of the sign precedes its significance, and which postulates its ambiguity. The sign – a product of gestural freedom, of the destruction of the image and the effacement of the symbol – is not merely the elemental core of gestural abstraction but also governs geometric abstraction; under its various aspects and its infinite possibilities of combination it also penetrates every sector of present-day creative art, including Pop art and the New Realism. Lucio Fontana, whose lacerated and perforated canvases simulate our

own condition at the heart of a hollow and sundered world ('I was born with holes', as Henri Michaux put it), avoids the exhaustion of gestural abstraction and the limitations of easel-painting through his novel perceptions of primary structures, of monochrome surfaces, of the environment, through his Venetian sense of pageantry and his impulse towards a spatialist integration of the arts in a natural or a technological milieu.

Expressionism is without doubt one of the major art currents of our epoch, appearing first and predominantly in northern Europe, with an impassioned violence often exceeding the artist's technical mastery. It is the frantic cry of anguish, intensified in times of social breakdown and psychological disorder; of the contemporary *Angst* which Kierkegaard identifies with the vertiginous experience of free will, and Heidegger with the realization of the fact of being in the world. Following the Second World War, American art broke the bounds of its provincialism and inaugurated a universal and potently specific style, abstract expressionism. This potent mixture of contrasting ferments – largely contributed by European refugee artists – developed in two principal streams, with internal variants: biomorphic and gestural painting, called action painting – an abrupt revelation of the individual in the spontaneity of his experience – and colour field painting, which deploys the silent and limitless strangeness of the universe over large radiant surfaces.

Geometric abstraction persists beneath the tidal wave of gestural abstraction, and, thanks to a better understanding of its origins and its principles, has recently branched out in a completely new direction. This has taken the form of kinetic and chromatic researches, many of which derive from pure play-experiment – the term is not used in a derogatory sense – and the most productive of which have undertaken a metaphorical exploration of light and movement, evoking a primordial space in which the life of instinct is reconciled with modern science. In this field, Vasarely has the same premonitory importance as has Fontana in the contrasting current, and both are at one regarding concepts of environment, play and spectacle.

Vasarely dreams of founding the solar cities of the future on a kinechromatic harmony, on dynamic colour-form units, polyvalent, controllable, conceived by the ingenuity of the artist but multiplied and diffused according to the norms of industrial production. The artist's objective no longer consists in the creation of a work perfect in itself, but in that of an evolutive succession, a perpetual becoming, within the human consciousness and sensibility. If, after sixty years of vicissitudes and triumphs, of alternating ebb and flood, abstract art has overcome the major reproaches to which it has often been justifiably subjected – decorative exhaustion, flight from reality, dehumanization, mystification – it remains inevitably subject to the dialectic of utopia and alienation which is imposed by historical conditions. It is from the intransigent radicalism of its approach that it has never ceased to derive its sense of involvement and validity.

But abstract art, with its handful of heroes and its swarm of vulgarizers, could not, in an era of aesthetic relativism, constitute itself an exclusive style, nor even dominate for long. A separate volume examines the figurative or quasi-figurative movements which have appeared parallel with the flowering of abstract art, or which tend to supplant it. The revival of the surrealist or fantastic current, with its dream-world, its unfamiliar associations and its erotic implications, has its exact counterpart in the cold, objective gaze that Pop art and the New Realism cast on our everyday environment in all its terrifying or marvellous crudity. Cubism introduced the use of the letter into painting, while instituting disturbing relations between writing and the image, between figuration and nomination; thus it invented the collage, itself a development from the principle of montage or assemblage, and this, in various forms, had undoubtedly become the most productive and most characteristic technique of an epoch dominated by the cinema, television, commercial art, strip cartoons and sensational newspapers. By incorporating raw materials, accepted as such in true reality, into the feigned reality of art – a development at once stimulating and disturbing – assemblage stands in opposition to the old *mimesis* of which it denounces the falsehood, and is also, according to a remark of Claude Lévi-Strauss's, the conversion to artistic ends of *bricolage*, the do-it-yourself tinkering which is taking the place of a vanished craftmanship.

The baroque, that union of the festive and the sacred, which evokes a certain nostalgia on our part, constitutes the last great symphonic style in which art signified something other than itself. In the nineteenth century, with the loss of any unifying principle, the arts separated into specific and autonomous entities, with no other resource *vis-à-vis* conventional society, from which they were excluded, than direct and necessarily critical experimentation. Now, for some years past, we have been witnessing a reverse movement of inter-penetration, and this dislocation of the frontiers between the arts, a reflection of the ideal future in which there will be no more artists because every-body will be an artist, coincides with a radical questioning of the meaning and the very existence of art. Ever since Hegel, the imminent death of art has been incessantly proclaimed, and there are those who consider it to be an accomplished fact, in a period of such intense technological pressure and cultural conditioning. 'The situation in which we find ourselves', declares the philosopher Theodor W. Adorno in *Ohne Leitbild* (1967), 'no longer per-mits of the existence of art – and it is to this which statements affirming the impossibility of writing poetry after Auschwitz were tending – and yet our situation has need of art. For a reality denuded of images is the exact opposite of the situation in which images would be abolished, and art disappear, because the utopia whose secret is inscribed in cipher in every work of art would have been achieved. By itself, art is not capable of such a disappearance. This is why the arts burn themselves out in contact with each other.' If the free and indispensable flame of the creative function is to burn more brightly, irreducibly joined to the springs and the mystery of life, it is to the function alone we must look, and not to the art products with which we are massively saturated. The entire planet which, from this time forward, man is as capable of destroying as he is of flying away from it – the proof is there – is in danger of being transformed into a gigantic and ridiculous *objet d'art* for the space museums of the future.

It is for this reason that the most conscientious artists, seeking to be in direct contact with con-temporary reality, and whose field of experimenta-tion is sociology, concern themselves less with the creation of works, in the material sense of the word, than with actions, events and environments. The latter cannot be hung on the stultifying walls of galleries, but go out into the street and transform life itself. It is worth remembering Schiller's profoundly serious remark: 'Man is not fully man except when he is at play.' Will automation make possible the reversal, without a violent revolution, of the inhuman principle of productivity, of yield, and replace it with the vital and natural principle of play? Then, in a fully harmonious society, the nature of which remains unforeseeable, would be seen a reconciliation between the two funda-mental instincts now visibly at war within both abstract and figurative painting; the instincts which Schiller called the instinct of form and the instinct of sensibility.

Part One: GESTURE

Masters of Gestural Abstraction

WERNER HAFTMANN

In Paris and New York, immediately after the Second World War, a new movement in painting made its appearance; the key year was 1947. People came to realize that art was developing in a direction totally different from that which had been expected.

Great retrospective exhibitions of Picasso, Braque and Léger were held in Paris, and attention was drawn to the example of these masters. Younger painters of the Paris school like Jean Bazaine and Alfred Manessier were trying to combine the formulas of late cubism with a more colourful way of painting, to give an abstract poetic interpretation of the forms of nature. The main interest of the artistic avant-garde was geometrical abstraction, which was being promoted by critics like Léon Degand and by the Galerie Denise René, and had already been well received in 1946 in the first 'Salon des Réalités Nouvelles'. Other painters, among them the young Bernard Buffet and his circle, and even great artists like Giacometti who belonged to no particular school, were trying to give plastic expression to the disillusioned and joyless world of existentialist philosophy. The more realistic movements attracted the interest of the Communist Party. Many artists were sympathetic to its ideology, and early in 1947, through its literary spokesman, Aragon, it began trying to impose its new slogan of 'socialist realism'; with Fougeron and the Italian Guttuso it succeeded.

Suddenly, and quite unexpectedly, a new type of painting emerged from this confused scene. There was no doubt as to its quality, and it was clearly in radical opposition to all these other trends. These new paintings seemed to have rejected all rules and traditional theories of composition. Their principal means of expression was an entirely automatic pictorial script which resulted from the movement of the hand or body and created a sort of 'psychogram' – a plastic representation of a dramatic or emotional state. Some of these expressionist paintings were quite chaotic, and tended to be vast in size; but others which had a certain meditative quality and were sensitive to the slightest nuance of feeling were compressed on to tiny canvases. Varying with the degree of emotional involvement, they showed either a violent and hectic explosion of lines twisting and whirling around on the surface, or a delicate mesh, woven lightly and as if in a trance out of a fine network of brushstrokes and spontaneously placed areas of colour. There seemed to be a common conception of the canvas as a mere empty space on which the painter's psychomotor energies were to be set in action, leaving behind the traces of their dance-like movements. Whatever appeared on the canvas was to emerge from this unconscious action. The work was 'discovered'. This was the final extreme of what Paul Klee once called 'psychic improvisation'.

The artist did not, however, rely entirely on abstract means of expression. Figurative shapes might appear almost of their own accord and give an unexpected twist to the content of the improvisation. This new painting was not to be confined under the convenient critical labels of 'figurative' or 'abstract': its free, almost arbitrary methods released it from them.

The new movement appeared almost simultaneously in New York and Paris, but both its origins and its later development in the two centres were entirely independent.

Its first centre in New York was the Art of this Century Gallery which Peggy Guggenheim had

founded in 1943. At the beginning of the war, and after the fall of France, many important painters, including Marc Chagall, Fernand Léger and Salvador Dalí, had fled to New York; the group included a number of surrealists – among them Max Ernst, André Masson, Yves Tanguy and André Breton – who there joined up with Marcel Duchamp. Breton gave influential lectures on the theory of surrealism and provoked discussion of its key concept, psychic automatism. Max Ernst, who married Peggy Guggenheim, advised her on the direction of her gallery. Among her followers was the young Chilean painter Matta, who had worked in Le Corbusier's studio in Paris in the late 1930s, and who had been an early member of the surrealist group. Before long Matta met Robert Motherwell, a very intelligent young American painter, and through him his friend Jackson Pollock. Listening to their long discussions, Pollock learned about surrealist automatism and about the possibility of finding a personal mythology – a current preoccupation of André Breton, and something which always interested Matta. Pollock was a totally unintellectual man who could really only express himself in paint, but he had involved himself deeply in Picasso's great range of forms and was therefore very receptive to the new ideas of his friends. The concept of automatism, in particular, and the possibility it raised of reaching the hidden depths of man's psyche, had a totally liberating effect on him. It enabled him to throw off all the formal restraints of cubism and, using all his energy, to make a sudden breakthrough to a new type of painting based on complete freedom and spontaneity. Other young American painters besides Motherwell belonged to this group – including such important figures as Arshile Gorky and Mark Rothko – but it was Jackson Pollock who first created works that were uncompromisingly in the new style.

In Paris the new tendency first became known through René Drouin's luxurious gallery in the Place Vendôme. Drouin had the advantage of friendly advice from several French poets and writers, such as Jean Paulhan, Francis Ponge and H. P. Roché, who kept a close watch on the artistic life of the country. Paulhan had introduced Drouin to Jean Fautrier and Jean Dubuffet in

1944; H. P. Roché drew his attention to Wols (Wolfgang Schulze), who since 1942 had been living as a poor refugee in Dieulefit, the place to which Roché had himself been driven during the German occupation. In spring 1945 Drouin went there to visit Wols, offered him an exhibition, and persuaded him to go to Paris that winter. All these contacts resulted in a remarkable series of exhibitions at the Drouin gallery which confidently, and with unfailing sureness of judgment, introduced the work of those artists who had created and who never ceased to influence the new movement.

In October 1944 Drouin organized the first exhibition of Dubuffet's early paintings, works that are scribbled and daubed in a naive and childlike way, and whose draughtsmanship shows signs of automatism – perhaps because Dubuffet was already under the influence of Klee. The treatment of the material is strangely hallucinatory; it evokes a subtle impression of something figurative, but no more.

In autumn 1945 there followed an exhibition of Jean Fautrier's long series of *Hostages*. He had painted them in the previous year, after seeing hostages being shot against the wall of a psychiatric hospital near Sceaux in which he was hiding. They show very vague human faces which seem to hover in the surface of the paint, barely discernible and yet somehow present, as if a general process of disintegration were removing all traces of individual life and leaving behind no more than a dim reminder of its having once existed before being obliterated in the general sacrifice. These faces are formed by a thick, impasted layer of paint which floats like an island on the sugary, opalescent colours of the background. It is only after absorbed contemplation of this basically abstract and shapeless material that the observer's gaze is answered by a forlorn, ghostlike suggestion of a human face.

In the winter of 1945-46 Drouin exhibited the tiny watercolours which Wols had done when in Dieulefit. They are often no larger than a hand, and were improvised directly from experiences and events in the artist's psyche.

There was another collection of Dubuffet's paintings in May 1946. These he had ironically entitled *Mirobolus, Macadam & Co.*, and it is a series that has

a strongly material effect. These 'high impastos', as Dubuffet called them, provided the painter with his *matière brute*, his *matière chaotique*, the crude, chaotic material with which he would play around like a child, and out of this aimless play would arise visual forms and signs which evoked long forgotten sensations.

Finally, in the early summer of 1947, came an exhibition of forty of Wols's oil paintings, which he had produced the previous winter in a great burst of activity. They demonstrate both the basic conception and the whole potential of this new way of painting by spontaneous improvisation. These works formed the first climax of the movement, for Wols was at its centre in Europe just as Pollock was its real originator in the United States. Wols is so important that it is tempting to describe the new style with reference to his work alone, but there were of course other people who added their own individual accents. The most important of these are Henri Michaux, Georges Mathieu and Hans Hartung.

Michaux was a poet and painter who had belonged to the circle round the Drouin gallery since shortly after he met Dubuffet in April 1945. In an attempt to express those subtleties that elude the written word, he had discovered a delicate way of drawing that was almost like writing. Georges Mathieu had found his own aims and ideas corroborated in the Wols exhibition of 1947, and almost immediately afterwards he embarked on an energetic burst of painting, writing, and exhibition-organizing, designed to promote them. Hans Hartung was a painter who had been working in complete isolation, and who became known in February 1947, after some of the paintings he had done since 1935 were exhibited in Lydia Conti's small gallery.

In the summer of 1947 the new Galerie du Luxembourg exhibited the works of six Canadian painters under the significant title 'Automatisme'. One of these was Jean-Paul Riopelle, whose thickly woven, vibrant areas of colour suggested intentions similar to those of Pollock and Wols. Largely through the efforts of Michel Tapié and Georges Mathieu, all these painters gradually began to form a group in 1947, and they tried to give collective expression to their common stylistic intentions. In December of that year their first exhibition was held in the Galerie du Luxembourg; there were paintings by Wols, Hartung, Mathieu, Riopelle, Camille Bryen and others. Mathieu suggested that the exhibition be called 'Vers l'abstraction lyrique' ('Towards lyrical abstraction') – a phrase which later became current – but 'L'Imaginaire' ('The Imaginary') was finally chosen. The Galerie Colette Allendy organized a similar exhibition in spring 1948, and Wols, Hartung and Mathieu were represented in the second Salon des Réalités Nouvelles in July 1947. From then on the new movement spread widely and rapidly, and its basic stylistic concepts expanded to become by far the most important influence on the painting of the next decade. When Michel Tapié published his *Une morphologie autre* in 1960, it contained a list of no fewer than 108 of these 'informal' painters, and in his introduction Tapié expressed the hope that he would soon be able to publish further volumes.

It had already been stated that the American and European branches of the new movement developed quite independently, but there were of course certain common sources. Most important for all these artists was the surrealist practice of psychic automatism. Klee's work greatly inspired Dubuffet, Fautrier and Wols, and his concept of 'psychic improvisation' long remained a silently active influence. The abstract, but dramatic and expressive style in which Kandinsky had painted between 1912 and 1914 stimulated the group of painters in New York, as they were able to study a whole series of these works in the Solomon R. Guggenheim Museum. Historically, these sources reach right back to the last years of Claude Monet, whom the artists rediscovered at about this time, and even to J. M. W. Turner, who made a lasting impression on Fautrier.

Because of their common inspirations and aims, and because of the lively atmosphere of the Paris art world, it was inevitable that the two groups should discover each other. By 1948 the names of Pollock, Willem de Kooning and Mark Tobey were circulating among members of the European avant-garde. Peggy Guggenheim exhibited a large group of important Pollocks from her own collection in Venice in 1950. In March 1951, Michel Tapié and Georges Mathieu arranged an exhibition in the Dausset gallery in Paris which they called

'Véhémences confrontées' (later translated as 'Opposing Forces'). This was the first time that representatives of the New York school, such as Pollock and de Kooning, had been shown together with Wols, Hartung, Mathieu and Riopelle. The American works gradually became better known in Europe, and the two groups of painters soon came to be associated under a single heading. In March 1952 Sidney Janis organized an exhibition for the Galerie de France called 'American Vanguard for Paris', and there was a Pollock exhibition at the Galerie Facchetti. In July 1953 the Musée d'Art Moderne in Paris held an exhibition of twelve American painters, including Gorky and Pollock, and in the same year there was a show entitled 'Opposing Forces' at the Institute of Contemporary Arts in London. Two years later Arnold Rüdlinger organized an exhibition in Berne called 'Tendances actuelles' ('Current Trends'), in which the most important representatives of the new movement, both American and European, could be seen together. It was here that Tobey was first introduced to Europe through an important group of paintings – and it was this exhibition that finally made people in the European art world think of the two groups as one.

If one wanted to sum up the difference between the styles of the American and the European painters in a few words, then one might say that the former tended to emphasize the dramatic potentialities, and the latter the lyrical elements, of these newly discovered means of expression. This same differentiation is discernible in the criticism which accompanied the new movement – for it soon found its apologists and interpreters who produced all sorts of labels for the style in an attempt to characterize what was common to all these individual painters.

In America two terms became prevalent, and they were soon current in Europe as well. 'Abstract expressionism' was suggested by the American critic Clement Greenberg in 1949. It was intended to emphasize the expressive and dramatic visions evident in the powerful lines of these works. His term was also meant to indicate the historical link with expressionism, and in particular with Kandinsky's expressive abstract painting of the 1912-14 period. Greenberg used Jackson Pollock as his main example.

The term 'action painting' was suggested in the same year by another American critic, Harold Rosenberg. He too based his argument mainly on the example of Pollock, who had once tried to explain to him that the pure 'act of painting' was itself an amazing source of spontaneous creation and inspiration. Rosenberg's term emphasizes the spontaneity of the very act of painting, and the automatism of the violent or dance-like gestures of the arm. These leave their trace on the canvas, and thus their rhythm is translated into an autonomous psychogram which, as a visual image, communicates the state of mind that originally set those gestures in motion.

Because of the particular style of the New York group, these two American terms emphasize the dramatic qualities of the new painting, whereas French criticism correspondingly stresses its lyrical nature. In 1947 Georges Mathieu introduced the term *'abstraction lyrique'*, which he later used constantly in his essays. Subsequently it was also adopted by the critic Pierre Restany. It was the work of Wols that gave Mathieu his ideas. His term emphasizes sensitivity to those subconscious stirrings of the mind which will rise to the surface and translate themselves spontaneously on to paper if conscious control is somehow removed, and a trance-like state achieved. This process is connected with Klee's concept of pure psychic improvisation, and also with the psychic automatism which André Breton had postulated and which became one of the most important creative processes of the surrealists. Spontaneity, improvisation, and automatism were for Mathieu the essential qualities of this painting, which was attempting to give plastic form to subtle inner experiences that lie far beyond ordinary everyday consciousness. This world of inner consciousness which they were trying to reach is well described as 'lyrical', if the word is taken to imply not only revelation of the poetic connection between man and the world of objects – the sense in which Mallarmé and Rilke used it – but also to include the darker, more passionate and despairing reactions to the world of which Lautréamont and Rimbaud wrote. Lautréamont's wild *Chants de Maldoror* and the tragic verses of Rimbaud's *Le Bateau ivre* are much closer in spirit to the new psychic improvisational painting than those delicate interpretations of the

auras of nature which are usually thought of as 'lyrical'.

In 1950 the French critic Michel Tapié introduced the term '*art informel*'. Like Mathieu, he at first had primarily Wols in mind, but by 1951 he was using the term for the work of Fautrier, Dubuffet, Michaux, Riopelle and others as well. Tapié wanted to emphasize the spontaneous freedom with which the painter approached his canvas – the liberation from all traditional notions of composition, the inattention to careful formal arrangement, and to placing the visual images in the usual hierarchical pattern, by emphasizing the centre or by harmoniously balancing several motifs. Instead the canvas was regarded as a sensitive instrument which recorded the impulses of the painter as they surged up and died away. Seen in comparison with late cubism or with geometrical abstraction, both of which were much in vogue in Paris after the war, it is no wonder that this new painting was regarded as *informel* or 'formless'. From 1952 on Tapié began to use another term as well: '*art autre*'. This was intended to emphasize the radically different, 'other' nature of the new art, and to establish this very strangeness as a criterion for its critical assessment. His book *Un art autre* was published in 1952.

'Tachism' was another term which soon became quite popular. It was first used by the French critic Charles Estienne in 1954, and although it implies something similar to *informel*, it is more concerned with colours and tones than with form. From the network of grey or coloured patches – the *taches* – a lively surface area would develop which showed neither precise confinement of the areas of colour, nor any conscious development of colour series or harmonies. On the contrary, the canvas was again thought of as a living echo of the physical or emotional state of the artist. Estienne, like other critics, pointed to Wols as the most perfect illustration of this theory.

There are, therefore, several terms for the new movement, each of which indicates a single aspect of its methods or results but fails to characterize the whole phenomenon. However, the proponents of nearly all these terms cite the work of the same two artists as being the most original and influential: Wols and Jackson Pollock.

These two painters never met, nor did they even see each other's work in the early, decisive years. One is therefore faced with the fact that a remarkably homogeneous style was developed simultaneously by two men each of whom had no knowledge of what the other was doing. This would be nothing remarkable if it had happened in the narrower circles of European art, where such coincidences are quite common; but the Atlantic divided them. It was the first time that European and American art had followed a parallel course, a course which was soon to spread right across the world. It is certainly possible to make the apparent coincidence of these two developments somewhat more comprehensible by pointing to their common artistic sources (Klee, Kandinsky, the automatism of the surrealists), to comparable historical circumstances, and even to a certain similarity in the characters of the two protagonists; but it cannot be entirely explained.

Looking back, it is in the years 1946-47 that the parallel development first becomes recognizable. In autumn 1946, when Wols was living in a cheap Paris hotel, the dealer Drouin took him some canvases and suggested that he stopped doing his tiny watercolours and drawings which often measured no more than a few inches, and turn to something larger, produce some 'proper paintings'. At first Wols refused, arguing that for him mere finger-movement was quite enough to create a work of art, and that to do anything larger which required movement of the whole arm was much too much like gymnastics. Apparently, however, he was finally tempted by the large, empty canvases, for one night he began a hectic, trance-like spell of painting which lasted for weeks. Within a few months he had done more than forty large canvases – those which Drouin exhibited in summer 1947. No great stir was caused, but a few discerning people such as Jean-Paul Sartre, Jean Paulhan and Georges Mathieu recognized the importance of the occasion. The exhibition showed the 'crucifixion of a man', as Mathieu, who was deeply moved, expressed it. 'Self-crucifixion' would be more accurate. The paintings are like soliloquies. Fleeting shapes suddenly arise and drift across the surface, free from any careful arrangement. They may form themselves into an oval like a hidden wound which has been covered by the blossoming of beautiful colour, spreading

like the shimmering wings of butterflies over the pain. Or sometimes a fiery, sulphurous shape explodes upwards, then drifts outwards into something reminiscent of the mushroom cloud of Hiroshima – Wols had an admonitory photograph of that first atomic explosion pinned on his hotel wall. Other paintings show hypnotic shapes like eyes that look out at the spectator and somehow suggest a destroyed face. Each painting seems like a living network of nerves; it almost seems as if every thread of the final texture had been drawn from his living body, his vital energy draining away with each one. It is this feeling of self-destructiveness that makes these paintings so very powerful.

In that same year Wols's drawing became more hectic, violent and chaotic. The old motif of the ship reappears – a motif which Wols continued to use all his life as if it were his personal symbol – but here it is mutilated, disintegrating, eddying round in whirlpools and hurricanes, a *bateau ivre* resigned to its fate. The violence and emotional intensity of these lines is particularly reminiscent of Pollock.

It was at this very time – the winter of 1946-47 – that Pollock, over in New York, was developing towards something similar. He was turning away from the descriptive and still basically figurative use of visual metaphors, and beginning, like Wols, to regard the canvas as a field for psychic improvisation, for experimentation, for the recording of his expressive gestures. Pollock's gestures were, however, much more forceful, more expressionistic, and encompassed much larger areas: Pollock was by nature more actively emotional than Wols, with his expectant passivity. Wols once said that he could do really good work only when lying down with his eyes closed, trying to record the images which presented themselves on the closed lids. Yet some of Pollock's paintings of that period – for example *Eyes in the Heat* – do show a comparable sensitivity to the surface tissue, a similar dynamic use of space, the same rejection of any preconceived compositional scheme, the same perpetual motion playing all over the whole surface; and, finally, there is the same automatism controlling the gestures of the hand. The eye-like forms scattered across the painting have the same hypnotic power as those in the work of Wols.

Plates 1-5

1 JACKSON POLLOCK. *The Flame*, 1937. Oil on cardboard, 51 × 79 cm. The Museum of Modern Art, New York. Photo O. Baker, New York.

2 JACKSON POLLOCK. *The Moon Woman cuts the Circle*, 1943. Oil on canvas. 109 × 104 cm. Marlborough Gerson Gallery Inc., New York.

3 JACKSON POLLOCK. *Totem II*, 1945. Oil on canvas. 183 × 152 cm. Collection Lee Krasner Pollock, Long Island. Photo Soichi Sunami.

4 JACKSON POLLOCK. *Blue Posts*, 1952. Oil, duco and aluminium on canvas, 211 × 488 cm. Collection Mr and Mrs Ben Heller, New York.

5 JACKSON POLLOCK. *Shadows*, 1948. Oil on canvas, 137 × 112 cm. Collection Mr and Mrs Ira Haupt. Courtesy Sidney Janis Gallery, New York. Photo O. Baker, New York.

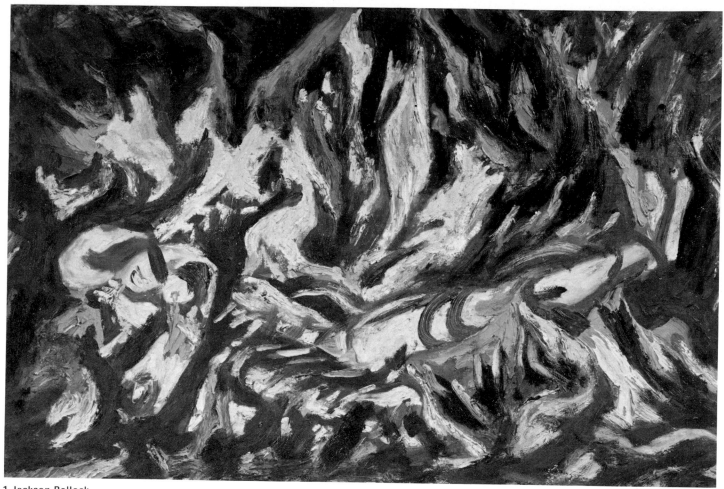

1 Jackson Pollock

2 Jackson Pollock

3 Jackson Pollock

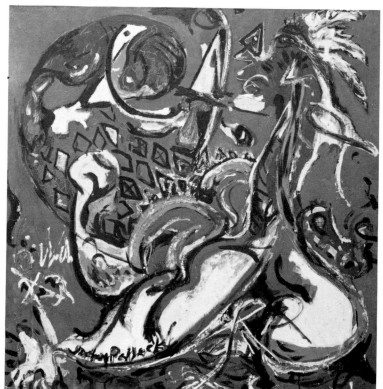

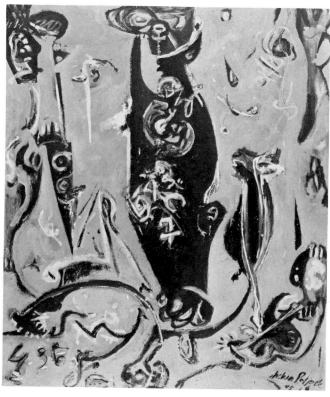

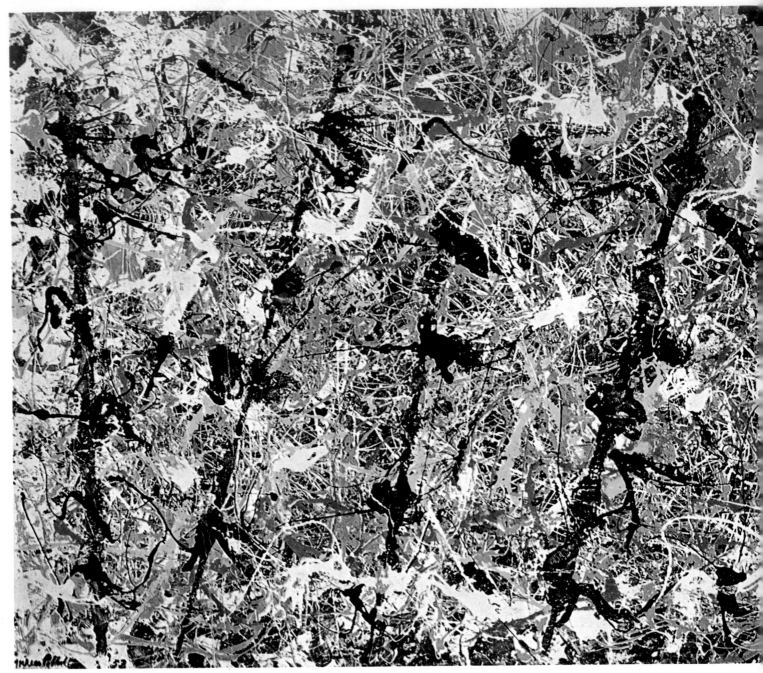

4 Jackson Pollock

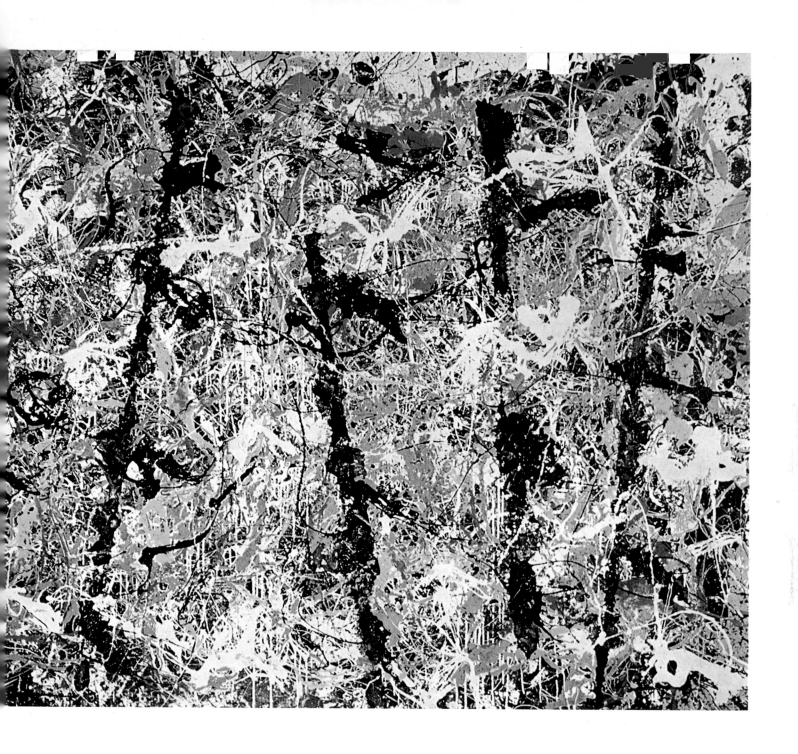

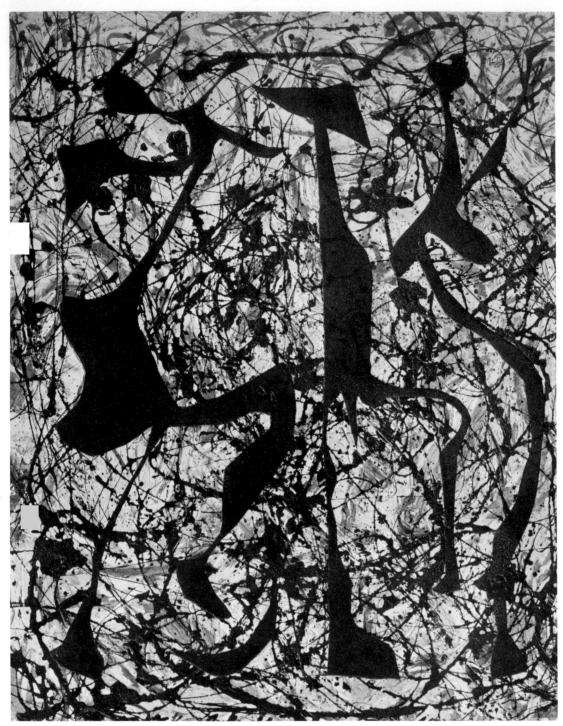

5 Jackson Pollock

Other paintings show that revolving movement, those despairing brushstrokes, those tortured twisted lines whose presence in Wols's drawings of the same period has already been indicated. The question of how they came to paint in such similar ways leads back to the characters of the artists concerned. It is worth studying them each individually.

JACKSON POLLOCK

Pollock [1-5, s. 1] was of mixed Scottish and Irish descent, and his father was a farm-labourer. He was born at Cody, Wyoming, in 1912 and grew up in the west of the United States. He had a difficult life, and he struggled through his youth working for a group of land surveyors. He was quiet and thoughtful, but was also easily roused and could be quite violent. He seemed to have difficulty in dealing with himself as well as with others, and, as a defence, out of desire for isolation, and perhaps also because of some self-destructive tendency, he became a very heavy drinker. He died in 1956, in a car crash which, ultimately, was perhaps caused by his growing weariness with life; violent emotion and visionary despair – which were the main themes of his art – always seemed to be guiding his life, and steering it towards catastrophe.

In 1929 he came to New York, where he began his career as a painter in Thomas Benton's studio. This was the year of the great financial crash, and there followed years of depression with thousands of people unemployed; then came the war. It was during this harrowing period that Pollock's work developed, and his painting was certainly affected by these circumstances. The only advantage was that a poor and unknown artist like Pollock had unlimited freedom; no one took any notice of him, so no one minded what or how he painted.

In the early 1930s several young Mexican painters, including José Clemente Orozco and David Alfaro Siqueiros, came to New York and introduced a new style of painting which involved the realistic treatment of themes of folklore. Their baroque expression of emotion and their use of popular myths made a strong impression on Pollock. He suddenly began to show a preference for historical subjects. In this early period he did many sketches after paintings by those masters of the early baroque, Tintoretto and El Greco.

In these copies he transmutes the original figurative elements into almost abstract ornamental patterns which twist and turn on the paper. He develops folds of drapery, which the old masters used to show their skill with form, into pure moving patterns filled with restless emotion. One of these drawings after El Greco shows fleeting sketches of female bodies, and strange, imaginary shapes like flowers and ears; they are clearly erotic, and suggest despairing and frustrated sexuality.

In about 1935 he began to draw much more turbulent forms, involved, intertwining and somehow evil shapes evocative of aggression and agitation, creation and destruction, chaos and devastation. In the arrangement of the canvas there is a similarity to cubism, but the fantasy is that of the surrealists.

In the years that followed the pictorial script becomes much freer, more spontaneous and improvisatory, more hectic and aggressive, and creates wildly animated compositions; they leave an impression of despair and of suffering caused by an evil world. The canvas is treated as a blank surface which waits for the autonomous pattern to appear – in this Pollock may have been influenced by the calligraphic brushstroke of Picasso's *Guernica* period. But there is also an entirely new element, which appears in some drawings alongside the other. This is a gently meditative script which is achieved by entering a trance-like state and allowing complete freedom to the brush. At first something like a landscape might appear, then perhaps transform itself into a face, then even develop further into strange, sexual and sometimes revolting shapes like those to be found in Wols's work; or it might turn into curious hybrids of flowers and insects, magic patterns of eyes, or erotic vaginal forms. One can discern in these works an early stage of psychic improvisation, that automatic drawing which springs directly from the psyche and which aims not to depict concrete objects, but to show man's reactions to the outer world by revealing his inner emotions. That these were often horrifying is not surprising if one considers the state the world was in.

Pollock turned to painting in 1937. One of his first canvases is *The Flame* [1]. It is a vision of licking flames – a theme which he used only this once. However his concern is not the mere representation

of fire, for the painting seems more like an attempt to express all burning, crackling, and destruction. There is almost a conspiracy between the artist and the flames, as if he were asking them to respond with a visual analogy to the state of his own soul.

Gradually this mythical quality becomes more marked. In 1943 Pollock did a painting called *The Moon Woman cuts the Circle* [2]. At that time he was fascinated by the mythology of the American Indians, and by their sand paintings in which colour assumes mythical significance. Some symbols appearing in his works – such as the knife, the moon, and perhaps even the entire mythical atmosphere – result from this involvement with early American folklore. He was also reading C. G. Jung and learning about the mythical capacity of the subconscious and about the archetypal myths which are recorded there. This particular painting is, therefore, part of a series in which he attempted to create a personal mythology of which the main elements are expressive lines, strong and evocative colours, and an imaginary system of hieroglyphs. *She-Wolf*, the famous painting of 1943, belongs to the same series. It shows a sort of totem animal, a creature, drawn from his personal mythology, that is the incarnation of all aggressive and erotic instincts. The six-foot painting of the same year entitled *Guardians of the Secret* is also a product of this preoccupation with mythology. There is a bright screen, shielded on the left and right by two sentry-like stone blocks, and displaying various hieroglyphs which seem to be taken from nature, but are also apparently ritualistic. A symbolic wolf lying underneath, and chaotic shapes flickering above, augur threats to the existence of this bright world. Particularly striking is the sense of ritual which frequently occurs in Pollock's work. The shapes are entirely two-dimensional, and the spatial composition of the painting is determined by a few flat planes. *Totem* [3], a painting of 1945, also seems completely flat. Its title suggests that it too originates from Pollock's private mythology.

If this particular series of paintings is studied within the context of contemporary art, one detects the influence of both Picasso and Miró. But also there is clearly a determination to combine increasing abstraction of form with the mythically-based subject matter introduced by surrealism. This clarity of purpose suggests that something had changed in Pollock's intellectual environment: he had in fact met Matta.

Roberto Matta Echaurren, a very young Chilean painter, had been living in Paris in close contact with Breton and the French surrealists, and had fled in 1940 to New York, where Motherwell introduced him to Pollock. It was from this gifted young painter that Pollock first heard about the surrealist concept of automatism, about the function of the subconscious, and about the part that myth plays in man's psyche. In long nocturnal conversations with Matta and Motherwell (which Arshile Gorky, the dreamy Armenian, sometimes joined), Pollock formulated more clearly the ideas which Jung's book had awakened in him. Gradually he came to see how he could give them plastic expression.

Something else happened that was very fortunate for Pollock. In 1942 Peggy Guggenheim had returned to New York with her collection of contemporary art and had opened the Art of this Century Gallery. Matta drew her attention to Pollock, and in 1943 she put him under contract. All his material needs were taken care of, and he had constant access to paints and larger canvases. Later that same year she gave Pollock his first one-man exhibition, and it was moderately successful. But equally important for Pollock's development was the arrival of a large number of European surrealists in New York, including figures as important as Max Ernst and André Masson. André Breton, the main spokesman of the surrealists, gave some influential lectures on the ideological and theoretical bases of their movement.

Peggy Guggenheim's gallery became the meeting-place of this whole circle, and it was here that Pollock came into direct personal contact with the masters of surrealism and learned many new techniques. In the sketches of 1944-45 there is increasing abstraction, and in the quivering, automatic brushwork, so sensitive to every slight impulse of the psyche, one can trace the development of that calligraphic expression of the inner self which the surrealists called automatic writing. There is however no sign of the comparatively playful and experimental attitude of the French

painters: Pollock's works are aggressive, torment-
ed, pungent outpourings, resulting from the total
involvement of the artist and forming a visual
record of the whole drama of his psyche.

This development culminates in Pollock's huge
'all-over paintings' which began in 1946-47, and
which usually come first to mind at the mention
of Pollock's name. Form is no longer recognizable.
There is a close web of colour which winds over
the entire surface and leaves no central point.
There are living lines which writhe around,
entangle and untie themselves, and then become
entwined again in a non-stop dance [5]. They twist
over the surface with neither limit nor contour,
like the choreography for a whirling dervish, and
because they result from a dancing movement of
the body these paintings really can be regarded
as a sort of choreographic notation. At this stage
Pollock no longer used an easel for his paintings,
but laid them on the floor and allowed colour to
trickle on to the canvas by using a thick brush
dipped in diluted paint or even a finely perforated
tin; the resulting lines were therefore a direct
record of the dancing movement of the arms and
the body. He probably learned this technique from
Ernst or Masson, both of whom used it occasionally,
although only experimentally. The longer the
movement lasted, and the more agitated and
uncontrolled it was, the deeper the artist was able
to penetrate into his picture until he became
inextricably caught up in the rhythmical pattern.
When the trance-like movement died down, the
painting was finished. If, later, a spectator tries to
enter the confusion of lines, then he too is drawn
into the twisting and turning of the dance.

Not only recognizable form has disappeared. The
traditional spatial organization of the painting into
clear planes, or into that progression from fore-
ground through middle ground into background
demanded by the rules of perspective, has also
been abandoned. The arrangement is entirely non-
perspectival; it is totally autonomous, and has
validity only within the frame of the picture.
The strange texture flows over the canvas like
waves, dipping, rising and rolling, and turning
space itself into an active partner of the painter
that responds to his impulses and emotions. Space
breathes with him as if it were recording the
rhythm of his heartbeats.

Occasionally this method produced very peaceful
paintings, meditative scenes, delicate filigrees like
a wild flower blossoming from the psyche. Yet
most of the paintings seem to result from an
explosive release of feeling discharged on to the
canvas by furious gestures. They sprayed the sur-
face with colour as they swirled across, sometimes
even following an entirely realistic course as if they
had been suddenly reminded of the existence
of the natural world. For Pollock, abstraction
was never a dogma. If the automatic movement
of the arm produced something figurative, then he
always accepted its presence. For example, the
painting of 1948 called *Shadows* [5] shows leaping
anthropomorphic shapes like shadows, which turn
the movement of the circling lines into a dance-
like pattern.

In his last years, the canvases often expanded to
an enormous size; they were almost real arenas or
dance-floors. A 1952 painting, *Blue Posts* [4], is over
five yards wide. It shows more control of colour
harmonies than his earlier works: there is a basic
blue which is accompanied by yellow and by a
secondary streak of orange. Liberal use of silver
emulsion gives a heraldic tone to this lively but
rhythmical harmony – here again is that ceremo-
nial quality which constantly recurs in Pollock's
work.

Pollock introduced an entirely new style of paint-
ing. It had moved on beyond all the concepts of
pattern, form, composition and space which had
hitherto been traditional. The surface became
a mere field of action. It was set in motion by the
energy of the automatically produced lines, by
their spatial impetus, and by colour. Eventually
a whole network of lines and colours appeared
– a visual expression of the artist's inner feelings,
of lyrical sensitivity, and of the drama and excite-
ment of existence. Pollock produced paintings with
a strongly meditative character; their patterns
involve not only the painter's consciousness of
life, they also stimulate the consciousness and the
imagination of the spectator. Leonardo da Vinci
once remarked, on the fascination and inspiration
that old, patchy walls could offer to an imaginative
eye, 'Looking at such walls is like listening to bells:
you can hear any name and any word that you
choose.' One could say the same of Pollock's
paintings.

But although Pollock's work seems so personal, it was by no means a solitary, private venture; it was clearly a response to a certain longing inherent in that age. Besides, there was Wols.

WOLS

Wolfgang Schulze [6-11, s. 2], who took the pseudonym of Wols in 1937, was born in Berlin in 1913, but grew up in Dresden. His father was head of the Saxon Chancellery, a very high office. Wols became a fine musician, and a good zoologist, geologist and botanist, took a keen interest in ethnology, and was very gifted in practical as well as artistic fields; perhaps it was because his talents lay in so many different directions that this brilliant young man was unable to decide on a profession. Photography became his main activity. In 1932, disgusted by the political atmosphere in Germany and driven by his longing for a life of total freedom, he went to Paris where he met Hans Arp, Fernand Léger, Nelly van Doesburg and the surrealist writers. He did little of importance: he sometimes played music in Paris society, he gave a few German lessons, he worked as a photographer when the occasion presented itself, and generally made the most of the artistic life of the town. In 1933 he felt a strong urge to travel. Setting off in an old car with a girl called Gréty, whom he later married, he drove to the south of France, on to Barcelona, and finally arrived in Majorca without a penny in his pocket. But life on the island was simple; their needs were small. Gréty found work as a dressmaker and Wols earned a little money as a chauffeur and guide. He still did not realize that painting was to be his vocation, but having lived in Dresden he had come into contact with Klee, the Bauhaus painters, Otto Dix, George Grosz, and others. After more than a year Wols and Gréty returned to Barcelona, and a difficult period began for them. Wols refused to return to Germany where he would have had to do military service, and as a result his passport was not renewed: he became an émigré. This situation was not without danger, considering that he was in Spain and that he was always extremely free in expressing his opinions; predictably, he was arrested at the end of summer 1936. He was kept in prison for a few months, and was finally deported to France on Christmas

Plates 6-11

6 WOLS. *On the Brink of the Abyss*, 1939. Watercolour, 31 × 22.8 cm. Collection Mme Gréty Wols, Paris.

7 WOLS. *The Spellbinder*, 1932/33. Drawing, 22 × 31.5 cm. Collection Mme Gréty Wols, Paris.

8 WOLS. *Nearby Star*, 1944. Watercolour, 16.5 × 13 cm. Collection Mme Monique Couturier, Paris.

9 WOLS. *Untitled*, 1942. Drawing, 18.5 × 27 cm. Collection Dr Elfriede Schulze-Battmann, Fribourg/Breisgau. Photo Krucker, Fribourg/Breisgau.

10 WOLS. *Blue Phantom*, 1951. Oil on canvas, 73 × 60 cm. Collection Dr R. Jucker, Milan.

11 WOLS. *The Drunken Boat*, c. 1945. Oil on canvas, 92 × 73.5 cm. Kunsthaus, Zurich.

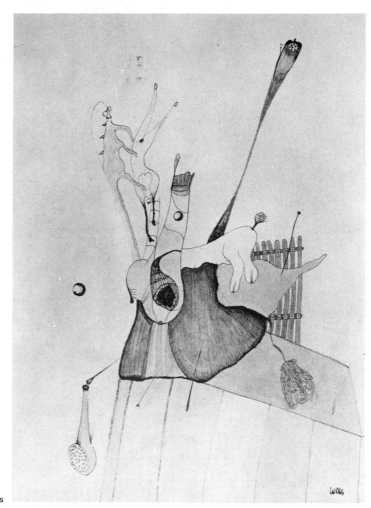

6 Wols

7 Wols

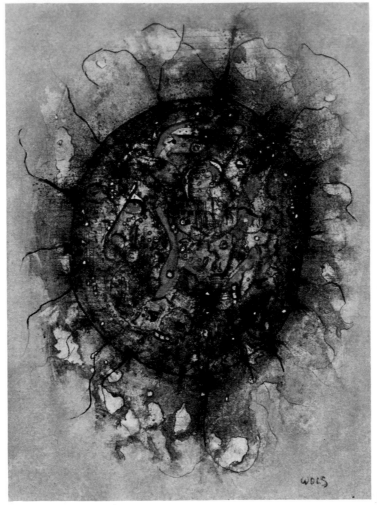

8 Wols

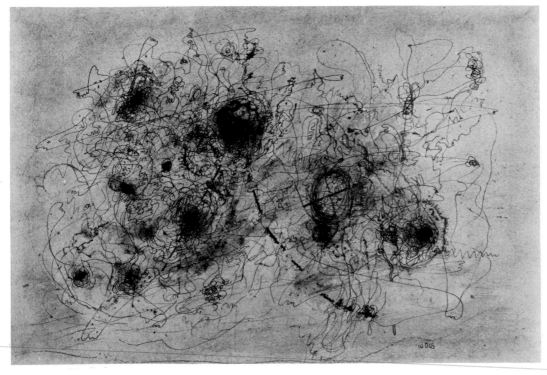

9 Wols

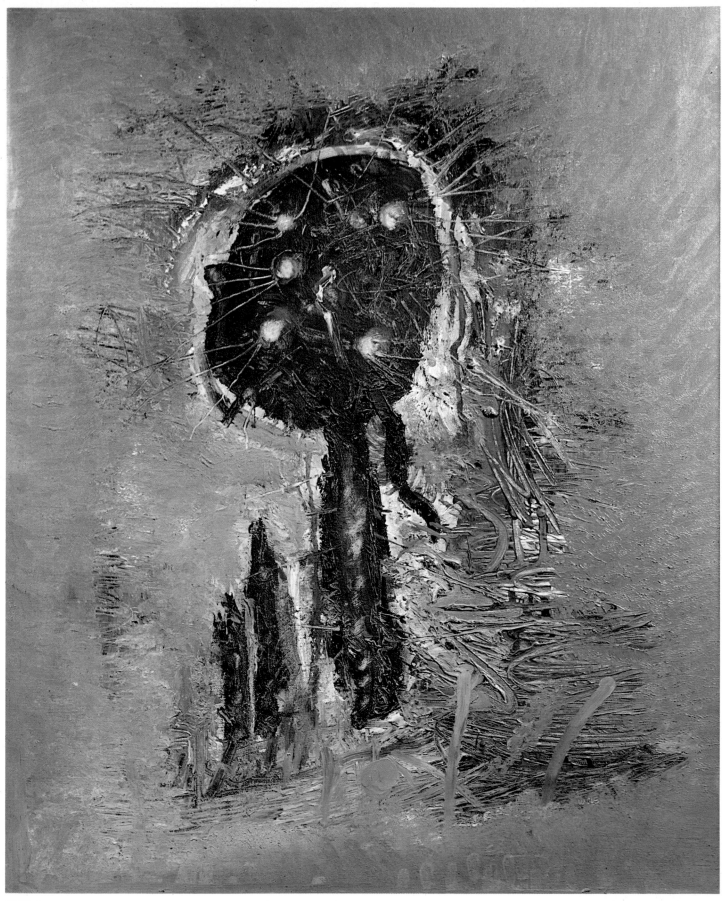

10 Wols

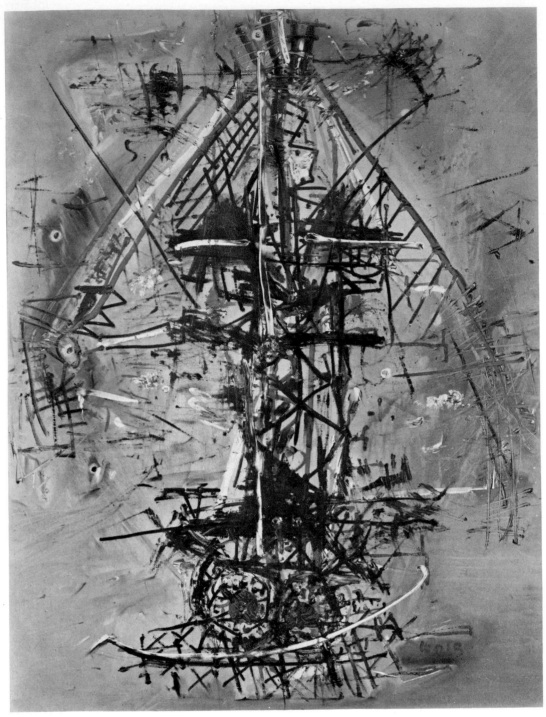

11 Wols

Eve. He was without money and, worse, without papers, but he managed to make his way to Paris and find Gréty there. Life in Paris in those days was far from easy, particularly without money or documents, and although Gréty managed to arrange things for him, Wols found himself obliged to report regularly to the police for the rest of his life. All the same, he was able to resume work as a photographer, and was even officially commissioned to photograph the Fashion Pavilion at the 1937 World Exhibition. In 1937 there was an exhibition of his photographs in a major bookshop on the Boulevard Saint-Michel. It was at this time that he took the name of Wols. Things were going quite well; painters and writers came to see him, and even André Gide used to drop in.

Then the war came. Wols was immediately interned and taken to a crowded Paris sports stadium, used as a clearing-house for prisoners, where he witnessed several suicides. For several months afterwards he was continually moved southwards from camp to camp. Now and then Gréty was able to take him some paper and paints. It was then, hidden in some far corner of the camp, that he began to draw ceaselessly – drawings which form a long and tragic personal record.

In the camp he began to take consolation in alcohol. None of his friends can remember ever having seen him eat. But he drank regularly, in small sips, and maintained a certain level of alcohol in his system without ever actually getting drunk. His daily ration gradually increased, and in the last years in Paris he was drinking two litres of rum a day.

He was released near Marseilles in spring 1940, and went to live with Gréty in Cassis, a little fishing village not far away.

The drawings he did in those years are remarkable. The earliest ones extant date from 1935. They are strangely grotesque with no element of light-heartedness. One of them [7] shows a jester; his legs grow like roots in the soil, a metaphor which occurs frequently in Wols's work. On the left of the drawing is the audience, a tangled, convoluted, viciously yelping little knot of people, and behind them, grinning out of the picture, towers a huge murderous face. A brilliantly drawn flying reptile passes over this eerie scene. Technically, the graphic detail is somewhat reminiscent of Klee; the knot

of people recalls Dix and Grosz. None of this is surprising, as Dix was teaching at the Dresden Academy when Wols was a schoolboy, works by Grosz hung in the local museum, and Klee was teaching not far away at the Bauhaus in Dessau. Wols's father, Chancellor Schultze, was the senior civil servant responsible for all these institutes, and although his main interest was music he invited many of the artists working at them to his house. Nevertheless the strange subject matter of these early drawings, and the half-conscious way Wols had of giving his imagination completely free rein, were his alone.

Every single one of the sketches he did in Spain has been lost, but there are quite a few extant watercolours dating from 1937 on. Many of these show strange, mythical beasts, festooned with all sorts of rags and tatters, which Wols has built up out of small crab-like legs – recalled perhaps from Mediterranean beaches. They are surrealistic in concept, although they clearly do not depict any actual object, and they are vaguely comparable to the figures which populate Tanguy's infinite landscapes, or to the playful inventions of the early Calder or of Giacometti. In other drawings, bristly, repulsive and rather obscene wormish creatures clown about on a vast landscape; often there is a single spectator, a tiny figure in a balloon. In later works, done shortly before the war, the atmosphere is more threatening. One of these watercolours [6] shows a ramshackle construction, made out of a variety of organic objects, standing poised over an appalling abyss under an endless empty sky; a ridiculous fragment of a fence seems to be supposed to shelter this unbalanced thing. On top of the shaky structure two grotesque acrobats are engrossed in their act, and the whole conglomeration blossoms out into a repellent bloom which is clearly derived from Klee's visionary flowers, but which has a nauseous air of evil. These watercolours reveal the subconscious preoccupations of this young painter: loneliness, fear of people and of a suspected hostility in inanimate objects, a sense that everything was suspended in a void – it was as if some vile exhalation were poisoning the beauty of the world. The whole atmosphere of these works suggests a creative affinity with Lautréamont, Rimbaud, Artaud and Baudelaire.

Then came the long months in the internment camps. Nightmare pictures appeared. They show endless spaces, here and there wired in with fences, nailed up by planks, barricaded by walls and rails; inside is a silent confusion of shapes. In these wastes there are terrifying visions: fantastic monuments fabricated out of animals' heads floating like captive balloons over the barren land, colonies of hopelessly entangled insects, fish bones which have been gnawed clean and seem to rustle along like centipedes. In a bleak landscape a single, rotting human figure lies like a fallen column. A huge lower jaw armed with vicious teeth lies somewhere; often an impaled kidney floats in an empty sky – both perhaps associations with Wols's own physical sufferings, for at that time he was tortured by terrible toothaches and kidney pains. In one picture a view of the camp melts into a ravaged human face, then stretches out to become the body of a horrifying multi-legged insect; it is as if the whole ghastly camp were one huge, vile louse.

In the earlier works these terrifying visions are described with a piercing exactness. Later the lines become more abstract, more flowing, and signs of automatism appear. Wols no longer drew from ready-formed images in his mind, but allowed fantastic visions to arise as he worked.

In 1940 he was freed, and he moved to the little fishing port of Cassis. He led a very poor life, but seems to have been content. The inlets in the cliffs down on the beach, the little hidden patches of sand between the bays, the quarries up in the hills – all these must have provided him with welcome retreats for his work or meditation. The strange forms and the bizarre Mediterranean plant and animal life which he found there clearly offered him an endless source of inspiration.

In this period his lines became even more automatic and somehow more searching, as if the psyche were gently putting out feelers. Visions which had come to him as he contemplated the rocks and cliffs were translated on to paper. The drawings and watercolours hover in a strange world somewhere between self-revelation and objective observation of nature. There are still horrific sights, spooky scenes created from the more grotesque shapes of nature. But there are also peaceable dreams – for example suggestions of a coastline out of which rhythmical forms rather like masts and tackle seem to grow, as if the whole island world were just waiting to drift off under a favourable wind. Sometimes these rhythmical forms cover the whole surface of the paper. They are drawn entirely under the control of some spontaneous inner vibration, but crystallize into recognizable objects: rigging, or masses of houses squashed together like an ant-heap. There are forms supported underneath by scaffoldings, balancing over ground which seems to be slipping away; one is faintly reminded of Klee.

This comparatively happy period ended in 1942. German troops occupied the whole of France. The south coast began to attract military interest, and Wols decided to move away from the trouble. He went further inland to the wide hill country of the Drôme and settled at Dieulefit, above Montélimar, where he found a deserted shepherd's hut. Here he used to sit leaning against the wall on a sack of straw, with his dog at his side, his bottle within reach, a few paints in a small box of watercolours, a worn-out brush and a rusty pen. From these wretched materials he created hundreds of watercolours, things of pure magic. Wols bothered about nothing around him, and Gréty had to take care of their most basic needs. If his spirit ration was not in its place he could become very unpleasant. He was in full control of his faculties, but entirely wrapped up in himself.

He often spent a whole day walking, looking at natural formations, always being more struck by the frightening ones. A broken fence or a strange bit of root could occupy him for hours while he assimilated all the poetic or associative possibilities which these fragments awakened in him. Later, when he was back dreaming on his sack at the corner of the house, these objects would float up from his subconscious. The broken bit of fence at the edge of a field would transform itself into mythical barriers, flaming gates which proclaimed that no one could pass through; they seem like metaphors for the impenetrable barriers that enclose man's life. The roots would come to form a procession of sinister, hurrying spirits. The vitality of roots, their serpentine twists, and their fibrous threads like flippers or feet on which they might unexpectedly escape – these made a strong and long-lasting impression on the imagination of the

artist. Wols was naturally inclined towards a sort of poetic animism, and it was perhaps inevitable that these images should eventually reappear on paper. In the evening the small pools in the valleys exhaled misty vapours, and Wols transformed them into swaying silhouettes. It was not that he had these themes ready-made in his mind; they would present themselves as he painted, groping their way out as his fingers moved gently over the tiny piece of paper. It was pure automatism, springing from a subconscious reserve which was filled with these poetic metaphors from nature. Pictures appeared that were somehow both hermetic and enlightening. One shows a round microcosm, suspended in nothingness, but filled with bizarre flora and fauna, a nest of miniature creatures waiting for birth – a metaphorical vision of a complete world that could, perhaps, be hidden in the tiniest seed [8]. There are also frightening erotic shapes: exotic blooms and a vagina are fused together into a singly bloody wound – the eternal wound of the earth which always haunted Wols, but which is here camouflaged by a sickly and morbidly beautiful efflorescence.

Hundreds of watercolours continued to stream forth. Describing their creation, Wols said that he would close his eyes and allow the images to form on his closed lids. From there they would be transcribed on to paper by his by now practised and extremely sensitive hand. These were the little leaves of paper which René Drouin, the Paris art dealer, saw early in 1945, after H.P. Roché had drawn his attention to Wols. Roché had been the only person in touch with Wols during those years, and he had watched him work with astonished admiration. Drouin immediately offered Wols an exhibition in his gallery, and invited him to come to Paris. At first Wols was reluctant, but he finally allowed himself to be persuaded to go there for a few days in the following December. Once there, finding himself back in the familiar atmosphere of the Latin Quarter, he stayed on. Drouin held the planned exhibition, but it caused no stir. Paris was still unprepared for such things. People were talking a little of Picasso, Matisse and Braque, but they still preferred Dunoyer de Segonzac. Klee was unknown. Kandinsky, who had been living in Paris since 1933, was known only to a few initiates, and was considered by most

people to be just a rather ludicrous Russian painter. The time was not ripe.

Wols rented a series of rooms in the small hotels of the Latin Quarter, miserable little rooms from which he was always evicted, after dreadful scenes, because he was unable to pay the rent. For days on end he would lie on his bed, thinking, painting, and taking no notice of the noise made by the rather questionable friends who came to visit him.

Late in the evening he would walk along the banks of the Seine with his dog, and visit his favourite trees which he would greet and talk to as if they were human. These nightly expeditions always ended in the Rhumerie Martiniquaise on the Boulevard Saint-Germain, where he would drink his evening quarter-litre of rum. The state of his health was deteriorating rapidly, the conditions in which he lived were deplorable, but he bothered about neither. This was his way of life when Drouin visited him and took him new canvases and paints.

In the winter of 1946-47 Wols made his last great creative effort – and turned a new page in the history of painting. These works were exhibited in early summer 1947. Their most obvious quality is the blurred and formless (informel) use of colour, and the restlessly searching brushwork. Sometimes the lines conglomerate or form into spirals suggestive of eyes; sometimes it seems as if an indistinct, even disintegrating human face is shapelessly peering out at the spectator – it is an image of decay, of mortality, of sinking into that state of non-being which Sartre has described. (Sartre was strongly affected by these paintings, and helped Wols several times when he got to the end of his means.) This subtle hint at the existence of a human face – a face which could be nothing other than a self-portrait – is not really an aberration; all the paintings produced at this time were basically self-portraits – not reproductions of his physical self, but expressions of his emotional state.

Painting has become a direct action, a record of the gestures of life, a choreography of its rhythms, the pulse of the artist. One of these canvases is covered with desperately circling knotted forms which twist together, then writhe around the point of contact as if they had been slashed by a

knife; a bloody red drips, trickles, then sprays across the surface. Across this bleeding creature Wols had repeatedly written the crazy refrain OUI OUI OUI, as if this were some magical formula designed to counteract the terrible decay.

This series of paintings reveals the use of techniques similar to Pollock's: trickling colour, paint sprayed on by the gesture of the arm. Sometimes comparatively familiar figures like the *Blue Phantom* [10] result. But at other times there will be a hideous festering wound which stares unflinchingly out of the painting like the lidless eye of a cruel god who is coldly presiding over the destruction of all sensuous life. These paintings really do record a human life and the moments of its existence in a script, formed by lines and coloured light, which registers the quivering of the artist's nerves in the very body of the picture.

Wols seems to have considered only the tensions of existence to be worth cataloguing in this way, and he therefore found it necessary to intensify them as much as possible by adding extra stimulus to his life – this was one function of alcohol. As with Pollock, this stimulation was tantamount to deliberate self-destruction; each painting extracted some of the artist's physical strength, each element of the work was created from his living tissue.

For five years Wols survived this slow suicidal sacrifice to his art. He died in September 1951 of ptomaine poisoning which his ruined liver was no longer able to counteract. He was thirty-eight. In the last years of his life he had done a final small group of paintings. Among them is the familiar and ever-recurrent image of the ship, but now the ship is a '*bateau ivre*', rolling violently, the tackle is in shreds, the mast in splinters [11]. The harmony of colours shows great beauty, but also great suffering.

These, then, were the paintings to be seen in Paris in 1947. Very few people grasped their significance, but these few people were deeply moved by the exhibition: among them was Georges Mathieu [s. 3].

It was Wols and Pollock who together began this radically new art movement, and its very essence is embodied in their work. They are 'primitives of a new sensibility' – a phrase which Cézanne once applied to himself. After the 1947 Wols exhibition, and as Pollock's paintings gradually arrived in Europe, the works of these two artists – which in both cases had sprung from a purely personal need – attracted strong and increasing admiration from the younger generation; they established the style which became the mainstream of art in the decade 1950-60. Because of their unprecedented acceptance of the terrible events of the desolate years before and during the war, the lives and works of Wols and Pollock seem to provide documentary evidence for that period. Pollock was rebellious, Wols passive and resigned; he merely recorded whatever happened to him – not the simple facts of his life, but the images which streamed from his wounded soul.

MARK TOBEY

Wols and Pollock were not entirely alone. As admiration for their work increased, other artists – some of whom had actually preceded them in experimenting with similar, if less spectacular, ideas – began to appear on the scene. One of these was Mark Tobey [12, s. 4].

Tobey was a West Coast American, from Seattle. Although he belonged to an older generation than Pollock (he was born in 1890), his work did not become known in America until after the war. It was not introduced to Europe until the 'Tendances actuelles' exhibition which Arnold Rüdlinger organized in Berne in 1955. Tobey had a remarkable gift for quiet meditation, and belonged to a Persian religious sect. He had lived for a while in a Japanese Zen monastery, where he learned about the ways of meditation that provide the spiritual and intellectual basis of Far Eastern calligraphy. This meditative calligraphy was the point of departure of Tobey's art. He created a fine, personal script, formed by small fragmented white strokes, which merely suggested rather than defined real objects; this he called his 'white writing'. Tobey believed that with this calligraphic script he could paint the noise and confusion of great cities. In 1936 his paintings of Broadway appeared – dazzling visions of the great street which emerge from a confusing mass of fine strokes. These paintings were done months after Tobey had last seen Broadway; they resulted from his reflective musings in the quiet of an English village.

In the following years his work became less and less figurative. From 1940 onwards he produced quiet,

gently moving pictures that are entirely abstract; yet some of them have titles like *Remote Field* [12], suggesting that they do ultimately originate from some visual experience. One is slightly reminded of Klee, but at that time Tobey knew nothing of him. After these paintings, Tobey's quiet art developed more in the direction of Pollock and Wols. In particular his few larger canvases show much that is comparable to Pollock, but they are entirely free from drama, and have only the living quality of the surface in common with Pollock's 'all-over paintings'. Other works show many amazing similarities to Wols, but there is no element of despair or sorrow, nothing disquieting, only serene thoughtfulness. Tobey's work shows how the desire for self-expression that compelled Pollock and Wols to paint can also be satisfied in a purely meditative way. It would be unjust to believe that Tobey was in any way influenced by these two painters.

WILLEM DE KOONING

Pollock soon found sympathizers in America who took up the expressive, dramatic qualities of his work. One of these was Willem de Kooning [13, 31, s. 5], who was a few years older (born in 1904). He developed the violent script of Pollock in several of his pictures. By the late 1940s he had reduced his palette to the dramatic contrast of black and white. Over a blackish background animated by patches and streaks of white light, the white brushstrokes form a powerful psychogram. The paintings are entirely abstract, yet they seem to have evoked visual associations even in the mind of the artist; some of them have been given figurative titles like *Night Square* [13].

In 1951 the *Women* series began – a theme to which de Kooning obsessively returned. Colour reappears with great expressive power. From the contrasting movements of form arises the figure of a woman – both daemon and erotic *anima*. This image was not copied from a model, but appeared during the act of painting itself. This woman-daemon seemed to force her way in everywhere, so that the painter was continually faced with a supernatural rendezvous. Her sinister presence gives the paintings an uneasy atmosphere, as if some secret horror hovered in the background.

FRANZ KLINE

In 1950, during the period of de Kooning's and Pollock's great black and white paintings, a new name appeared: Franz Kline [32, 112, s. 6]. It was in 1950 that Kline (b. 1910) began to paint his first really large canvases, with their heavy black signs against a white background. They were exhibited in New York later that same year. Although they may remind one of the characters of Oriental writing, these spontaneous signs are a purely personal expression. A large format was needed to produce them, so that the explosive movements of the body could intensify the force of the brushstrokes. The surface of the canvas came to represent an enormous space, closing in oppressively like some cosmic being; it is in order to support this weight that the sturdy framework of lines has been erected. One of the forms most commonly used by Kline is a powerful beam which incorporates all forces of supporting and falling, of pushing and pulling. Right up until his death in 1962, he continued to produce increasingly large variations of this simple but powerful shape. It was adopted by many European and American painters.

HANS HARTUNG

In Europe after the war, as in America, the new style of painting quickly won its adherents. Here too it had its forerunners whose importance was not recognized until 1947, when they quickly became associated with the new movement – although in some cases all they had in common with it was the extremely personal quality of their work. One of the most important of these was Hans Hartung [14, 15, 107, s. 7].

Hartung was, like Wols, a German émigré, but having been born in 1904 he was nearly ten years older than Wols. Their tragic lives had much in common. Hartung emigrated to Paris in 1935, and lost a leg when he served as a volunteer in the Foreign Legion during the war. He was unable to take up painting again until 1945.

Long before the war he had been exploring much the same possibilities as Wols. Right back in 1922, encouraged by the example of Kandinsky and Nolde, he began a long series of watercolours [14] in which he translated psychomotor energies into concrete forms. These watercolours may

even constitute the first embryonic stage of the new style. Working very methodically, he continued these experiments, and by shortly before the war he had found his own personal means of expression. In these paintings a vague yet spatial atmosphere is created out of diffuse patches of colour. This atmosphere contains a sort of tense energy which is expressed graphically in patterns of lines: one exploratory line feels out the way, elsewhere a whirling knot of lines shows that some conflict is taking place. Because of this transformation of emotional energy into graphic form, Hartung's way of painting at this time can be called psychic improvisation. After 1946 the improvisatory quality became much stronger, and colour began to play a more active part. On an expressive background of colour appear energetic complexes of strokes which have a peculiar dynamic expressiveness of their own. Sometimes the strokes play lightly over the surface, or they can plunge hesitantly and jerkily down into the colour; they can be swift or slow, feverish or indecisive. These variations in movement allow the psychomotor energies to be directly transcribed. The creative process can be clearly seen – the whole drama of the picture is preserved in the changeability of these strokes; if the spectator allows his eye to follow them, they seem like an eloquent script which tells of all the tensions and conflicts that created it. But in order to produce the careful arrangement of the finished work, the improvisation – which at first was allowed total autonomy – is taken under very strict control. It is this method that differentiates Hartung's work from that of Pollock or Wols. In the decisive years, however, this difference seemed almost irrelevant, considering that these three painters shared a conception of the picture as psychic improvisation, and of the painting process as a direct gestural action: Hartung was included in the very first exhibitions of the developing movement.

JEAN FAUTRIER

One painter of French origin who can be considered an early representative of the new style is Jean Fautrier [16, s. 8]. Fautrier (b. 1898) became known in 1945 through his *Hostages* exhibition at the Drouin gallery, an exhibition which gave Paris its first chance to see gestural

Plates 12-23

12 MARK TOBEY. *Remote Field*, 1944. Tempera, pencil and charcoal on cardboard, 71.4 × 76.5 cm. The Museum of Modern Art, New York. Gift of Mr and Mrs Jan de Graaff.

13 WILLEM DE KOONING. *Night Square*, 1950/51. Oil on masonite, 76 × 101 cm. Martha Jackson Gallery, New York. Photo Schiff, New York.

14 HANS HARTUNG. *Aquarelle*, 1922. Collection of the artist.

15 HANS HARTUNG. *T 1948-19*, 1948. Oil on canvas, 97 × 130 cm. Collection J. J. Sweeney, New York.

16 JEAN FAUTRIER. *Sarah (from the 'Hostages' series)*, 1943. Oil on canvas, 116 × 81 cm. Collection M. Couturier, Paris.

17 JEAN DUBUFFET. *Business Lunch*. 1946. Oil on canvas, 89 × 116 cm. Private collection.

18 JEAN DUBUFFET. *Dancing Earth with Mist*. 1952. Drawing in India ink, 50 × 65 cm. Private collection, New York.

19 JEAN DUBUFFET. *Flowers and Soil Viscera (Topography)*, 1958. Oil and collage on canvas, 89 × 116 cm. Private collection, Paris.

20 ANTONI TÀPIES. *C. 89 Grey Ochre Square*. 90 × 90 cm. Private Collection, Johannesburg.

21 ALBERTO BURRI. *The Real Umbria*, 1952. Oil and burlap, 100 × 150 cm. Private collection, Brussels.

22 K. R. H. SONDERBORG. *10.VIII.58,19.27 to 21.30*, 1958. Tempera, 108 × 70 cm. Collection Otto Preminger, New York. Photo O. E. Nelson, New York.

23 GEORGES MATHIEU. *The Capetians Everywhere*, 1954. Oil on canvas, 295 × 600 cm. Musée National d'Art Moderne, Paris.

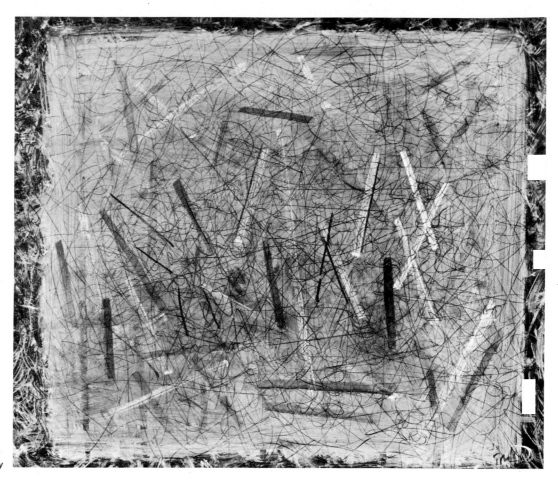

12 Mark Tobey

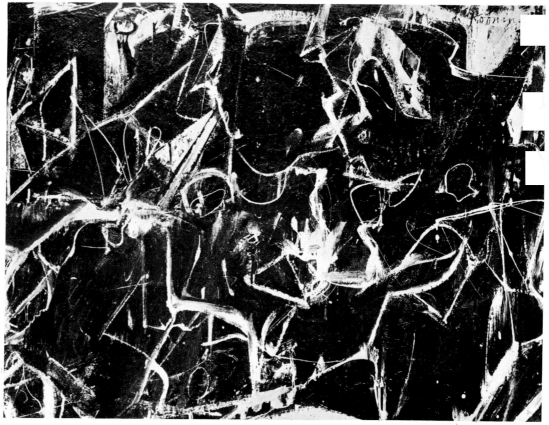

13 Willem De Kooning

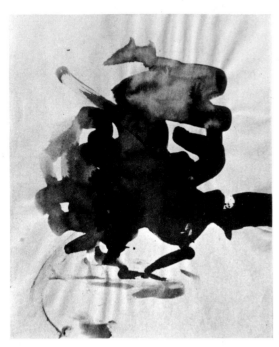

14 Hans Hartung

15 Hans Hartung

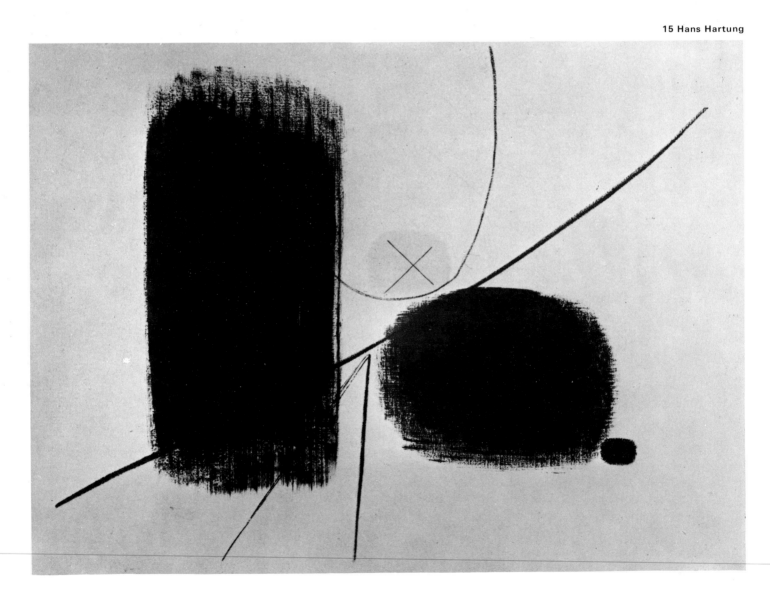

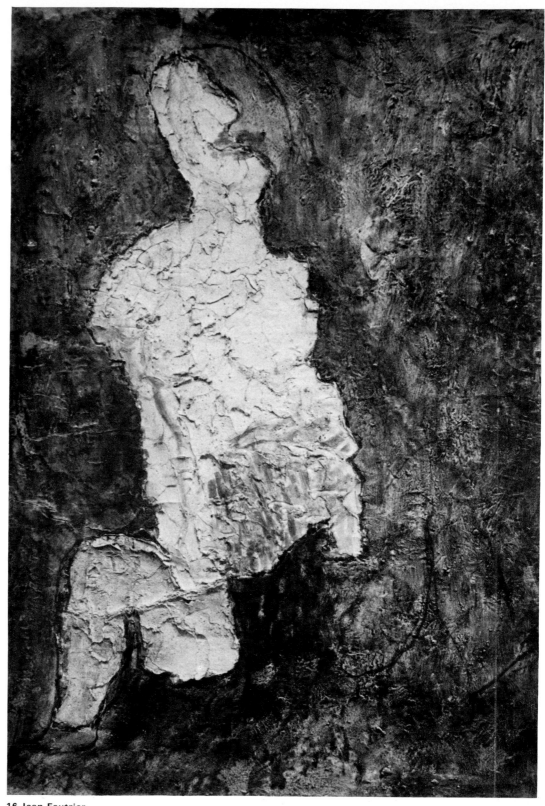

16 Jean Fautrier

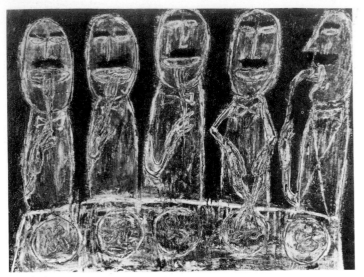

17 Jean Dubuffet

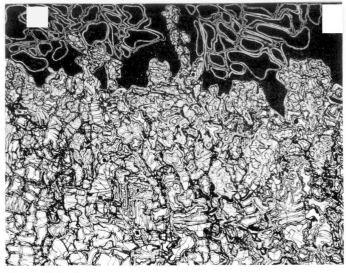

18 Jean Dubuffet

19 Jean Dubuffet

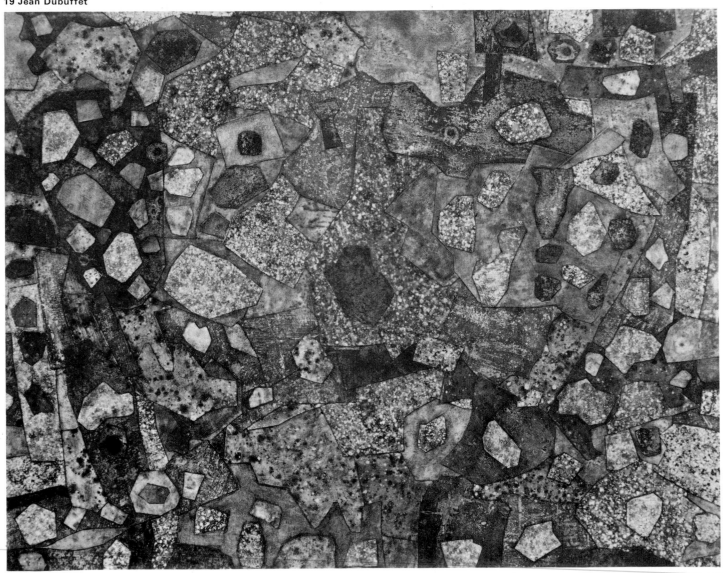

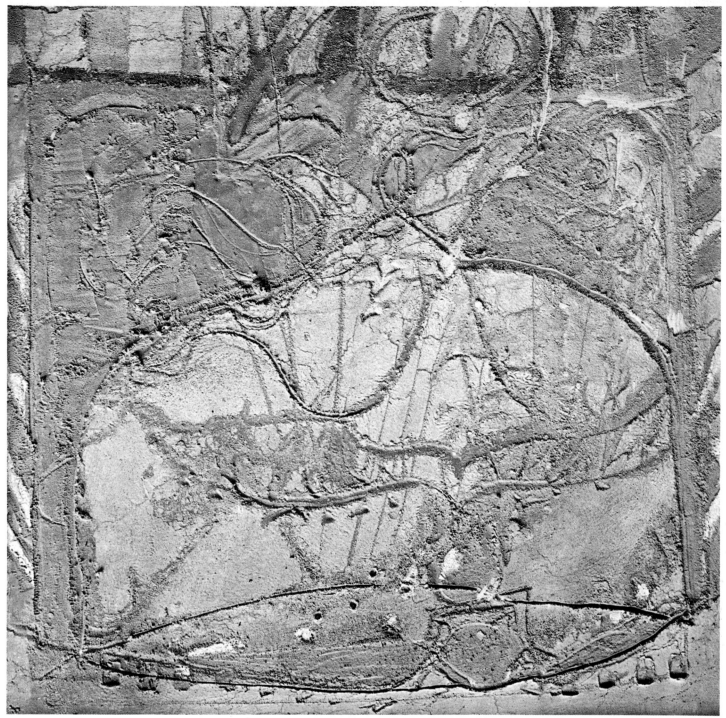

20 Antonio Tapies

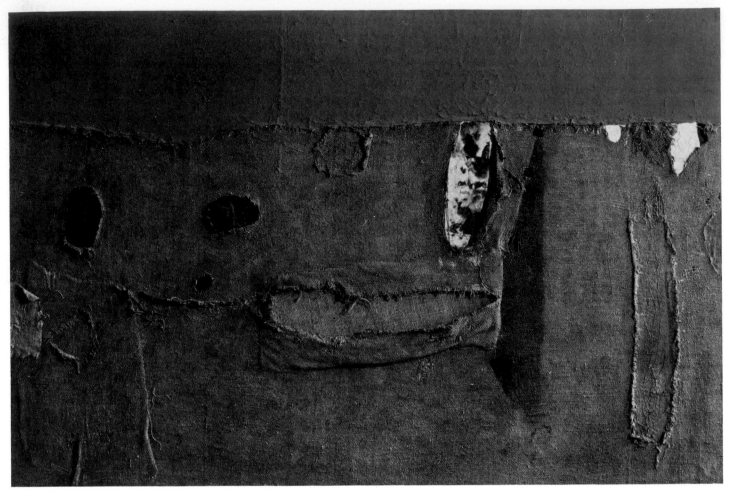

21 Alberto Burri

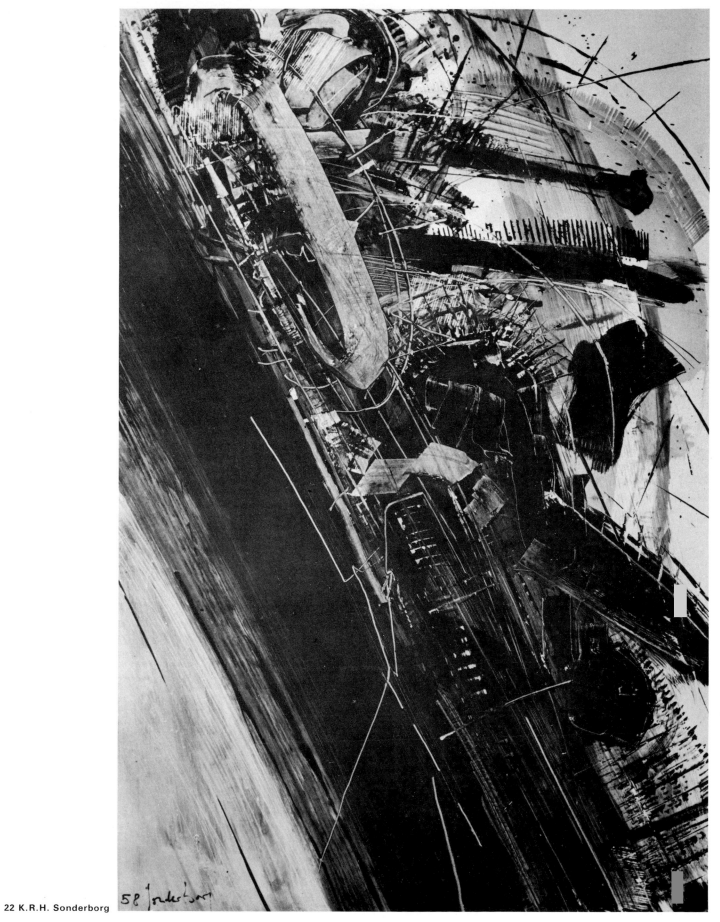

22 K.R.H. Sonderborg

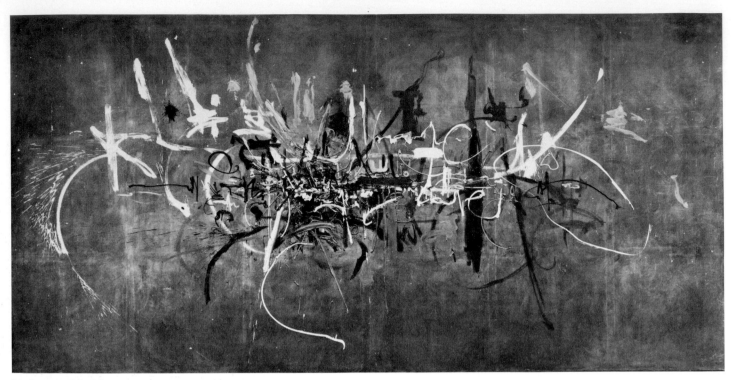

23 Georges Mathieu

abstraction. In 1928-29 he was under contract to Gallimard to produce a series of lithographs to illustrate Dante's *Inferno*. Their drifting lines, and fleeting, scarcely recognizable shadow-like figures, seem to anticipate *art informel*. But nothing followed, and in 1934 Fautrier gave up painting. Taking it up again in 1940, he began to do simple, dark, figurative paintings. In 1942 this figurative quality disappeared, and the texture of his paint became thicker and strongly evocative.

He began the *Hostages* series in 1943 [16]. These figures emerge from a thick paste made out of paint mixed with cement and plaster, and applied with a palette knife. Using these materials, he changes the surface into a highly suggestive area covered with plastic patches of colour which protrude like islands from the light, almost transparent background. Out of this evocative surface, out of the very structure of the material, vague figures appear like suggestions of tragic heads and faces – but if one tries to focus on them more clearly, they disintegrate and fade back into their dim colours. This technique of allowing the material to speak for itself was not in fact new. Paul Klee had been using it repeatedly as a stimulus to the imagination since 1915; Baumeister and Winter had used it frequently in the 1930s. But in Paris in 1945 it was new and unexpected. The terrible experiences of the war had prepared the public to understand and accept the deep grief which emanates from Fautrier's small, sad icons. The *Hostages* drew the attention of the Paris school to the evocative potential of the material itself, and to a conception of the actual surface of the painting as a field for irrational inspirations and poetic insights. Fautrier's work also helped to end the predominance of late cubism and of geometric abstraction. Yet he never succeeded in developing beyond his original themes and methods, so this sensitive beginning never realized its full potential. In 1945 he replaced the abstract heads and faces with objects, nudes, and landscapes; these too are only just to be distinguished, lurking in the actual material, and without their titles they might be quite unrecognizable.

In 1949 Fautrier again stopped painting. When he began again in 1954, the climate had become very favourable to gestural abstraction, and Fautrier's work rose to great but perhaps exaggerated

fame. Skilful presentation even allowed him to appear for quite a while to be the real initiator and master of *informel* painting. But even his later and larger paintings just repeated the old theme that he had created in 1943; they are pretty and sensitive, but very slight.

JEAN DUBUFFET

Dubuffet [17, 18, 19, s. 9] explored deeply all the possibilities offered by Fautrier's technique. Born in 1901, he began in 1942 to paint after a very long interruption, and in 1944 he showed a group of these new works in the Drouin gallery. They were pictures of old houses, still-lifes, figurative scenes, all drawn as if by a child, in the way of naive painters. This technique, which he called *maladresse antiplastique* ('antiplastic clumsiness'), was certainly influenced by Paul Klee. In 1946 Drouin held a second exhibition. Its title, 'Mirobolus, Macadam & Co.', suggests the billboard of a conjuror setting up at a suburban street market, and these pictures do indeed display a remarkable combination of magic tricks and disarming naivety. It is as if they have turned their backs on culture. The surface consists of a thick plastic mixture of glue, sand and asphalt. Dubuffet probably learned this 'high impasto' technique from Klee and Fautrier, but he used it for an entirely different purpose. With their roughly modelled shapes, accidental scratches, and apparently aimless patches of colour, these paintings seem like old weathered walls, in whose cracks and crevices we like to imagine all sorts of strange images. It was in response to just such suggestions that the painter used to work on the wall-like surface. From the murky, formless background would emerge grotesque heads, masks, figurines, droll landscapes with droll inhabitants. Little matchstick men stroll across the picture and turn it into a gay children's world. Dubuffet's scratching technique is like the direct and naively inventive style of children, amateurs, psychic mediums and lunatics – all of whose work Dubuffet, like Klee, had studied carefully. In *art brut* ('crude art'), his own term for this unsophisticated painting, he found an analogy and an inspiration for his own particular method of creating pictures.

These strange figures and scenes belong to that category of images which are present in everyone,

but which rarely emerge from the subconscious. Our eye constantly presents us with a multitude of observations and sensations which, because they are banal and of no actual use, are condemned to silence by the selective process of the brain. But they can suddenly strike a chord in the irrational depths of our psyche, or gradually develop into a poetic metaphor that provides us with sudden enlightenment. For example, our eye may pass swiftly over the wall of a house and pause for a second to look at its cracks and patches – and suddenly we may see a striking metaphor for the passing of time and the transient nature of life. A few steps farther on we may find a little matchstick man, scribbled on the wall by some child, and it awakens a poetic image of our childhood. A dried-up puddle or a lump of earth on our path seems suddenly to reflect the tired face of the earth; even a broken stone can make us think of the sad history of our slowly cooling planet. All such optical experiences arouse insights which seem to demand poetic expression, but they get forgotten or pushed aside as soon as our conscious self intervenes. In an attempt to stir up this reserve of strange and wonderful images, and to capture and prolong these fleeting poetic visions, Dubuffet tried to create conditions on his canvas that would provide the eye with similar sensations, and provoke similar responses. He worked, kneaded, scraped and scratched his surface until it acquired the same evocative character as that once-seen and long-forgotten wall which had first called forth the image of time passing. He would crumble up his materials, smear them around, or allow them to dry until the wrinkled face of the earth or a prehistoric landscape seemed to appear in the plastic surface. Once this association had become clear he would manipulate it consciously and with the help of refined techniques; the poetic vision could not be lost again.

Whole cycles of paintings were produced by this evocative method. In 1947 and 1949 Dubuffet made long and productive journeys through the Sahara, and was deeply impressed by this primeval landscape which was formed by nothing but the forces of the earth, the wind and the sun. His droll little figures disappeared. A cycle of paintings dedicated to the loneliness of the earth was formed out of sand, glue, and plaster. In 1950 he began the series *Corps de Dames (Female Bodies)*, shapeless figures which emerge from the clayey background like personifications of the earth's fruitfulness, comparable to prehistoric fertility idols. In 1951 followed the long series *Soil and Ground* and *Radiant Land* which Pierre Matisse exhibited in New York in March 1952. The carefully worked backgrounds suggest geological structures, cross-sections of the earth, fossil forms. This prepared landscape is then peopled with various passing creatures – friendly animals and nice little men. The poetic content always stresses the subterranean element; it is a solemn eulogy of the earth. The themes are reminiscent of Max Ernst's *Natural History*, and it was from him that Dubuffet learned some of his techniques. All sorts of casting, stamping, pressing and rubbing procedures were used to produce a background which is richly suggestive of images.

In 1956 Dubuffet adopted a new technique [19]: he cut painted canvases up into various little shapes like stars, circles, or lozenges, then stuck them on to another canvas as if he were making a mosaic, allowing the arrangement to be automatically determined by the suggestions they aroused. The results were like star-strewn meadows, gardens of paradise, pure dream landscapes. After this series Dubuffet turned his attention to other creative problems not directly connected with the theme of this chapter.

Whatever image his painting might suggest, and whichever technique he used, the poetic metaphor is always called up by the evocative power of the actual physical material. This material transforms the surface into a field which is rich in images, and allows sensations to surface that are suppressed during the everyday act of seeing. Although there is no representational intention, the suggestive power of the material frees the creative imagination and allows it to conceive images never seen before, totally strange. It was looking at Dubuffet's work that Michel Tapié thought of the phrase *un art autre*. The term is meant to cover a radically new, and hence 'other', type of painting, free from all classical rules and traditions, and concerned only with elements that are stimulating, unexpected, even revelatory; this is a concept which is basic to all gestural abstraction. In a lecture in 1951, Dubuffet expressed his intentions as follows:

'Art, as I understand it, consists essentially in externalizing the most intimate variations of mood'; his painting was intended 'to make those truths which exist in our psyche visual and concrete'. Dubuffet's art was widely influential, and among younger painters he is now regarded as one of the most exciting artists of the post-war years.

HENRI MICHAUX

In 1945 Dubuffet had met the poet Henri Michaux [111, s. 10], and from then on Michaux circulated in the group around the Drouin gallery. He had begun to draw in an attempt to break through the barriers of verbal language and to express the many things that elude it. These sketches are covered with rhythmical patterns of delicately contrived graphic signs like small ideograms or tiny calligraphic psychograms; they are like poetry made visual. Michaux regarded these fragmented and fragile little signs as a means to reaching those vibrations of the mind which are inaccessible to words – as a new means to recording the subtleties of the psyche. He experimented with mescalin and all sorts of other drugs, trying to reach a state of heightened sensitivity, and then to transcribe this state into visual psychograms. In 1951 his book *Mouvements* appeared in Paris. Its many pages were covered with completely abstract signs, interspersed with a few lines of poetry. This book, by a highly articulate poet, enables us to study and come to understand the necessity of this psychic calligraphy. In his own hermetic terms Michaux describes the mental state which produced the new means of expression: it was a desire for new ways of communicating the multifarious emotions which man experiences during his lifetime. This poet-draughtsman represents the creative desire for self-expression at its extreme: he is little more than a sensitive human recording-instrument.

ANTONI TÀPIES

As previously stated, one of Dubuffet's basic concerns was to allow the plastic material itself to speak. In this connection one can mention a young Catalan painter, Antoni Tàpies (also known by the Castilian version of his name, Antonio Tapies). Born in Barcelona in 1923, he moved to Paris in 1950, and in 1954 his paintings began to attract considerable attention [20, 117, s. 11]. Their wall-like surfaces remind one of Dubuffet, but whereas Dubuffet's imagination produced all sorts of naive narrative scenes with landscapes and various burlesque figures, Tàpies's paintings are completely self-contained. They are austere, reserved, solemn, and have a certain Spanish *grandeza*. By using plaster, glue, and sand, he raises his surfaces into gritty, stratified relief. The rises and dips give the surfaces a peculiar tactile quality. Here and there Tàpies splits the top coating of mortar and scrapes through to the layer of painting underneath; or he bores holes into it, or scratches linear signs, rhythmical patterns, cryptic symbols; then, using thin paint, he sets a colourful seal on the gritty, dry background. All this makes the surface strongly evocative, but it never has the provocative quality of Dubuffet's *art brut*. Tàpies's pictures have a reserved beauty, a quiet charm, which greatly increases their meditative quality. The firm background is like a wall which is hiding some wonderful secret – an infinite, magical space which occasionally lets itself be glimpsed through the openings in the surface. They are, almost literally, walls of meditation. They release their poetic message 'when the dull, sluggish material begins to speak with its incomparable force of expression' – this is how Tàpies himself has described the magic of this style.

ALBERTO BURRI

Once the eloquence of various inorganic materials that have no connection with art has been recognized, then they can almost be used in their natural state as a means of expression. In about 1952 the works of an Italian painter, Alberto Burri (b. 1915), became known [21]. They are assembled from nothing but rags and bits of old sacking. Although they are reminiscent of the collages of Schwitters and the dadaists, they have a real pathos of their own. The torn and patched bits of sacking form a desolate expanse. Threads and cords fasten the miserable tatters together. Here and there a seam has burst and red paint trickles like blood out of the body of the picture. Where rotting or a burn has made a hole, a gloomy background is revealed. As in Tàpies, the tissue of the surface seems to be trying unsuccessfully to hide some-

thing – a terrible wound or some incomprehensible danger. One painting of 1954 is nothing but a large dark area with a fragile bit of sacking stretched so tightly across the centre that it looks as if it will tear apart. A few taut, thin threads pull this hopelessly overstrained rag towards the edges of the picture as if its few remaining shreds were still trying in vain to hide something which was inescapably approaching – endless space, some eternal void.

In their own way these paintings define that metaphysical *Angst* which was so widespread in those post-war years, and which made existentialism the dominant philosophy of the period. Indeed, existentialism, which J.-P. Sartre expounded from the hermetic philosophy of Heidegger and made more easily comprehensible through his literary works, can be regarded as the true intellectual basis of the whole art movement with which we are here concerned.

K.R.H. SONDERBORG

Tàpies was Spanish, Burri Italian – proof that the new style had gradually spread to other centres of art. The extent of its influence cannot be described here, nor its many adherents be listed, but mention should be made of the German painter K.R.H. Sonderborg [22, 115, s. 12]. Sonderborg (b. 1903) lived in Hamburg, and although his work was perhaps slightly influenced by Julius Bissier it developed quite independently in a way that was similar to these other painters, yet very personal. In 1950, the same year as Kline, he began to do small ink drawings which translated the automatic movement of the hand into dynamic forms. Slowly he moved on to larger formats. In contrast to Kline's sombre structures, Sonderborg's graphic signs seem to be aiming for a lightening dynamism. The principal shapes are diagonals, drawn with a swift gesture, that give an impression of great speed. Small kinetic signs beat to a fast rhythm. The swift pulsation and the energetic movement of the spatial image indicate a sensitivity to the factors of modern life – speed, the conquest of space, the extraordinary perspectives of technological thought. Sonderborg's automatic improvisations do not originate from comparatively passive emotions; they are aggressive responses to the new realities of life which we are only slowly beginning to grasp, direct reactions to the creations of technology.

GEORGES MATHIEU

One French painter who did more than any other to further understanding of the new movement was Georges Mathieu [23]; he was also the first to recognize and point out the artistic correlations described in this chapter. Gestural abstraction culminates in his work, but at the same time it seems to discover new possibilities. Mathieu was a friend of Wols, and organized the first exhibitions of the new group of painters. As early as 1948 he established a tentative relationship with the American group. In his many articles and books he elaborated the theory of the new painting which he had called *abstraction lyrique*.

His own painting at first followed quite deliberately in the steps of Wols, whose works had had such a staggering effect on him when he saw them in Drouin's 1947 exhibition. But shortly afterwards he began to work out his own style – a sort of 'action painting' inspired by Oriental designs, which left capricious patterns on the white surface looking as if an arabesque had been danced over it.

He believed that the spontaneity of the psychic improvisation was determined by the speed of the act of painting. In Tokyo he once painted a canvas more than twelve yards long in less than twenty minutes. Many people would regard such an enterprise as mere clowning, but the important thing about it is that the speed of the creative act makes it possible to avoid conscious control – normally very difficult – and keeps the painter in unbroken contact with his inner impulses; these are then recorded on the canvas like the tracing of a rhythmical dance. Speed also imposes extreme tension on the painter and drives him to take great risks. In order to stimulate himself and to heighten this tension as much as possible, Mathieu used sometimes to paint in front of crowds of people. Meditation, concentration, speed and improvisation are the methods of his art – but its intellectual premises are daring, abandon, and hallucination. There are three concepts which return regularly and give a certain continuity to his work: *le jeu, la fête, le sacré*. It is round this triad of the playful, the festive and the sacred

that his imagination plays. The first concept, the playful, meant for him gratuitousness, but also boldness and audacity. The festive signified the artful and artistic celebration of life. The sacred he interpreted as a ritualistic honouring of the endlessness of the universe and the boundless power of memory. It is memory that is revered in Mathieu's paintings, paintings to which he liked to give titles taken from French medieval history, like *Homage to the High Constable of Bourbon* or *The Battle of Bouvines*. He studied contemporary philosophy, mathematics and physics, and all the wonder that the universe inspired in him was expressed in the interaction of light and colour, the areas of moving space, the dynamic rhythm of his drawing as it disperses or converges. When working he would first allow his feelings to build up. Then, faced by the liberating emptiness of the canvas, he covered it with fleeting arabesques like personal signatures which, if the painting succeeded, left behind a splendid and audacious pattern which represented his liberation from *Angst*. It is this aspect of his style which makes it like some grand decorative scheme, but it nevertheless retains its own peculiar meditative quality; it is rather like the painting of the age of Louis XIV, which Mathieu so much admired.

This style of gestural abstraction, which we have tried to define through the works of its main exponents, attracted many disciples who continued to develop it for several years before abandoning it to follow other fashions and new artistic trends. As a style it now seems to be finished. It provided a means of expression for some of that generation of artists who are now fifty or sixty years old, and it was obviously connected with the terrible experiences many of them had lived through. The picture was for them a theatre for the expression of passionate emotion, a place where they could literally 'write from the soul' and free themselves from the experiences which obsessed them. The power of the painter, and the extent to which his whole personality was involved, determined his ability to make these visual records of his gestures into a true expression of his emotional life. Pollock, Wols and Hartung all achieved this total involvement; with the first two it actually led to self-destruction. It was this involvement that gave their work its dazzling persuasive power and made it so amazingly effective that it influenced the painting of the whole world.

This effectiveness will remain even after the whole school and its followers has disappeared. It will show what this generation suffered in a world which it had not asked for and which it could not change, a generation of artists that was lost and betrayed right from the very start, and that could do nothing but remain separate and let each individual lead his own solitary life. There was no easy friendship for these painters; that is why their group spirit was so fragile, and why any description which tries to define that spirit must be very inexact. Really they exist only as solitary individuals.

Abstract Expressionism

IRVING H. SANDLER

During the 1940s and 1950s, a group of New York artists, now known as abstract expressionists, painted the most vital, radical and influential pictures of the time. Most had begun their careers during the preceding decade, the period of the Great Depression at home, and of Hitler's rise to power, the Spanish Civil War, the Moscow trials, the Nazi-Soviet Non-Aggression Pact and the outbreak of the Second World War. These economic, political and social disasters shaped the aesthetic viewpoints of American artists in general, and during the 1930s motivated most to work either in 'social protest' or 'regionalist' manners; the one issuing from leftist dogmas, the other from the rightist, isolationist ideology.

Given the temper of the Depression decade, it was natural for social protest and regionalist styles to grow in importance, styles whose aim it was to communicate social ideas to a mass audience; their form was consequently an easily understood figuration. It was also natural for artists intent on producing propaganda to revile experimentation with difficult avant-garde ideas. Yet an increasing number of young artists, relying on their eyes, saw that American realist pictures of the 1930s did not stand up against modern European paintings. They began to realize that what was good for political causes was not necessarily good for art, and that art which ignored the freshest ideas of the time – those originating in Paris, the vital hub of global art – could only be stale to begin with.

The problem for these young artists was how to overcome provincialism and to assimilate the traditions of modern art. To solve it, they began a transatlantic dialogue with living masters abroad. Of inestimable help were the modern paintings and sculptures being amassed by the Museum of Modern Art, A.E. Gallatin's Museum of Living Art and the Museum of Non-Objective Art (now the Solomon R. Guggenheim Museum). Younger artists also learned about twentieth-century developments from such teachers as Hans Hofmann. To keep up with the latest trends, vanguardists pored over French magazines, notably *Cahiers d'Art*. Having rejected retrogressive realist styles, a number, who organized themselves into a group known as American Abstract Artists, were drawn to antithetical tendencies – non-objective, structural and concerned with formal values. As a result, they found the geometric variants of cubism – neoplasticist, constructivist and Bauhaus – the most congenial. Surrealism was spurned because of its reliance on literary themes, outworn, old-masterish rendering, and deep illusionistic space. American modernists were intent on catching up with the European avant-garde, and by 1940, they had succeeded. But in the process, they produced work which was largely derivative and eclectic. This led to the decline of the American Abstract Artists group. Another cause of its eclipse was the change in the intellectual climate generated by the Second World War.

Geometrical abstraction tends to be a rationalistic and idealistic art. It attracts artists who aspire to the simple, pure, essential and universal, and who, when they do think in social terms, assume utopian positions. Such values lost their credibility during the early 1940s. The war threw into sharp relief the dark side of man as inherent to his being. A small number of New York painters, including Arshile Gorky, Jackson Pollock, Mark Rothko, Adolph Gottlieb, Robert Motherwell and William Baziotes, felt, as Motherwell put it, ill at ease in

the universe. This caused them to become 'rebellious, individualistic, unconventional, sensitive, irritable' – to assume a romantic stance. Unlike the geometrical artists, they came to value the personal and the subjective, relying on their particular experiences and visions, no matter how private or indecorous so long as they were intensely felt.

Unwilling to continue existing modes, the New Yorkers faced what they referred to repeatedly as a 'crisis in subject matter'. As the phrase indicates, their preoccupation was with *what* to paint rather than with *how* to paint. Indeed, as late as 1948, when Baziotes, David Hare, Motherwell, Rothko and Clyfford Still organized an art school, they called it The Subjects of the Artist, at the suggestion of Barnett Newman.

The urgent need for a new content led these artists to re-evaluate surrealism. They were now drawn to its stress on meaning, at once humanist and irrational. However, they were unimpressed with surrealist pictures, which, with the exception of Miró's and Masson's, they found lacking in aesthetic quality. They had seen enough of these works in local museums and galleries to be familiar with them, but the surrealist *state of mind* remained largely unknown. The war changed that, for, with the occupation of Paris by the Nazis, leading artists who lived there, including André Breton, Marc Chagall, Salvador Dalí, Max Ernst, André Masson, Matta, Yves Tanguy and Pavel Tchelitchew, fled to New York, enabling artists there, through personal contact, to assimilate their creative spirit. The fall of Paris had another effect; the city was cut off from the world, and American artists, who could no longer look to it for ideas, became increasingly self-assured and independent and were motivated to develop original styles. Because of that and the large number of artists in exile residing there, New York became the capital of world art.

Abstraction had become too intrinsic to the culture of the New York painters for them to accept the academicism of a Dalí or a Tanguy, which entailed no new ways of seeing. But they did adapt the technique of automatism, promoted by Matta, as surrealism's most liberating innovation in that it enabled the unconscious mind to speak freely. Automatism had been widely practised during the initial years of surrealism, but it was generally abandoned for what Breton termed the 'reasoning stage', particularly during the 1930s. The New Yorkers returned to the earlier emphasis, attracted by the freshness and viability of the technique and by its tendency to yield abstract and biomorphic images. They felt that organic as opposed to geometric forms suggested life, both inner and outer, in all its rich, changeable and ambiguous variety, and so pointed to a new humanist content.

The New Yorkers, reared in the traditions and values of modern art, were far less anti-aesthetic on the whole than the surrealist émigrés, who exploited art as a means of provoking psychic and social revolution and who ridiculed artists who sought for aesthetic quality. To Gorky, Pollock, Hofmann, Motherwell, Willem de Kooning, Baziotes, Rothko and Gottlieb, painting had to be 'plastic'. Indeed, a primary problem for them was to paint spontaneously and directly while at the same time cultivating the pictorial values which are threatened by this method – the structural cogency and painterly finesse that they admired in the canvases of Picasso, Matisse, Mondrian and Miró, from whom they derived their conception of a modern picture and the sense of how it should project.

Arshile Gorky's career [24, s. 14] typifies the change in attitude of the New York vanguard from the 1930s to the early and middle 1940s, the shift from abstract cubism, imitative of the School of Paris, to an original variant of abstract surrealism. His canvases executed from 1942 to 1948 (the year of his death) are the first by an American which do not appear to be provincial adaptations of European styles. During that period, Gorky looked for inspiration into his inner world and out at nature instead of at the pictures of others. In his mature work, he improvised in a free-association manner with observable phenomena to invent a new order of organisms which Breton called 'hybrids', amalgams of human, animal and plant parts. Gorky's flowing lines and plumes of colour, which suggest rather than define soft, bulging, yielding, viscera-like areas, and hard, skeletal or thorny protuberances, evoke the poetry of sex, at once sensual and cruel. His biomorphic abstractions are distinguished by an intensely personal fantasy, and by master-

liness; he was, as Ethel Schwabacher characterized him, 'the Ingres of the unconscious'.

Gottlieb, Rothko, Pollock and Baziotes – unlike Gorky and the surrealists in exile – looked to mythology and primitive art rather than to psychoanalysis for subject matter. Oriented toward Freud, the Parisians in the main depicted psychological experiences: dreams, hallucinations, etc. In contrast, the New Yorkers used automatism to reveal what they believed to be the residues of universal myths, timeless and tragic, that continued to live in the unconscious mind – an approach that was anticipated by Jung. During the 1940s, Gottlieb executed a series of 'pictographs' [103], each of which was sectioned into an all-over, roughly rectilinear grid. Within the compartments were painted flat, cryptic images which ranged from schematic anatomical segments, fish, reptiles, birds and animals, to abstract signs, subjects meant to recollect man's prehistoric past. Rothko also combined biomorphic motifs from diverse sources, but he invented hybrid figures engaged in contemporary re-enactments of Graeco-Roman myths. Baziotes [26, s. 15] and Stamos [25] used doodling to reveal the fantastic creatures that haunted their inner worlds. The images of these four artists often suggested underwater life, becoming metaphors for an *other*, unearthly, amorphous realm of the imagination and reflecting, probably unintentionally, an extreme reaction against the rational and willed approach that had dominated European art since the Renaissance. Clyfford Still, living out west, independently painted pictures whose themes – horizontal, female, dark earth juxtaposed against vertical, male, light suns – were akin in meaning to the New Yorkers'.

From 1942 to 1947, Jackson Pollock [1–5, s. 1] was also a myth-maker, his canvases alluding to animal sexuality, nocturnal rites and Graeco-Roman legends – violent themes which were embodied in tempestuous painting. During that period, he increasingly suppressed literal references and focused on the expressive properties of biomorphic forms in themselves. Motivated by what Newman called a 'ritualistic will', Pollock concentrated on the process of painting as a ritual act. In 1947, he eliminated all recognizable symbols and signs and began to rely exclusively on gestures – impetuous lines of flung and dripped pigment

Plates 24-28

24 ARSHILE GORKY. *Agony*, 1947. Oil on canvas, 101 × 139 cm. The Museum of Modern Art, New York. A. Conger Goodyear Fund.

25 THEODOROS STAMOS. *Sunrise I*, 1957. Oil on canvas, 213 × 183 cm. Collection Berthold von Bohlen und Halbach, Essen. Courtesy André Emmerich Gallery, New York.

26 WILLIAM BAZIOTES. *The Flesh Eaters*, 1952. Oil on canvas, 152.4 × 182 cm. Marlborough-Gerson Gallery, New York. Photo O. E. Nelson, New York.

27 CLYFFORD STILL. *1954 (formerly Red and Black)*. 1954. Oil on canvas, 288 × 396 cm. Albright-Knox Art Gallery, Buffalo, Gift of Seymour H. Knox.

28 MARK ROTHKO. *No. 8*, 1952. Oil on canvas, 204 × 173 cm. Collection Mr and Mrs Burton Tremaine, Meriden, Conn.

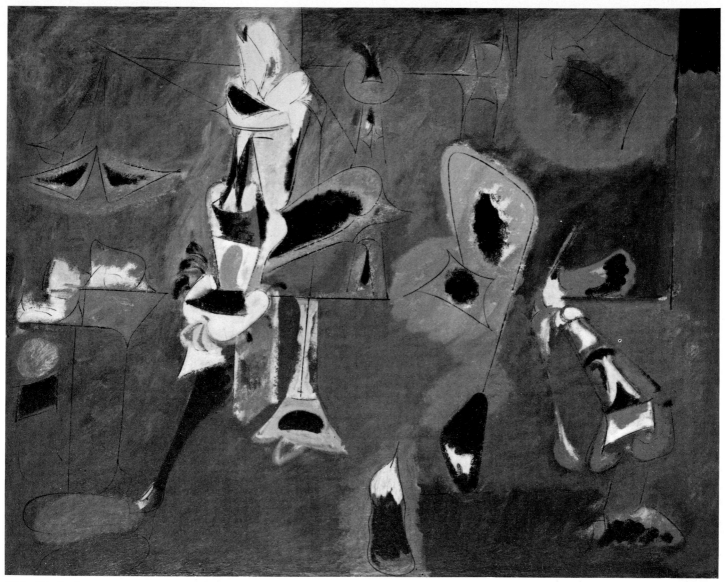

24 Arshile Gorky

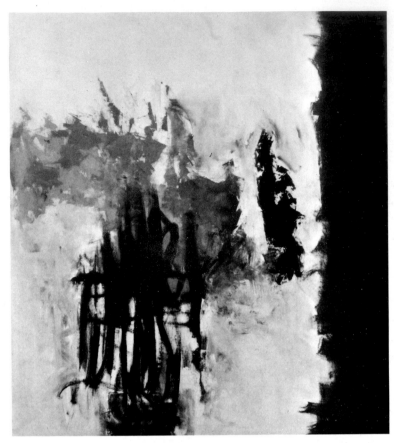

25 Theodore Stamos

26 William Baziotes

54

27 Clyfford Still

28 Mark Rothko

lashed together into frontal, maelstrom-like fields. Pollock no longer illustrated, interpreted or symbolized myths, yet his content remained mythic in spirit, the abstract painting becoming a kind of total, private ritual made visible. It was as if Pollock had found the primitive common denominator of art and ritual. As Jane Harrison remarked: 'At the bottom of art, as its motive power and mainspring, lies not the wish to copy Nature or even to improve on her... but rather an impulse shared by art with ritual, the desire, that is, to utter, to give out a strongly felt emotion... This common emotional factor it is that makes art and ritual in their beginnings well-nigh indistinguishable.'

Above all, Pollock valued directness; he wanted, as he said, to 'literally be in the painting', and his all-over configurations are produced by the gyrations of his entire body – the instantaneous register of his creative process. The shift from the hand-painted to the 'dripped' line also issued from a desire for directness. The huge dimensions of Pollock's greatest canvases seemed to have been determined by the scope needed by his sweeping motions. Directness and size contribute to a sense of immediacy, that is, the sudden powerful impact made by the painting on the viewer. The dynamism of Pollock's interlace contributes to this effect. Seeming to surge out at the viewer, it fills his world, enmeshing him in it. The wall-size picture engages him as an encompassing environment rather than as an over-the-mantel object to be contemplated at leisure, impelling him to respond as an active participant rather than as a passive observer.

During the late 1940s, other myth-makers – Rothko, Still and Newman – also universalized their subject matter. They came to believe that any reference to familiar and finite imagery, either in nature or in earlier and existing art, conflicted with the evocation of the universal spirit of myth. Consequently, their calligraphic, semi-figurative inventions began to appear too commonplace and limiting to provoke transcendental experiences in the viewer. The need was for pictorial means of such dramatic immediacy as to grip and numb him, to prevent the introduction into his response of any reminder of past events and attachments, of any habitual or outside experiences. The intention was to shock the spectator into a state of detachment from the everyday habits which shield him from the strangeness of the world, and, at the same time, to suggest this strangeness.

Rothko [28, s. 17], Still [27] and Newman [235, s. 55] began to explore the expressive possibilities of colour, painting fields of chromatic expanses which saturate the eye. To maximize the visual impact of colour, they eliminated figuration and symbolism, simplified drawing and gesture, suppressed the contrast of light and dark values – neutral tones that dulled colour – and enlarged the size of their canvases.

For its innovators, this colour-field abstraction realized their visionary aspirations: what Newman called the 'sublime', Rothko, the 'transcendental', and Still, 'revelation'. Colour-field painting jars conventional modes of perception by departing from the familiar structural basis of Western art, the modulation of values to produce the illusion of mass in space. As Clement Greenberg has pointed out (1955): 'The most radical development in the painting of the last two decades... involves a more consistent and radical suppression of value contrasts than has been seen so far in abstract art.' Moreover, to quote Matisse, colours have 'the inherent power of affecting the feelings of those who look at them.' Earlier, Van Gogh had written of 'the vast intense things... that rise up in me... these things of colour, these infinite things'. And Gauguin had said: 'In painting, it is values that destroy the harmony of the tones by the introduction of elements alien to colour and partaking of chiaroscuro.' 'Since colour itself is mysterious in the sensations it gives, we can logically enjoy it mysteriously... not as drawing, but as a source of... sensations proceeding from its own nature, from its inner, mysterious, enigmatic force.'

Working more or less exclusively with colour, the colour-field painters have avoided composing tightly-knit designs of intricate shapes, that is, criss-crossing elements to produce relational structures. Nor have they contained their images within the picture limits. Instead, their areas are unlocked, constituting fields that are open and that seem to continue indefinitely beyond the canvas limits. Indeed, it is this sense of expansiveness, more than any other quality, that distinguishes abstract expressionist painting in general from previous styles.

The feeling of boundlessness in colour-field abstraction baffles customary ways of seeing, while suggesting the infinite. So does the simultaneous enlargement of format and simplification of pictorial means. Even after prolonged exposure to these pictures, viewers find it difficult to accustom themselves to what appears to be so little on so vast a scale. Size has other functions. A mural-like canvas can become a special space that screens the onlooker from his known environment and frees him of it. 'Space, like time', Thomas Mann wrote, 'engenders forgetfulness; but it does so by setting us boldly free from our actual surroundings and giving us back our primitive, unattached state.' Sheer magnitude can also provoke feelings of awe, as Edmund Burke observed: 'Greatness of dimension is a powerful cause of the sublime.' Perhaps the best summary of colour-field abstraction and its effect was Meyer Shapiro's; he called it 'an absolute in which the receptive viewer can lose himself... in an all-pervading... sensation of a dominant colour.'

Despite certain affinities, the styles of Still, Rothko and Newman are highly dissimilar. Of the three, Still's canvases [27], consisting of verically directed, flame-like expanses of pigment trowelled on with palette knives, are at once more muscular and more exultant than Rothko's and Newman's. Critics have related his imagery to gigantic crags, fissures and other natural phenomena, but such references to landscape are superficial. Instead, the terrain in these pictures is mythic, that of a modern Ulysses. Still once said that his painting was a journey one made 'walking straight and alone... until one had crossed the darkened and wasted valleys and had come at last into clear air and could stand on a high and limitless plain.' Rothko's abstractions [28] are composed of a few soft-edged, horizontal rectangles of eye-filling colour, placed symmetrically one above the other on vertical grounds. Unlike Still's opaque and tactile impasto, Rothko's surfaces are thinly painted in overlapping scrims which generate dark yet luminous atmospheres, calling to mind Dylan Thomas's line, 'light breaks where no sun shines'. The blocks of coloured ether that Rothko conjures up are more explicitly tragic than Still's or Newman's. They threaten to suck the viewer into their apparitional and ominous depths, and to dissolve his thickness

and that of the world. Newman's pictures, each comprising a field of a single, almost matt colour cut by one or more narrow vertical bands of contrasting colours, carry the colour field idea to greater extremes than Still's or Rothko's. But their effect is not cerebral. As Harold Rosenberg observed: 'The most extremely rational art of our century has been rationalized over the borders of rationality and converted into a vehicle for cosmic emotions.' The main expressive element in Newman's painting [235] is the total field of colour. The bands function primarily to activate the field and to give it scale. But they are also gestures, their eroded edges suggesting vulnerable human touches while their verticality evokes aspirations to the sublime. The bareness of Newman's surfaces calls attention to his negation of voluptuousness, virtuosity and expressionist narcissism, directing the imagination to supra-personal meanings.

In 1957, Gottlieb [29, s. 18] reduced and simplified the diverse symbols and signs in his earlier 'pictographs' into a luminous disc suspended above a jagged opaque area on a monochrome ground. The two contrasting forms in each of his pictures, which came to be called 'bursts', evoke every kind of duality: earth and sun or earth and moon, the tactile and the immaterial, the explosive and the calm, the gesturally free and the controlled. The 'bursts' tend towards colour-field painting, though they have less of a limitless field effect; the centred elements are perceived as symbolic shapes.

Motherwell's painting [30, s. 19] is similar in this respect. Central to his body of work after 1949 is an open-ended series, titled *Elegies to the Spanish Republic*, each composed of simple, roughly oval and rectangular, black, vertical planes that loom large on white horizontal grounds. In these stark funeral friezes, Motherwell has symbolized his private responses to a political event, but on an epic mural scale. Indeed, it is part of Motherwell's artistic strategy to monumentalize the symbols of his intimate experiences.

Ad Reinhardt [236, s. 54], who in the 1930s had been a geometrical abstractionist, in the middle 1950s began to paint a series of 'black' paintings sectioned into symmetrical rectangles whose grey tones were so close in value as to make them appear homogeneous. In this, they were related

to colour-field painting, but with a difference – their affinity to purist abstractions of the 1930s. In his aesthetic outlook, Reinhardt was a purist, and much as he has been linked with the abstract expressionists, he detested their romantic aspirations. He believed that art ought to be isolated from life – depersonalized. He also thought that art which represents anything but itself is immoral; no extra-aesthetic meanings are permissible. In his 'black' abstractions, he systematically negated everything but what he felt to be the artness of art.

To distil the essence of colour, he greyed it, making it colourless. The more or less indistinguishable greys also rendered the drawing invisible. Yet, he allowed the ghosts of colours to remain, and they function as colours. His pictures emanate a dark atmosphere that is haunting rather than purist. Despite his programme, Reinhardt appears to have been involved with colour interactions, and he was a masterly colourist who cultivated a low-keyed palette.

Willem de Kooning once said that Pollock 'broke the ice', and what he most likely meant was that Pollock opened the way to a new kind of abstraction, composed of a field of open, non-separable areas, that was more improvisational and dynamic than any earlier style, so much so that it could not be subsumed under existing categories. In so doing Pollock revitalized American abstract art, giving his contemporaries the confidence to risk basing their work on free, painterly marks, knowing that this process could yield unified pictures full of energy, drama and passion. The artists who ventured in this direction – de Kooning himself, Hans Hofmann, Frans Kline, Philip Guston, James Brooks, Bradley Walker Tomlin, Esteban Vicente, Jack Tworkov, Milton Resnick – may be called the gesture painters (Rosenberg called them the action painters) to differentiate them from the colour-field painters. Like colour-field painting, gesture painting has significance beyond its physical attributes, but its intentions are different. Gesture painters believe that if they allow what Kandinsky called 'inner necessity' to dictate the direct and unpremeditated process of painting, the images which result will embody their felt, creative experiences, and that the feeling with which the painting is imbued will be conveyed to the sensitive viewer. As Kline put it: 'If you meant it enough when you did it, it will mean that much.'

Because the gesture painters are open to every variety of experience, their pictures tend to be more packed with incidents than do colour-field abstractions. The most complex of these artists is Willem de Kooning [31, s. 5]. His gestures – bludgeoning linear slashes of fleshy pigment – have multiple meanings, changing as the eye picks up different relationships. De Kooning arrived at gestural abstraction by fragmenting the human image and improvising with the separate parts of the body. His gestures, though abstract, evoke anatomical segments, opulent as a Venetian Venus or tortured in their dislocation. They also call to mind scrawls on tenement walls, and landscape and still-life motifs. The muscular shapes, as they interpenetrate, overlap and collide, open up space and generate energy. During the early 1950s, de Kooning reconstituted his gestures into recognizable female figures that in fierceness, garishness and hysteria are unequalled in the history of art. Since then, he has worked on and off in both abstract and figurative veins. De Kooning's painterly draughtsmanship is virtuoso, but it is also raw and ambiguous, suggesting the squalor, violence and restlessness of urban life. Vehement and anxious, in the expressionist tradition, his gestures are stabilized into impacted structures that derive from cubism. Indeed, it is de Kooning's formal achievement to have synthesized in an original style both expressionist facture and classicizing cubist design, two tendencies in modern art with competing demands.

Like de Kooning's painting, Franz Kline's dizzying black-and-white swaths [32, s. 6] also allude to the ever-changing city: in Kline's case, to massive sections of partly demolished or constructed skyscrapers and bridges. But there are other kinds of drama in the clash of oppressive blacks that hurtle in off the canvas edges and threaten to swamp the equally assertive whites that struggle to be free – the two forces held in precarious equilibrium. Kline's blacks and whites do not read as figures-on-ground, as in Oriental sumi-ink calligraphy, but are charged equally with energy, functioning more like complementary colours (making it natural for Kline to venture into colour more towards the end of his career). The stark simplicity

and the dynamism of these abstractions cause them to project with an immediacy rarely matched in art. It is this impact in part that makes it difficult to look at any black and white gesture paintings without thinking involuntarily of Kline, despite the fact that many of his contempories have frequently used this 'palette'.

Kline's pictures are generally more exuberant than de Kooning's. In this, they are closer to Hofmann's. Indeed, the latter's canvases [33, s. 20], composed of richly textured areas of vivid colour, are rarely scarred by anxiety – unlike gesture painting on the whole. From 1904 to 1914 Hofmann lived in Paris, a probable source of his painterly *joie de vivre*. At the time, he befriended many of the pioneers of modern art and witnessed at first hand the birth of fauvism and cubism. These events affected his future thinking and prompted him during the 1940s to attempt, in the direct process of painting (what he called 'push and pull'), grand syntheses of rational cubist design and impulsive fauve colour. But above all, it is the ebullience of his colour that distinguishes his painting.

Those gesture painters who received the greatest public recognition were the ones whose canvases were aggressive, and the idea developed that this kind of painting was only aggressive. That idea is untrue, for a number of gesture painters of quieter temperament have created 'lyrical' (i.e. non-violent) abstractions. Indeed, to differentiate them from the abstract expressionists, critics have called them the 'abstract impressionists', even though that label is inaccurate because their work does not record the movement of light in nature or any other visual phenomenon. Among these artists are Guston, Brooks, Tomlin, Vicente, Tworkov and Resnick.

One is struck by the painterly finesse of their canvases, which rarely lapse into the pretty, seductive or precious. Robert Goldwater has speculated that the Americans, unlike the School of Paris, possess this quality because 'they had no tradition of "well-made pictures" and *la belle peinture* to react against. Their "academy" was one of subject-matter, of realism and social realism, rather than the European one of clever, manipulative skills, so that they have been able to rediscover the pleasures of paint. They have thus been able, as David Sylvester has said, "to be sensitive without being aesthetic", and have "avoided a gratuitous beauty or charm without at once producing its opposite"'.

For Brooks [36], Pollock's 'drip' paintings were the liberating influence. In 1949, he began to pour thinned pigment on to the back of absorbent canvas and to use the hints of forms that showed through as points of departure. But his painting is far different in feeling from Pollock's. The one is measured, nuanced and slow in tempo; the other is paroxysmal, raw and fast in tempo. Unlike Pollock, Brooks works and reworks his chance shapes, thoughtfully shaping and relating them.

Tomlin [35] was also interested in building spontaneous gestures into clearly articulated patterns. In his late abstractions, he improvised with free brushstrokes to form roughly rectilinear grids contained within the picture limits (carryovers from analytical cubism). The colours that Tomlin favoured – tans, browns, olives, off-whites – are as restrained as his calligraphy, producing an effect that is at once elegant and elegiac.

Vicente [34] composes with areas of colour that maintain their character as colour while generating a uniform luminosity, at once sober and sensuous, which is the sign of his artistic identity. Vicente's pictures do not refer to landscape; still, the space in them is suggestive of landscape. In a similar manner, Tworkov's imagery [37] evokes the human figure, screened from the viewer, secreted within the depths of the painting and transformed into an enigmatic presence. During the late 1950s, Resnick amassed dabs of pigment, reminiscent of Monet's, into all-over fields whose rhythms tense and relax, breathing like a living organism.

Guston [38] is the least assertive of the gesture painters. His abstractions after 1951 appear tentative in the extreme. They are composed of short strokes (congealed into tremulous areas during the middle 1950s) which are partly erased – prompting the viewer to feel that Guston lacked the decisiveness to let the marks stand. The colours are greyed, suggesting that once Guston asserted a hue, he nervously took it back. The images, clotted near the centres of the canvases, grope tortuously towards the edges, but rarely break them, as if lacking the resolution to do so. Critics have disparaged Guston for his hesitancy, but they have failed to grasp that his painting is largely about the agony of making felt decisions in the process of

painting. The painterly nuances and the half tones, produced by the greyed colours and erasures in Guston's pictures, generate an amorphous, shadowy atmosphere that evokes a mood of brooding melancholy. In his works of the 1960s Guston's shapes allude increasingly to figures, ominous phantoms populating a dark reverie.

Despite the divergences in their pictorial means, the colour-field painters (with the exception of Reinhardt) and the gesture painters hold in common a number of attitudes – the desire to achieve an abstract art that is original, passionate and dramatic; the refusal to repeat the already known; and the continual venture into the unknown, renewing art in the process. These values have been embraced by a younger generation of artists who emerged in the 1950s, a number of whom have continued with vigour the ideas originated by their elders.

Among the younger gesture painters are Sam Francis [39, s. 21], Joan Mitchell [43], Helen Frankenthaler, Paul Jenkins and Norman Bluhm. Francis's canvases prior to 1952 are marked by a frank hedonism. Each is composed of a luminous, monochromatic curtain of loosely painted, ovular cells that drops down to a horizontal opening into whose depths the eye is drawn. In later works, the cells, singly or in clusters, are multicoloured and isolated against fields of white. During the 1960s, the forms become sparer and are located near the picture frames, emphasizing the central expanses of limpid white. Mitchell's images – interlaces of arm-long, swift, arcing strokes – are lyrical evocations of landscape [43], Frankenthaler's fields strewn with stained areas are buoyant and delicate [42]. They have been influenced by Pollock, but where the older artist tended to rely on dripped calligraphy, Frankenthaler focuses on the interaction of fluid colour expanses. Jenkins [41] finds iridescent images in the flowing together of pools of thinned paint which he pours on to the surfaces of his canvases. In another vein, Bluhm's paintings [40], composed of sweeping swaths of pigment, are muscular and assertive.

Other artists, following the examples of de Kooning and Pollock, have sought to find human images in the process of painting. George McNeil (who is of the older generation of abstract expressionists) coagulates vehement gestures into areas of colour, smouldering yet sumptuous, which constitute recognizable figures. Nicholas Marsicano takes the female nude (the central theme in Western art) as his subject; however, he paints it in a fresh way by improvising with impetuous black contours. Like Marsicano's figures, Lester Johnson's are heavily outlined silhouettes, but the latter images are the lonely inhabitants of the cities' lower depths.

Venturing in another direction, Robert Rauschenberg has incorporated specific urban imagery into gesture painting. His works – aggregates of painted shapes, newsprint, billboard fragments and other found materials of city origin – more explicitly express the urban environment than do the pictures of the older abstract expressionists. Rauschenberg's 'combine paintings' catch the spectacle of city life with verve, irony and artistic finesse. Rauschenberg named his works 'combines' because he so blurs the boundaries between painting and sculpture that these traditional headings are meaningless.

Many other artists have been exploring the possibilities of intermedia, and a number have attempted to break down the barriers between art and everyday life. Abstract expressionist canvases, particularly Pollock's, have been influential in this latter development. Their environmental size has stimulated Allan Kaprow, Claes Oldenburg, Jim Dine and others to turn actual spaces into works of art (environments) and then to stage events in them (Happenings). As Kaprow wrote: 'Not satisfied with the suggestion through paint of our senses, we shall utilize the specific substances of sight, sound, movement, people, odours, touch.' These artists have transformed the entire gallery, as well as other places, into a stage set, a kind of collage-theatre in which are superimposed simultaneously improvisational drama and dance, electronic music, noise, silence and audience participation.

However, for Oldenburg and Dine such events are too impermanent; instead they create paintings and sculptures of mass-produced objects which symbolize the contemporary environment. These artists have been called Pop artists, but they differ from Andy Warhol and Roy Lichtenstein, also categorized under this label. The latter duplicate advertisements, comic strips and commodities literally – without interpretation. Oldenburg and

Dine express a *personal* vision of everyday phenomena, and so continue the spirit of abstract expressionism.

A number of younger artists have extended colour-field abstraction in fresh ways. Raymond Parker [44] spreads colours on white grounds until each is ample – visually and emotionally. His roughly oval and oblong planes of colour are at once weightless and as weighty as the megaliths at Stonehenge. Morris Louis [254], Kenneth Noland [253] and Jules Olitski [45] soak areas of thinned paint into unsized canvas. The pigment fuses with the fabric, whose weave shows through, producing a textural uniformity. But the colour is 'optical' – disembodied. In their technique of paint application, the three artists have taken their cues from Pollock's 'dripped' calligraphy and from Frankenthaler's stained areas. But in the all-over resonance that they achieve, a resonance that animates the polychromed and bare areas alike, they follow Newman, Rothko and Still.

Although their pictorial ideas are similar, Louis, Noland and Olitski have developed highly individual styles. In his canvases of the late 1950s, Louis painted diaphanous veils whose pale and flowing colours call to mind Art Nouveau. In later works, he abridged these open areas into pulsating shafts of multicoloured ribbons that thrust across white fields which convey a strong sense of colour compression. In contrast, Noland's designs – symmetrical patterns of concentric rings, chevrons and horizontal stripes – are expansive, reverberating beyond the picture limits. Olitski carries the field effect to a greater extreme than Louis or Noland in his recent abstractions, each of which is a field of drifting zones of sprayed pigment (whose edges are occasionally punctuated by painted lines). Of the three artists, Olitski is the most sensuous, but that quality also characterizes the feeling of Louis's and Noland's canvases. Unlike that of Still, Rothko and Newman, the palette favoured by the younger painters is bright and decorative; the dyed surfaces are soft and buoyant, resulting in pictures that are hedonistic, frankly handsome, passive and seductive.

Al Held has been linked to Louis, Noland and Olitski (in his earlier works), because he paints simple, clearly defined areas of clear, flat colour. But he differs from them in that he is preoccupied

Plates 29-45

29 ADOLPH GOTTLIEB. *Cool Blast*, 1960. Oil on canvas, 288.5 × 183 cm. Property of the artist.

30 ROBERT MOTHERWELL. *Elegy to the Spanish Republic, No. 45*, 1960. Casein, 57 × 72.5 cm. Marlborough-Gerson Gallery, New York.

31 WILLEM DE KOONING. *Gotham News*, 1955. Oil on canvas, 175 × 200 cm. Albright-Knox Art Gallery, Buffalo, N.Y. Gift of Seymour H. Knox.

32 FRANZ KLINE. *Vawdavitch*, 1955. Oil on canvas, 157 × 203 cm. William Rockhill Nelson Museum, Courtesy Sidney Janis Gallery, New York. Photo O. Baker, New York.

33 HANS HOFMANN. *Effervescence*, 1944. Oil on canvas, 134 × 89 cm. University of California, Berkeley.

34 ESTEBAN VICENTE. *Three*, 1961. Black chalk on paper, 68.5 × 94 cm. André Emmerich Gallery, New York. Photo E. Politzer, New York.

35 BRADLEY WALKER TOMLIN. *Number Twenty*, 1949. Oil on canvas, 218 × 202 cm. Museum of Modern Art, New York. Gift of Phillip C. Johnson.

36 JAMES BROOKS. *Dobson*. 1965. Oil on canvas, 91 × 101.5 cm. Collection Kannin Pound Ridge. Photo J. D. Schiff, New York.

37 JACK TWORKOV. *Crest*, 1957-58. Oil on canvas, 190.5 × 150 cm. Cleveland Museum, Cleveland. Photo R. Burckhardt.

38 PHILIP GUSTON. *Painting 1954*, 1954. Oil on canvas, 160 × 152 cm. Museum of Modern Art, New York. Gift of Phillip C. Johnson.

39 SAM FRANCIS. *Black and Yellow Composition*, 1954. Oil on canvas, 194.5 × 130 cm. Kunstsammlung Nordrhein-Westfalen, Düsseldorf. Photo W. Klein.

40 NORMAN BLUHM. *Sinbad's Grave*, 1962. Oil on canvas, 203 × 178 cm. Private collection.

41 PAUL JENKINS. *Phenomena Long Shield*, 1962. *Oil on canvas*, 100 × 50 cm. Galerie Daniel Gervis, Paris.

42 HELEN FRANKENTHALER. *Mountains and Sea*, 1952. Oil on canvas, 218 × 297 cm. André Emmerich Gallery, New York.

43 JOAN MITCHELL. *Cercando un ago (Looking for a Needle)*, 1960. Oil on canvas. Private collection. (Erratum: for Robert Motherwell read Joan Mitchell, p. 69.)

44 RAYMOND PARKER. *Untitled*, 1961. Oil on canvas, 214 × 213 cm. M. Kootz Gallery, New York.

45 JULES OLITSKI. *Julius and friends*, 1967. Acrylic on canvas, 182 × 381 cm. André Emmerich Gallery, New York.

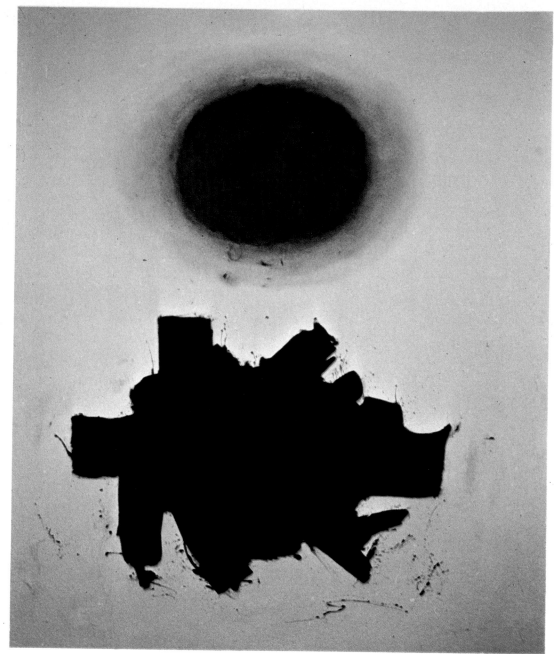

29 Adolph Gottlieb

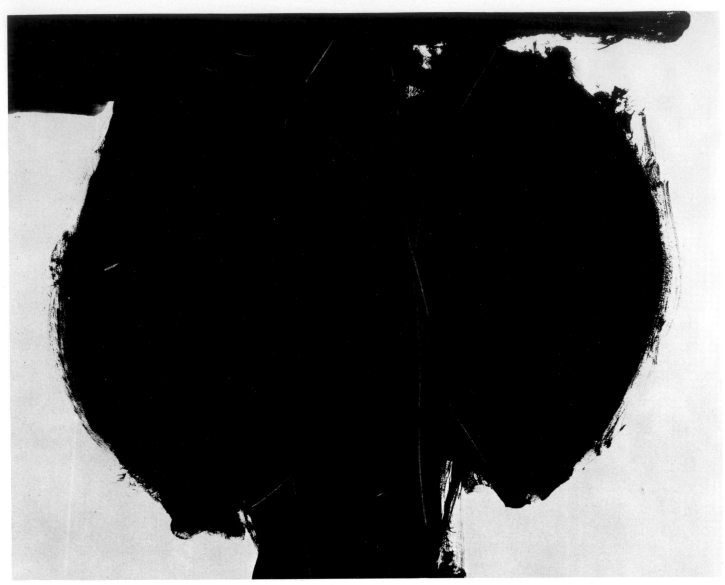

30 Robert Motherwell

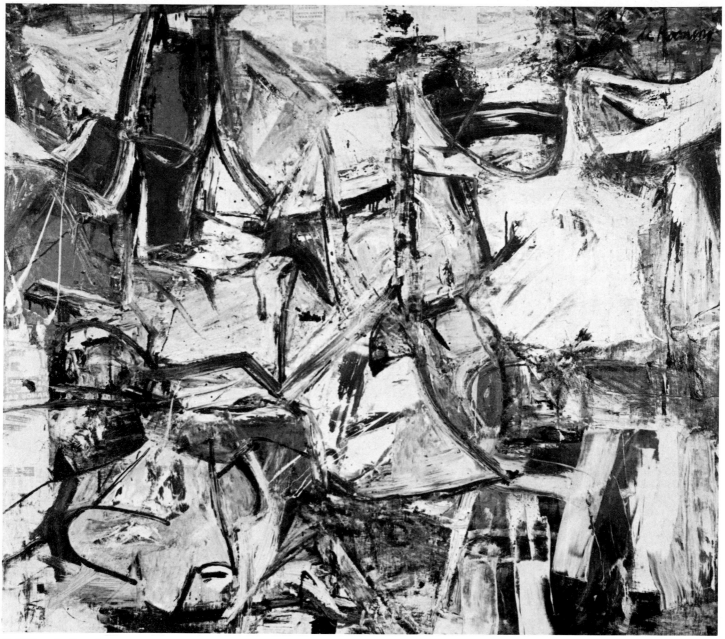

31 Willem De Kooning

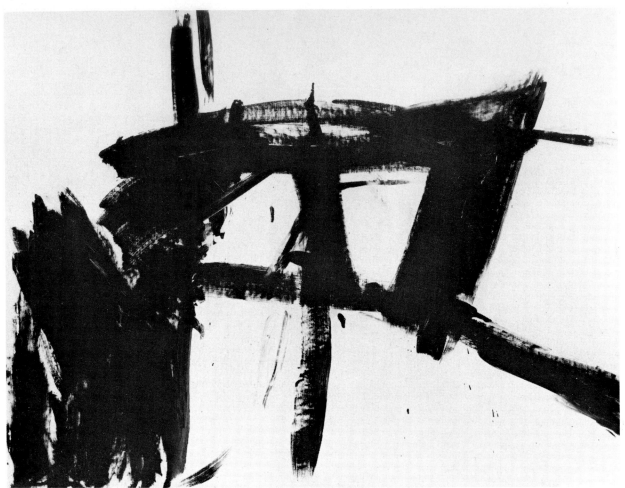

32 Franz Kline

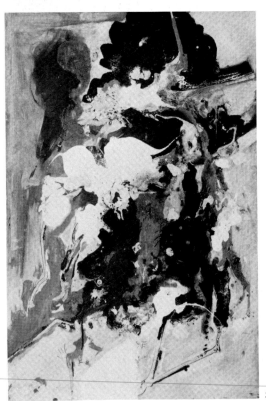

33 Hans Hofmann

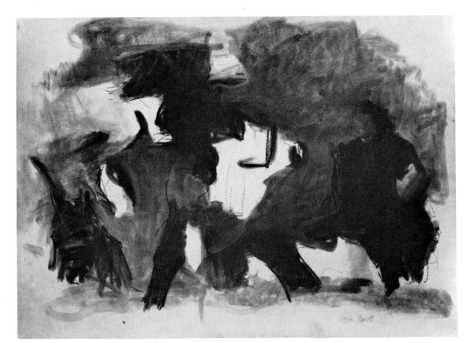

34 Esteban Vicente

35 Bradley Walker Tomlin

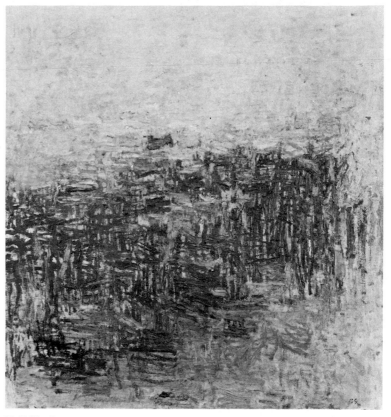

38 Philip Guston

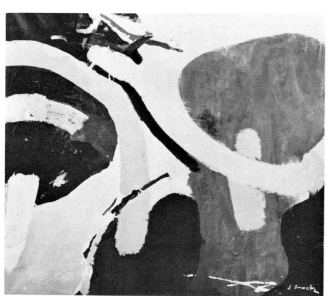

36 James Brooks

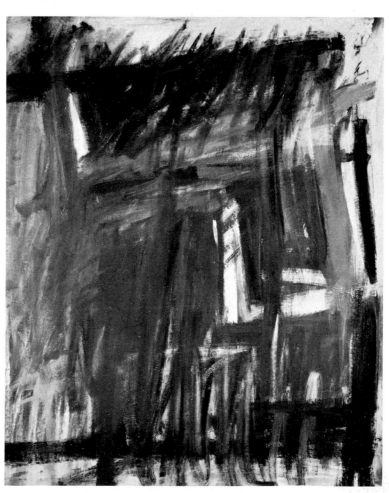

37 Jack Tworkow

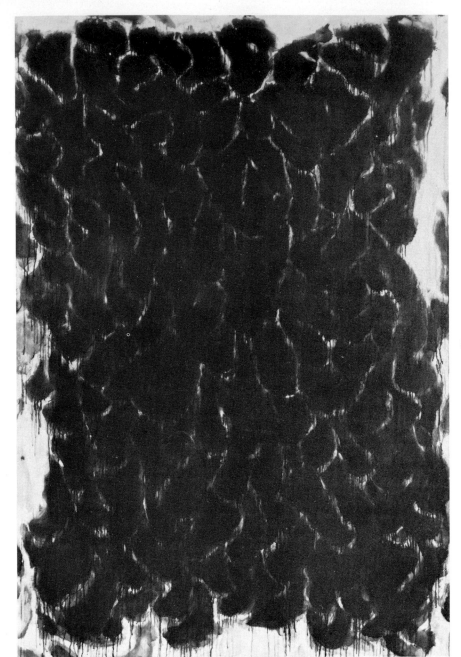

39 Sam Francis

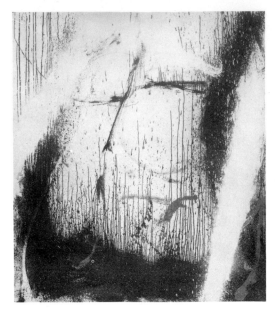

40 Norman Blum

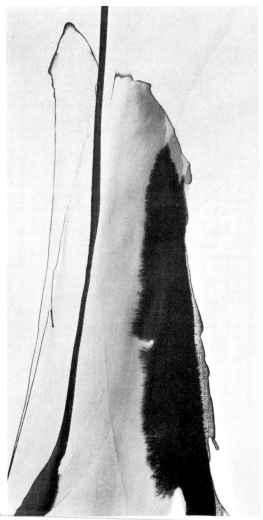

41 Paul Jenkins

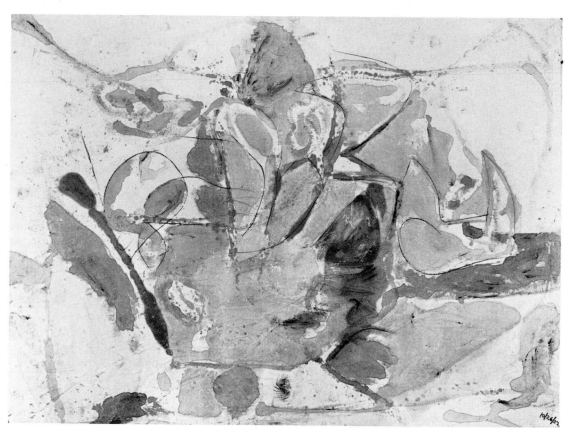

42 Helen Frankenthaler

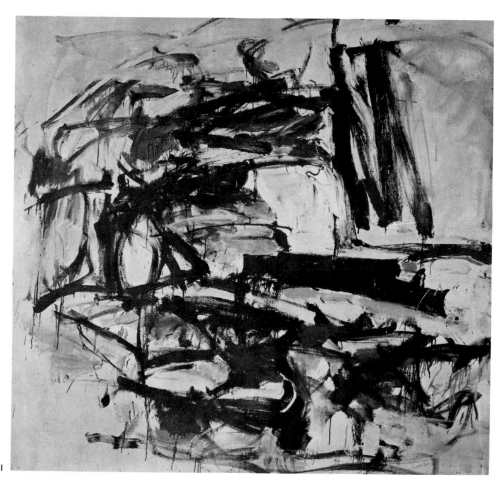

43 Robert Motherwell

69

44 Raymond Parker

45 Jules Olitski

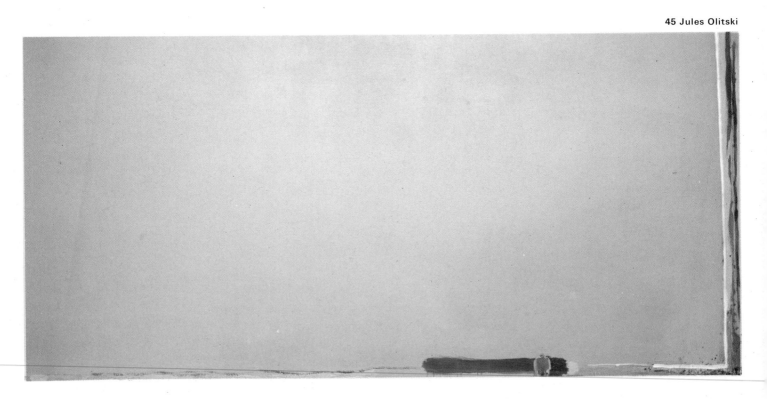

with form rather than with field, and because his images are assertive, muscular and imbued with energy. The pictures for which he is best known are composed of rectangles, circles and triangles that exist each in its own isolated, self-contained space. To make each of his generalized geometric shapes distinctive and unique, Held has disassociated them: that is, instead of repeating more or less similar elements to produce a unified design, he has placed disparate images side by side in extended sequence (a formal principle new in art). He also has aimed to make his flat forms appear volumetric, thrusting out strongly at the viewer in what may be called inverse illusionism. Recently, Held has extended this tendency in a new direction. In his latest works [252], a series of black and white abstractions, he builds structures of massive geometric volumes pieced together like masonry. The emphasis is on volume and its projection, but more important, on pictorial architecture (as against the open field idea), furthering a classicizing proclivity that has always motivated his painting.

With such exceptions as Francis, Mitchell, Frankenthaler, Jenkins and Bluhm, whose pictures in appearance resemble those of their elders, the styles of the most interesting abstract painters who matured in the late 1950s and early 1960s can no longer be subsumed under the heading of abstract expressionism, even when they continue its romantic spirit. Other artists in varying degrees have reacted against that spirit. In 1958, Jasper Johns began to exhibit a series of pictures whose subjects were commonplace objects – American flags, targets, letters, numbers – but whose designs were filled in with free painting resembling that of the gesture painters. His proto-Pop themes in their literalness constituted a departure from those of the older artists: although his painting looked akin to theirs, it actually called their premises into question. The older artists strove to *find* their imagery in the action of painting; consequently they spurned 'picture-making'. Johns elevated the ideal of the well-painted picture as a major end in his art. His brushwork is not as impulsive as it seems; rather, he 'crafted' the look of de Kooning's and Guston's technique, in a dispassionate and self-detached manner.

After 1959, other young artists, among them Frank Stella, Donald Judd, Robert Morris, Andy Warhol and Roy Lichtenstein, rejected even more strongly the romanticism in abstract expressionism, developing in its stead styles that are extremely conceptual and impassive. These artists have taken the limelight, and their attitudes have marked the art of the 1960s as abstract expressionism did that of the 1940s and 1950s.

Lyrical Abstraction from Explosion to Inflation

MICHEL RAGON

It all began in 1947. In fact it was, strangely enough, in that same year that Hartung and Schneider held their first exhibition in the Lydia Conti gallery; that Atlan exhibited at the Galerie Maeght; that at the Salon des Surindépendants, a young painter, Pierre Soulages, showed for the first time a large, dark canvas, firmly architectonic in structure; that at the 'Salon des Réalités Nouvelles' Wols showed his first 'informal' painting, and that in New York Jackson Pollock launched his 'drip painting'.

These artists had one thing in common: their opposition to geometrical and 'utilitarian' abstraction, offspring of the Bauhaus, of De Stijl and of constructivism. Against this historical abstraction, whose descendants were to dominate the Parisian scene up to 1950, these painters appeared as solitaries – heretics. While antecedents for lyrical abstraction may be found in certain works of Kandinsky, of Klee, even of Miró, the paintings being shown by Atlan, Hartung, Schneider, Soulages, Wols and Pollock in 1947 seemed totally original and unprecedented.

In December 1944, and again in February 1945, Jean Atlan had already shown some very curious works, in which the heavily applied paint-surface was animated by a kind of graffiti, drawn in the still wet impasto; these prefigured *informel* painting in a remarkable manner. In 1947, the organization of his strongly rhythmical canvases was dictated by the gesture. This gestural quality was also to be met in the works of Hartung, of Schneider, of Soulages and of Pollock (but Pollock was still unknown in Paris).

One could say too that with Hartung [14, 15, 107, s. 7] the essential principle of his work was already, and had been for a long time, the 'sign' (1933), after having been the *tache* (1922). Most of the artists of the generation of lyrical abstraction had arrived at abstract art about 1947. For Hartung, whose painting at that time showed an extraordinary maturity, the adventure of lyrical abstraction was indeed of very long standing. But his solitary achievement, lacking an audience, had no impact before his exhibition at the Lydia Conti gallery in 1947. Hartung was not alone in such case, although his example as a precursor may be the best-known one. Lapicque had painted his first 'lyrical' abstract canvas, *Homage to Palestrina*, in 1925. Camille Bryen had exhibited a 'tachist' canvas at the Salon des Surindépendants in 1936. Lanskoy had painted his first non-figurative works in 1937. Gerard Schneider had arrived at abstract art in the course of his pictorial researches in 1932. Poliakoff had exhibited an abstract work in Paris in 1938, as had Olivier Debré in 1943. From 1943 to 1946, Charles Lapicque had also been one of the most advanced among the leaders of lyrical abstraction.

While geometrical abstraction constituted a well-defined stream, and soon a 'school', lyrical abstraction was first and foremost the work of individuals with nothing to bind them together, unless it were certain affinities such as those which united the inseparable trio of Hartung, Schneider and Soulages round about 1950.

In December 1947, and again in 1948, two exhibitions were to attempt the canalization of this diffuse current. The first, 'L'Imaginaire' at the Luxembourg Gallery, and the second, 'HWPSMTB' at the Galerie Colette Allendy. One young painter, a great admirer of Wols and of Bryen, who was not to enjoy the benefit of a first exhibition until 1950, at the Galerie Drouin, was the instigator of these two exhibitions. His name: Mathieu.

'L'Imaginaire', however, presented a thoroughly heteroclite selection, since there alongside Arp, Picasso and Brauner were Atlan, Bryen, Hartung, Mathieu, Riopelle, Ubac and Wols. The preface, written by Jean-José Marchand, nevertheless proclaimed it the advent of lyrical abstraction – 'on the one hand, Cézannean abstractivism, constructivist or neo-plastic, and on the other, lyrical abstractivism… take up their positions, to do battle for a lyricism freed from all enslavements and from pseudo-problems.'

Selection in the case of 'HWPSMTB' was more precise: Hartung, Wols, Picabia, Stahly, Mathieu, Tapié and Bryen. In October 1948, a third collective exhibition, organized by Camille Bryen, 'La Rose des Vents', at the Galerie des Deux Iles, grouped Christine Boumeester, Greta Sauer, Nicolas Schöffer (at that time a gestural painter), Selim, Marcelle Loubchansky and William Gear.

This current of lyrical abstraction (gesture, sign, *matière*, metamorphosis) was matched by a parallel current – a rather more 'orderly' one – springing from cubism, which tended towards a transfiguration of nature by means of abstraction. This tendency was for a long time considered, outside France, to be specifically that of French painting. It is not very clear why, unless for the reason that these painters described themselves as 'painters in the French tradition'.

But at the time they chose this phrase as the title for their first collective exhibition, in 1941, at the height of the German occupation, it had the virtue of a challenge. Among them, Bazaine [48, s. 22] and Lapicque [46], from 1943 onwards, were producing non-figurative painting, even if they were giving figurative titles to their pictures. A taste in common for bright colours, carefully modulated, was the link which united them. And also an admiration for Villon and Bonnard. A certain number were old pupils of Roger Bissière, who had retired to the country, far from Paris, but who was to make a resounding comeback in 1947 with his retrospective at the Galerie Drouin. The Salon de Mai was to be their particular salon.

In contrast with artists like Hartung, Schneider, Soulages, etc., whose forms constituted an expression in themselves, without its being possible to assimilate them to any figurative recollection whatever, the 'painters in the French tradition' sometimes drew from the subject, later transposing their landscapes in a sort of naturalist symbolism. Moreover, they did not consider themselves as in any way abstract painters, and Bazaine, Manessier and Ubac frequently rose up in vigorous protest against the fact that they had been classed with abstract artists. Nevertheless, history has placed them, although in a slightly marginal position, in the current of lyrical abstraction.

With Bissière [47] painting becomes a hymn to nature, in the manner of St Francis of Assisi, an expression of wonder in the presence of the plants, the flowers, the trees, the pebbles in the stream. As a teacher at the Académie Ranson, from 1925 to 1938, Bissière had, as pupils, Manessier [50, s. 23], Le Moal and Bertholle. These were, after the war, to form the kernel of that painting which sought to 'decipher the alphabet of the world'. Manessier held a place apart by reason of the Christian symbolism which he attempted to give to his forms and colours, and it was this which led him to play an active part in the renaissance of a modern sacred art, notably in his abstract stained glass.

Gustave Singier [49], Raoul Ubac, O. Debré, Zoran Music [54], Marie-Hélène Vieira da Silva, Pierre Tal Coat, M. Prassinos, and Zao Wou-ki are close to the 'painters in the French tradition' by virtue of shared concern for the transposition of naturalist elements. Ubac [67] derives his abstracts from memories of the Ardennes forest, Vieira da Silva [75] from the proliferation of forms in the Gare Saint-Lazare or the labyrinths of vast libraries, Prassinos from a forest fire. Zao Wou-ki [80], however, returns to the naturalistic-abstract calligraphy of the ancient Chinese painters.

The lyrical abstractionists may, with equal justice, be regarded as including the *peintres de matière* – painters for whom the sensuous textural quality of the impasto was of prime import – such as Nicolas de Staël, Lanskoy and Riopelle; certain 'colourists' like Poliakoff [51], Estève [52] and Gischia; and a certain number of marginal cases, artists of the type of Deyrolle, Geer Van Velde, Piaubert [73] and Bissier.

From 1948-50 onwards, a sort of institutionalization of abstract art began to make its appearance. The Salon des Réalités Nouvelles, which had counted

no more than 89 participants at its foundation in 1945, saw its effective rise to 400 in 1948. Abstract art had its own review, *Art d'Aujourd'hui*, and even its Académie in Montparnasse, directed by Dewasne and Pillet. This officialization developed with a slant in the direction of geometrical abstraction, which was then labelled 'cold abstraction' to differentiate it from lyric abstraction, described as 'warm abstraction'. Meanwhile the 'painters in the French tradition' in their turn set up a sort of new École de Paris.

In the presence of this disturbing phenomenon, a certain number of parallel events in 1951 sounded a warning. In December 1950, Charles Estienne who, with Léon Degand, had been the great defender of orthodox abstraction – which is to say, abstraction which conformed to the theories of its first masters – published a pamphlet entitled *L'art abstrait est-il un académisme?* in which he made a violent attack on 'cold abstraction', and the fact that the formulas for it could be taught in an Academy. In February 1951, I myself published a little book called *Expression et non-figuration*, in honour of lyrical abstraction; it was a plea that expression should take precedence over form.

Two series of exhibitions were to serve additionally as particularly explosive missiles against the façade of the École de Paris, which was beginning to take a beatific satisfaction in its own reflection. On the one hand Michel Tapié introduced the American exponents of 'action painting' to Paris. On the other hand I introduced the Cobra painters.

Jackson Pollock had exhibited the previous year at the xxvth Venice Biennale. But in Paris American art had remained practically unknown, and no one suspected that a 'school' had been born in New York which could set up in opposition to the École de Paris. Moreover, when Michel Tapié (who had been seen as a sculptor in 'HWPSMTB') presented, at the Galerie Nina Dausset, rue du Dragon, under the title 'Véhémences confrontées', canvases by Pollock, de Kooning and Riopelle, alongside those of Hartung, Wols, Bryen [53] and Mathieu, the shock was considerable. In this same year of 1951, I organized the first exhibition in Paris of Cobra, plus an exhibition of Karel Appel, Balle, Corneille [55], Egyll Jacobsen and Asger Jorn [56] at the Galerie Pierre. Cobra was

Plates 46-56

46 CHARLES LAPICQUE. *Quetzalcoatl*, 1953. Oil on canvas, 46× 27 cm. Private collection. Photo J. Dubourg, Paris.

47 ROGER BISSIÈRE. *Composition*, 1951. Egg tempera on canvas, 127×44.5 cm. Galerie Jeanne Bucher, Paris.

48 JEAN BAZAINE. *The Diver*, 1949. Oil on canvas, 146×114 cm. Private collection.

49 GUSTAVE SINGIER. *Watercolour*, 1956. Galerie de France, Paris.

50 ALFRED MANESSIER. *Lord, shall we strike with the Sword*, 1954. Oil on canvas, 200×80 cm. Musées Royaux des Beaux-Arts, Brussels. Photo A.C.L., Brussels.

51 SERGE POLIAKOFF. *Painting*, 1956. Oil on canvas, 97×130 cm. Collection Achille Cavellini, Brescia.

52 MAURICE ESTÈVE. *The Lock at Haut-pont*, 1953. Oil on canvas, 100×73 cm. Collection Achille Cavellini, Brescia.

53 CAMILLE BRYEN. *Ribbons of Air*, 1959. Oil on canvas, 146× 89 cm. Private collection.

54 ZORAN MUSIC. *Wind-Sun*, 1958. Oil on canvas, 130×162 cm. Galerie de France, Paris.

55 CORNEILLE. *Tropic of Cancer*, 1958. Oil on canvas, 130× 97 cm. Private collection.

56 ASGER JORN. *Valley in Revolt*, 1957. Oil on canvas, 81× 100 cm. Galerie Rive Gauche, Paris. Photo Poplin, Villemomble.

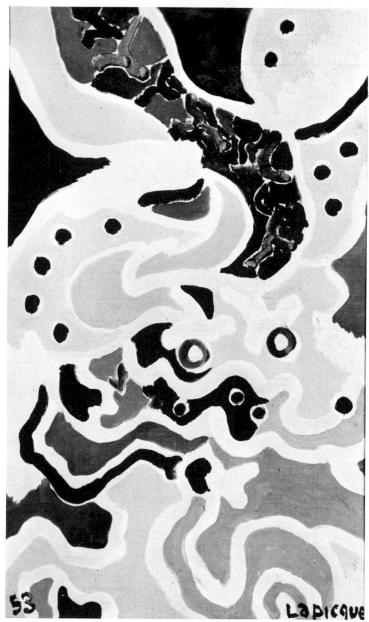

46 Charles Lapicque

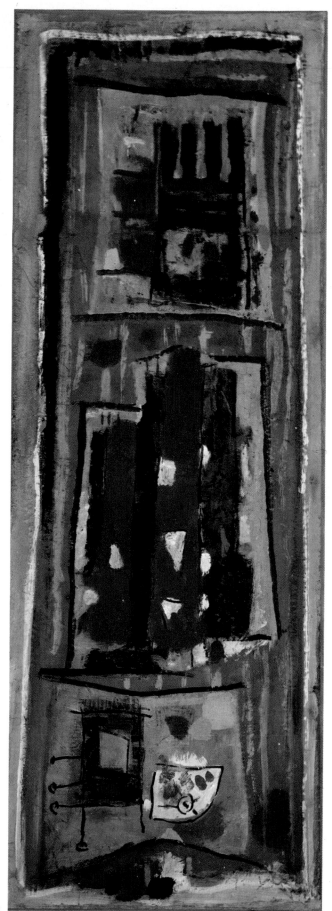

47 Roger Bissière

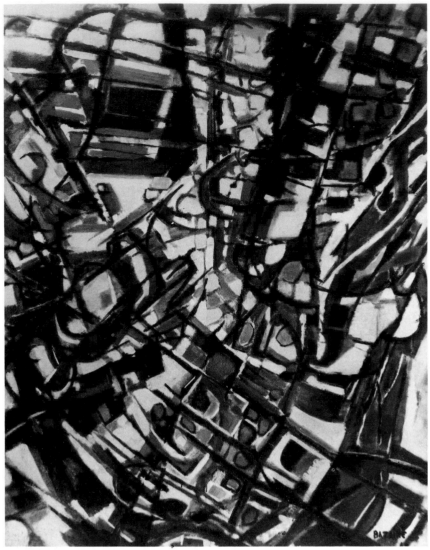

48 Jean Bazaine

49 Gustave Singier

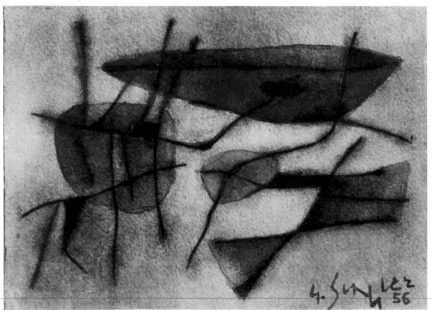

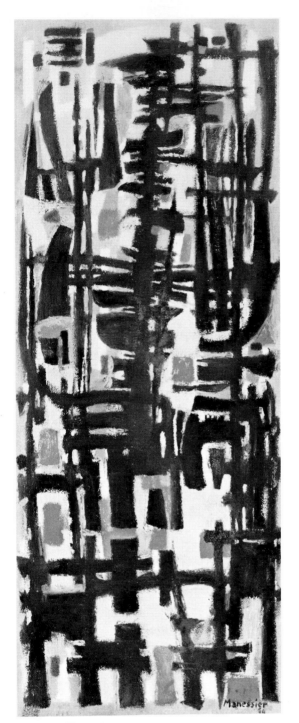

50 Alfred Manessier

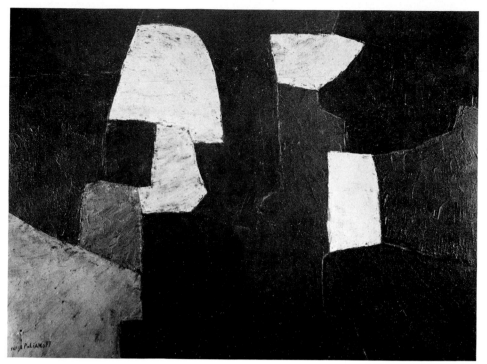

51 Serge Poliakoff

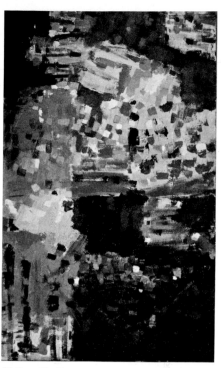

53 Camille Bryen

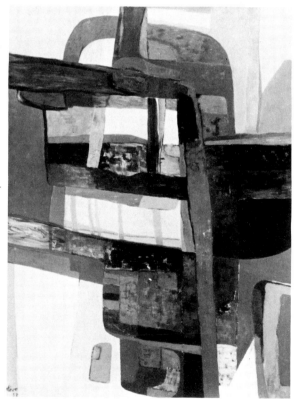

52 Maurice Estève

54 Zoran Music

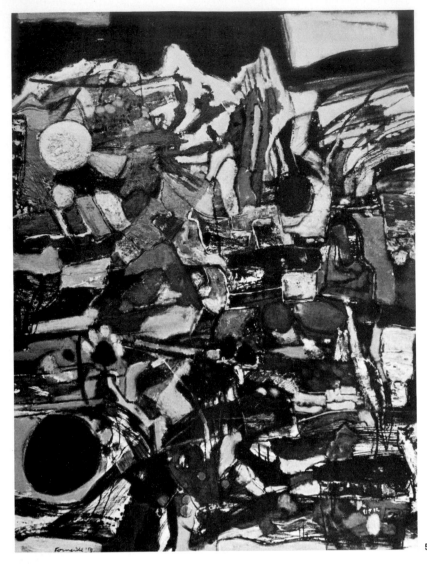

55 Corneille

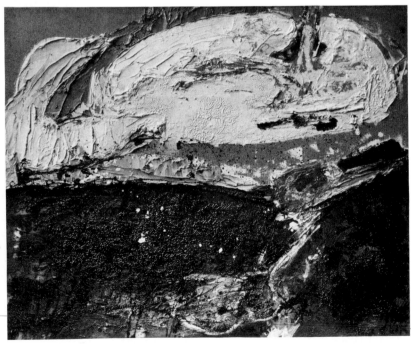

56 Asger Jorn

an international group of northern artists (Danish, Dutch and Belgian) which placed itself in opposition to the École de Paris and to a certain kind of 'good taste' in French painting.

Tapié went even further in 1952, with his exhibitions 'Signifiants de l'informel', 'Peintures non-abstraites' and 'Un art autre' (this last being also the title of a book which he published in the same year). From the exhibitions organized by Tapié was to spring the movement known as *art informel*. *Art informel* and Cobra had many points in common. Moreover, some of the artists forming Cobra were soon to be exhibiting with Tapié's groups. These two movements were completely indifferent to the hiatus between figuration and abstraction, giving predominance to expressiveness, to violence and to lyricism. But in mixing post-surrealists, lyrical abstractionists and figurative expressionists, all this under the dadaist patronage of Marcel Duchamp and Francis Picabia, Michel Tapié was adding to a confusion which was to reach its zenith when Charles Estienne allied himself with André Breton to promote an unexpected regeneration of tachist abstract art through surrealism. *Art informel* dates from 1951-52, tachism from 1954.

Tachism was the expression of a second wave of lyrical abstractionists whom Charles Estienne had attempted to re-group from 1950 onwards in the Salon d'Octobre, itself mounted in opposition to the Salon de Mai, considering the latter to have been monopolized by the 'painters in the French tradition', and to the Salon des Réalités Nouvelles, stronghold of the 'cold abstractionists'. Preceding the Salon d'Octobre, the annual exhibitions entitled 'Les mains éblouies', at the Galerie Maeght, had presented an excellent survey of the young lyrical-abstract painters, included F. Arnal, F. Doucet, Huguette A. Bertrand, S. Rezvani, Corneille, Pierre Alechinsky and Dimitrienko.

Then, in 1951, the Galerie Arnaud, rue du Four, decided, in effect, to reserve its walls for the artists of this second wave, a vocation which was confirmed in 1953 with the foundation, by Jean-Robert Arnaud, of a new review, *Cimaise*, which proceeded to take up a position unequivocally in favour of the lyrical abstractionists of the first and second waves.

In 1955, the Salon d'Octobre disappeared, as the result of a cleavage into two groups. The first, remaining faithful to Charles Estienne, restricted itself effectually to tachism alone (Duvillier and Loubchansky); the second participated in the exhibition mounted by myself in the same gallery: '17 peintres de la génération nouvelle' (Messagier, [57], Doucet, Bertrand [64], Laubiès, Martin Barré [63], Sugai, Guitet [66], Rezvani, Carrade, J. F. Koenig [65], etc.).

Tachism has frequently appeared as one version of *art informel*. But whereas 'informal' painting expanded to such an extent that its success looked more like a state of inflation than sober appreciation, tachism, for its part, shrank to just a very small *tache*. This, at any rate, if one is to limit tachism to its orthodox Estiennian usage. For, otherwise, is not everything in lyrical abstraction which is neither 'sign' nor *matière* more or less *tache?* From the Hartung of 1922 to Sam Francis, a complete history of tachism could be written.

Tachism of the Estienne school had, nevertheless, the merit of forming a coherent group which, even today, displays affinities between its artists: Duvillier, Loubchansky [59], Degottex, Hantaï. Although, if we look closely, the only genuine *tachist* among them is Marcelle Loubchansky. It is the 'sign' and the gestural quality, rather, which characterizes the work of Duvillier, Degottex [108] and Hantaï [58]. Degottex and Hantaï were more influenced in their early days by the 'Western calligraphy' of Mathieu than by tachist ideology.

It is possible that tachism found its most absolute, its most ecstatic, exponent in Austria, with Rainer [84]. To tachism in France, one could assimilate such painters as Bellegarde and Claude Georges [62]. Not forgetting an epigone of tachism: *nuagisme*, a group formed by Julien Alvard, of which the principal representatives were Benrath, Graziani and Nasser Assar.

The *informel*, born of the cross-fertilization of prodigious artists like Wols, Pollock, Fautrier and Dubuffet, produced an inflation of tachism, of *signisme*, of colours and of splashes, of which today very little is remembered, except perhaps Sam Francis, the Canadian Jean-Paul Riopelle, the Frenchman Serpan and the two Japanese Domoto and Imai.

The streams, the schools and the groups are all, moreover, more or less mixed together in the great magma which lyrical abstraction became when, in 1956, it exploded like a giant firework, covering the world, like the legendary shadow of Fantômas. Let us try, however, to sort out certain lines of force or of convergence.

The Gesture and the Sign. After the first wave which gave rise to the current (Hartung, Schneider, Soulages, Atlan, Michaux, Mathieu, Bram Van Velde), a second wave internationalized it, with Vedova and Scanavino in Italy, Brüning in Germany, Kantor in Poland, Alan Davie in Great Britain, and the Japanese Saito and Sugai, not to mention the large group of abstract calligraphers assembled in Kyoto by Shyriu Morita, and the Gutai Group.

Matiérisme. After the first wave which created this current (Nicolas de Staël, Lanskoy, Dubuffet, Fautrier, Riopelle), a second wave internationalized it with Hosiasson, Bogart, Kay Sato, Linstrom and Lataster in Paris; Schumacher and Dahmen in Germany; Tàpies, Feito, Cuixart and Millares in Spain.

Abstract landscape. We have seen that, in the first wave of lyrical abstraction, there were non-figurative painters whose affinity for one another consisted principally in the manner in which they transposed or transfigured nature. Bissière, Manessier, Bazaine, Tal Coat, Ubac, Vieira da Silva, and Zao Wou-ki are the first great representatives of a tendency to which I attempted to give a reference point in 1956 by christening it *paysagisme abstrait*, later *naturalisme abstrait*. The earlier term prevailed. At the outset, I created this designation in discussing two new artists of the second wave, James Guitet [66] and Martin Barré [63]. (Barré has changed a great deal since then, moving to *signisme* via painting with the tube, and then to the tracer-bomb. Guitet, with his high impasto, also established a relationship with *matiérisme*.) In an article published in November 1956 in the Italian review *14 Soli*, I wrote:

'The fact remains: numbers of young painters, described as abstract, are haunted by the vision of nature. This includes Corneille, with his geological forms inspired by his journey to the Sahara; Messagier and his yellow-ochre and green compositions, like sandbanks between screens of trees; Arnal and his "cliffs"; Koenig, Carrade and plenty of others … such as Martin Barré and James Guitet.

'The term "abstract landscape" is manifestly absurd. Nevertheless, it is certainly a new school that concerns us here. These painters are not working in concert. These are their individual manifestations, which end up by revealing the spirit of an ensemble.… Neither Carrade nor Koenig nor Arnal has the slightest qualms in using the colour green, or other 'naturalist' colours. With Martin Barré the dominant colour is red-ochre… In fact, at his point of departure, Barré no doubt had Mondrian in mind. Then, one day, he received a picture postcard of a fishing village – an aerial view of the anchorage. The composition was almost exactly that habitually used in his paintings. It was from this point that one became aware that he was a "landscape painter" without knowing it. But then in Mondrian one can certainly find, if one looks for them, the rectilinear landscapes of Holland, with its canals and roads at right angles.

'For a long time, the sands of the Loire have haunted James Guitet, and their golden tones could be found in his abstracts. Now, he has introduced structures into his compositions, with a body of paint in relief. His thoughts, no doubt, run less on the landscape than on the details of the landscape. The single stone concerns him more than the cliff; the tree-bark more than the forest.'

With Messagier, James Guitet, John F. Koenig, Luis Feito, Tàpies, Corneille, Arnal, Dmitrienko, Lapoujade (at the time of his exhibition 'L'Enfer et la Mine'), Rezvani, Dahmen, Hosiasson, Camille Bryen (his new manner), Gastaud, Kay Sato, etc., a new painting came into being, far more sensory than that of their elders, 'painters in the French tradition' and the like; a painting in which the impasto, the 'sign', the vibrations of the colours and the textures conveyed a morphological impression. This young painting, less individualistic than that of the preceding generation, tended towards a collective style. It bore a reference to nature without describing it; it was sensitive, not to things, but to the effects which those things produced – walls, rippling water, the bark of trees,

waves, sky, nebulae, mud.... At this same time, Jean Dubuffet, who was employing less and less figuration, created his 'texturologies' [19].

'The entire visible universe', said Baudelaire, 'is but a storehouse of images and of signs to which the imagination will give a relative place and value; it is a sort of green fodder which the imagination should digest and transform.' And, taking up a phrase which Delacroix used often to repeat to him, he added: 'Nature is no more than a dictionary.'

The 'abstract-landscapists' went through this dictionary with passionate absorption, perceiving that the naturalist painters of the past had only made use of the most restricted vocabulary; seeing the tree but not the structure of the wood and the leaf; seeing the meadows but not the three little stones near to the yellow spot of a buttercup.

Space and structure, forms and textures – reference points which enable us to place, more or less accurately, the seething upsurge of divergent experiment in the second wave of lyrical abstraction from 1950 to 1960.

The new space perceived by certain painters, unrelated to abstract landscapism, was neither linear nor aerial, but frankly utopian. This, in the same way as the building up of impasto, the gesturalism and the use of the sign, led to a new baroque style which was a feature not only of the painting, but even more of the sculpture, and of the new architecture.

Of this new space we find examples in Great Britain with William Scott and Roger Hilton, in Greece with Jannis Spyropoulos, in Germany with Küchenmeister, in France with Pierre Fichet, Marfaing and Huguette A. Bertrand.

In 1957 Pierre Restany organized an exhibition which attempted to canalize this tendency under the title 'Espaces imaginaires', with Bellegarde, Bertini, Brüning, Hundertwasser, Halpern and Vallorz. And, as related painters, he cited Sam Francis, Benrath, Tàpies and John F. Koenig.

'There you are,' said Restany, 'the odd men out, the abnormals, the non-significants of *Art informel;* those who deliberately sacrifice the families of signs and the signs as such; those who refuse to transcribe the promptings or the outcrops from their innermost being by means of a contaminated

calligraphy, and who have been capable of keeping themselves in a state of total availability towards the basic, universal osmosis.

'We enter here the domain of *imaginary space* of infinite depth, as in the Kai-Song landscapes, and of full rhythmic reversibility: The imagination of space plays here a considerable role. Space is the agonic field par excellence, the particular zone of tensions and resonances, the site of elementary negations, at once form and non-form, sense and non-sense.'

In the preceding year, the Salon des Réalités Nouvelles had adopted a new orientation, detaching itself from geometric formalism in favour of a lyrical abstraction which was itself beginning to become formalist. And a new Paris gallery had been opened, that of Jacques Massol, devoted, like the Galerie Arnaud, to painters of the second generation of lyrical abstraction. But the Galerie Massol placed itself rather in the wake of the 'painters in the French tradition', or of abstract painters practising a controlled lyricism, such as Deyrolle and Geer Van Velde. Its painters were Busse, Cortot, Ravel, Dmitrienko, Gastaud and Kay Sato.

To conclude this fleeting panorama of the varying aspects of lyrical abstraction, let us pause a moment over certain predominant personalities and certain important geographical locations. If I give no more space to lyrical abstraction in the USA, to painters of the 'sign' or to capital personalities like Wols, Hartung and Burri, this is because my colleagues Werner Haftmann, Francine C. Legrand and Irving H. Sandler have studied them individually in other chapters of this work.

Hans Hartung, Gérard Schneider and Pierre Soulages constitute an indissoluble trinity, even though today each of these artists has put a certain distance between himself and the others; we could equally, for other reasons, bring together three determined solitaries: Nicolas de Staël, Atlan and Bram Van Velde. These six artists exerted a real fascination, firstly over the young artists, whom they influenced considerably, and then over an ever-widening public.

With Schneider and Soulages it is the gesture that counts, the ample sweeping hand, the great orchestrations of surface-areas. Following a period of abstract expressionism, immediately after the war, Gérard Schneider went through a short phase

(1947-49) of reflection on form, to end up, very quickly, in an explosion of form and of colour [68]. Romantic, emotive, vehement, Schneider is an inspired painter who leaps to grasp the fugitive moment. His paintings, executed with wide gestures of the brush, can give the impression of a sort of automatic writing. And indeed there exists a certain automatism in this painting, but the hand is guided by the cultivated mind of the painter. It is doubtless because of this mental restriction that Schneider has never been welcomed among the 'informalists'. Nevertheless, this is a painting characterized by violence, eddying, tumult and dynamism, tending towards paroxysm.

Soulages and Mathieu must have been the first to impose, on the École de Paris, a gestural quality similar to that of the painters of the New York school. And this at a time when cultural exchanges between the two countries were non-existent. But, while Mathieu diverged from the *informel* towards the calligraphic, Soulages on the contrary [70, 113] abandoned the graphism of his early work, which he now saw as a sort of figuration of movement. Turning in on themselves, his canvases took on a gravity underlined by the rhythms of the large black forms. Then, during a third period, an invasive *tache*, a single 'blot', sometimes swallows up the whole picture. This so-called 'painter in black' has passed through numerous phases, and with some exceedingly rowdy and highly-coloured canvases (reds and blues). From his beginnings, in which movement and script were predominant, to the flowering of his present work, Soulages' painting has passed through a rigorously hieratic period, and then through a dynamic and syncopated phase.

Finally, the art of Soulages is perhaps more fraternally close to that of Nicolas de Staël than to that of his 'team-mates' Hartung and Schneider: it has the same need of ample compositions, and of a firmly architectonic structure, the same tranquil strength, and the same power of conviction. About 1950, Nicolas de Staël [71, s. 25] exerted an enormous influence over the younger painters. Later, his return to figuration, beginning in 1953, can hardly have failed as an incitement to the 'new figuration' of the 1960s. His large compositions, organized in rectangular 'blocks' of colour, laid on thick, his brilliant colours, his deep blacks, all

Plates 57-77

57 JEAN MESSAGIER. *Painting*, 1957. Oil on canvas. Private collection. Photo R. David.

58 SIMON HANTAÏ. *87*, 1957. Oil on canvas, 180 × 305 cm. Galerie Jean Fournier & Co, Paris.

59 MARCELLE LOUBCHANSKY. *Painting*, 1954. Oil on canvas. Galerie Jean Fournier & Co, Paris.

60 BRAM BOGART. *Pink-Yellow*, 1965. 150 × 160 cm. Collection J. Huysmans, Brussels.

61 GER LATASTER. *Alert*, 1966. Oil on canvas, 127 × 86 cm. Galerie Paul Facchetti, Paris.

62 CLAUDE GEORGES. *Sunstone*, 1962. Oil on canvas, 81 × 60 cm. Private collection, Paris. Photo J. Hyde, Paris.

63 MARTIN BARRÉ. *Painting*, 1957. Oil on canvas, 89 × 116 cm. Collection Helena Rubinstein, New York.

64 HUGUETTE BERTRAND. *Cela qui va fraîchissant*, 1968. Oil on canvas, 162 × 130 cm.

65 J. F. KOENIG. *THU B. 11*, 1967. Oil on canvas, 146 × 89 cm. Centre National d'Art Contemporain, Paris. Photo R. David.

66 JAMES GUITET. *120 P. 8. 66*, 1966. Oil on canvas, 195 × 114 cm. Galerie Arnaud, Paris.

67 RAOUL UBAC. *Still-life with Tangled Skein*, 1952. Oil, 130 × 197 cm. Galerie Maeght, Paris.

68 GÉRARD SCHNEIDER. *Painting*, 1962. Oil on canvas, 200 × 150 cm. Property of the artist.

69 BRAM VAN VELDE. *Gouache*, 1961. 127 × 122 cm. Galerie Knoedler, Paris. Photo Marc Lavrillier.

70 PIERRE SOULAGES. *Painting*, 1955. Oil on canvas, 162 × 130 cm. Private collection.

71 NICOLAS DE STAËL. *The Roofs*. Oil on canvas. Musée National d'Art Moderne, Paris.

72 PIERRE TAL COAT. *Passage*, 1957. Oil on canvas, 130 × 195 cm. Galerie Maeght, Paris.

73 JEAN PIAUBERT. *White UR*, 1959. Oil on canvas, 130 × 195 cm. Private collection, Brussels.

74 JEAN ATLAN. *Painting*, 1951. Pastel, chalk and oil on Isorel, 65 × 80 cm. Collection Michel Ragon, Paris.

75 MARIE-HÉLÈNE VIEIRA DA SILVA. *Gare Saint-Lazare*, 1949. Oil on canvas, 60 × 73 cm. Galerie Jeanne Bucher, Paris. Photo Luc Joubert, Paris.

76 JAN LEBENSTEIN. *Figure No. 125*, 1961. Oil on canvas, 195 × 130 cm. Private collection. Photo R. G. Lurie, Paris.

77 JANNIS SPYROPOULOS. *Diotima*, 1963. Oil on canvas, 114 × 146 cm. Private collection.

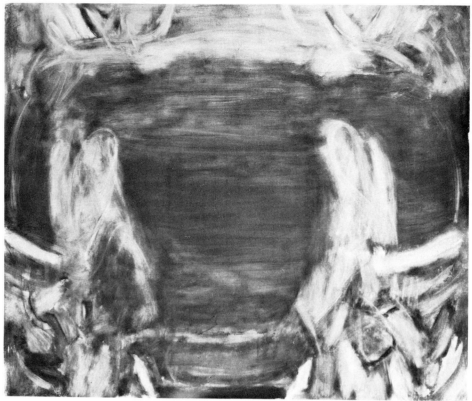

57 Jean Messagier

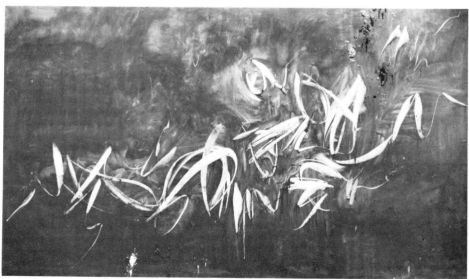

58 Simon Hantai

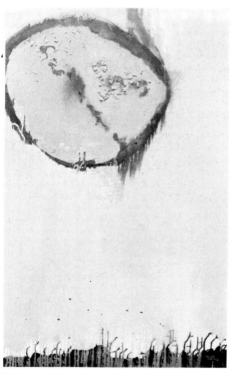

59 Marcelle Loubchansky

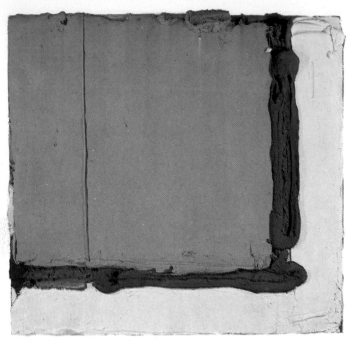

60 Bram Bogart

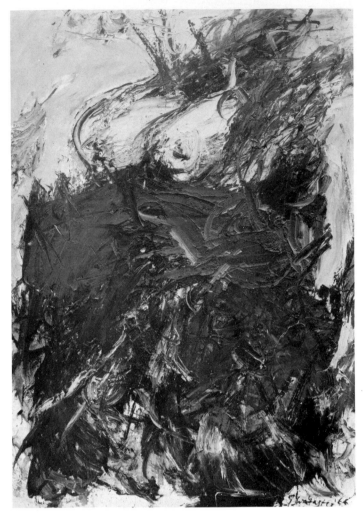

61 Ger Lataster

62 Claude Georges

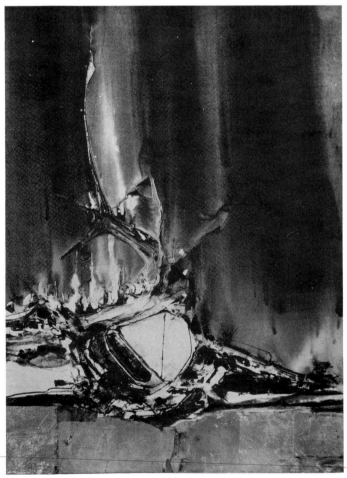

63 Martin Barré

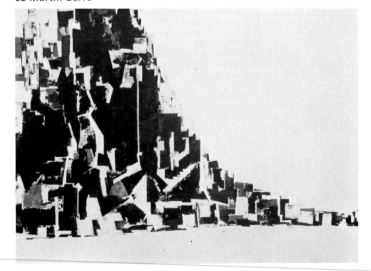

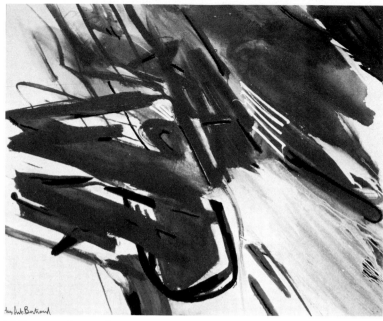

64 Huguette Bertrand

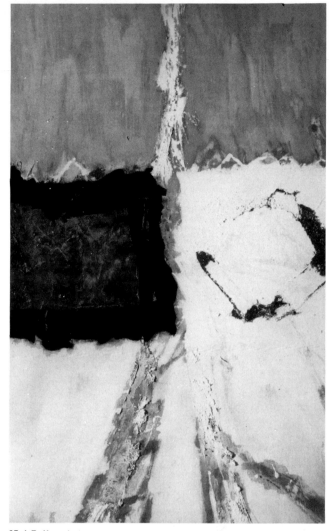

66 James Guitet

65 J.F. Koenig

67 Raoul Ubac

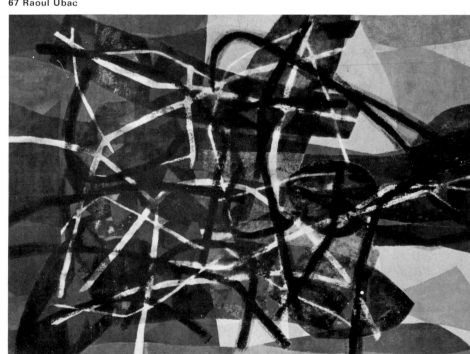

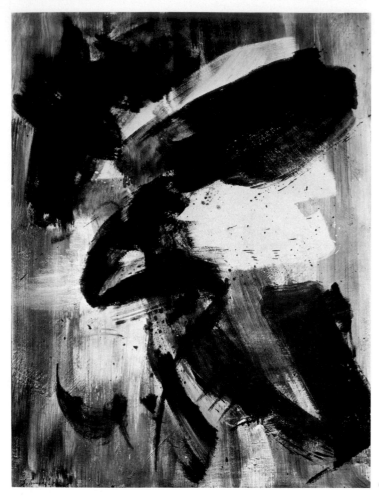

68 Gérard Schneider

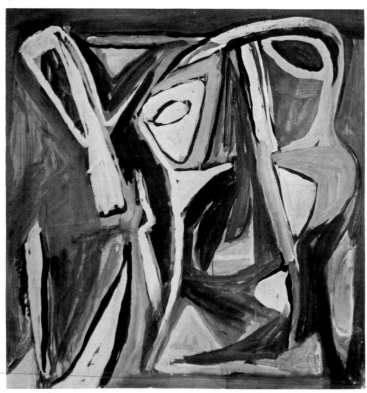

69 Bram Van Velde

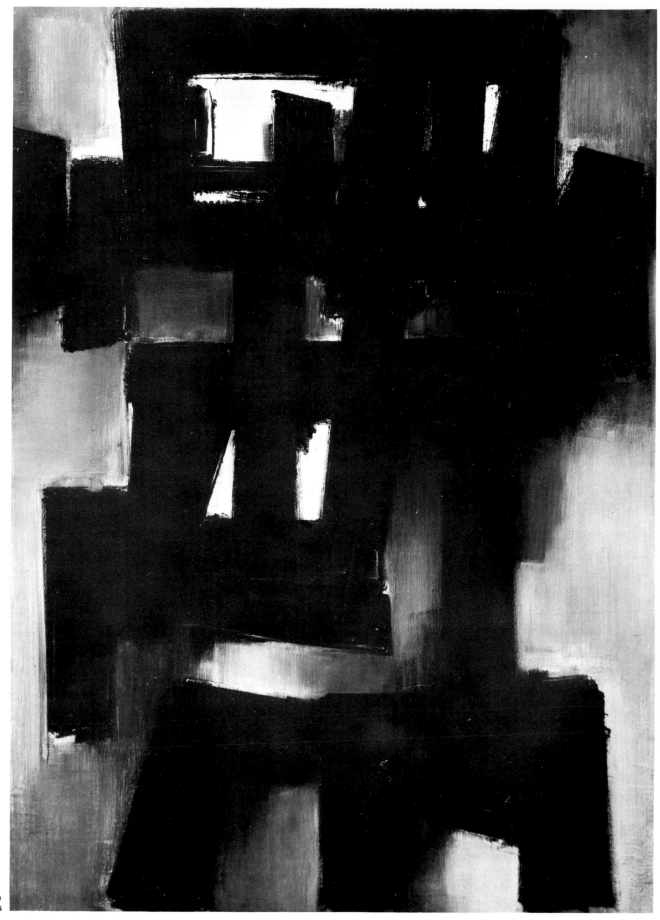

70 Pierre
Soulages

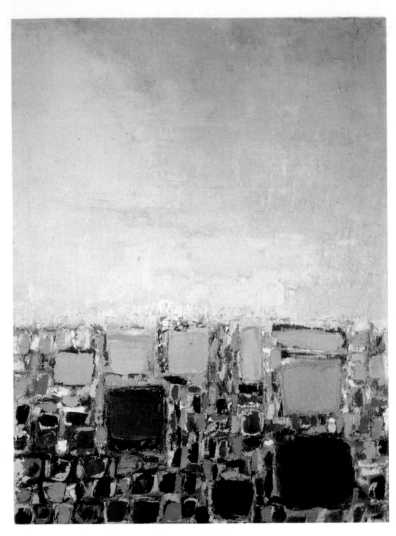

71 Nicolas de Staël

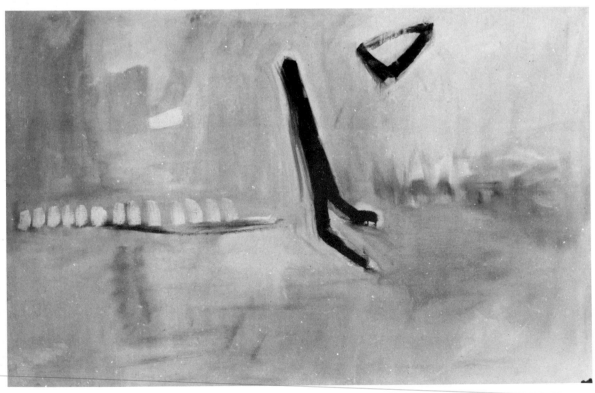

72 Pierre Tal Coat

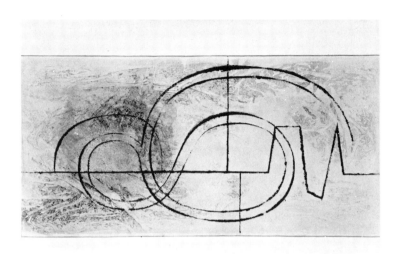

73 Jean Piaubert

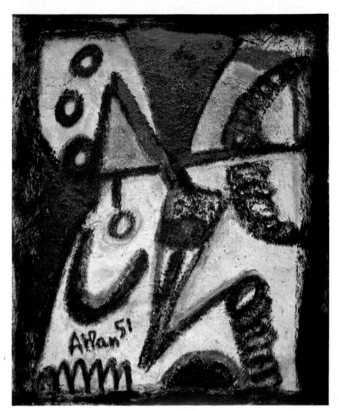

74 Atlan

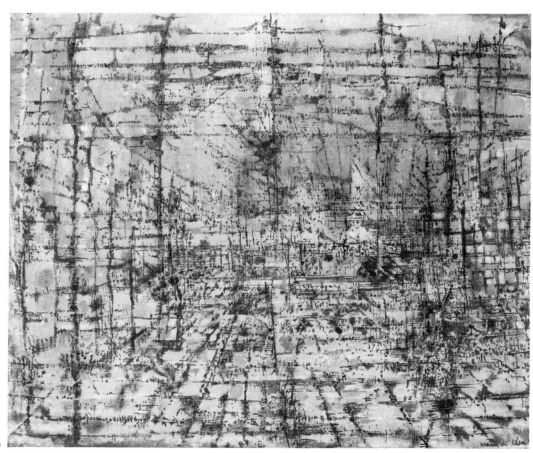

75 Vieira Da Silva

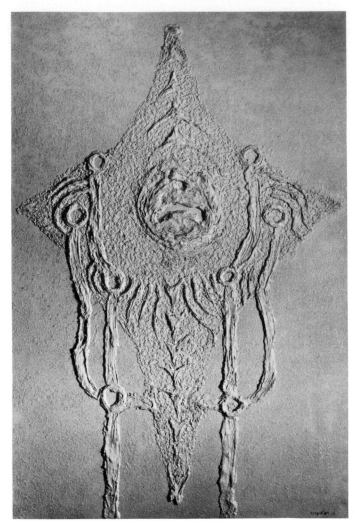

76 Jan Lebenstein

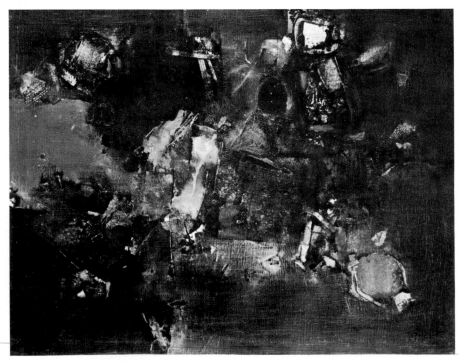

77 Jannis Spyropoulos

contribute to making this art – which has nothing in common with the first masters of abstraction – a classic *œuvre*. Nicolas de Staël is more closely related to Braque than to Kandinsky, in the same way as Atlan is more readily associated with Soutine than with Delaunay or with Kupka. In fact it is one of the characteristics of the lyrical abstract painters that most of them display no affinity with the abstract painters of the preceding generation. This applies not only to the geometrical painters, but also to the painters of the *Blaue Reiter*.

Paul Klee, who was to exert a great fascination over the second wave of lyrical abstraction, left scarcely a mark on the first, except for Vieira da Silva and Zao Wou-ki: and again, only in their first period. Delaunay influenced Lacasse and Polia-koff, equally in their early stages. But Atlan, de Staël, Schneider, Soulages, Bram Van Velde and Tal Coat, on the contrary, mark a break as total with the great figurative artists of the preceding generation (Matisse, Bonnard) as it was with the first masters of abstract art. Tal Coat [72] makes a backward leap over abstract art and cubism, to find himself at home with the Cézanne of the almost non-figurative watercolours. Schneider [68] back-somersaults impressionism to find himself close to Delacroix. Finally, Zao Wou-ki [80], leaving Klee in the anteroom, goes back in time, in search of the Chinese landscape painters.

At its best, therefore, one can say that the lyrical abstraction of post-1945 displayed a total orginality. A new painting was born at that time, practically without antecedents.

Atlan's work, for example [74], embodies a singular amalgam of the great art-currents which preceded it. Not orthodox abstraction, in that it by no means excludes morphological allusions, nor yet is it figurative. But it partakes of these two 'schools', just as it shows connections with surrealism and expressionism. A precursor, in 1945, of *matière* painting (Fautrier's *Hostages*, and Dubuffet's high impasto, are of the same time), and forerunner of gestural painting, Atlan reached the height of his powers in 1956. The talk at that time was of totemism. Atlan was moving towards the monu-mental, towards Assyrian art, which held a high place in his *musée imaginaire*, alongside that of the Aztecs, and African and Romanesque sculpture.

With Bram Van Velde [69], the art is not one of metamorphosis, as it is with Atlan, but of the death-throes of the image. A slow decomposition. One can see Samuel Beckett liking this painter. But there is nothing sordid with Bram Van Velde. Jean Leymarie speaks of a 'reckless plunge into the abyss, from which nevertheless he climbed back, surrounded with an aura of light wrenched from life, from death, from depths unknown, but in the event more sumptuous than funereal'.

Tal Coat [72] regards the sky as it reflects in the convex mirror of the earth, watches the mountains and the prairies, the woods and the waters, and tries to decipher the wealth of signs, of mirages. In a different way, it is the same pursuit as that which engages Ubac, or, again, Messagier, Debré, Guitet and Koenig.

Vieira da Silva's world [75, s. 26] is that of Gulliver, of Kafka and of José Luis Borges, not forgetting, indeed, that of Alice in Wonderland. In his *Biblio-teca de Babel*, Borges seems to be describing Vieira da Silva's work when he says: 'The universe (which others call the library) is composed of an indefinite, perhaps an infinite, number of hexagonal galleries, with vast ventilation shafts in the centre, edged with very low balustrades. From each of these hexagons one can see storeys above and below, interminably. Twenty-five tiers of shelv-ing.... the open side gives on to a narrow passage, which opens on to another gallery, identical with the first and with all the others.'

One of Vieira da Silva's favourite themes is precisely that of libraries. And her 'libraries' blend with her other familiar theme of cities, and with that of stones. And all these themes are linked together by the idea of fragmented immensities. These intricate mazes rise in their abstraction to the dimensions of an imaginary universe, in which the multiple hallucinations form a sort of labyrinth of mirrors.

Beckett is a help to the better understanding of Bram Van Velde; Borges of Vieira da Silva. For Zao Wou-ki [80] we shall cite Chou Chang-wen, who wrote under the T'ang dynasty, apropos the calligrapher Yen Chang-ching: 'His lines are like pebbles, his brushstrokes as the thin clouds of summer, his hooks are the like of wrought iron, his curves have the movement of a bent bow.' A description, surely, of a painting by

Zao Wou-ki, with its sensitive blend of calligraphy and landscape painting.

Having become one of the most celebrated Chinese painters in the West, he epitomizes, uniquely, the distinction of having been able to link together two apparently antagonistic civilizations. In him the abstraction of modern European and American painters joins hands with the very ancient semi-abstraction of the Chinese calligrapher-landscape artists.

And since we are speaking of calligraphy, we must not forget that in Japan, in 1952, the Bokusin-Kai (The India-Ink Men), a group of calligraphic abstract painters, was founded as a reaction against the decadence of traditional calligraphy. Painting and calligraphy are two quite distinct arts in Japan, each with its own laws and its own traditions. Shiryu Morita was the architect of this revolution in calligraphy, which he pushed to total abstraction in 1949-50. His reviews *Bokubi* and *Bokusin* created a substantial public for an art which has often, in the West, been confused with that of painting. Yuichi Inoue, Yoshimichi Sekiya, Sogen Eguchi, Toko Shinoda and Bokushi Nakamura succeeded, with Morita, in creating an extremely important 'stream' in Japan, but entirely independent of that of abstract painters like Saito, or again from the Gutai group, founded in 1951 in Osaka by Yoshihara. Gutai, after the visit of Michel Tapié and Mathieu to Tokyo in 1957, became the Japanese branch of *art informel*. It organized performance-ceremonies which, just like those of Mathieu, anticipated the Happenings of today.

Lyrical abstraction, born in France and the United States, and with a firm bridgehead in Japan, also promoted a completely unexpected regeneration of Spanish art. Ever since Picasso, Miró, Gris and Dalí, it had been accepted that Spanish art was an art of exile, and that no modern art existed in Spain. But, in 1956, at the international Biennales, Spanish painting made its appearance, under the auspices of the Franco regime. And this painting was abstract, lyrical and vehement. In 1958, the Spanish pavilion at the Venice Biennale was given over to these young painters, and one of them, Antoni Tàpies, was a prizewinner. From then on, the banner of the young Spanish painters was unfurled, and was to bear high the names of Tàpies, Feito, Millares, Sara and Cuixart.

This explosion had, of course, had its prehistory. After 1948, a regroupment of young avant-garde artists had taken place in Catalonia, with the foundation of the Dau al Set group in Barcelona, by the painters Joan Ponç, Antoni Tàpies, Modest Cuixart and Juan-José Tharrats. Expressionist and surrealist influences played some part in it. It was only after 1954 that Tàpies came close to his *informel* manner [20, 117], at a time when Tharrats was using strident colours, evoking the richness of mineral textures, and Cuixart [79] was using collages and perforations.

In February 1957, another group was founded in Madrid: El Paso, with Antonio Saura, Manolo Millares, Luis Feito and Rafael Canogar. Tàpies, Cuixart and Feito had in common a taste for heavy impasto. Saura [78], for his part, was more closely related to de Kooning. Was it 'informalist' – this new Spanish painting? Michel Tapié was quick to claim it, and to exhibit Tàpies and Saura in his groups. But Lasse Söderberg has made an excellent analysis of what distinguishes this Spanish *informel* from the Parisian *informel*: 'charged with a more profound antagonism, carried to the length of a dramatic condensation, which makes of it a definite testimony'. What Ricardo Gullón said of the expressionist Manuel Solana (a sort of Spanish Ensor) might be applied to it: 'Solana transforms the paint-substance into a cry of pain, and the broad strokes of colour wrinkle and pucker to express the agonized stupor of the Spaniard in defeat.' It all takes place as though the young Spanish painters, through their involvement with the *matière* – manipulation of the paint-substance – sought to join the painting and truth itself.

In the East another country, itself intellectually oppressed, was to loose a similar cry, voiced by the young painters breaking away from socialist realism. In 1959, the section of works from Poland, centred entirely on lyrical non-figuration, was the revelation of the Paris Biennale.

One painter dominated this Polish section: Jan Lebenstein [76], awarded the Grand Prix of the City of Paris. In his painting, from an impasto built up to the point of relief, merge vaguely defined figures resembling gigantic larvae. One was reminded, of course, of the hero of Kafka's *The Metamorphosis*, the man who, one morning, found himself transformed into a woodlouse.

The colours, greenish, earthy, muddy, corpse-like, succeeded in giving an impression of nausea to this sinister painting. Lyrical abstraction stumbled here on the beginning of a new figuration. But a song of despair remains a song, and hence a manifestation of lyricism. Other artists, such as Kantor, were related to a more orthodox gestural abstraction.

In Yugoslavia, where the liberation of the plastic arts was rapid, lyric abstraction was widespread. Lubarda, Janez Bernik, Edo Murtić [83], Ordan Petlevski, Oton Gliha, Ferdinand Kulmer – these are a few names among the very numerous Yugoslav artists whose work in general displays fine qualities of *matière*.

Jannis Spyropoulos [77], the first Greek artist to have been awarded a prize at the Venice Biennale (the Unesco prize of 1960) established a reputation with a discreet, intimist style of painting, animated with sudden flashes of colour. This is painting which, in an entirely different manner from that of Tàpies and Feito, seems nevertheless the expression of a lyricism of the Earth Mother. An arid earth, severe, burnt, incandescent, but also marvellously overwhelmed with light.

In Western Germany, Emil Schumacher [91, s. 27] and K. F. Dahmen [92] are the two painters most closely linked with that family in which the physical body of laid-on paint seemed to have a life of its own. 'From nests of dense and concentrated paint flow brimming waves of colours, spattering the rest with a fine spray of droplets', writes Franz Roh. 'Schumacher gives us *Erdlebenbilder*, "pictures of the life of the earth", to use the expression of the Romantic philosopher Carus. He seems to spy out the enigmatic reactions of our terrestrial crust. But nowhere in his pictures does one find a trace of commitment to a specific taste, of concern with an "optical problem". The surfaces, smooth or rough to the touch, heavy or light, continuous or intermittent, luminous or matt, seem to owe their origin to pure chance, and never seek or attain to a lifeless perfection.'

From Baumeister to Sonderborg by way of Ernst Wilhelm Nay, German post-war art has been strongly marked by lyricism. In Nay's painting, the German tradition of expressionism is joined to colouristic improvisation, and abstract writing to the explosion of colour [93].

Canada presents us equally with a stream of lyrical abstractionists, in the channel opened up by Paul-Émile Borduas and Jean-Paul Riopelle. From 1946, the Canadian group Automatisme (Borduas, Riopelle, Leduc, Mousseau) was manifest in Paris. Borduas and Riopelle were to settle in the French capital in 1955, and Borduas died there in 1960.

Painter, sculptor, teacher, theoretician, and animator, Borduas [94, s 28] had been the pioneer of modern Canadian art. From 1940, he was a lyrical abstract painter in a style close to that adopted later by Bram Van Velde. From 1942 to 1949 he devoted himself to a series of automatic paintings which anticipated what would happen later in New York, as also in Paris. As the author of the manifesto *Refus total*, signed by Riopelle, Mousseau, Leduc, etc., Borduas was dismissed from his teaching post because of the scandal it provoked. He emigrated first to New York, where he found among the action painters artists of his own kind, associating himself particularly with Franz Kline. For him, Paris was to be less favourable; he would find himself eclipsed by his pupil Riopelle [95]. The latter occupied a place between Borduas and Pollock. But Pollock's drip painting, by comparison, was lacemaking. That of Riopelle was mason's work. It is a peasant texture, made up of cracks and furrows.

In Italy, the dominant personality of lyrical abstraction is most certainly Emilio Vedova [85] in Venice, with his ample gestural quality. But Afro, Giuseppe Santomaso, Antonio Corpora, Scanavino and Bertini have also left their mark on one phase of Italian lyrical abstractionism [86, 87, 88].

Belgium brings together, in the same current, a certain number of original personalities: Louis Van Lint [90], Anne Bonnet [89], Antoine Mortier [114] – and the first phase of Alechinsky in the Cobra period. Antoine Mortier is an expressionist who often veers towards the tragic. His violence contrasts with the discretion of Anne Bonnet, or with the joy of painting in Louis Van Lint. René Guiette, Jean Milo, and Georges Collignon all united lyricism and abstraction with more or less happy results.

Great Britain, finally, has suffered under the heavy yoke of two influences: first that of France, during the great days of the Cornish School, when

William Scott and Roger Hilton bore the marks of Bonnard, Bazaine and Manessier; then that of America. But these two antagonistic influences ended by marrying, and by producing some fine offspring in the work of Scott, Hilton and Alan Davie.

Scott and Hilton are intimists, their work a play of counterpoint between the *tache* and graphism. Scott [96], all finesse, creates a subtle poetry with his *taches*, his squares, and with an almost oriental graphism. A simple drawing on the canvas, with a body of white paint of astonishing sensitivity, characterizes the work of Hilton [97]. In contrast, Alan Davie [98, s. 29], after a period under the influence of Pollock, arrived at a painting in which lyric abstraction aims at being symbolic, even magical. It is a happy mixture of action painting and of reminiscences of Celtic folklore, set down in sinewy calligraphy with splashes of brilliant colour.

Plates 78-98

78 ANTONIO SAURA. *Fele*, 1957. 130 × 97 cm. Private collection.

79 MODEST CUIXART. *Painting*, 1960. Oil on canvas, 89 × 116 cm. Private collection. Photo Henri Glaeser.

80 ZAO WOU-KI. *In memory of Chu Yan*. 1956. Oil on canvas, 130 × 162 cm. Collection Dr Larivière, Montreal. Photo Galerie de France, Paris.

81 YOSHISHIGE SAITO. *Work R*, 1960. Oil on wood, 183 × 122 cm. Collection Takashi Yamamoto, Tokyo.

82 KAMI SUGAI. *Yamato*, 1956. Oil on canvas, 130 × 89 cm. Private collection.

83 EDO MURTIĆ. *White Departure*, 1964. Private collection. Photo Gattin Nenad, Zagreb.

84 ARNULF RAINER. *Parting*, 1964. Oil on canvas, 50 × 70 cm. Property of the artist.

85 EMILIO VEDOVA. *Image of Time*, 1957. Tempera, 200 × 90 cm. Collection Achille Cavellini, Brescia.

86 ANTONIO CORPORA. *Painting*, 1952. Galerie de France, Paris.

87 GIUSEPPE SANTOMASO. *The White Wall*, 1965. Tempera, 70 × 50 cm. Collection Max Kahn, New York.

88 AFRO. *Burnt Shadow*, 1956. Catherine Viviano Gallery, New York. Photo Giacomelli, Venice.

89 ANNE BONNET. *The Golden City*, 1955-56. Oil on canvas, 150 × 100 cm. Musées Royaux des Beaux-Arts de Belgique, Brussels. Photo A. C. L., Brussels.

90 LOUIS VAN LINT. *Geological Section*, 1958. Oil on canvas. Musée des Beaux-Arts, Ghent. Photo Bijtebier, Brussels.

91 EMIL SCHUMACHER. *Big Red Picture*, 1965. Oil on canvas, 150 × 270 cm. Kunstsammlung Nordrhein-Westfalen, Düsseldorf.

92 KARL FRIENDRICH DAHMEN. *Terrestrial Formation*. Oil on canvas. 132 × 132 cm. Private collection.

93 ERNST WILHELM NAY. *Yellow Chromatic*, 1960. Oil on canvas, 125 × 200 cm. Folkwang Museum, Essen

94 PAUL-EMILE BORDUAS. *Black star*, 1957. Oil on canvas, 162 × 130 cm. Montreal Museum of Fine Arts, Montreal.

95 JEAN-PAUL RIOPELLE. *Painting*, 1951-52. Oil on canvas, 195 × 114 cm. Galerie Stadler, Paris.

96 WILLIAM SCOTT. *Yellow, Red and Black*, 1958. Oil on canvas, 76 × 91 cm. Private collection. Photo W. Churcher, Chelsea.

97 ROGER HILTON. *September 1961*, 1961. Oil on canvas, 89 × 107 cm. Private collection.

98 ALAN DAVIE. *Heavenly Bridge No. 3*. 1960. Oil on canvas, 101 × 122 cm. Gimpel Fils, London.

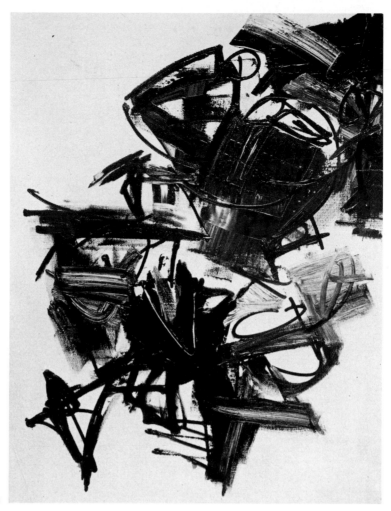

78 Antonio Saura

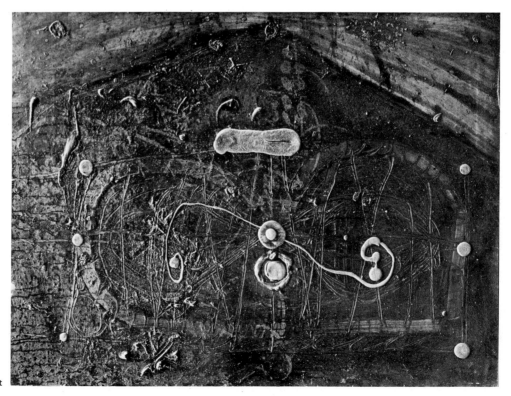

79 Modest Cuixart

95

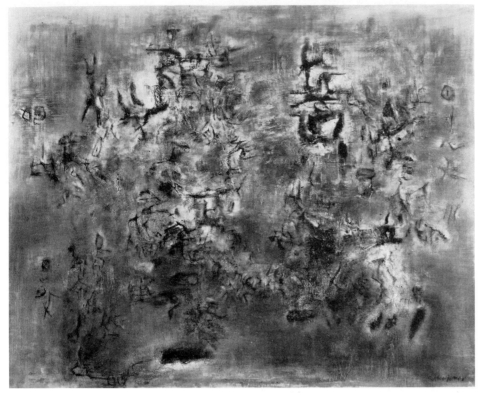

80 Zao Wou-Ki

81 Yoshishige Saito

82 Kami Sugai

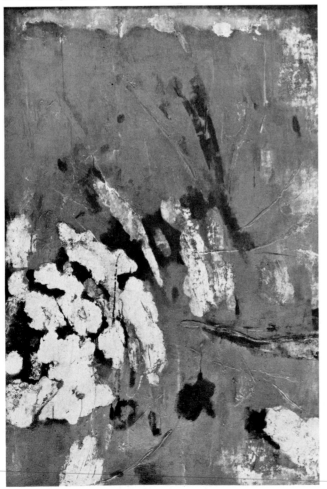

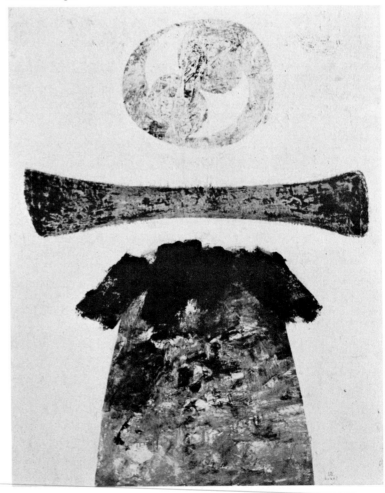

96

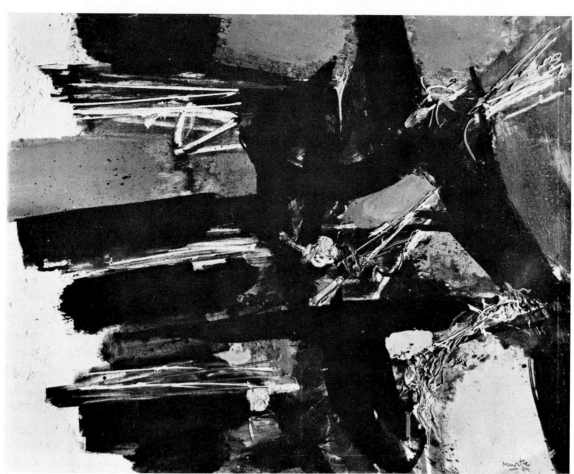

83 Edo Murtić

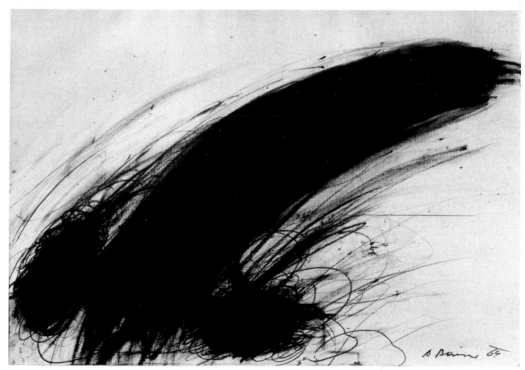

84 Arnulf Rainer

97

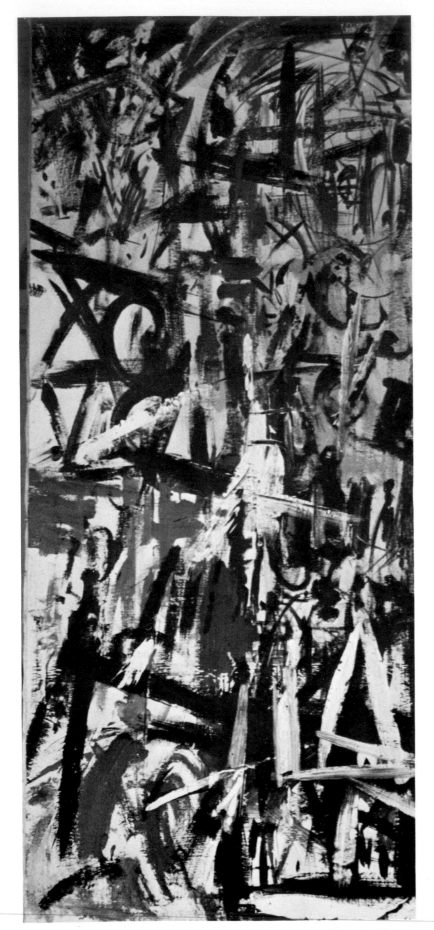

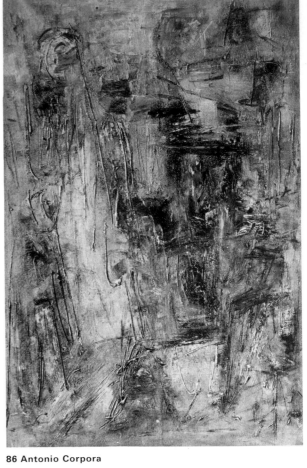

86 Antonio Corpora

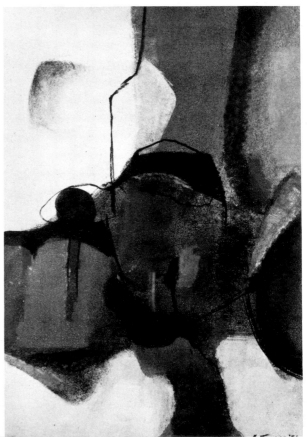

85 Emilio Vedova **87 Giuseppe Santomaso**

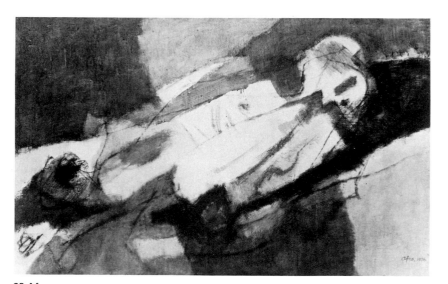

88 Afro

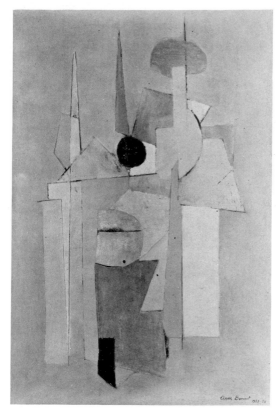

89 Anne Bonnet

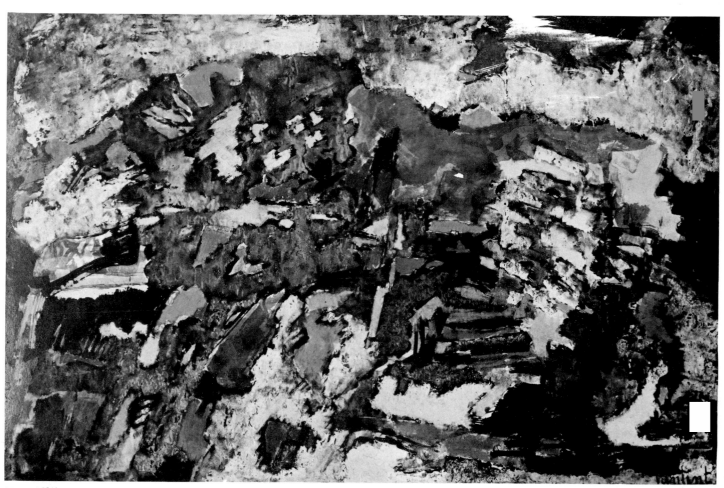

90 Louis Van Lint

99

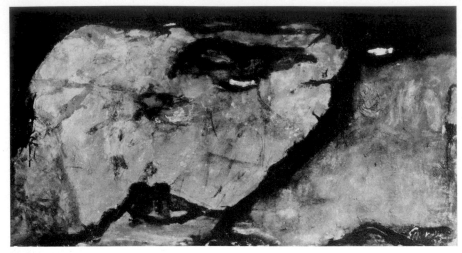

91 Emil Schumacher

92 Karl Friedrich Dahmen

93 Ernst Wilhelm Nay

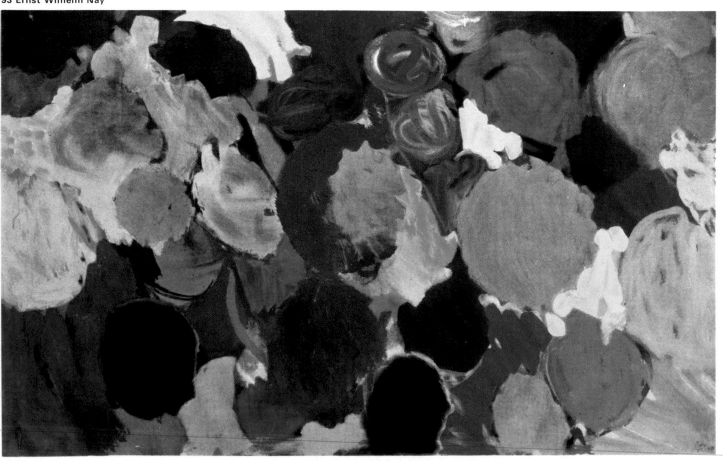

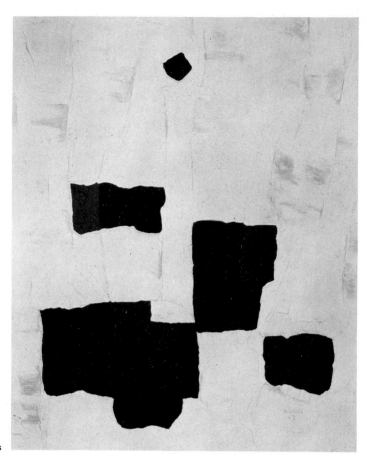

94 Paul-Émile Borduas

95 Jean-Paul Riopelle

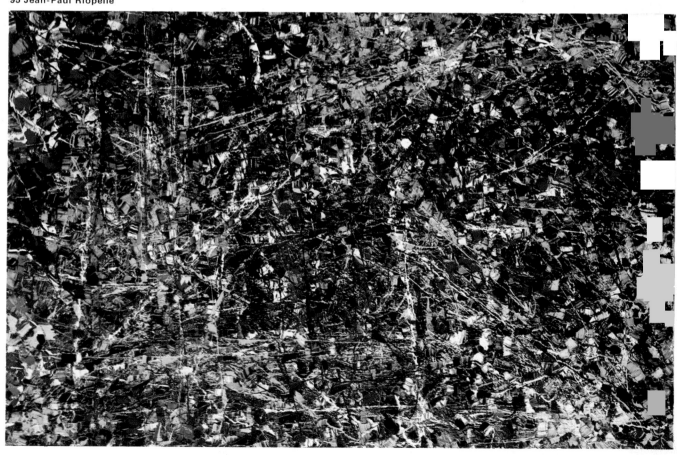

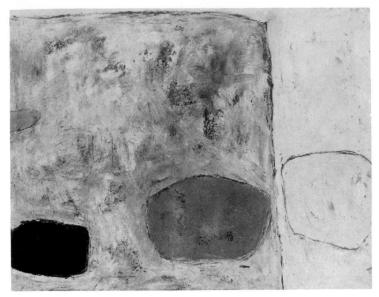

96 William Scott

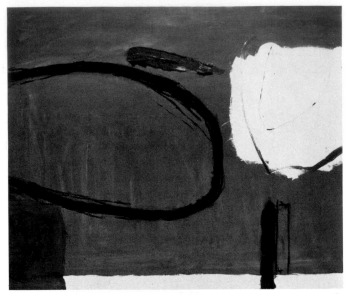

97 Roger Hilton

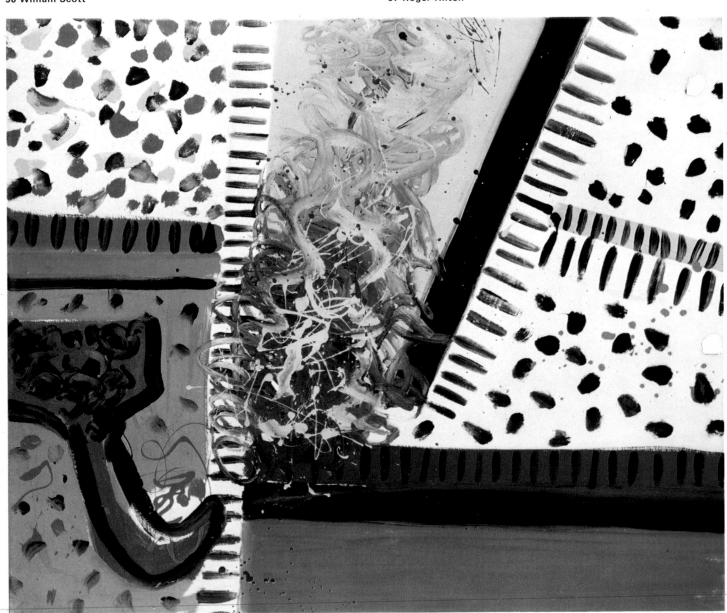

98 Alan Davie

The Sign and the 'Open Form'

FRANCINE C. LEGRAND

Art should be the language of the secret through that which is secret.
KANDINSKY

It is generally accepted that all forms of civilization are bound up with the use of certain signs and systems of signs. The functioning of the human spirit depends upon it, all the more so since an inclination which appears to be innate impels man to decipher, interpret and use signs. Admittedly, language and the sign bear a close relationship to each other, as witness the language of gesture. In times past, the terms 'word' and 'sign' were used indifferently, the object of both being the transmission of the thought.

In the pictorial field, the sign is a section of compositional elements, or a combination of those elements, the appearance of which is expressive and not exclusively aesthetic. It embodies an object, an action, a gesture, an idea, or one of those interior movements which we call passion or sentiment, sometimes all of these intermingled. These various uses have a common denominator: the pictorial sign, like the other signs, assumes a symbolic function. It is not, however, a symbol in the true sense if what is signified pre-exists, even as a hypothesis inserted into a clearly defined social context. Further, pictorial signs have benefited from the freedom enjoyed by modern art. They are not bound by a code, are not subject to a syntax, nor to relationships determined by a pre-established structure. They may refer to something which is buried in the subconscious, which does not actually exist, or which eludes the realm of visibility. If they reveal something, this can only be on the emotive plane, through an analogous connection open to an extensive range of interpretations. In contrast with the analytical reading of language, their immediate, total decipherment invades the realm of the subjective.

For this reason, recourse to the sign imposes itself on contemporary art just as the image of visible reality, that is to say figuration, disappears from it. Painting then stands at the intersection of two worlds, the interior and the exterior; the emergence of the sign being the mark of this encounter. It is this mark, this trace, or more precisely, the course followed by the artist in order to place himself in relation to the universe in an entirely new perspective, which is reinstated in the first abstract works of Kandinsky. In the series of *Improvisations*, strong black lines, at angles or in bundles, collide, or descend the gentle, brightly-coloured slopes with impetuous verve. Because our eye has become accustomed to ignoring descriptive or narrative elements, what we see here, first and foremost, is the graphic transcription of Kandinsky's cosmic lyricism. We are already looking for the gesture. But in truth, Kandinsky was so preoccupied with the problems of colour, of composition or of harmony that at this time, say about 1912 to 1914, he was not looking for the sign as such. He endeavoured, within himself, to establish dynamic relationships, animating the ensemble of the canvas, or to impose a rhythmic general order, in the service of an underlying theme that was still figurative, and often religious or symbolic. [1] It was only later, during his constructivist period, and, after the perfecting of his teaching method, [2] that he elaborated some autonomous plastic signs, based on three primary forms, the circle, the triangle and the square, organizing them with the intention of converting them into vehicles for a philosophical message [162]. The circle, in particular, with its cosmic and religious connotations, connected with the mandalas of India and of

eastern Asia, goes back to primitive forms expressing the unity of knowledge and of life.

It remains, however, that his work implements the two fundamental vocations assumed by the pictorial sign in contemporary painting. It establishes the rediscovery of the sign as an archetype of magical origin; and it proclaims the sign, as a lived experience and as a form of knowing, which characterizes lyrical and gestural abstraction.

(I) THE SIGN OF MAGICAL ORIGIN – THE SEARCH FOR ARCHETYPES

The relation of the sign to the object signified is often magical, in the sense that the sign is the projection of a desire, implying an intention to act upon the real through the sign, but to act in an occult manner, preserving the secret of that action, without completely revealing the correspondence between the sign and the signified. When this correspondence is of an analogical order, the analogy involves a certain degree of ambiguity. Several levels of significance are simultaneously in question. This relationship, at once analogous and ambiguous, conditions the efficacy of this type of sign.

'All poetic language', wrote Mircea Eliade, 'begins by being a secret language, that is to say, the creation of a completely closed universe.' Robert Amadou,[3] commenting on this remark, added: 'That sort of shared secret remains a secret to all those who share it, for, to tell the truth, they are links in the chain of a secret which they do not share.' Certain groups of plastic signs give one the feeling that they are one link in a chain of which the artist himself knows only that link. For our part, it seems to us that the artist, despite his partial ignorance, is attached to the world by a mysterious bond which allows him either to discover the essential symbolic schemas which Jung calls archetypes, or to reproduce the natural processes of life.

In both cases, the artist is in the position of an initiate. His attitude derives from magical aspirations, and it follows from this that an intimate awareness of his work constitutes, for the spectator, a certain degree of initiation. This is what renders modern art so hermetic at first approach, and so profoundly rewarding as, little by little, one penetrates into it, like a traveller in a strange land.

Men in prehistoric days, like so-called 'primitive' peoples today, made use of the sign with a magical function. So it is natural that the will to restore this function to the sign should be, in modern art, a function of those artists who are aware of the importance of man's early days on earth, and even desirous of drawing inspiration from them, in the hope that this move may lead them, as Paul Klee has expressed it, 'a little nearer to the heart of creation than usual'. Klee, Miró and Arp showed the way, but this way may also lead, as we shall see, to Capogrossi's single sign, to Torres García's pictogram, or to the giant sign of Franz Kline. It is worth remembering that Paul Klee's primitivism [99] is the considered product of a discipline tending to reduce the representation of the world, and that of the sentiments, to their essentials. The sign is the natural end-product of this search. Klee was the first to proclaim the equivalence of the letter and the sign,[4] the latter being no more than an ideogram of unknown ancestry, not yet worn threadbare by the passage of thousands upon thousands of inattentive eyes; free to convey a message not corresponding to words. The course of lectures he gave at the Bauhaus, from 1920 onwards, obliged him to systematize his ideas. The sign, up till then woven into the pictorial fabric, became the object of a presentation in which it assumed the principal rôle. Thus we have a resplendent mime of that which takes place beyond the visible, in those genetic strata which are as yet pure energy. Finally, during the last three years of his life, 1937-40, his signs, organized in a system of notation, attain heroic dimensions, sustained by authority, by the will to eloquence and by deliberate choice of schematization.

At the moment when Klee's sign crystallized into an ideogram, that of Miró [100], which in the beginning was developed along the wayward trace of 'writing', in curled and dancing pothooks – 'the absence of forms like a swing-door kept incessantly on the swing, open and shut, by the wind of one's own passage', 'a movement towards something of which the most thrilling characteristic is its elusiveness'[5] – this sign in its turn fragmented, and moved towards the pictogram, adapting itself to that love of the concrete which is proper to Miró. Memory feeds invention, accompanied by the intervention of transcriptions from

the visible world or, more precisely, of objects peopling the poetic world of Miró: heavenly bodies, birds, women, and the ladder which unites them. Thus, from 1942 onwards, a vocabulary came into being which 'crystallizes' at times, as Jacques Dupin remarks, 'in insistent configurations'.[6] The process of association which presides at their inception remains free to cast its net at random; it embodies simultaneously the elements, the sensations of plenitude and of terror which these inflict on man, and the rhythm which passes from one to the other, that respiration which the Chinese call the 'movement of life'.

Since 'art is the fruit which grows in man as the fruit grows on the tree or the child in its mother's womb',[7] a very close bond exists between this fruit and the original tree; the one may signify the other, the part represent the whole. Clarified, this sign becomes more and more symbolic because, thus stripped down, it rediscovers a morphology in the initial form, emblematic of the biological evolution of the world.[8] From the dadaist period onward, Hans Arp's reliefs [101] are particularly rich in signs of this sort. The egg, the navel, the moustache and the fork are initial and initiatory motifs, and are succeeded by constellations of forms which represent nothing very definite, but which, confronted with nature, proclaim their analogies. In sculpture, configurations and concretizations are again examples of that faculty which distinguishes the artist: the faculty of creating, according to a schema analogous to that which produces organic growth. Appeal is made here, not to a logical knowledge of the world, nor to a reasoned symbolism, but to an intuitive recognition of the original sources and of their progression. This point of departure awakens on the part of the spectator a response of a sensuous nature. The growth due to life brings joy to him who feels himself alive. But, however sensuous this joy may be, consciousness of the sacred is not far removed from it. 'For, in the end,' wrote Gérard de Champeaux, 'it is always a matter of being *born with*, the accent being on the *with*, that small mysterious word in which lies the whole mystery of the symbol.'[9]

Arp, Klee and Miró set the tone for numerous attempts to create a vocabulary of pictorial signs with magical repercussions. This influence was felt, in the first instance, by Willi Baumeister, who was to dedicate a great part of his *œuvre* to the search for, and then to the modulation in serial variations of, symbols of an extremely personal morphology [102, s. 30]. His first ideograms, from the years 1937-38, are, as it were, a meditation on the initiatory power of signs; the silhouette of the *torii* which mark the threshold of Shintoist temples appears very frequently. Later, his language was enriched by references to the primitive arts and to the myths they served to celebrate. About 1948, a long series of paintings was devoted to Gilgamesh, the Babylonian hero. In 1955, with the series entitled *Han*, Baumeister seemed to be turning again towards China. The dancing aspect, the freedom in space, of Miró's signs is preserved, but so too is the principle of organic growth dear to Arp. These characteristics are, however, controlled by a respect for order and for readability which reminds one of Baumeister's interest in typography. The background plays an active part, the outline of one sign constituting another sign in the negative. Finally, technical experiments brought Baumeister at times close to the *informel* painters. In German painting, he plays a determinant role, notably in the formation of the Zen 49 Group, which also included Winter, Cavaël, Geiger and, later, Theodor Werner and Julius Bissier.

In the later 1940s, many artists on the American continent turned to the use of signs, amongst others Torres García, who in this respect, appears as a forerunner, Pollock, Gottlieb, Baziotes, Stamos and even Tomlin. These painters are poised between Arp's organically inspired morphology – this is very evident, for example, with Gorky – and the reminiscences of primitive art which characterize Klee and Miró, although with Miró the two families of signs intermingle.

The search for this vocabulary was at times accompanied by practices derived from an automatism of surrealist origin: practices which were to end up, moreover, by destroying the sign. Pollock, notably, renounced the sign in favour of a gestural automatism, while Motherwell and Kline arrived at a creative method in which the pictorial instinct orients and controls the impulses of automatism. Very often, as with Torres García and with Gottlieb, archaism is sustained by totemic allusion:

the signs refer to the magical union between man and the animal, and promise a glimpse into the mystery of his ancestry; certain objects, which are themselves parts signifying a whole, are charged with a fundamental symbolism. Thus the fish, the eye, the tree, the house, represented in elementary fashion, seem to be the keys of destiny. Undoubtedly the linear partitioning used by Torres García from 1932 or 1933 onwards has been thought to be a heritage from neo-plasticism. It remains that the pictograms lodged in 'boxes' derive from pre-Columbian symbolism, and are in the nature of horoscopes. Adolph Gottlieb [103, s. 18] was under his influence when, in 1941, he embarked on his *Pictographs*, a series of paintings with compartmented symbols. He claims to have exhumed certain relics from the crypt of Melpomene – the tragic Muse – relics which are assumed to originate from the collective patrimony of humanity, and to refer to myths. [10] At the conclusion of a period of evolution covering several years, he came to dramatize his message by reducing the number of signs and by enlarging their size.

Beginning in 1957, in the series entitled *Bursts* [29], he had rejected all calligraphic transcription of symbols. The resources of colour and of the pictorial *matière* are exploited for the benefit of a much stronger emotional impact than that of his previous works. The circle, the cross, the square, exist in thickness; the signs have become volumes of velvety consistency, surrounded by an aura, exploding in an irradiated space. The mystery no longer lends itself to decipherment: it commands attention in its totality. Size is a factor in its efficacy.

While repetition had already endowed many of Torres García's pictograms with an incantatory rhythm, Giuseppe Capogrossi's obsessional sign [104] is the most magical of all the archetypes of unknown ancestry brought to light by modern art. Capogrossi has used it since 1949 without its efficacy becoming impaired. Here we have a toothed mark, always of the same type, and one which is yet subject to constant metamorphoses. Its insertion into a grid, a linear scaffolding, or its isolation, its size, its relationship with space and with its likes, the spectator's angle of vision and his method of 'reading' – analytic or in totality – endows it with

Plates 99-106

99 PAUL KLEE. *Red waistcoat*, 1938. Casein on jute on plywood, 65 × 42.5 cm. Kunstsammlung Nordrhein-Westfalen, Düsseldorf. Photo W. Klein, Düsseldorf.

100 JOAN MIRÓ. *Le corps de ma brune*, 1925. Oil on canvas, 130 × 96 cm. Collection Mme Cuttoli, Paris. Photo Studio Y, Hervochon, Paris.

101 JEAN ARP. *Plate, Fork and Navel*. 1923. Relief on wood, 59 × 61 cm. Sidney Janis Gallery, New York.

102 WILLI BAUMEISTER. *Runner II*, 1934. Oil and sand on canvas, 65 × 81 cm. Marlborough Fine Art Ltd., London.

103 ADOLPH GOTTLIEB. *The Alkahest of Paracelsus*, 1945. Oil on canvas, 152 × 112 cm. Property of the artist.

104 GIUSEPPE CAPOGROSSI. *Surface 327*, 1959. Mixed technique, 159 × 195 cm. Musées Royaux des Beaux-Arts de Belgique, Brussels.

105 ANDRÉ MASSON. *The Wild Beast and the Bird*, 1927. Coloured crayon. Museum des 20. Jahrhundert, Vienna.

106 GEORGES MATHIEU. *Werther*. Oil on canvas, 145 × 145 cm. Private collection.

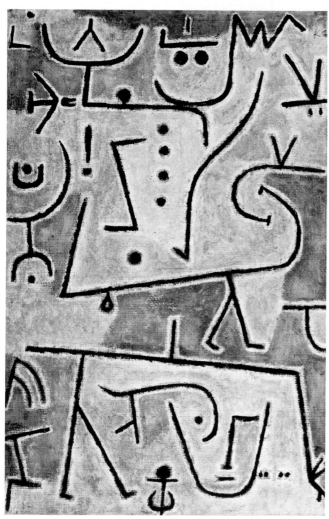

99 Paul Klee

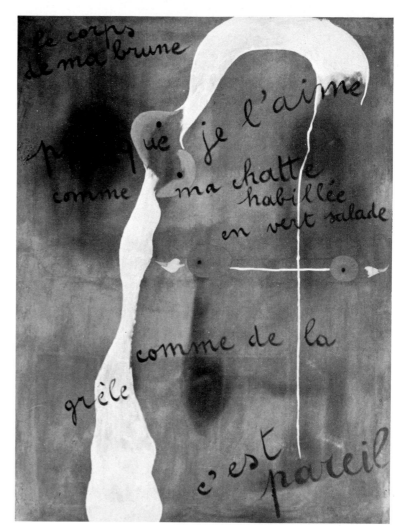

100 Joan Miró

101 Hans Arp

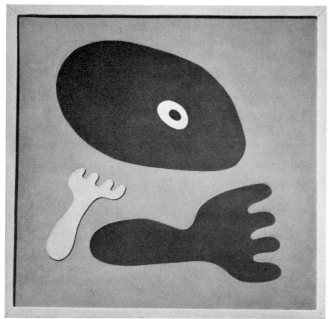

102 Willi Baumeister

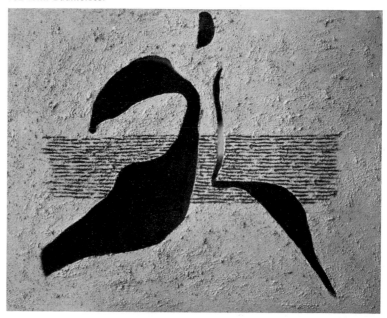

103 Adolph Gottlieb

104 Giuseppe Capogrossi

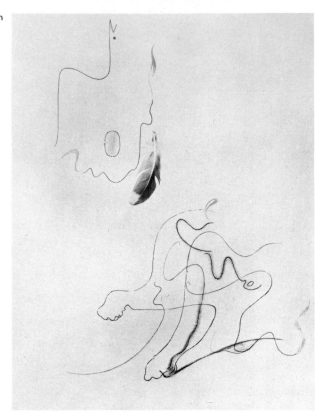

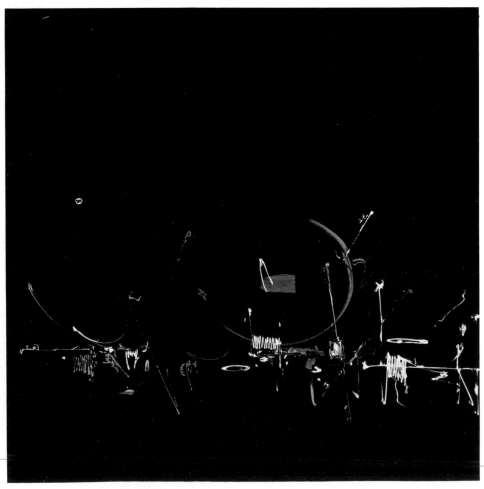

106 Georges Mathieu

a range of expression which is virtually inexhaustible. Let us take the two extremes: on the one hand a precise assemblage of meshing cogs takes up the entire space; no place here for gods or men: the robot signs function on their own. On the other, a hierarchy among the signs appears to distinguish between the principals and mere players; and all gesticulate like human beings. An expressionist drama is being acted out on the screen of the canvas. Beneath this uniform dress we find Klee's mimed sign. But the operative field of this sign is time. The artificial structure of time, the fabrication of a society, is abolished by the sign; the sign becomes common denominator of all things. There is no longer any perspective, nor any ranging in tiers, neither in space nor in time. Today does not exist; yesterday is the same as tomorrow. All divisions are absurd. As in Michaux's ink drawings, a line drives its way, in an endless spiral, into the pliant, living substance of events.

On a quite different scale, Julius Bissier's endeavours, in the wake of Paul Klee and Baumeister, are equally characterized by the search for the archetype [109]. From 1956 onwards, his pictograms have a metaphysical resonance, impregnated with an Oriental quality of meditation; the drop of water is in the image of the cosmos. The road, the house, the tree, the fruit – ideas and emblems – float in an immaterial space which sustains and sanctifies them. Each miniature takes possession of the world at the moment of its birth, and of the object at the moment when this assumes a sort of eternity; trail-marks to an elsewhere devoid of grandiloquence. The most familiar figurative signs, carefully denuded of any mark of individuality, go back from the species to the genus and from the genus to the essence. Like letters, to which they are often compared, they have their abstract and initiatory value.

THE SIGN AS EXPRESSION OF EXPERIENCE

In gestural painting, sign and gesture are merged. A sign is a curtailed act, and therefore a gesture; but, better still, it is a gesture which leaves a trace. It should be understood as being in opposition to that form and mass which it seems to eliminate. Rejecting all that delimits, it is open. The effects and consequences of non-premeditation – the

degree of which is extremely variable from one creative artist to another – meet together in it. In principle, it allows of no previous operation of decipherment on the part of the artist. Thus it becomes the medium of emotions, of aspirations, carrying these latter to their furthest point. It nails the lightning-flash, and may well share its intensity. It attains the concentration of a note of music resonating indefinitely in a given space, abolishing the notion of time which conditions musical expression. The miraculous fact of survival exalts it. It is at once the instrument of interior liberation and of union with the cosmos. Moreover each artist solves differently the problems posed by this type of sign, the problem of the dynamic of signs and of automatism, personality problems and behaviour, the problem of the reciprocal activation of signs and space. This type of experience can best be approached through a few examples. Umberto Apollonio has drawn attention to the importance of Hans Hartung [14, 15, 107] in 'sign' painting. [11]

From 1920 to 1922, which is to say from the age of 18 to 20, Hartung began to disentangle the sign from that which obscured it – the *tache*, the blot, the skein of tangled lines. He delved into the contradictory heritage left by Kandinsky, introducing the primacy of the act over the meaning, whereas Kandinsky's sign still betrays the search for meanings. [12]

His biographers have stressed the accord between his life and his *œuvre*. [13] We would underline, in addition, the similarities between his character and his gesture. One finds, in one and the other, energy combined with patience; what René de Solier calls 'an acute meditative force', [14] a quality richer and more complex than intelligence alone; a quality which sharpens the inward-looking and the outward-looking perceptions. Hartung's signs are not pure spiritual energy. They are grasses, whiplashes, silk, tufts, bunches, manes, the crackle of burning twigs, a tornado shaking the trees. The graphic expression is linked to drawings of substance and texture. Hartung seeks to immerse the brushstroke in a milieu which breathes. Also, the expressionist dynamism of the brushstroke feeds on a multiplicity of sensory perceptions. Even if 'the start is the great moment', even if what he enjoys above all is to 'act on the canvas', something

of the impressionist attitude towards nature subsists. In addition, Hartung, because of his disciplined technique, stands apart both from surrealist automatism and from gestural painting. This is because, while exercising his ability to let himself go, he also practises the art of recapture. He alone can interrupt a gesture and return to it without losing the original freshness, or allowing any deviation in the movement. At the heart of the 'active dialectic of creation', the impulse and the control correspond, and their dialogue is continuous. That is why, although Hartung's sign has left a profound mark on contemporary art, although it has inspired, for example, Mathieu, Soulages and Karl Otto Götz, the sign is unique and inimitable.

The first artist, without a doubt, to deliberately explore the virgin territory of automatism was André Masson [105], who blossomed, like Miró, in the surrealist hothouse. From the year 1924, his drawings are relevant to the subject in hand. Despite a temporary rupture with the group in 1929, [15] automatism, in various phases of his work and even to this day, provides him with a technique for 'plunging to the deep springs of lyric effusion'. His romantic nature incited in him a will to express both the constant metamorphosis of form and the tumultuous rush of feeling. Fascinated, from his early years, by the Far East, he was to have the opportunity, in Boston during the war, to familiarize himself with Sung painting, of which 'the line is so open that it returns to universal fluidity'. His credo becomes more clearly defined. He sees in the sign, among other things, a method well-suited to man in his appeal to nature. His example, and his remarkable writings, were to be a source of instruction to the young New York school. He is in truth the link which unites the surrealist automatism of the years 1926-28 with post-1945 gestural painting. After those of Hartung, it was his signs which paved the way for Mathieu [23, 106, s. 13].

For the latter, improvisation in its raw state and the duel with chance were essentials. A spectacular duel it was, animated for several years by a genuine spirit of provocation. At that time, Mathieu was like a man possessed, a mad pilot performing vertiginous power-dives. But the flight was brief. Following this, despite more and more brilliant effects, only the actor remained on the stage; the god he had housed had departed. In his later work, there is no longer a sign, properly speaking, but a bundle of fireworks, in which the stroke – the line – broken in zig-zags, returns incessantly upon itself, with a nervous, twitching mannerism, subject to involuntary tics, and devoid of any real invention. Mathieu, who had regarded himself as the leading exponent of the 'aesthetic of speed', was merely its vulgarizer. The term, which is his own, is in any case a source of confusion. Speed is not an aesthetic, unless perhaps in the work of the Venetian *fa presto* painters. It is an instrument, a condition and a result: an instrument, or rather a weapon, used by the hunter to overtake his prey; a condition which favours a type of sign, but in no way guarantees its quality; and the result of a 'sudden illumination'. Blaise Distel, alias the Belgian painter René Guiette, has given a qualified opinion on this matter. We must remember that between 1951 and 1955, Mathieu's example, his writings, [16] the confrontations between European, American and Japanese artists in which he, with Michel Tapié, took the initiative, even his exhibitions – all these helped to make it clear 'that the sign precedes the meaning', and that, in consequence, new paths had opened up in painting. [17]

Jean Degottex [108, s. 31] did not really become a gestural painter until the years between 1955 and 1966. In his work of that time, the sign is possessed of a particular intensity. Very often his paintings form a series, and from one canvas to another the signs correspond: the one accomplishes what the other promised, impelling us to reconsider the relationship between space and sign. In fact, whereas the sign does not represent anything – that is to say, does not refer to any pre-existent image – the virgin, prepared canvas does represent something, for the painter, at least for a few seconds: it represents space. Between it and the sign a reciprocal play of activation is established. Now for Degottex this space does not end with the canvas. If the latter is the scene of the apparition, the void which separates it from the neighbouring canvas is the true seat of the mystery. The sign no longer rises solely from the field of the canvas, but also from the void which surrounds it, that void of which one could say that it is defined by its opposite, plenitude.

To have functioned creatively with the minimum taint of the aesthetic is the distinctive achievement of the poet Henri Michaux [111, s. 10]. 'To paint, to compose, to write, to explore myself. In this lies the adventure of being alive.' His ink drawings, even more than his writings, are to be seen in the light of an interior exploration, systematic, quasi-scientific, and at the same time prodigiously rich on the affective plane. Bertelé, who has analysed the importance of this body of work better than anyone, writes: 'Michaux succeeds in making a direct transfer to paper of the charge of energy tapped from the profoundest springs of being: the interior ferment in its raw state.' [18]

Historically, his position is that of a forerunner. The first pages of his written work date from 1927. At a time when the majority of surrealists were seeking the truth in other directions, and avoiding the sign in favour of the image, he was testing the potentiality of the sign, and had engaged himself in an entirely solitary, almost clandestine enterprise. Like Hartung, he takes as his point of departure the *tache* – the blot – the 'original cell'. The effervescent pictograms he extracts from this proclaim the mobility and emotiveness which were to become the dominant feature of his language. In 1948, he produced three hundred gouaches in forty nights. According to Henri P. Roche, his inspiration was so highly charged that with his left hand he threw down a finished gouache and with his right, without stopping, began another. Indeed, speed and the series functioned as 'developers'. Pursuing his investigation, Michaux came to find that, at another level of consciousness, the sign is merely a link in a held chain, the unreeling of which, when accelerated, can become endless. The numberless crowd of signs transformed Michaux into a medium. Pursuit of heightened awareness led him to the use of drugs. The tight spirals again became a texture in which being and non-being, the sign and the non-sign, are inextricably mixed. Was he the first to reach this distant shore beyond the sign?

The notion of unity through the multitude; of an extent and of a multiplicity of directions concentrated on a small surface, is one shared by Mark Tobey [12, 110, s. 4]. He too inclines finally to abandon the sign in favour of a rhythm integrated with a texture. But here the austerity of Michaux has no place. We are in the presence of a painter who does not exert his attraction through the intermediary of a highly elaborate technique. The infinite is not only signified, it is suggested emotionally, through a general animation of the surface, on which the peregrinations of the brush are superposed in interlacing rhythms so as to create a field in depth. As with Masson, allusions to nature have a romantic character, and derive from a mysticism far removed from Michaux's positivism; Tobey places himself in the orbit of Chinese thought, which seeks 'the fusion of spiritual rhythms with the movement of living things'. [19] About 1934, under a direct Far Eastern influence, not excluding reminiscences of American Indian folklore, Tobey sought to embody his message in an accomplished calligraphic sign. At various times in his life, Tobey reinvents ideograms, sometimes in conformity with the Zen spirit, according to which the idea and its carrying into effect are simultaneous, the idea 'freeing itself' as the brush moves. From the beginning, he has pursued effects which contradict the architectonic organization of forms customary in Western art; he tends to eliminate mass and to dematerialize the brushstroke. His essential contribution goes back to the 'white writing' of the years 1935-38, which is, according to him, the notation of imprints and traces left by men of their activity in a certain environment and within the bounds of their survival. From that time on, he has aimed essentially at suggesting a balance between energy and matter, space and movement. This balance is usually the fruit of a meditation, the object of which is indicated in the title of the work. The sign is not the end in view, but when he does use it in isolation, in the form of an explosive calligraphy, for example about 1957, in his ink drawings (sumi on paper) it is rather, so it seems to me, to provide an outlet for an excess of energy which might distort the meditation.

Sonderborg [22, 115, s. 12] has often been compared with Tobey. He too starts from the spectacle of reality, but what he wants to express is neither the forms, nor the masses, but the movement, the trajectory of human actions. In 1948, he was drawing isolated signs. Five years later, the visual impressions, transformed into accelerated notations, form a writing. From this time onward, the

rapidity of execution becomes a determinant factor, which diverts him from the search for plastic equivalents for things seen. The name of Karl Otto Götz [116] comes to mind here. Like Tobey, he expresses natural forces. The elements – water, wind, fire – seem to control the gesture. Speed, allied to dexterity, is indispensable for transmission of the message. Finally, with all of these, it is the feeling for speed, for the life-force, which they are concerned to transcribe. We touch here on a notion that was to be developed later by the *matiériste* painters, using other methods, that perhaps life itself is a writing and that it is this that one is concerned to show.

Towards 1950, a few American artists, such as Gottlieb, Motherwell and Kline, and Europeans, such as Soulages and Mortier, effortlessly bridged the gap between the sign within the scope of the hand or the arm, and the sign of monumental proportions, witnesses of the human scale and sometimes of its surpassing that scale. The huge scale of these works reunites creator and spectator, immersed in a total experience which engages the physical and the intellectual faculties; an experience which may be lived sometimes as an event. Rothko has let it be understood that the aim of his giant dimensions was to provoke a feeling of intimacy, through the absorption of the surrounding world by a painting of which it is an integral part. It is not a question, here, of opening a *trompe-l'œil* window on the surrounding world, but of attracting the spectator into an expanding magnetic field. When there is a sign, it constitutes a summons to participation in the movement, to taking possession of space, or to any other event which is happening within or in front of the painting. It is no longer possible to spell out the parts like successive syllables. Everything takes place at the same time.

Although they may not be premeditated or elaborated like composition of a classical type, these paintings have nothing to do with an instantaneous execution, such as those of gestural painting. They come into being on the surface of the canvas itself, sometimes slowly and in continous evolution. Their quality of direct and spontaneous expression is preserved by a process of maturation which, to the very end, keeps the

Plates 107-120

107 HANS HARTUNG. *T 1958-4*, 1958. Oil on canvas, 92 × 60 cm. Saidenberg Gallery, New York.

108 JEAN DEGOTTEX. *En Shira* (or *En Shinra*), 1961. Oil on canvas 162 × 114 cm. Musées Royaux des Beaux-Arts de Belgique, Brussels. Photo A. C. L., Brussels.

109 JULIUS BISSIER. *I feel the Autumn, 16.8.59*, 1959. Tempera on canvas, Private collection, Brussels. Photo P. Bijtebier, Brussels.

110 MARK TOBEY. *Towards the Whites*, 1957. Tempera on paper, 114 × 72 cm. Museo Civico di Torino. Photo O. Baker, New York.

111 HENRI MICHAUX. *Painting in India ink*, 1966. 75 × 107 cm. Galerie Le Point Cardinal, Paris. Photo J. Hyde, Paris.

112 FRANZ KLINE. *Elisabeth*, 1961. Oil on canvas, 200.5 × 150 cm. Collection A. I. Sherr, New York. Courtesy Sidney Janis Gallery, New York. Photo E. Pollitzer, New York.

113 PIERRE SOULAGES. *Painting*, 1958. Oil on canvas, 195 × 130 cm. Private collection.

114 ANTOINE MORTIER. *Daily Bread*, 1954. Oil on canvas, 162 × 114 cm. Private collection.

115 K. R. H. SONDERBORG. *Drawing, 14.IV.59*. India ink on paper, 75 × 56 cm. Private collection.

116 KARL OTTO GÖTZ. *Stordo*, 1957. Oil on canvas, 145 × 175 cm. Private collection, Rome.

117 ANTONI TÀPIES. *Gouache on Paper*, 1967. 78.5 × 64.5 cm. Galerie Maeght, Paris. Photo Claude Gaspari.

118 JAROSLAV SERPAN. *Tnan*, 1952. Oil on canvas, 81 × 111 cm. Collection Max Clarac-Sérou, Paris.

119 JOHN FORRESTER. *Mark Black Two*, 1961. Oil on canvas, 92 × 73 cm. Collection McRoberts, London. Photo Ducommun, Paris.

120 CY TWOMBLY. *A Crime of Passion*, 1960. Oil, chalk and crayon on canvas, 190 × 200 cm. Wallraf-Richartz Museum, Cologne, Collection Peter Ludwig. Photo Rheinisches Bildarchiv, Cologne.

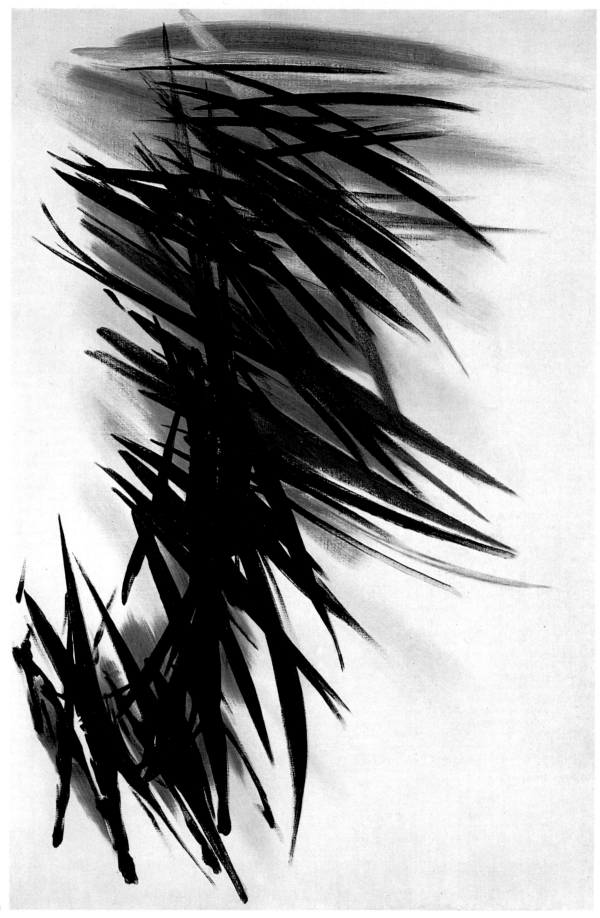

107 Hans Hartung

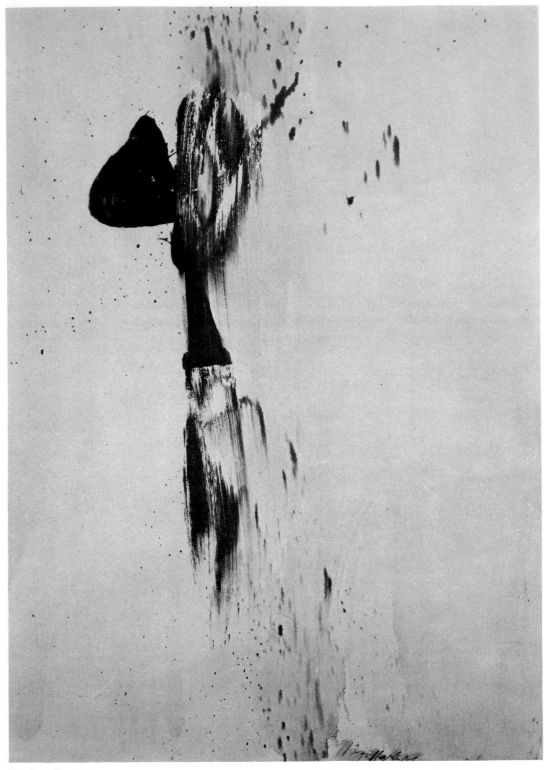

108 Jean Degottex

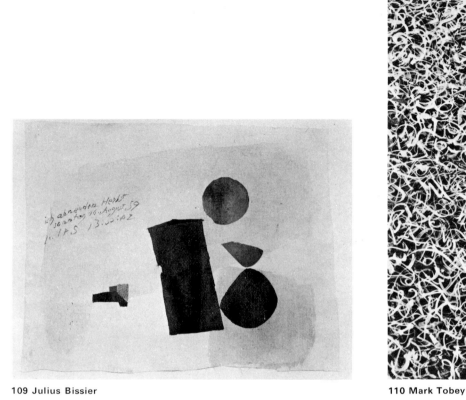

109 Julius Bissier

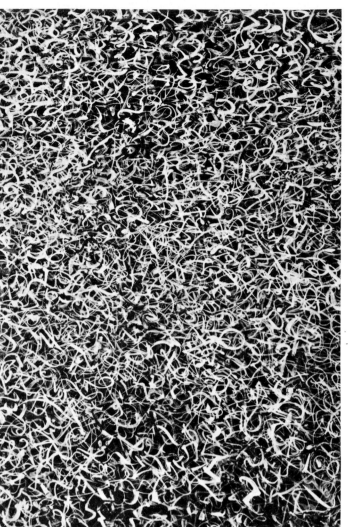

110 Mark Tobey

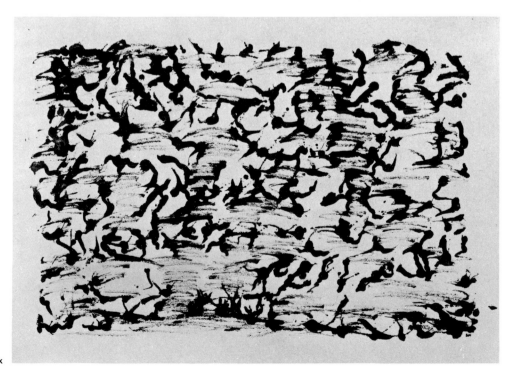

111 Henri Michaux

117

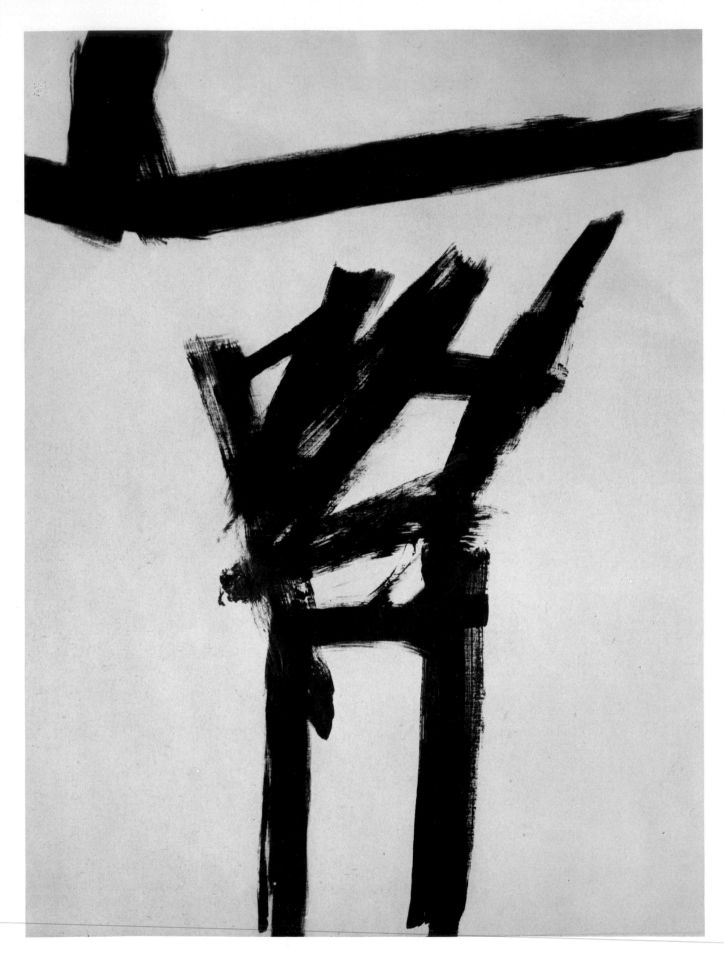

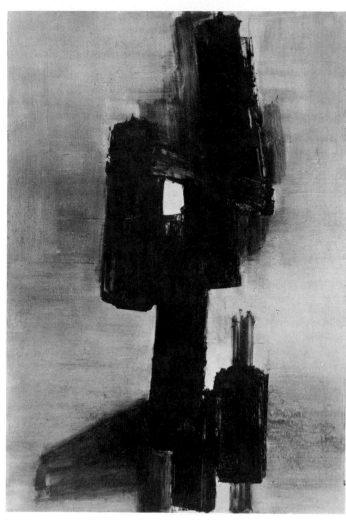

113 Pierre Soulages

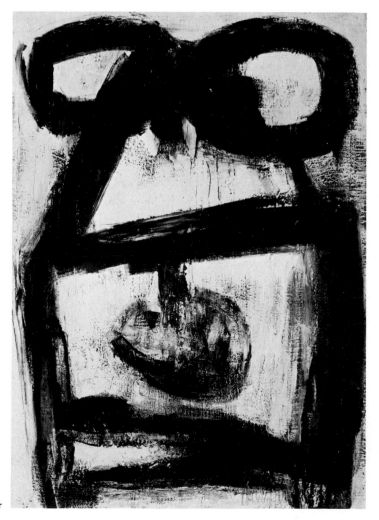

◀ 112 Franz Kline

114 Antoine Mortier

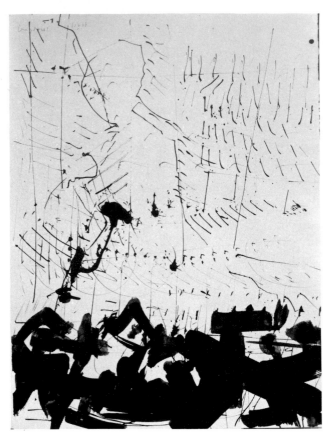

115 K.R.H. Sonderborg

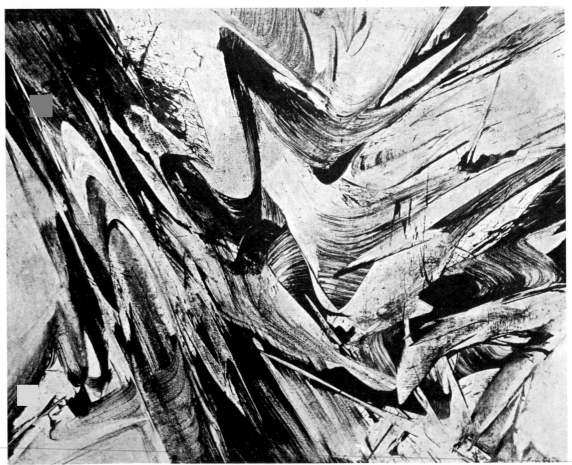

116 Karl Otto Götz

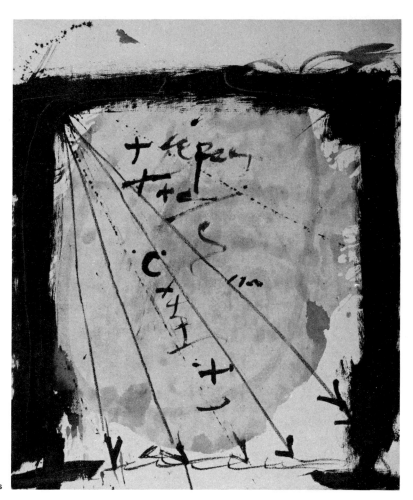

117 Antoni Tapies

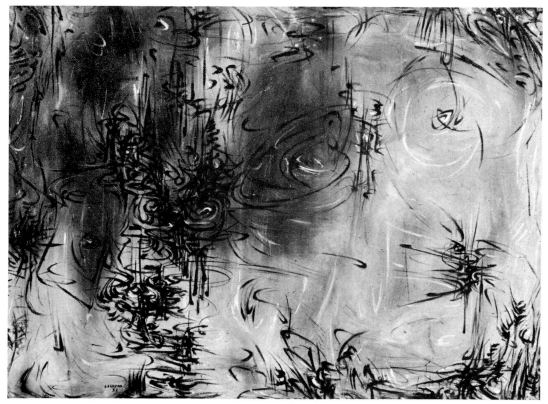

118 Jaroslaw Serpan

119 John Forrester

120 Cy Twombly

work open to contradictory possibilities. The sign, brought to perfection through a sort of active dialectic, should not be confused with the definitive trace of a calligraphy, where nothing more and nothing less can be said. Laurence Alloway and Georgine Oeri[20] have rightly shown the opposition between the Oriental or quasi-Oriental sign, conceived as a function of limitless space, and to which the paper serves provisionally as a tangible support, and Kline's approach [32, 112], after the 1950s, which aims to create, by means of black as much as of white, and as a function of the format of the canvas, a sensation of tension, even of conflict. In general, however, the artist tends to avoid an autobiographical motivation. His predilection for large-sized works is, in part, founded on the will to transcend the self.

When it concerns a European, like Soulages [70, 113, s. 24], the first state of the sign is a humanist ideogram in which every individual feature is transcended from the start. The walnut stains on paper of the years 1947-48, trees or crosses, express, as Léopold Sédar Senghor has said, not man in isolation, but man in his relation with the celestial world. We should add: in his *magical* relation. Whatever the size, the concentration suggests monumentality and the equilibrium confers power. Unlike the giant signs of the Americans, those of Soulages long continued to be structured like works of architecture or of sculpture, pierced with peepholes to the interior rather than arched openings on the outside world. If it be true that Kline destroys all barriers between the spectator and the work, the latter ramming itself into our living-space, Soulages, in classic manner, continues to draw us towards the hidden centre, the golden-glowing heart. These glimpsed vistas in depth, moreover, are counterbalanced by strong vertical movements. A dynamic which is a function of the pictorial density welds together the dark, shadowy compartments. A single sign arises; it is apprehended in its totality, but lends itself afterwards to an analytic reading, like a piece of architecture the elements of which are arranged according to a hierarchy. This hierarchy is something that we do not find in gestural painting, in which all notions of principal and subordinate are abolished.

Antoine Mortier's signs [114] are possessed of a savour and an amplitude nourished from the substance of things; shaped, as it were by a wild, obstinate, blind force. A true descendant of Permeke, and, like him, subject to failures and then, from time to time, like him, capable at one savage blow of uniting heaven and earth.

Jean Paulhan defined *art informel* as a new way of apprehending reality or, rather, that part of reality which eludes observation or reason; that which is situated in an 'obscure half-world' in which 'the interior is not distinguished from the exterior'.[21] It is the approach of an event which takes place in ourselves and, at the same time, in the world; and it is, with this, a drawing near to the springs of the mind and of life. The act of writing is closely linked to this double source. That is why 'informal' art has favoured the introduction of writing into the picture, basing itself, now on the imagination of the gesture, and again on the imagination of the *matière*.

There is no need to revert to a discussion of the individual expression of artists whose 'writing' is an extension of gestural painting, such as Degottex or Mathieu, Michaux or Tobey, Masson, Alechinsky or Sonderborg, nor of the areas of reciprocal stimulation between painting and poetry, which I have written about elsewhere.[22] Nor, equally, shall I concern myself here with the other forms of 'interference' between poetry and writing, which have been amply stressed by D. Mahlow.[23] Let us concentrate rather on the act of writing as free expression. At certain times, in certain psychic states, the signs regroup themselves and form a chain; their continuity, their interdependence, is affirmed within a horizontal or a vertical register. We can then speak of writing, and even of calligraphy, but of writing delivered from those set forms which restrict it to being merely 'an instrument of intellectual communication, parallel to language and presenting to the eye what the latter present to the ear'.

This free writing is charged with a plurality of meanings. Answering to the need for a formulation in totality, essential to gestural painting, it offers additionally the possibility of a rhythmic connection between the hand and regions of the spirit that are ill-adapted to verbal expression. One could call this 'pseudo-writing', if it were not that

true writing, fragmented into words, broken up with punctuation, could better be considered as a succession of pseudo-signs, to the extent that there is no correlation between their appearance and their message. Here, on the contrary, concern for the pictorial presides over this relation between the vehicle and what is conveyed, while the priority given to rhythm guarantees the unity of the graphic expression.

The term 'calligraphy' is more especially employed to indicate the transfer to Western painting of forms of expression familiar to Oriental artists, and particularly to Zen painters. It is not a matter of the imitation of a style, but of certain analogies of attitude abolishing the contradistinction or the separation of the subject and the object, which forms the premisse of European art. The notion of the representation of a reality, exterior to the subject, is replaced by a feeling of active participation in the continuous succession of events, real or imaginary. The importance of the brushstroke, as the immediate vehicle of the creative impulse, results from this. This poses, in a special way, the problem of the completion of a work, which is conditioned by the *élan*, or the current activating the writing process. When this current is broken off, the work is finished; nothing further can be said which is not a lie. [25] Equally, the problem of the space imparted to the work is defined in different terms. As with Oriental calligraphy, no account is taken of the limits of the support; on the contrary, an extension suggested beyond the paper or the canvas is evidence of the link between the artist and the universe. [26]

The similarities between certain calligraphic expressions in gestural painting and Chinese writing are legitimized by a theory according to which Chinese characters are 'congealed gestures'. In this view of things, the signs are not representations of objects or of feelings, but records of the gestures which signify them, records characterized by a tendency to extreme concision. [27]

There are, however, fundamental divergences. While Oriental art unites itself with the vital flux through an act of joy and acceptance, serenity is generally absent from Western art, and the latter is very often aggressive and violent in character. In the Orient, liberty and spontaneity function through a rigorous discipline and an extreme economy of means. Western calligraphy, on the contrary, whatever the degree of mastery, is not heir to a tradition. It has to find its own way; writing only provides an occasional outlet, and this is why only a part or a phase of Western art production derives from this mode of expression. After all, and this is the vital point, everything in Western art leads to a questioning of the world and of itself. Writing too is a method of interrogation.

Let us turn to the relations between the sign and the *matière*, that is to say, to imagination working within the paint or other substance manipulated by the artist. Man is not alone in inventing signs. Sometimes one discovers, as it were, a deposit of time on things, or again, an energy which animates matter and which, itself, is none other than the writing of life. The so-called *informel* artists of the 1940s thought that they could bring this out from the pictorial *matière*. [28] They aimed to provide an operative field in which these indications of life would be able to manifest themselves, as it were, spontaneously, in magical fashion, – the magical force being, in this case, imprisoned in the material itself – the matter itself being at work, and not the sign. From 1925, Max Ernst had thought of interrogating certain textures by means of a rubbing, so as to extract from them more or less diffuse images which he then proceeded to clarify and define. Twenty years later, Fautrier and Dubuffet on the contrary disdained fantastic imagery, as, a little later on, did Tàpies, Donati, Emil Schumacher [91], K.F. Dahmen [92], Georges Noël [124], and innumerable successors in all parts of the world. Their sources of inspiration were stains and dirt, wear and tear, and chance effects. Painting does not represent, but resembles, places. With Dubuffet it is a terrain; the bearer of imprints. With Tàpies [20, 117] it is the terrestial crust, or an archaeological site. Something stirs in what one had thought to be inert, and the sign, invoked by the material, emerges, now in the form of an upheaval, now through erosion, now through cracking, now a more human trace of a forgotten event, in the form of a cross, a circle, illegible characters of scribblings. In the most successful works, the play of the *matière* introverts itself, and the signs seem to spring both from the depths of time and from the depths of consciousness. At

times, as with Serpan [118], the *matière* is a tissue of signs inspired by microforms. The energy of these signs derives not only from their recorded form, but from an accumulation of similar indications, behaving gregariously in space; capable, for example, of contracting their mass into a nucleus, and then of extending it into an aggressive spiral. No contour can contain these signs, which can be neither enumerated nor strictly localized, so mobile do they appear to be. They uncoil like dragons, or circle about like swarms of insects, and their dance in space has the lanceolate grace of Oriental motifs.

As an unconditional support for signs, which it preserves, and guards against aesthetic criticism, the wall is paramount; better even than the ground or space itself. Traced by anonymous hands, at the dictates of violent, primitive instincts, time has later confused the marks of nature and of man. In this way a sort of collectivization of signs has taken place, a regression to the stage of elementary and archetypal configurations, which may appear charged with incantatory powers. This is why, in succession to Dubuffet and his *Walls*,[29] so many artists like Cy Twombly [120] or John Forrester [119] imitated graffiti, in the same way as they imitated textural surfaces. Here we are concerned with a different type of calligraphy,[30] popular in origin, as opposed to the calligraphy of the *literati*. It is again a manifestion of the 'return to the sources' which is one of the determinant objectives of the modern mind. By virtue of the *matière*, through the sign, or again, thanks to a random word, the artist finds himself once more in the state of innocence and acts as a good conductor of the current.

Having started with graffiti, *art informel* rediscovered the word. A restructuring of the sign under cover of the word links up with a type of approach of surrealist origin which had taken form some twenty years earlier. Various manifestations, supported by a number of critics and of poets, among them Pierre Restany, Edouard Jaguer and Jean-Clarence Lambert,[31] bear witness to the serious purport of these experiments. From 1955 onwards, painting teemed with inscriptions. From Bryen [121] to Laubiès, Benrath [123], Bellegarde [122] and Bertini; from Götz [116] to Hoehme [125] and to Mendelson [126]; from Rauschenberg [138] to Schultze, from Motherwell [30] to Rivers,

from Novelli [127] to Földes [128], the artists were seeking to trigger off a reaction, a conditioning, by introducing portions of text, words, or even syllables, and by giving them a truly pictorial role. Certainly, the words derive from the *informel* by their incoherence, by the disarticulation of a language reduced to its raw state; to the state, in fact, of matter in effervescence, mysteriously fecund. The proliferation of word-signs, springing from automatism or chance and thrown on to the canvas, recreated Paulhan's 'obscure half-world'. However, the luminous trail of the word illuminates the darkness and reveals an outlet. Even the arbitrariness of the word must be compensated for by a rigorous pictorial justification, i.e. by a strict organization of the pictorial relationships. And, little by little, form comes to the surface again. The intervention of the word in the painting also betrays an approach analogous to that of *musique concrète*, which makes frequent use of words, both for their sound value and for their reverberation in the consciousness, as disordered allusions with multiple meanings.

Again, ten years earlier, about 1949, some artists of the Cobra group, or of related tendencies, had used the serpentine movements of the brush to trace words. The outline of the word, while obeying certain imperative rhythms, assumed a motor rôle, sustaining an *élan* in which the act of writing was no longer distinguishable from that of painting. These artists, no doubt, were closer to automatism, the immense pictorial resources of which the surrealists, apart from Max Ernst, Miró and Masson, had not used. But additionally, with Jorn [56] and Alechinsky [129], the word was corrosive; it indicated a first step towards the comic strip, whose invasion later was to bring in its train a reorganization of the image, and would then destroy the value of the word-as-sign. For Alechinsky, the sign is, and has been ever since *Migration* (1951), a snakelike but essentially human wandering entity.

The sign, to be exact, was not the central problem, even if writing was frequently a favoured medium. The aim was, in Jacques Putman's words, 'to tell, to live in telling, to draw in discovering'. The other great problem was that of the *self* and the *other*, a problem which took Alechinsky to the outposts of communication: to painting for four hands.

(3) THE SIGN AND THE OBJECT

The sign extends very far beyond the confines of lyrical or informal abstraction, the subject of this chapter. I would like to indicate briefly in what directions. A civilization of a technical and collectivist type, founded on the production of consumable goods and their immediate enjoyment, demands new relationships between man and the world, and, in consequence, new forms of language, whether in the field of music, of poetry or of plastic art. In this context, the social experience takes priority over the psychic behaviour of the individual. The transformation of the urban environment and the dynamic of speed – from the jet to the computer – are the components of this experience, which is more or less the same in all industrialized countries. A common folklore expresses itself in aggressive and ephemeral manifestations. The poster and the neon sign, the mushroom cloud and the space rocket, James Bond and Marilyn Monroe, Cinemascope and the supermarket; these constitute a collective patrimony, a mass culture, which the artists accept as a springboard. Their attack moves in the opposite direction to that which we have been describing, for it starts from the known, from the obvious, from the literal sense and from common sense. In drawing on the techniques of advertising, it reveals man's dependence with regard to the object and proclaims the familiarity between man and the object which is incorporated in his everyday world, integrated to his sensibility.

Attention has, quite rightly, been drawn to the influence of Fernand Léger, and of Marcel Duchamp, on the generation of Pop artists and their successors. Léger was one of the first, if not the first, to hail the advent of the mechanical civilization in plastic terms, terms based on an urban and industrial environment. His comment on Pierre Reverdy, 'He's like me, he picks up everything in the street', is applicable to almost the entire Pop generation. In order to express the intensity of modern life, Léger incorporated, in colour and form, the instantaneous impact of the event. In this he set the example; the mode of incorporation, on the other hand, was to be modified, as was the event itself, for to Léger the world of today would be unrecognizable. Soon, the gramophone record, that signal of urban activity, became

Plates 121-138

121 CAMILLE BRYEN. *Poem-object Exploded.* 1956. Watercolour and India ink, 54 × 36 cm. Collection Pierre Restany, Paris.

122 CLAUDE BELLEGARDE. *Typogram of Camille Bryen.* 1963. Oil on canvas, 81 × 100 cm. Private collection.

123 FRÉDÉRIC BENRATH. *The Great Itinerants of the Dream,* 1961. Oil on canvas, 130 × 160 cm. New Smith Gallery, Brussels. Photo A. Dumage, Paris.

124 GEORGES NOËL. *Palimpsest White Effigy on Azure.* 1962. Oil on canvas, 130 × 97 cm. Collection Paul Fachetti, Paris.

125 GERHARD HOEHME. *Hong Kong,* 1960. Oil on canvas, 99 × 72 cm. Private collection.

126 MARC MENDELSON. *Tellurian Immanence,* 1961. Oil on canvas, 90 × 130 cm. Collection J. Janssen, Brussels.

127 GASTONE NOVELLI. *Tender as a Rose,* 1960. Oil on canvas, 73 × 60 cm. Collection Sauvage, Paris.

128 PETER FÖLDES. *I hate them,* 1961. Private collection.

129 PIERRE ALECHINSKY. *Imaginist diary of 6-31 May 1968.* Pen and ink, 200 × 200 cm. Galerie de France, Paris.

130 MARTIAL RAYSSE. *One Moment More of Happiness,* 1965. Assemblage with neon tubes, 250 × 40.5 cm. Stedelijk Museum, Amsterdam.

131 PETER PHILLIPS. *For Men Only, starring M M and B B,* 1961. Oil and collage on canvas, 274.5 × 152.5 cm. The Calouste Gulbenkian Foundation.

132 WINFRED GAUL. *Three Little Roses,* 1965. Lacquer on wood, 150 × 110 cm. Collection Dr Weinsziehr Düsseldorf. Photo R. Häuser, Mannheim.

133 ALLAN D'ARCANGELO. *Composition 14,* 1965. 203 × 56 cm. Galerie Yvon Lambert, Paris. Photo A. Morain, Paris.

134 JIRO TAKAMATSU. *Six Objects,* 1966. Cutout and painted wood, 116 × 89 cm. Musées Royaux des Beaux-Arts de Belgique, Brussels. Photo A. C. L. Brussels.

135 PETER BRÜNING. *Legends No. 16/64,* 1964. Oil on canvas, 150 × 150 cm. Collection Dr Peter Ludwig, Aachen. Photo Ann Münchow, Aachen.

136 GIANNI-EMILIO SIMONETTI. *Archaic Zelotypia.,* 1966. Mixed media on canvas, 89.5 × 89.5 cm. Musées Royaux des Beaux-Arts de Belgique, Brussels. Photo A. C. L., Brussels. (Erratum: captions 136, 137 on p. 133 appear transposed.)

137 GIANFRANCO BARUCHELLO. *To All: Be Happy Staying Behind,* 1967. Mixed media on aluminium, 100 × 100 cm. Galleria Schwarz, Milan. Photo Bacci. (Erratum: captions 136, 137 on p. 133 appear transposed.)

138 ROBERT RAUSCHENBERG. *Untitled,* 1950/51. Oil and pencil on canvas, 100 × 60 cm. Collection Mr and Mrs Victor Ganz, New York. Photo E. Pollitzer, New York.

121 Camille Bryen

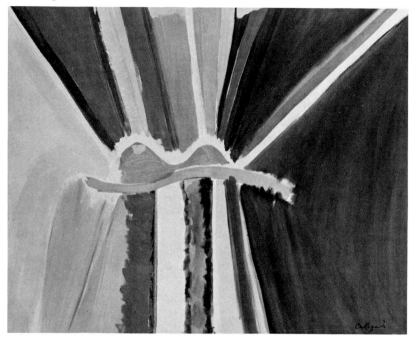

122 Bellegarde

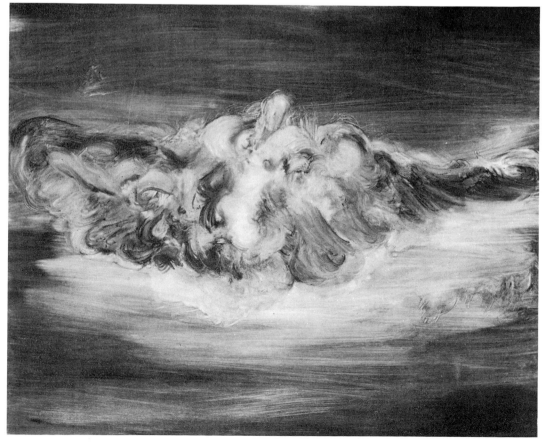

123 Frédéric Benrath

127

124 Noël

125 Gerhard Hoehme

126 Marc Mendelson

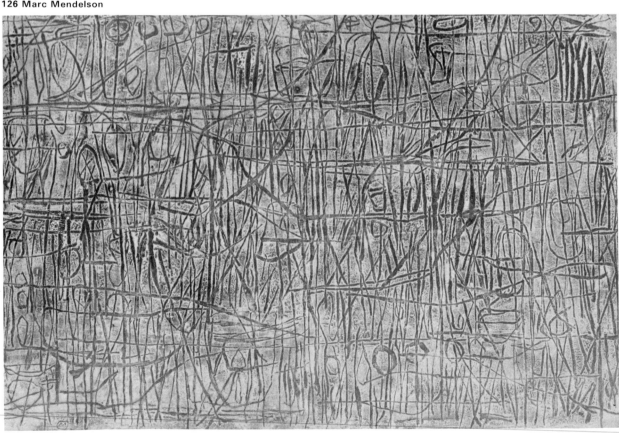

127 Gastone Novelli

128 Peter Foldes

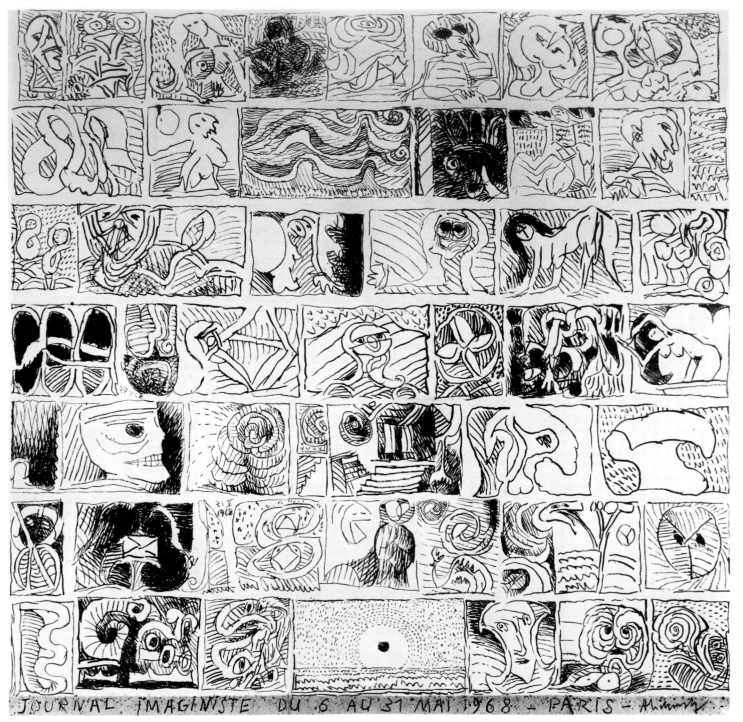

129 Pierre Alechinsky

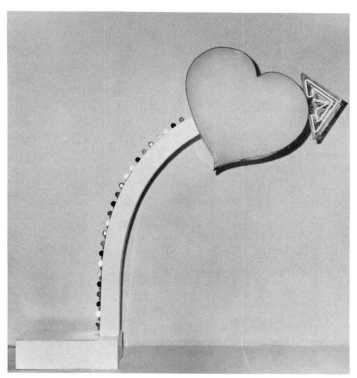

130 Martial Raysse

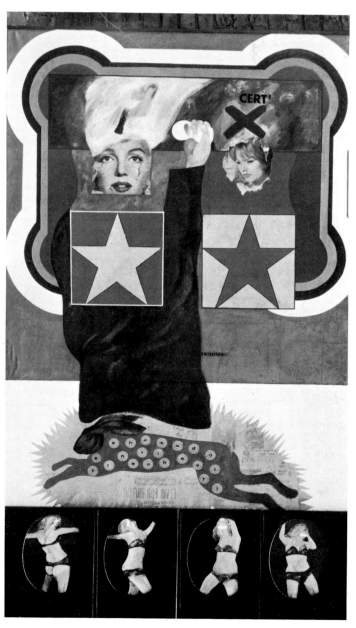

131 Peter Phillips

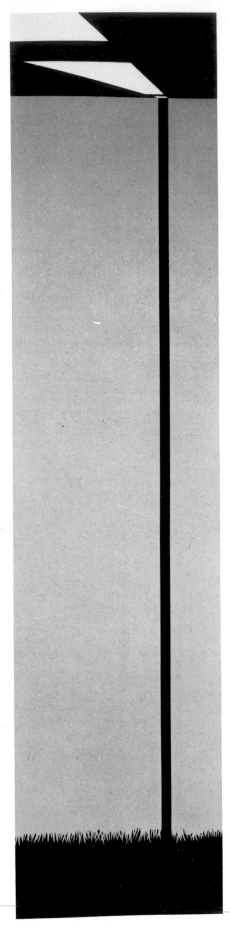

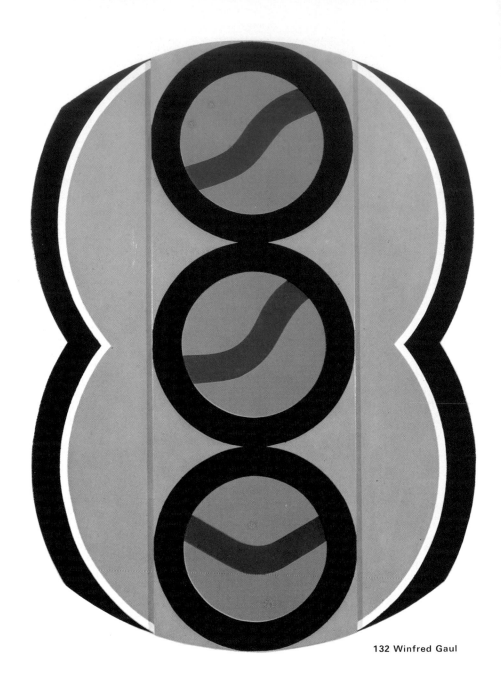

132 Winfred Gaul

133 Allan D'Arcangelo

132

134 Jiro Takamatsu

136 Gianfranco Baruchello

135 Peter Brüning

137 Gianni-Emilio Simonetti

133

138 Robert Rauschenberg

the 'total expression of a mechanized world', and the 'symbol of the geometric order enclosing modern man'. [32] In his film *Ballet Mécanique* (1924), he heralds Pop art by the way in which he isolates an object, or part of an object, and projects it in close-up, depriving the spectator of any opportunity of recoil. The years 1927-30 correspond to the phase of objects projected in an abstract space and juxtaposed with purely abstract forms.

Most of the American and English Pop artists, a few of the New Realists and new figuratives, French, German or Japanese, were to go over the same ground as that covered by Léger. They began by abolishing the sign as it was used in abstract expressionism and lyrical abstraction, and they repudiated writing, the 'easy way out' taken by *art informel*, suspecting all of them of affectivity or of intellectualism or of *matiériste* degeneracy. It is the object, often in isolation, or the fragment of an object, preferably even the giant fragment of the object, that is elected, again following the example of another precursor, the American Stuart Davis. In the sixteenth century, the faces which Arcimboldo composed, using fruit and vegetables, became enigmatic or obsessional; so today, the giant image of a banal object, intact and intangible, or heaped up in the sordid state to which wear and tear has reduced it, or its shadow silhouetted against the void, violently abstracts the object from the production, consumption cycle, treadmill of an indifferent society, and gives it the sense of a message, a 'Pop sign'. Or again, from the urban context which for him is nature, the artist retains that which is 'sign' in order to incorporate it in a texture of discontinuous images.

Finally, as Léger himself had done without knowing it – for his veneration for the modern myth would have suffered thereby – from an object in common use, handled by man, the artist came to extract the object as signal, the manipulator of man, which sanctions or forbids, orients or canalizes, following a code which directs human actions, suspends emotional drives, or triggers off needs, when its giant symbol appears against the night sky. Thus, from 1960 onwards, Peter Phillips [131], Patrick Caulfield and Derek Boshier in England, Arman and Martial Raysse [130] in France, Roy Lichtenstein, Andy Warhol, James Rosenquist, Tom Wesselmann, Jim Dine, Nicholas Krushenick

and Allan d'Arcangelo in the United States, Konrad Klapheck and Winfred Gaul in Germany, and Jiro Takamatsu in Japan, were all formulating a new heraldry of the sign, based on the object. [33] Their attention shifts from Léger to Duchamp. It is known that the latter allowed himself to reproduce his readymades freely, resuming a dialogue – more coherent than is generally believed – with the systems of industrial production. In its first stage, the selection exercised by the artist diverts the object from its function in a consumer society, and turns it into a significant representation, endowed with a quality of uniqueness. The object is sanctified through the artist's choice, raised by him as a fetish, as a signal. [34] In its second stage, when he accepts that the object may be reproduced and disseminated, the artist replaces it in the circuit, but now in the circuit of mass communication and not that of consumption, the object having become a quasi-abstract sign, seasoned with ambiguity.

I use the term 'Pop sign' for plastic signs arising from a mass culture and rendered fertile by Pop art. I shall now use the term 'tech sign' to qualify certain systems of the new figuration, closely related to technology. Towards 1965, with Oyvind Fahlström, Gian Franco Baruchello, Gianni-Emilio Simonetti, Hervé Télémaque, Peter Brüning, Arakawa and others, the signs relate quite as well to a supposed language as to methods of scientific notation, or again to instruments, to operative procedures, or to the signals which condition the industrial world. They are usually distributed over the field of the work in sequences or in nuclei which suggest the mobility of an open space, magnetization or dynamic mutation, rather than a hierarchy. Even if they reproduce, with calligraphic minuteness, symbols which normally organize logical thought, these artists are using them to code a message deriving from an irrational mode of communication, with the derisive overtones that one finds in Picabia's mechanistic pictures, and a play of truncated references drawn from science fiction. Perhaps, too, they thought to note down events of a subjective and autobiographic order, relived in the world of memory, the breaking off, the taking up again, the repetitions and the bursts of semi-automatic writing of a James Joyce. Mixed together, just as are Pop signs,

in the structuring of new myths, the tech signs form a bridge, establish a relation between semantic interpretation and optical representation.

Between these two groups are situated those works of which the principal sign is a letter or a figure. One remembers Rauschenberg's variations [138], such as the *White Painting with Number*, 1949 and the pictures of Jasper Johns, which paradoxically endow the number – a neutral element denuded of subjectivity – with pictorial flavour possessed by a flower or fruit in a traditional still-life, and at the same time, a rhythmic element which forces one to 'read'. Finally, let us consider the recent morphological and optical experiments in Indiana, inspired by the electric indicator boards of juke boxes and, like them, obsessional. It is still a matter of the investigation of symbols that are so deeply rooted in our civilization that they appear as archetypes. Letters and figures lead to the reassessment of the units of measurement and the imperatives of our life. Here again, just as with the lyrical signs, the sign is invested with a plurality of meanings, the coexistence of which is intentionally disturbing.

(4) THE SIGN AND THE 'OPEN FORM'

I have not undertaken to cite all the artists who have used the sign as a basic element of their pictorial language. Essentially, I have attempted to indicate, through the analysis of different types of plastic expression, how the symbolic function of the sign in general has been understood and interpreted by the painters. The summary account to which I have had to limit myself in the framework of this survey, brings out clearly the privileged place held by the sign in post-1945 painting. As we have seen, one can distinguish the sign of magical intent, the lyric and gestural sign and informal writing – now in the form of a quasi-Oriental calligraphy, now of graffiti – although the various categories overlap. The sign does not disappear with the new figuration, for the latter cannot make a clean sweep of the reading habits which had been inculcated by abstract painting. Equally, in the new wave of geometrical abstraction from America, and even in minimal art, the sign reappears in the form of a giant or repetitive sign, sometimes difficult to distinguish from certain

geometric metaphysical signals which virtually constituted a code – those of Herbin [169], for example.[35] The geometrical sign has often represented a bridge from figuration to abstraction. Later, it existed on its own, in rhythmic and chromatic relation to its pictorial context. It may be that certain artists are again using it as a bridge, leading back to man or to the object, but on a different scale and in relation to the world. In any case, here the aim is not the sign; it is behind the sign, beyond the sign. It should be noted, moreover, that this sign, if indeed we can still call it that, is never confined to the plane of the picture. It overflows this, whether in completing itself outside it, or whether the vibration of the colour projects it into space, forwards or backwards. It is a matter of relation. The sign is *a relation with the world*, or an attempted relation. It will correspond with the desire for direct action, for immediate but elliptical communication, appealing warmly to the spectator to participate, which is characteristic of all the arts of our time. It is the trace, the mark of this approach to painting. Finally, its brief message allows of more than one interpretation, is simultaneously addressed to different levels of consciousness, and strikes home, according to the individual, in this or that zone of sensibility. As I have tried to show, the sign remains, in each of its varying embodiments, fundamentally ambiguous, 'a plurality of things signified, coexisting in a single signifier'.[36]

No frontier limits the domain of the sign. Anything can be a sign, in nature as in art, from the moment when 'I beckon to him'. In short, whenever there is the intention to open a dialogue referring to a reality which remains elusive, there may be a pictorial sign, but the sign is only a fragment of the 'argument', a part of a whole which is situated elsewhere, outside the picture. It evades the rules of classical composition, explodes the closed form and the enclosed space, refuses all hierarchic structure and dissolves coherent narration or description, to replace them with a play of interlaced cross-references in which chance intervenes, giving the spectator 'a feeling of suspension, of uncertainty'. It therefore corresponds to the definition of the 'open form', which is characteristic of contemporary art.

1 WILL GROHMANN, *Kandinsky, Life and Work*, New York 1958.

2 WASSILY KANDINSKY, *Punkt und Linie zu Fläche* (Bauhausbücher, 9), Munich 1926.

3 R. AMADOU, 'Postface', in Kurt Seligmann, *Le Miroir de la magie*, Paris 1961, p. 386.

4 For the use of letters of the alphabet in cubism and in the work of Malevich's circle, see F. C. LEGRAND, 'De la lettre au signe', in 'Peinture et écriture', *Quadrum* 13, 1963, pp. 5-58.

5 MONNEROT, quoted by Georges Duthuit, *L'Image et l'instant: vertige du merveilleux*, Paris 1961, p. 352.

6 JACQUES DUPIN, *Joan Miró*, London and New York 1963, chapter 15.

7 JEAN ARP, *On my Way*, New York 1948, p. 93.

8 GIOVANNI MARCHIORI, *Arp*, Milan 1964.

9 GÉRARD DE CHAMPEAUX and DOM SÉBASTIEN STERCKX, *Introduction au monde des symboles*, Paris 1966, p. 26.

10 Declaration by Gottlieb and Rothko, on their interest in primitive art, *New York Times*, 13 June 1942; reprinted in the catalogue of the Gottlieb exhibition at the Whitney Museum of American Art, New York 1968.

11 UMBRO APOLLONIO, *Hans Hartung*, Paris 1966.

12 Johannes Itten, in his Bauhaus preliminary course, had used rhythmic studies very similar to Hartung's signs. See the studies by Werner Graeff reproduced in the catalogue of the exhibition 'Bauhaus 1919-1969', London 1969, no. 34.

13 R. V. GINDERTAEL, *Hans Hartung*, Paris 1960.

14 R. DE SOLIER, 'Hans Hartung', *Quadrum* 2, 1956, p. 29.

15 The continued adherence of André Masson to the surrealist movement is hardly contestable. Hubert Juin points out that in 1936 he renewed his links with the group. He thenceforward contributed to surrealist publications and took part in most of the major surrealist exhibitions.

16 GEORGES MATHIEU, 'Note sur le poétique et le signifiant' (1951), *Au delà du tachisme*, Paris 1963, p. 163; other texts dating from 1951 and 1952, ibid., pp. 159, 177; 'Vers une nouvelle incarnation des signes', in 'Structure et liberté', special number of *Études Carmélitaines*, 1958.

17 RENÉ BERTELÉ, introduction to the catalogue of the exhibition 'Georges Mathieu', Palais des Beaux-Arts, Brussels April 1963.

18 RENÉ BERTELÉ, 'Notes pour un itinéraire de l'œuvre plastique d'Henri Michaux', *Les Cahiers de l'Herne*, Paris 1966.

19 M. COURTOIS, 'Tobey', *Cahiers du Musée de Poche*, 1, March 1959, pp. 59-88.

20 LAWRENCE ALLOWAY, - 'Sign and Surface', *Quadrum*, 9, 1960, pp. 49-62.

21 JEAN PAULHAN, *L'Art informel*, Paris 1962, p. 45.

22 F. C. LEGRAND, 'Peinture et écriture', *Quadrum*, 13, 1962, pp. 5-48.

23 DIETRICH MAHLOW, introduction to the catalogue of the exhibition 'Schrift und Bild', Amsterdam and Baden-Baden 1963, pp. 17-174.

24 M. COHEN, *La Grande Invention de l'écriture*, 3rd edn, Paris 1958, vol. 1, p. 411.

25 KEIJI NAMURA, 'Le Problème de l'inachèvement dans l'art japonais', *Revue d'esthétique*, 1965, pp. 87-93.

26 Japanese calligraphic artists often begin and end a brushstroke off the paper, using a special cloth called *mosen*, which is spread on the floor.

27 PÈRE TCHANG TCHING-MING, *L'Écriture chinoise et le geste humain*, Shanghai and Paris 1937; P.P. Vuiclamey, *La Pensée et les signes autres que ceux de la langue*, Paris 1940.

28 Fautrier's first exhibition at Drouin's took place in October 1943. Two shows of capital importance for sign and *matière* painting were Fautrier's 'Otages', 1945, and Dubuffet's 'Mirobolus, Macadam et Cie: Hautes Pâtes', 1946, both at the same gallery. See also p. 14 of this book.

29 JEAN DUBUFFET, *Les Murs*, 15 lithographs done in 1945 and published by Éditions du Livre, with poems by Guillevic, Paris 1950.

30 PIERRE RESTANY, 'Le Poème-objet', *Cimaises*, January-February 1957: 'The notion of calligraphy, taken in its widest sense, covers: all attempts to distort for aesthetic purposes the letter, the character, the word; and all its artistic uses independent of signification.'

31 An exhibition of poem-objects, frottages, collages and sculptures was organized in Santiago, Chile, in 1941, by the Chilean surrealist group (mentioned by J. L. Bedouin, *Vingt ans de surréalisme 1939-1959*, Paris 1961, p. 38). From 1946 onwards there were the *Lettristes*, who set out to reduce all painting to a system of letters and signs, based on existing or imaginary alphabets, returning to the common origins of painting and writing. Their enterprise became bogged down in rhetoric, and has remained marginal; they were, however, responsible for one major show, 'La Lettre et le signe', at the Galerie Valérie Schmidt, Paris 1963, which brought together 'sign' painters of the *informel* school, *Lettristes*, and a number of independent painters employing the same vein. From 1955 onwards, and independently of the *Lettristes*, there were many exhibitions of poem-objetcs in Paris, put on by Pierre Restany (also in Germany), Edouard Jaguer and Jean-Clarence Lambert. Most important of all was the 'Schrift und Bild' show (see note 23). Finally, the practitioners of what I have called 'tech signs' (p. 135) showed their work in 'Pictures to be Read, Poetry to be Seen', Museum of Contemporary Art, Chicago 1967.

32 R. L. DELEVOY, *Fernand Léger*, Geneva 1962, p. 98.

33 LAWRENCE ALLOWAY, in Lucy R. Lippard, ed., *Pop Art*, London and New York 1967, maintains that the second phase of Pop art is marked by an evolution from the figurative towards the abstract.

34 R. LEBEL, *Eau et gaz à tous les étages*, Paris 1959, p. 36.

35 See p. 178 of this book.

36 DANIELA PAOLOZZI, 'Towards a Cold Poetic Imagery', *Art International*, 20 February 1967.

Lucio Fontana and his Influence

GILLO DORFLES

With the death in 1968 of Lucio Fontana, a period in the history of Italian and European visual art was closed, a period dominated by one of the most remarkable personalities of the century [139-145, s. 35]. Only in his later years did Fontana laboriously achieve the fame which had come so easily to others of his generation. And for this totally extrinsic reason, only in his very last years was he able to 'permit himself' that productive autonomy which had been denied him in his youth. This seemingly unimportant fact is in reality vital in understanding the evolution of his work and in accounting for the frenzied rhythm of the last few years. He was trying to 'relive' all the time he had lost in churning out decorative pieces (ceramics, reliefs, *objets d'art*) – all executed skilfully and with great inventiveness, but almost always for money reasons only.

I wanted to make this point clear right away, to discredit a whole series of facile accusations often thrown at Fontana's early period, up till about the 1950s. But it is also worth noting that the fabulous and creative quality of these works comes out as more dominant than the commercial motives behind them. Thus a balanced judgment of his entire output should never ignore his youthful graffiti, ornamental ceramics, etc.

It is not too much to devote a whole chapter of this book to Fontana and his 'school', when the authentic limits of his procedures are defined, and his contribution to the general evolution of European visual art sufficiently emphasized. But of course to do this it is necessary to strip the artist's features of that cheery, off-beat halo people have thrust on him, and put him back instead into the context of the more authentic art of our times. And another comment should be made: very often,

Fontana's hagiographers have tended to dwell on his programmatical declarations on art, to the point of treating his *Manifiesto Blanco* (1946) as a new aesthetic gospel. And they have tended to find something clearly defined and programmed, something scientifically analysable, in the 'spatialist' movement founded by Fontana. But these things are just not so.

While I am aware of the acuteness of some of his intuitions, and the precociousness of some of his judgments and inventions, I have never held that Fontana should be considered important for his aesthetic theories (like certain artist-theoreticians such as Klee and Kandinsky). Fontana was an authentic 'creative' artist, instinctive and impassioned, a complex, moody personality, not an academic, nor a meticulous theorizer of abstract schemes. Even when he claimed to be putting into practice an aesthetic 'creed', or an exact programme of action, he ended up doing something quite different and often more successful than what he set out to do.

Born in Rosario (Argentina) in 1899, of Italian parents, he went to live in Milan as a child, and stayed there all his life (except for a time during the fascist period when he returned to Argentina). Fontana created between the wars a series of works, both plastic and pictorial, in which he made evident his desire to abandon the traditional formulae and create something completely cut off from the mainstream of lifelike representation of reality.

The most notable of these early works – since they tie in with tendencies which developed in his more mature years – are some statues in white, black and gilded plaster, and some graffiti, already totally abstract in form. These can be considered as the first non-figurative sculptures to appear

in Italy, along with those of Melotti. His enormous output of abstract works belongs roughly to the period 1931-35. Today most of them are scattered or destroyed, but in them Fontana was among the first in Italy to release sculpture from a naturalistic figurativeness, perhaps partly under the influence of Arp, Archipenko and Zadkine. The sculptures were often predominantly two-dimensional, with graphic signs added to enhance the effect. Already they were pointing to the 'garden sculptures' in sheet metal, which he would perfect later.

This first period in Milan, which he spent pouring out graffiti and sculptures as well as 'ornamental' ceramics, was followed by the Argentine period. This was the time of the famous *Manifiesto Blanco*, published by Fontana and his disciples [s. 35].

In this manifesto – and later when the spatialist movement was founded in Milan – Fontana called for an art that would overcome the limits of the easel painting. It would transcend the area of the canvas, or the volume of the statue, to assume further dimensions and become a spatial art, an integral part of architecture, transmitted into the surrounding space and using new discoveries in science and technology.

Back in Milan after the war, Fontana wasted no time in putting his ideas into practice. In 1947 he created a 'black spatial environment', which was a room painted black and lit by a Wood light. This spatial environment (then ignored or ridiculed by the critics) represents one of the most significant achievements of Fontana's extraordinary 'premonitory' capacities – it was a full decade later that the concept of environment became dominant on the international painting scene. In 1966, at the Palazzo Trinci, Foligno, an exhibition was mounted devoted exclusively to the problem of environment. Every artist invited to participate presented an entry designed specifically as a 'unified and self-sufficient work'. Fontana's old black environment was faithfully reconstructed, and turned out to be as instructive as it was admonitory. And in the very recent historical exhibition 'Lines of Research from the *Informel* to Today', held at the 1968 Venice Biennale, the reconstruction of the same environment showed it to be one of the most original advances in the series, still worthy of being taken as a model by younger artists.

In 1948, in the same period, Fontana entered a huge neon chandelier in the Milan Triennale. This was a definitive sample of his 'spatial art', showing how it could function as an integrating medium between architecture and the other visual arts. Other examples of the practical applications of spatialism were certain luminous pierced ceilings, lit by fluorescent lights.

Fontana's true influence on Italian and European painting was mainly in the maturing of *oggettuale* currents, which came into their own around the 1960s. All the same, in the period following the spatial environment exhibition at the Galleria del Naviglio and that of the luminous spiral at the 1948 Triennale, a few artists, most of them from Lombardy, were attracted by Fontana's strong and warm personality and followed his methods more closely. In this way an initial group of 'spatialist artists' was formed in Milan in 1958, centred around the Galleria del Naviglio, and a manifesto of Italian spatialism was drafted. (In Giampiero Giani's study *Spazialismo*, several artists are listed along with Fontana, such as Crippa, Dova, De Luigi, Capogrossi, Peverelli, and others who in reality had little in common with them.)

This Italian spatialist movement was to have little vitality, and even the best artists who belonged to it at the beginning quickly branched off into other directions. Some tended towards a vaguer *art informel* or tachism, as in the case of Bacci, Morandi, and De Luigi, others towards a sort of latter-day surrealism (Dova), and others again towards a *matière* style of painting (Crippa). Even if many of these artists can thus be seen as owing something to Fontana's most mature work, I would hesitate to say that they fall completely within what I should like to define as his area of influence. And so I shall place more emphasis on the *oggettuali*, a group who fell much more under Fontana's influence (Castellani, Bonalumi, Manzoni). Still in the same period (1948 to 1958), we should note the existence of another Lombard group called MAC, Movimento per l'arte concreta (concrete art movement), among whom were Munari, Soldati, Monnet, Dorfles, Nigro and Bordoni. Fontana enjoyed close ties with this group as well, collaborating in the staging of exhibitions both in Italy and abroad. However the position maintained by MAC was tending towards

a geometrical abstraction, while Fontana was on the verge of following an *informel* line which, as we shall see, led to the *oggettuale* position.

After the period culminating in the black spatial environment, Fontana began a new series (1948-49) which was to be his most celebrated and popular 'line': the 'holed canvases', begun in 1948 and followed, around 1958, by the 'slashed canvases'. Before going on to consider these two series of works, I would like to touch on another phase of his activity, and its importance both for him and his followers. This was a series of lightly covered canvases, often monochrome, where the superimposition of two or more layers of canvas gave rise to a disorienting effect, one which hinted at the workings of a different spatial dimensionality. I consider this to be the period in which the Lombard artist's work came closest to that of Rothko. Both artists came to renounce the use of thick, impasted colour, and abandoned the then dominant satisfactions of drip painting or the laying on of wads of pigment *(matière)*. Their action was a driving force behind many of the successive stages of post-*informel* international painting.

The opposition to the blobs and slag of tachism and action painting was in a certain sense, a repetition of the opposition of constructivism to the expressionist blotches of the 1920s. Further, by using one colour only in many of the paintings of this period, and in nearly all the holed and slashed canvases, Fontana was anticipating the revolution against *art informel* which in other places came about much more slowly than in Italy.

Works by other artists, much younger than Fontana, such as the Italians Manzoni, Castellani, Scheggi and Mari, and the Frenchman Yves Klein, can certainly be traced directly or indirectly to the influence of Fontana's great monochrome canvases, completed around 1950.

But let us pass on to analyse in more detail the 'holes' and 'slashes' series. The 'holes' [139, 141] should be considered, first, as *signs* pointing to a compositional tracing, a two-dimensional design, and second, as constituting a plastic, volumetric structuralization. The quality, as a 'sign', of a single hole or series of holes is bound to the particular necessity indicated by all the 'sign' art which dominated that period of Western painting (consider the 'signs' of a Mathieu, or a Soulages).

Plates 139-151

139 LUCIO FONTANA. *Spatial Concept*, 1950. Oil on canvas, 99.5 × 69.5 cm. Collection Signora Teresita Fontana, Milan.

140 LUCIO FONTANA. *Spatial Concept*, 1962/63. Yellow cementite on canvas, 80 × 64 cm. Collection Signora Teresita Fontana, Milan.

141 LUCIO FONTANA. *Spatial Concept*, 1963. Oil on canvas, 73 × 60 cm. Private collection.

142 LUCIO FONTANA. *Quanta – Spatial Concept*, 1959. Marlborough Galleria d'Arte, Rome.

143 LUCIO FONTANA. *Spatial Concept 'End of God'*, 1963. Oil, 178 × 123 cm. Collection Mario Dora, Brescia.

144 LUCIO FONTANA. *Spatial Concept*, 1965. Cutout and lacquered wood on canvas with perforations, 128.5 × 166.5 cm. Musées Royaux des Beaux-Arts de Belgique, Brussels. Photo A.C.L. Brussels.

145 LUCIO FONTANA. *Nature*. Bronze. Private collection. Brussels.

146 ZERO GROUP. View of an exhibition (works by OTTO PIENE and GÜNTHER UECKER).

147 ENRICO CASTELLANI. *White Surface No. 32*, 1966. Varnished canvas, 181 × 252 cm. Galleria dell'Ariete, Milan. (Erratum: For Leonardo read Enrico, p. 146.)

148 PAOLO SCHEGGI. *Progression of the Circle*, 1965. Wood, 50 × 100 cm. Galleria Arco.

149 PIERO MANZONI. *Untitled*. 20 × 35 cm. Collection Luciano Pistoi, Turin.

150 AGOSTINO BONALUMI. *Untitled*, 1963. Canvas, 90 × 120 cm. Property of the artist.

151 ENZO MARI. *Structure No. 862*, 1968. Anodized, natural and black aluminium, 61 × 61 × 52 cm. Property of the artist.

139 Lucio Fontana

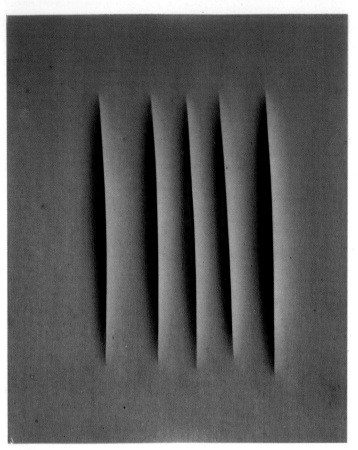

140 Lucio Fontana

142 Lucio Fontana

141 Lucio Fontana

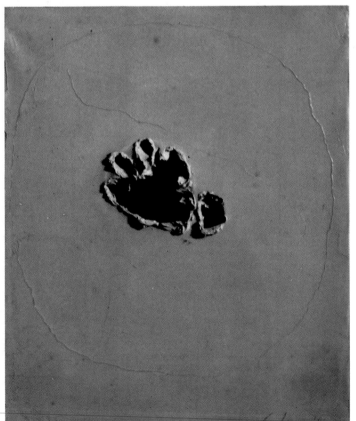

143 Lucio Fontana

144 Lucio Fontana

145 Lucio Fontana

144

146 Zero

147 Leonardo Castellani

148 Paolo Scheggi

149 Piero Manzoni

150 Agostino Bonalumi

151 Enzo Mari

148

But the presence of an aperture in the canvas – and thus of an absence of the material constituted by the canvas – disrupts its two-dimensional spatiality, and allows the *void* behind the canvas to project in front of its surface.

Thus the *hole* embodies in itself the double aspect of design and the modulation of volumetric spatiality. It is not by chance that in the paintings of one of the most competent followers of Fontana, Enrico Castellani, the holes are translated into projections of the canvas due to the presence of nails placed under the canvas, with a function analogous to that of the holes.

The 'slashes' [140] can be discussed by analogy with the holes: here we are dealing with huge monochrome canvases, with one or more clean slashes in them, and where the shadow itself of the slash creates the relief that gives a greater spatial quality to the painting. The slash, a long and dramatic sabre-cut, ruptures the compact design of the canvas, and by means of the unequal extensions of the borders, often chipped and open, offers that tiny element of chance which takes away any mechanical aspect of the work. (Only in the very last stages of his life – when because of ill-health Fontana preferred not to tire himself out painting – do we have a series of works where the holes and slashes are executed mechanically on sheet metal or wood.)

Another field of application of the slashes which interested the artist for a short time around 1960 was that of the *Quanta* [142]. The name, obviously, is taken from physics, and refers to the theories of Bohr. These are canvases of irregular shape, often trapezoid, which are slashed in the usual fashion, thus creating free compositions on the wall. Even if Fontana did not follow these experiments up, they stand once again as pointers to his intuition in putting his finger on the hastening of certain fronts in modern art towards discontinuity and indeterminacy of structure.

All the works I have discussed till now were labelled by Fontana with the general name 'spatial concepts'. Until the works became more extreme, this was to remain the only indication and description of his procedures. The few exceptions to this rule were the *Ova* (eggs, ovals), though these were often defined as 'spatial concepts' [143], and the series of plastic compositions he sometimes called *Natures* [145]. These were massive sculptures built around 1959-60, with great clods of clay, and no clearly discernible shape. They were then slashed open, to provide the plastic equivalent of the canvases. The almost carnal quality of these body-like statues is balanced by the extreme and chaste simplicity of the material used: a rough, coarse clay, left usually with its natural colouring. This is a form of sculpture that is almost anti-sculpture, and in a way it points to the 'art of poverty', Arte Povera, a recent development in the panorama of Western art which arose as a counter-balance to an excess of refinement in the use of new plastic and metal materials.

Beside these massive *Natures* I would like to mention – among the volumetric works of the artist – the whole series of ceramic spheres, sometimes oval-shaped, and often glazed and lightly coloured. These represent a link with the ceramics he made solely for decorative and commercial reasons in the first years of his activity.

In the two or three years before his death, Fontana's activity was ever more frenzied, due not least to the growing interest the public was finally showing in his work. Thus, alongside a prolonged output of holed and slashed canvases and metal sheets (these last, as we noted, executed semi-industrially, we should recall one last artistic typology which refers back precisely to this last period: that of 'spatial concepts' involving a wooden frame. These are a series of 'object-frames' [144], paintings in which the frame is the figurative element and the canvas, nearly always punctured by numerous holes, functions as a sort of mysterious background. Thus an extra dimension is added to the painting, due to the superimposition of the two distinct strata of the canvas and the wooden frame.

Once again it should be recognized that in these works Fontana knew how to make use of certain elements made familiar with the advent of Pop art, and transform them into something totally different and autonomous. The signs we are able to recognize in these 'frames' as clouds, plants and faces retain a somewhat ambiguous character and act as a sort of counter-index to the cosmic ambiguity of the holes and slashes. Cut into the fine, smooth surface of the wood, the profiles of these configurations stand out as barely recognizable shapes. A continual interaction, a continual dialogue grows

between the wooden silhouettes and the shadows they cast on the underlying canvas. Looking at these we realize how skilful Fontana was in his use of the abstract and figurative aspects of his art to attain a constantly self-renewing expressive quality.

Fontana's work was destined to find widespread resonance in European and particularly Italian painting circles, a resonance, however, which should be considered as bound to a common atmosphere in which a few artists could experiment, rather than to a 'school' led by Fontana. The Milanese artist in fact stayed clear of the academies and exerted his influence more because of a lively personality than doctrinaire pronouncements. And yet without his inspiration, it would be unthinkable that other artists would have used the forms and methods they did. Without wishing to exaggerate Fontana's sphere of influence, I believe it is possible to class the following Italian artists as among those who were directly influenced by him, and whose work (at least till the contemporary phase of their evolution) is artistically analogous or related to his: Piero Manzoni, Enrico Castellani, Agostino Bonalumi, Getalio Alviani (in part), Enzo Mari and Paolo Scheggi, apart from numerous others of the younger generation still too immature to list here [147-151]. But even abroad Fontana's work was not without a following; and, without wishing to get sidetracked by certain complex questions of priority and dating, I would just like to point to the evident parallelism between a phase in the work of Yves Klein and that of Fontana, where Fontana was tending more towards tonal monochromes. There are also affinities between Fontana and a few German artists, especially those who led the Zero group [146, s. 36] in his time (such as Otto Piene, Günther Uecker and Heinz Mack). Perhaps the culminating point of this united aesthetic front between Fontana and certain groups of European painters came in 1959-60 with 'Monochrome Malerei', an exhibition of monochrome canvases mounted in the Schloss Morsbroich in Leverkusen by Udo Kultermann. In this exhibition Fontana displayed his work alongside that of Yves Klein, Rothko, Still, Newman, Mack, Dorazio, Holweck, Uecker, Manzoni and Castellani. (The same museum was to exhibit a superb Fontana retrospective a few years later.)

Of course in later years all these artists went off in different directions, but there is no doubt that around the early 1960s they shared – by direct influence or community of interests and feelings – a style of working which Fontana, a much older man, had fashioned before them.

What would be interesting now would be to analyse one by one the works of those Italian artists who were most directly involved with Fontana's artistic platform, but this would be a lengthy job and would stretch the subject of this chapter. Perhaps it is just as well to mention, though, how the artistic tendencies I have been discussing flowered in Italy between 1960 and 1965. Let us take first the work of Piero Manzoni [149], undoubtedly one of the most original and inventive artists within the genre. Assembling unusual materials, he created a series of white paintings which fully expressed a concept of *oggettuale* painting, a precursor of the successive currents of Arte Povera and *oggettuale* abstraction. After Manzoni, Enrico Castellani [147] came to prominence: taking monochromes as his starting point, he exploited the play of light on the surface of the canvas. Assembling multiple extensions, usually regular in shape, he succeeded in obtaining a significant spatial vibration of the canvas. In other works Castellani adopted forms shaped into canopies and triptychs which finally expanded into particularly effective systems of false perspective.

Besides Castellani, another Lombard artist, Agostino Bonalumi [150], should be mentioned in this context. He works in a style of 'stuffing' canvas or plastic material, and often attains an ambiguous and almost volumetric spatiality, where the monochrome material is not confined to the sculpture but works through optical illusions.

The youngest member of this group, Paolo Scheggi [148], also exploits the spatial element he gets by superimposing two or more layers in the same painting. The canvas, gaping in one or more places where circular or oval lacunae have been cut, gives rise to a sensation of spatial disorientation which in turn creates a curious perceptual ambiguity.

These artists are the ones most closely related to Fontana's teaching and methods of working. They all share the need and the ability to avoid the

slavish reproduction of real-life objects in their canvases, thus clearly differentiating themselves from the poetics of Pop art. Instead they have taken a form of *oggettuale* art to its limits, thus forming a link between abstract-geometrical art (derived from constructivism and concretism) and those 'primary structures' which were later to occupy such a dominating position in the panorama of international visual art.

I hope from what I have said that the importance of Fontana's art to this mid-century period is now clear. Fontana advanced from proclaiming the necessary emancipation of visual art from the 'easel painting', from static and two-dimensional limits, and was able to progress beyond the period of *art informel*, so destructive to many other artists. His works were a prelude, on the one hand, to the revolution that Pop art was bringing about in re-evaluating the consumer product, and on the other, to the revolution that would lead to an *oggettuale* art – an art, that is, of 'self-sufficient objects', which are in reality 'primary structures', or minimal art. But – and this, I believe, is the true prerogative of his art – Fontana was never the prisoner of a particular current or fashion. And in a time like ours of facile conformity and rapid consumption, this is the mark of a man who has kept intact his own personality and originality.

Artists' Statements

1 Jackson Pollock

I accept the fact that the important painting of the last hundred years was done in France. American painters have generally missed the point of modern painting from beginning to end. (The only American master who interests me is Ryder.) Thus the fact that good European moderns are now here is very important, for they bring with them an understanding of the problems of modern painting. I am particularly impressed with their concept of the source of art being the unconscious. This idea interests me more than these specific painters do, for the two artists I admire most, Picasso and Miró, are still abroad. ...
The idea of an isolated American painting, so popular in this country during the thirties, seems absurd to me, just as the idea of creating a purely American mathematics or physics would seem absurd. ... And in another sense, the problem doesn't exist at all; or, if it did, would solve itself. An American is an American and his painting would naturally be qualified by that fact, whether he wills it or not. But the basic problems of contemporary painting are independent of any one country.

From *Arts and Architecture*, February 1944, p. 14.

Abstract painting is abstract. It confronts you. There was a reviewer a while back who wrote that my pictures didn't have any beginning or any end. He didn't mean it as a compliment, but it was. It was a fine compliment.

From the *New Yorker*, 5 August, 1950, p. 16.

2 Wols

In Cassis the stones, the fish
the rocks seen through a glass
the sea-salt and the sky
have made me forget the importance of man
have invited me to turn my back
on the chaos of our activities
have shown me eternity in the little waves
of the harbour
which repeat themselves
without repeating themselves....

It is superfluous
to name God
or to learn something by heart.

When one has in view a journey
to the sky
the details lose their importance
but retain their charm.

All our loves lead to one only
beyond personal loves
there is the love unnamed.

A personal prayer is not a prayer
a prayer of less than two words
may hold the universe....

At each instant
in each thing
eternity is there.

The ungraspable is everywhere
one needs to know that all relates.

From *Wols*, Éditions Claude Bernard, Paris, 1958

3 Georges Mathieu

Forty canvases: forty masterpieces. Each one more shattering, more harrowing, more sanguinary than the last: an important event, undoubtedly the most important event since the works of Van Gogh. The clearest, the most obvious, the most heartrending cry from the drama of one man and of all men.... With this exhibition, the last phase of the formal evolution of Western painting, as it has shown itself over the past seventy years – since the Renaissance – over ten centuries.... Wols has from the start used with genius, irreversibly, irrefutably, means of expression which are those of our time, and carried them to their maximum intensity.
What is more, these means of expression are – and they could not be more so – those of one who has lived. Wols has painted these forty pictures with his own drama, with his blood. The proof will be found with his death, and after his death – these are forty moments of man's crucifixion; a man who was the incarnation of a purity, a sensibility and a wisdom which does honour not only to the West but to all Creation....

From *Au-delà du Tachisme*, Julliard, Paris, 1963.

4 Mark Tobey

In China and Japan I was liberated from form through the influence of calligraphy. I already knew this means of expression when I was in Seattle. I studied this calligraphic method with a Chinese painter, Ten Kuei. I did not go to China and Japan in order to find something new for my work. I went to those countries simply because I had the opportunity to go there. I think my work has evolved unconsciously rather than consciously. My work is inner contemplation.
The central problem in painting as far as I am concerned lies, I think, in rhythm and in plastic form, often in the emotion of the application of colour – what one might call structure. As I have no hard and fast ideas, no philosophical affinities with preconceived methods, my work obviously changes all the time, or at least it looks like it.

From the catalogue 'Mark Tobey', Galerie Beyeler, Basle 1960.

5 Willem de Kooning

Everything is already in art – like a big bowl
 of soup
Everything is in there already:
And you just stick your hand in, and find
 something for you.
But it was already there – like a stew.

There's no way of looking at a work of art
 by itself
It's not self-evident
It needs a history; it needs a lot of talking
 about:
It's part of a whole man's life.

I'm in my element when I am a little bit
 out of this world:
then I'm in the real world – I'm on the beam.
Because when I'm falling, I'm doing all
 right;
when I'm slipping, I say, hey, this is interest-
 ing!

From 'Sketchbook I: Three Americans,
film script', *Time*, New York, 1960.

6 Franz Kline

It wasn't a question of deciding to do a
black-and-white painting. I think there was
a time when the original forms that finally
came out in black and white were in colour,
say, and then as time went on I painted
them out and made them black and white....
If someone says, 'that looks like a bridge',
it doesn't bother me really. A lot of them
do.... I like bridges.... Naturally, if you
title them something associated with that,
then when someone looks at it in the
literary sense, he says, 'he's bridge painter',
you know.... There are forms that are
figurative to me, and if they develop into
a figurative image that's – it's all right if
they do. I don't have the feeling that some-
thing has to be completely non-associative
as far as figure form is concerned.... I think
that if you use long lines, they become –
what could they be? The only thing they
could be is either highways or architecture
or bridges.
What I try to do is to create the painting
so that the overall thing has that particular
emotion; not particularly just the forms
in it....

From an interview with David Sylvester
published in *Living Arts* (London), vol. I,
no. I, Spring 1963.

7 Hans Hartung

In my opinion, the painting called 'abstract'
is not an 'ism', of which there have been
so many in recent times, nor a style, nor a
'period', but an entirely new means of ex-
pression, another human language, more
direct than the painting which preceded it.
Our contemporaries, or the generations
to come, will learn to read, and one day
this direct writing will be found more
normal than figurative painting, just as we
find our alphabet – abstract and unlimited
in its possibilities – more rational than the
figurative writing of the Chinese. This new
means of communication must not be con-
fused with its specific forms and content
of today.
These latter will be subject to complete
changes. But the new acquisition – the fact
of expressing oneself pictorially without
making a detour via nature – will probably
be with us always (alone or parallel with
figurative painting).
I have a horror of people who make figura-
tions, so to speak, from astronomy or
physics. This is a new figuration which
has no meaning. That these things penetrate
the mind, that they participate in the forma-
tion of thought, amen. But if someone sets
himself to paint microbes which he has
observed under the microcope – he would
do better to paint the women of Mont-
martre or Montparnasse.

From 'Pour ou contre l'art abstrait', state-
ments collected by D. Chevalier and
G. Diehl, *Cahiers des amis de l'art*, II, Paris
1947.

8 Jean Fautrier

One can hardly talk painting except on the
technical level. Should any rules whatever
apply in the matter of painting – should
drawing play an insignificant part or should
it succumb beneath a *matière* which takes
possession of the painting to the point of
becoming no more than an effect – should
colour be the essential purpose? Every
opinion has had its moment of validity,
and no logical or proportional balance
between them should be granted. It is
above all not to be recommended. The
balance exists in a period, it exists in its
inventor, each new balance destroys the
preceding one....
Nothing counts in art except the quality

of an artist's sensibility, and art is nothing
more than a way of externalizing, but a
mad way, without rules or calculations....
Whatever may be the value of today's
experiments, they cannot but appear salut-
ary – whatever the faults, the exaggerations
or the mistakes, today's eye has changed –
no one can deny that its needs are no longer
the same, they are so completely evolved
that it seems frightening to think that only
twenty years ago, the best artists were
fully satisfied and appeared as innovators
with their black fish and red trees, and that
they could only paint by placing themselves
in front of the subject. Painting is something
which can only destroy itself, which should
destroy itself, in order to re-invent itself.

From 'La peinture doit se détruire', *Cahiers
du Musée de Poche*, no. 4, Paris 1960.

9 Jean Dubuffet

Many people, having made up their minds
to run me down, have imagined that I take
pleasure in showing sordid things. What a
misconception! I had wanted to show them
that these things, which they had considered
ugly, are great marvels. Do, above all,
refrain from talking of humour, of satire,
as some people stupidly do, or of bitterness,
which has also been spoken of; I do my
best to rehabilitate objects regarded as un-
pleasing (do not, I beg of you, deny these
despised objects all hope), and my work
always stems from an attitude of celebration
(of incantation). But a clear-sighted cele-
bration, once all the smoke and camou-
flage is away. One must be honest. No
veils! No shams! Naked, all things first
reduced to their worst.
It is true that, in the paintings exhibited,
the manner of drawing is completely in-
nocent of any of the conventional skills,
such as we are used to finding in the works of
professional painters, and is such that no
special studies or natural gifts would be
needed to carry out similar ones. I would
reply that I hold to be useless those kinds
of acquired skill, and those gifts, whose
sole effect seems to me to be that of ex-
tinguishing all spontaneity, switching off
the power and condemning the work to
inefficacy.

On 'Mirobolus, Macadam & Cie., Hautes
Pâtes', Galerie R. Drouin, Paris 1944.

I have always dearly loved – its almost a vice with me – to make use only of the commonest of materials, those one would not think of at first, because they are too vulgar and ready to hand and seem to us unfit for anything. I like to proclaim that my art is an enterprise for the rehabilitation of values that are decried. It is also that I am more curious about these elements which, being so widely distributed, are, for that very reason, veiled from us, than I am about all the others. The voice of dust, the spirit of dust – these interest me many times more than a flower, a tree or a horse, for I feel instinctively that they are more foreign to us. Dust is an entity so different from ourselves. And particularly this absence of definite shape.... One would like to change oneself into a tree, but to change into dust – into an entity so continuous – would be so much more tempting. What an experience! What an investigation!

On the series 'Tableaux d'assemblages et Assemblages d'Empreintes', Galerie Rive Droite, Paris 1956/57.

10 Henri Michaux

I was possessed by movements, completely tensed by these forms which came at me full speed, in rhythmic succession....
Also, I saw in them, new language, turning its back on the verbal, *liberators*.
Abstraction of all heaviness
of all languor
of all geometry
of all architecture
abstraction made: SPEED!
Signs not of roof of tunic or of palace not of archives or of encyclopaedia of knowledge but of torsion, of violence, of jostling of kinetic desire.
Signs, not for being complete
but for being faithful to one's transient
not for conjugating
but for rediscovering the gift of tongues
its own at least, which, if not oneself, who would speak it?

From *Mouvements*, Gallimard, Paris 1951.

11 Antoni Tàpies

To remind man of what he is, to provide him a theme for meditation, to shock him

out of his frenzied pursuit of the spurious, this is the aim of my work; not a contempt for technique, but an effort to combat and to overcome the state of material and spiritual dependence into which technique has thrown us. I think of technique in the broad sense of the word, as of that which is necessary to the good functioning of a machine, and as of that which governments employ to control their subjects. Through my work, I do my best to help men to overcome their alienation, by surrounding them in their daily life with objects which confront them, in a tangible way, with the fundamental problems of existence.
About my work?
We live in a technological world stifled by material comfort. We live in a constant state of distraction, and our most elemental roots, even our instincts, these we have forgotten long since. Our environment is, in many respects, artificial and false. We are always dragging behind us absurd superstitions and atavisms, which alienate and enslave us.

Catalogue of 'Antoni Tàpies', Galerie Im Erker, St Gall, 1963.

12 K. R. H. Sonderborg

It has been a source of many misunderstandings that, since 1963, I have given no titles to my works, and restrict myself to noting the place and time of execution. I sometimes produce very rapidly, and this worries me. Monet, too, painted very fast, as many as three pictures a day. The title given to a picture is an unsupportably trite concession to everything that is not relevant to what I do. I'd rather they trod on my feet or attached a celluloid parrot to my rear-view mirror. You cannot explain POODLE by CORKSCREW. My time is not clock time – 10. X. 58., 20.21 to 20.27, 27 rue Boromée, Paris. It is the ultimate attempt to designate what is fugitive.
Work-note – catalogue-entry. Perhaps this makes it clear that I cannot and do not want to say any more about it. When and where, that is enough. I know nothing, my products tell me every time that everything is something else; then tell me what I don't know and what I again forget.

Catalogue of 'K. R. H. Sonderborg, Peintures et dessins', Galerie Carl Flinker, Paris 1960.

I work very slowly, although the act of painting sometimes lasts no longer than forty-five minutes. During painting I achieve a high degree of reality and concentration, but this does not preclude a simultaneous condition which is peaceful, contemplative and observant.
Great stillness and high speed are the extremes between which my life is stretched. Swift action and passive readiness for whatever is to be discovered next – during painting these things merge to become one. My main concern is to show the beauty and rhythm of the technical world that surrounds us, and the beat of the human heart. I think I observe an increasing concretization in my painting.
Often there are signs which are nothing but the trace of a trace of a movement.

From 'Ruhe und Geschwindigkeit', in *blätter+bilder*, No. 3, Zettner, Würzburg 1959.

13 Georges Mathieu

From the Ideal to the real, from the real to the abstract, from the abstract one moves on to the possible. Becoming has passed from the realm of man to that of cybernetic machines. Logic is based on contradiction, physics on relations of uncertainty or indeterminacy....
Evolution in art is produced by the saturation of the means of expression (significations) replaced by new means, of which the efficacy is unknown at the moment of use. The significance of these new means supposes a necessity, a structuring of the pictorial material, such as that realized to a lesser degree in psychic or biological facts. This intrinsic autonomy is, in fact, the only quiddity possible for the work of art in its relation with its own existence.... Art is in going beyond the signs. The sole chance, eventually, of an *informel* can only rest in the transcending of non-signs. The question is posed: it does more than put the basis of Western civilization at stake....
In this *informel* which precedes the coming into existence, in this freedom to restructure, the signs, which are the structuring elements, have to be made, but how? The phenomenology of 'the very act of painting' alone can tell us.... The phase which might be called FROM THE ABSTRACT TO THE POSSIBLE is more than a phase. It is a new era of art and of thought which is beginning, and which

is precisely that of a new incarnation of signs.

From *Vers une structuration nouvelle des formes, (le signe)*. Les Études Carmélitaines, Desclée De Brouwer, Bruges 1958.

14 Arshile Gorky

I call these murals non-objective art... but if labels are needed this art may be termed surrealistic, although it functions as design and decoration. The murals have continuity of theme. The theme – visions of the sky and river. The colouring likewise is derived from this and the whole design is contrived to relate to the very architecture of the building.

I might add that though the various forms all had specific meanings to me, it is the spectator's privilege to find his own meaning here. I feel that they will relate to or parallel mine.

Of course the outward aspect of my murals seemingly does not relate to the average man's experience. But this is an illusion! What man has not stopped at twilight and on observing the distorted shape of his elongated shadow conjured up strange and moving and often fantastic fancies from it? Certainly we all dream and in this common denominator of every one's experience I have been able to find a language for all to understand.

From article and interview with Malcolm Johnson in the *New York Sun*, 22 August, 1941.

15 William Baziotes

To be inspired. That is the thing.
To be possessed; to be bewitched.
To be obsessed. That is the thing.
To be inspired.

From *Tiger's Eye*, No. 5, October 1948, p. 55.

It is the mysterious that I love in painting. It is the stillness and the silence. I want my pictures to take effect very slowly, to obsess and to haunt.

From *It Is*, Autumn 1959.

16 Clyfford Still

That pigment on canvas has a way of initiating conventional reactions for most people needs no reminder. Behind these reactions is a body of history matured into dogma, authority, tradition. The totalitarian hegemony of this tradition I despise, its presumptions I reject. Its security is an illusion, banal, and without courage. Its substance is but dust and filing cabinets. The homage paid to it is a celebration of death. We all bear the burden of this tradition on our backs but I cannot hold it a privilege to be a pallbearer of my spirit in its name.

From the most ancient times the artist has been expected to perpetuate the values of his contemporaries. The record is mainly one of frustration, sadism, superstition, and the will to power. What greatness of life crept into the story came from sources not yet fully understood, and the temples of art which burden the landscape of nearly every city are a tribute to the attempt to seize this elusive quality and stamp it out. The anxious men find comfort in the confusion of those artists who would walk beside them. The values involved, however permit no peace, and mutual resentment is deep when it is discovered that salvation cannot be bought.

We are now committed to an unqualified act, not illustrating outworn myths or contemporary alibis. One must accept total responsibility for what he executes. And the measure of his greatness will be in the depth of his insight and his courage in realizing his own vision.

From *15 Americans*, edited by Dorothy C. Miller, New York, Museum of Modern Art, 1952, pp. 21-22.

The fact that I grew up on the prairies has nothing to do with my paintings, with what people think they find in them. I paint only myself, not nature.

I am not an action painter. Each painting is an act, the result of action and the fulfillment of action. I do not have a comic or tragic period in any real sense. I have always painted dark pictures; always some light pictures. I will probably go on doing so.

From 'An Interview With Clyfford Still' by Benjamin Townsend in *Gallery Notes*,

Albright-Knox Art Gallery, vol. 24, No. 2, Summer, 1961, pp. 10-16.

17 Mark Rothko

I paint very large pictures. I realize that historically the function of painting large pictures is painting something very grandiose and pompous. The reason I paint them, however – I think it applies to other painters I know – is precisely because I want to be very intimate and human. To paint a small picture is to place yourself outside your experience, to look upon an experience as a stereopticon view or with a reducing glass. However you paint the larger picture, you are in it. It isn't something you command.

From *Interiors*, vol. 110, May 1951, p. 104.

There is, however, a profound reason for the persistence of the word 'portrait' because the real essence of the great portraiture of all time is the artist's eternal interest in the human figure, character and emotions – in short in the human drama. That Rembrandt expressed it by posing a sitter is irrelevant. We do not know the sitter but we are intensely aware of the drama. The Archaic Greeks, on the other hand used as their models the inner visions which they had of their gods. And in our day, our visions are the fulfilment of our own needs....

Today the artist is no longer constrained by the limitation that all of man's experience is expressed by his outward appearance. Freed from the need of describing a particular person, the possibilities are endless. The whole of man's experience becomes his model, and in that sense it can be said that all of art is a portrait of an idea.

From the *Pratt Lecture*, 1958, text annotated by Dore Ashton, in *Cimaise*, Paris, December 1958.

18 Adolph Gottlieb

Certain people always say we should go back to nature. I notice they never say we should go forward to nature. It seems to me they are more concerned that we should go back, than about nature.

If the models we use are the apparitions seen in a dream, or the recollection of our prehistoric past, is this less part of nature or

realism, than a cow in a field? I think not. The role of the artist, of course, has always been that of image-maker. Different times require different images. Today when our aspirations have been reduced to a desperate attempt to escape from evil, and times are out of joint, our obsessive, subterranean and pictographic images are the expression of the neurosis which is our reality. To my mind certain so-called abstraction is not abstraction at all. On the contrary, it is the realism of our time.

From *Tiger's Eye*, No. 2, December 1947, p. 43.

I adopted the term Pictograph for my paintings... out of a feeling of disdain for the accepted notions of what a painting should be.
My Pictographs have been linked with totem-poles, Indian writing, psychoanalysis, neo-primitivism, private symbolism, etc., the implication being that my work is not quite what painting should be. This has never disturbed me because my aim has always been to project images that seem vital to me, never to make paintings that conform to the pattern of an external standard....
The important thing is to transfer the image to the canvas as it appears to me, without distortion. To modify the image would be to falsify it, therefore I must accept it as it is. My criterion is the integrity of the projection.
I frequently hear the question, 'What do these images mean?' This is simply the wrong question. Visual images do not have to conform to either verbal thinking or optical facts. A better question would be 'Do these images convey any emotional truth?'

From *The New Decade*, Whitney Museum of American Art, New York, 1955, pp. 35-36.

19 Robert Motherwell

We feel through the senses, and everyone knows that the content of art is feeling; it is the creation of an object for sensing that is the artist's task; and it is the qualities of this object that constitute its felt content. Feelings are just how things feel to

us; in the old-fashioned sense of these words, feelings are neither 'objective' nor 'subjective', but both, since all 'objects' or 'things' are the result of an interaction between the body-mind and the external world.

From 'Beyond the Aesthetic', *Design*, April 1946.

The emergence of abstract art is a sign that there are still men of feeling in the world. Men who know how to respect and follow their inner feelings, no matter how irrational or absurd they may first appear. From their perspective, it is the social world that tends to appear irrational and absurd.

From 'What Abstract Art Means to Me', *The Museum of Modern Art Bulletin*, Spring 1957.

Art is much less important than life, but what a poor life without it! This is not aestheticism, but recognition that art as much as anything – perhaps more – conveys how men feel to themselves. In this sense, even the most difficult art is meant to be shared, and does communicate.
One does not have to 'understand' wholly to feel pleasure.
Drawing is dividing the surface plane.
Colour is a question of quantity, i.e., extension in space.
But it is light that counts above everything. Not coloured light, but colour that gives off light – radiance!
The supreme gift, after light, is scale.
The technique of painting is the simplest of all the arts: For that reason it demands the greatest sensibility.
Every painter *au fond* is a voyeur: the question is whether he has a vision.
Painting is a totally active act.

From a letter to Frank O'Hara, 18 August 1965, printed in the catalogue 'Robert Motherwell', Museum of Modern Art, New York 1965.

20 Hans Hofmann

America is at present in a state of cultural blossoming. I am supposed to have contributed my share as teacher and artist by the offering of a multiple awareness. This awareness I consider to constitute a visual experience and a pictorial creation.

'Seeing' without awareness, as a visual act, is just short of blindness. 'Seeing' with awareness is a visual experience; it is an art. We must learn to see. The interpretation in pictorial terms of what we see is 'another' art....
Like the picture surface, colour has an inherent life of its own. A picture comes into existence on the basis of the interplay of this dual life. In the act of predominance and assimilation, colours love or hate each other, thereby helping to make the creative intention of the artist possible.

From *It Is*, No. 3, Winter-Spring, 1959, p. 10.

21 Sam Francis

What fascinates me is the blue of the atmosphere, seen from a jet 30,000 feet high.

From an article by Lil Picard, *das Kunstwerk*, IV, 16, Baden-Baden, October 1962.

I believe the value of an action (painting) lies in the realm of the unintentional.... For the intended necessarily has a surface which betrays us.... I feel the work must put one in a position of doubt.

From Michel Seuphor, *A Dictionary of Abstract Painting*, Methuen, London 1958.

The true dream image leaves behind the tripartite soul and its miasma. It is the cloud that passes over the sparkling sea. You can't interpret the dream of the canvas, for this dream is the end of the hunt on the heavenly mountain, where nothing remains but the phoenix caught in the midst of the wonderful blue.

From a letter in the catalogue 'Die neue amerikanische Malerei', Kunsthalle, Basle 1958.

22 Jean Bazaine

One does not succeed in painting as one wants to; it's a matter of 'willing' to the end the painting one can do, the painting that is possible in the historical context. And this is not done by an effort of the intelligence or through historical knowledge, but through the most obscure functioning

of the instincts and the sensibility. One single rule stands, absolute: with each new canvas to have lost the thread.

A painter's invention is a secret thing; it expresses an epoch, a world, or a state of sensibility, all the more forcibly in not having started out with a clear intention of expressing it. The painter never discovers anything but his own sensibility; this may be through a subject – king, apple, barricade – but we know very well that it is the quality of the invention which renders the work universal, not the subject.

It is not through images that the human being can prove his existence and bear witness to his aspirations, but in giving life to stupendous doubles of himself, which is what works of art are.

From *Notes sur la peinture d'aujourd'hui*, Le Seuil, Paris 1960

23 Alfred Manessier

Artistic creation pre-supposes... two conditions. First, not saying 'I want', since the externalization of interior states demands a sort of abandon to oneself, then much love; this alone enables one to carry one's subject to its conclusion – to the point where it humanizes itself to the extent of taking on a general value.

The art of non-figurative painting seems to me to be the chance, today, through which the painter can best reach back towards his own reality, and again become aware of what is essential to him.

Only from this vantage-point will he be able, as a consequence, to recover his own force and to revitalize even the external reality of the world.

From B. Dorival, 'Alfred Manessier, artisan religieux', in *L'Œil*, Paris 1959.

24 Pierre Soulages

My painting has always remained outside the dilemma of figuration – non-figuration. I do not start from an object or from a landscape with a view to distorting them; nor, conversely, do I seek, as I paint, to provoke their appearance.

I hope more from rhythm, from the pulsation of forms in space, from this cutting-up of space by time.

Space and time cease to be the milieu in which painted forms are suspended; they have become instruments of the poetry of the canvas. More than a means of expression and supports for the poetry, they are themselves that poetry.

What I have just said is only an attempt to explain a painter's approach; what happens in a picture which, from being an object in course of fabrication, suddenly becomes something alive, seems to me to be beyond words.

From J. Grenier, *Entretiens avec dix-sept peintres non-figuratives*, Calmann-Lévy, Paris 1963.

Painting is above all a poetic experience. It is a metaphor; it does not permit of explanation, does not even allow itself to be broached by explanation; it is the point where the meanings one gives to it come to be made and unmade.

This is why art provokes, disturbs and exalts, like life.... The one thing which eludes everyone, spectator and critic alike, is precisely the reality of the painting. 'Here begins the poetry.'

From G. Charbonnier, *Le monologue du peintre I*, Juilliard, Paris 1959.

25 Nicolas de Staël

What gives the dimension, is the weight of the forms, their situation, the contrast.

For myself, in order to develop, I need always to function differently, from one thing to another, without an *a priori* aesthetic.

I do not paint before seeing; I look for nothing but the painting which can be seen by everyone. I lose contact with the canvas every moment and find it again and lose it.... This is absolutely necessary, because I believe in accident. I can only go forward from accident to accident – as soon as I feel a too logical logic, this upsets me and I turn naturally to illogicality.

One never paints what one sees or believes one has seen. One paints, in a state of wild resonance, the shock received.

From the catalogue 'Nicolas de Staël', Galerie Beyeler, Basle 1964.

26 Vieira da Silva

L'incertitude, c'est moi. I am uncertainty personified. It is uncertainty that is my certainty. It is on uncertainty I base myself.... When I paint, I do not know. I do not know, which is to say, I know. But... I do not know. I never do what I want to do. It is the picture that answers me.... Basically, when I paint I think about nothing but painting well.

But how can I explain myself? It is this thing all round me that I paint, do you understand? It is this thing. For many painters, the visual world does not count. For me it counts a lot; it is the vocabulary. There is the rhythm, too, the beating of one's heart, that is a very important thing too...

G. Charbonnier, *Le monologue du Peintre II*, Juilliard, Paris, 1960.

27 Emil Schumacher

When I paint I am always very feverish and tense; it is an act of will in which I hover somewhere between feeling and reason.... I grope my way slowly forwards without having any exact idea where I will arrive. At each moment of work I see only what is then on the canvas. I paint a form, add a line to it, I oppose one movement with another one, then I scratch this out; here I let the canvas show through, there I add a thick patch of impasto – all just as I feel and think, without actually being able to explain the reason. I have no scheme by which I paint....

No preparation, no explanation can lighten the effort of again and again re-experiencing the work of art.

The suspended state of the creative moment demands a concentration of the senses which obliterates the difference between deep dreaming and bright wakefulness.

The element of chance is dangerous. Destroy the picture again and again. Through this new layers are discovered which otherwise one would never glimpse.

From 'Farben und Einfälle', in *blätter+bilder*, no. 1, Zettner, Würzburg 1959.

28 Paul Emile Borduas

The secrets of [surrealist] canvases, and of pictures from the past, are locked up in form. There are few people who will be capable of reading the forms; of perceiving the profound reality of a canvas, any more

than that of the smallest pebble. Only children and the simple-minded possess the enviable gift of being able to enter into direct contact with form without going through the intermediary of words (verbal dialogues); of being able to recreate in themselves the reality of the object they have before their eyes, or in their hands.

From the catalogue 'Borduas', Stedelijk Museum, Amsterdam 1960/61.

29 Alan Davie

Painting has taught me much, mainly that it is impossible to paint a picture and that if a picture is to be, it must happen in spite of me rather than because of me.
I paint because I have nothing, or I paint because I am full of paint ideas, or I paint because I want a purple picture on my wall, or I paint because after I last painted, something appeared miraculously out of it... something strange, and maybe something strange may happen again. (The real thing is always strange: that is, beyond understanding.) Or I paint in the hope that once more I might be able to excel my own capabilities. But all these reasons are only excuses, and paint ideas are significant only if they are the outcome of painting, coming at the end and not at the beginning. The preliminary idea, no matter how insistent, must be broken down, superseded.
There can never be a complete or perfect work of art, for perfection is death. Perfection is finite, imperfection is infinite.
The artist is never sure, because he knows that knowledge is of no value and not knowing is of more value than knowing which is mere cleverness. The artist is always sure, because he has faith in intuition, and intuition is knowing without knowledge.
The artist was the first magician and the first spiritual leader, and indeed today he must take the role of arch-priest of the new spiritualism.

From the catalogue 'Alan Davie', Galerie Charles Lienhard, Zurich, April-May 1960.

30 Willi Baumeister

The real power of the means of expression lies in the actual visible surface of the work. For the modern artist this surface is of the greatest importance. Its various areas are his keyboard, but at the same time they also have an expressive function of their own. The forms, the colours, the dark and bright patches, the thickness of the lines, the precise or the vague, relief in contrast to flatness – these are all the notes of his composition. Entirely on their own, without being a mere copy of some natural object, they emit their peculiar power.

From *Das Unbekannte in der Kunst*, DuMont Schauberg, Cologne 1960. See also *Quadrum*, No. 8, Brussels 1960.

31 Jean Degottex

The idea of reality is not reality. Painting is an emotional language which is in opposition to everything that is fixed in conventional language. What draws me into the unconscious is its limitlessness, that is, the part of it which exceeds what one can expect from the individual unconscious....
I can say without hesitation that for me the encounter with Zen has been capital... It is in any case very difficult to explain what it is that attracts me so much in the writings. I believe that, little by little, they reveal very important things to me. The up and the down strokes are a respiration. I would like my painting to be a deeper respiration, if I can put it like that.... It is possible that the painter himself may be a sign. There is, as it were, a sort of effacement of the individuality before this thing which is more exalted than the individual. The painter animates his own activity in some way.

From an interview with J. Alvard in *Quadrum*, No. 10, Brussels, 1961.

32 Jaroslav Serpan

Strange situation! Assigned by the inevitable stickers-on of labels to several successive movements, how is it that I have never felt completely at home in any of them? An '*informel*' painter in the eyes of some (although despising non-form, and more concerned with structural writing), 'action painter' in the United States, 'biologist painter' or 'mathematician painter' in Europe (although inclined to grant no more

to scientific knowledge than the value of a notional framework), and finally, in these last few years, 'baroque' (although the meaning of this term has never been made clear): I have been and I am all these things, and I am none of them.

From a work published by the artist, 1965.

33 Pierre Alechinsky

Shall I begin? Shall I begin with little lines, with little crosses, with little dots, with a big thing going from there to there, with a blot that will watch me making it, with an idea? Shall I begin by caressing the canvas that I dream of as finished? No, I begin.

From 'Paysages poursuivis poursuivants', in *Cahiers du Musée de Poche*, No. 4, Paris 1960.

34 Winfred Gaul

The world around us is second-hand nature, prefabricated. It gives us the models from which we compose the picture. Seven years ago I turned my attention to a specific phenomenon of our mass society: road signs and traffic lights. Road signs are omnipresent and omnipotent. They command and forbid. They direct us hither and thither. They are both writing and picture, message and symbol.
They seem to be a modern form of primitive hieroglyphs, but they are also more than this: they are taboo images which have a subconscious effect, they are concrete manifestations of something which exists in our subconscious. As art is obviously concerned with this subconscious reality, even when it attacks or exposes it, road signs and traffic lights seem to me especially suitable models for an art form which is concerned with communication.
My traffic signs are the hieroglyphs of a new city art. They assume the banal jargon of their prototypes so as to create from it a new language with a new, fresh and untouched beauty. Their aestheticism is that of the new dimensions, of harsh colours and enormous forms; it is an art that has its place between skycrapers and industrial

complexes, and at the intersections of high-ways where traffic swirls around it.

From 'Verkehrszeichen und Signale – Zur Situation des Bildes in der technologischen Zivilisation', in the catalogue 'Winfred Gaul', Galerie Ráber, Lucerne 1967.

35 Lucio Fontana

Genuine ideas are not to be refuted. They are found, in germ, in the community, and it is the artists who express them. All things are necessary and have a value in their own epoch.

We need an art which draws its value from within itself, and not from any ideas we might have about it.

Abstraction results from the progressive destruction of form.

Existence, nature and matter constitute a perfect unity, extended in time and in space. Change is the essential condition of life. Movement, evolution and development are the fundamental conditions of matter; the latter only exists in movement. Colour and sound are found in nature, and linked with matter. Matter, colour and sound – these are the phenomena whose simultaneous evolution forms an integral part of the new art.

The discovery of new physical forces, the mastery exerted over matter and space, gradually impose on man conditions which have never existed previously. The application of these discoveries to all forms of life entails a radical modification of human nature. Man acquires a different physical structure. We live in the mechanical age. Painted cardboard and plaster sculpture have no further justification for existence. We are postulating a total comprehension of the profound values of existence. That is why we install, in art, the fundamental values of nature. We present the substance and not the accidents. We turn our attention to matter and its evolution, the creative sources of existence. We take our stand for the veritable energy of matter, its irrepressible need of being and of movement. We postulate an art free of all aesthetic artifice. We put into effect what man possesses of the natural and the true. We reject the aesthetic inauthenticity of speculative art.

An art based on forms created by the unconscious, and equilibrated by reason, constitutes an authentic expression of being and a true synthesis of the historic moment. After many millennia of analytical artistic evolution, the moment for synthesis has come. Separation was necessary at the beginning; today it represents the disintegration of lost unity. We understand by synthesis a sum of physical elements – colour, sound, movement, time and space – which are based upon a psycho-physical unity. Colour, the element of space, sound, the element of time, and movement, which is extended in time and in space, are the fundamental forces of the new art, which embraces the four dimensions of existence – time – space.

From *Manifiesto blanco*, Buenos Aires 1946.

36 Gruppe Zero

Zero is silence. Zero is the beginning. Zero is round. Zero turns. Zero is the moon. The sun is Zero. Zero is white. The desert Zero. The sky above Zero. The night flows Zero. The eye Zero. Navel. Mouth. Kiss. The milk is round. The flower Zero the bird. Silent. Drifting. I eat Zero, I drink Zero, I sleep Zero, I wake Zero, I love Zero. Zero is beautiful. Dynamo dynamo dynamo. The trees in the spring, snow, fire, water, sea. Red orange yellow green blue indigo violet Zero Zero rainbow. 4 3 2 1 Zero. Gold and silver, sound and smoke travelling circus Zero. Zero is silence. Zero is the beginning. Zero is round. Zero is Zero.

(This poem was written in a cafe in Krefeld during a Mack – Piene – Uecker exhibition in the Hans Lange Museum in 1963. Each of the three artists spoke a phrase in turn and it was written down.)

HEINZ MACK

The dynamic structure of colour and light delights my eye, disturbs my lazy thoughts, lends wings to the rhythm of my heart and to the quick breath of my wishes.
In my reliefs light itself becomes the medium instead of colour, the movement – as well as causing the light vibrations – produces a new, immaterial colour and tonality, and

the intangible and entirely non-figurative nature of these suggests a possible reality whose aura and secret beauty we already love.

From 'Nota 4', 1960, in the catalogue 'Mack, Piene, Uecker', Kestner-Gesellschaft, Hanover 1965.

OTTO PIENE

Light paints.
I wish for a heart with seven chambers, for a heartbeat as strong as the tides, and for a lung with twenty-two lobes that can calmly breathe through any storm.
I wish for a heaven in whose brightness slow and fast are the same thing, where men are like doves and doves like eagles.
I wish for a day that is clear and bright and long-lasting, and for a night and silence.
And the light is there and penetrates everywhere, and it is not I that paints, but the light.

From the catalogue of the Ad Libitum Gallery, Antwerp 1961.

GÜNTHER UECKER

I deliberately call my white structures 'objects', as they are different from illustrative projections on a screen. I built them with prefabricated elements like nails. At first I used strictly arranged rhythms, mathematical sequences, but these dissolved into a free rhythm. Then I tried to achieve an integration of light which, by changing light, would set these white structures in motion, and which could be understood as a free, articulate area of light. I decided on a white zone, as it is the extreme of colourfulness, the climax of light, triumph over darkness. I believe that a white world is a humane world in which man can experience his colourful existence, in which he can be truly alive. These white structures can be a spiritual language in which we begin to meditate. The state of White can be understood as a prayer, its articulation can be a spiritual experience. This existence in whiteness is different from darkness, from our fleshly existence that manifests itself in a scream....

From the catalogue 'Mack, Piene, Uecker', Kestner-Gesellschaft, Hanover 1965.

Part Two: GEOMETRY, COLOUR AND MOTION

Geometrical Abstraction: its Origin, Principles and Evolution

HANS L. C. JAFFÉ

'Art will be something which will hold the balance between algebra and music.'
GUSTAVE FLAUBERT

It is more than a century ago that the above definition, in which are combined the origin, principles and history of geometrical abstraction, was set down as a vague prediction of a new and purified form of art. When Flaubert wrote this sentence in a letter in 1852, the visual arts had just arrived at realism, which Courbet had so strikingly and strictly defined in the following terms: 'Painting is an essentially concrete art and can consist only of the representation of real and existing things; an invisible, non-existent, abstract object does not belong to the sphere of painting.'

These two quotations, both dating from the beginning of the second half of the nineteenth century, throw into sharp relief the situation at that time, but also show the polarity of the alternative paths. Flaubert, the poet, dreamed of an art that had left behind the data of observation and would obey only its own laws, those of harmony and relationship. Courbet, the painter, made faithfulness to observed reality the highest law of his art, in order to free it of literary influences and of domination by religious and mythological themes, so that it was just in those years that painting again became the discoverer of daily reality, of actual life. With this realism began a development which – however remarkable it may sound – ended in the realization of Flaubert's prophecy, in an abstract painting and, at the same time, in an abstraction based on geometrical laws.

What, in fact, had Flaubert predicted? A visual art which would hold the balance between mathematics and music, which would be tied (like mathematics) to strict laws of number and relationship, and which, at the same time, would not derive its aims and intentions from the appearance of reality, but (like music) would determine its own arrangement, according to this reality. Just as in the ancient myth Apollo divided all the sounds of the world among the tones of the seven strings of the lyre, so also must the visual arts be able to approximate to the wealth of form and colour of reality with a simple division comparable with the musical structure of pitch and rhythm. Flaubert must have been aware in his prediction that a part of music – notably the strictly polyphonic – has a strong connection with mathematics, a connection which emerges clearly, *inter alia*, in the figured bass. Indeed, the whole structure of music, not only of the chords, but also of the melody, was based in his day on a system of intervals, relationships and combinations which derived from the spirit of mathematics, and in which number and proportion played a predominant part.

At that time, however, the stage had by no means been reached when his prediction would be realized in the visual arts – it was to be more than half a century before abstract art would be not just a dream, but a fact, and still longer before geometrical abstraction would be practised consciously and systematically. That did not really happen until fifty years ago, in 1917, when the periodical and group De Stijl were founded in the Netherlands, although works had already been created a few years previously which may now rightly be regarded as forerunners of geometrical abstraction. It was, however, in the nineteenth century that the foundations were laid for the emergence of this form of abstract art, and it is exciting to see how, here also, Flaubert's prediction came true, for the genesis of geometrical abstraction did derive from the spirit of mathematics, on the one hand, and from that of music on the other; and, once it had emerged, it did indeed hold the balance between

its two sources. Without too much simplification, we can see the spirit of mathematics represented in Cézanne [S. 37] and that of music in Seurat – and, in addition to their works, a few passages from their writings will help to bear this out.

It is clear that, for Cézanne, the appearance of things is no longer the painter's chief concern, but rather it is the laws, the system of mathematical co-ordinates by which creation – the term which Cézanne ultimately sets alongside the word 'nature' – is held together. For Cézanne, creation must be based upon a plan, a system, and man can approach this system only by way of mathematics, by way of the rigorously objective method represented by mathematics in the human spirit.

Seurat created a kind of musical language that no longer started from what was given, from the observation of reality, but was especially concerned with the *mode* – again a musical term – the feeling to be evoked by the work of art. Both Seurat's aesthetic [S. 38] and his technique are constructed on a theory of harmony.

Thus, when geometrical abstract painting manifested itself for the first time, its two sources had again become clear. The trend deriving from Seurat, which concentrated upon colour and its harmony, passage and movement, had at its very beginning such remarkable representatives as Robert Delaunay [153] and Frank Kupka [152]. They were both members of the Section d'Or group in Paris in the years immediately following 1910 – that separatist band of cubist heretics who wanted to build their art on relationships of number and dimension.

It cannot be stated with complete certainty when the first work was created that may be regarded as a geometrical abstract painting. It is certain that Kupka produced a painting in 1910 – the same year in which Kandinsky painted his first abstract watercolour – a work entirely free of any reference to observed reality. But it is difficult to speak at this stage of *geometrical* abstraction. He first approached this during the period 1911 to 1912 in studies for a work that was called – typically enough – *Fugue*, and he attained it completely in 1913 with the ambitious work *Philosophical Architecture* [152], a canvas on which large, regularly formed areas of colour stand in a precise dimensional and colour relationship to

Plates 152-168

152 FRANK KUPKA. *Philosophical Architecture*, 1913. Oil on canvas, 192 × 112 cm. Private collection, Paris.

153 ROBERT DELAUNAY. *Rhythms without End*, 1934. Oil on canvas, 200 × 100 cm. Collection S. Delaunay, Paris.

154 PIET MONDRIAN. *Composition*, 1919. Oil on canvas, 48.5 × 48.5 cm. Kunstmuseum, Basle. Photo D. Widmer, Basle.

155 CASIMIR MALEVICH. *Eight Red Rectangles*. 1914. Oil on canvas. Stedelijk Museum, Amsterdam.

156 THEO VAN DOESBURG. *Dissonant Counter-composition XIV*, 1925. Oil on canvas, 100 × 180 cm. Gemeentemuseum, The Hague.

157 BART VAN DER LECK. *Geometric Composition II*. Oil on canvas, 100 × 101 cm. Stedelijk Museum, Amsterdam. (Erratum: for Bert read Bart, p. 167.)

158 GEORGES VANTONGERLOO. *Construction of Volumes*, 1918. Cement, height 25 cm. Stedelijk Museum, Amsterdam.

159 CESAR DOMELA NIEUWENHUIS. *Neo-plastic Composition No. 10, Lozenge-wise*, 1930. Wood, copper and plexiglass, d. 110 cm. Gemeentemuseum, The Hague.

160 EL LISSITZKY. *Proun 30 T*, 1920. Mixed media on canvas, 50 × 62 cm. Private collection.

161 FRIEDRICH VORDEMBERGE-GILDEWART. *Composition III*, 1939. Oil on canvas, 80 × 100 cm. Stedelijk Museum, Amsterdam.

162 WASSILY KANDINSKY. *Arrow*, 1927. Oil on canvas, 88 × 48 cm. Private collection, Paris. Photo Claude Gaspare. Courtesy Galerie Maeght, Paris.

163 SOPHIE TAEUBER-ARP. *Horizontal and vertical No. 2*, 1916. Pastel. Collection Michel Seuphor, Paris. Photo E.B. Weill, Paris.

164 OTTO FREUNDLICH. *Composition*, 1940. Gouache on paper, 84 × 60 cm. Collection Wilhelm Hack, Cologne. Photo Y. Hervochon, Paris.

165 JOSEF ALBERS. *Homage to the Square*, 1963. Oil on canvas, 101 × 101 cm. Galerie Denise René, Paris. Photo A. M. Desailly.

166 WILLI BAUMEISTER. *Wall Picture with Metals*, 1923. Gold and cardboard on canvas, 89 × 61 cm. Private collection. Photo W. Klein, Düsseldorf.

167 FERNAND LÉGER. *Mural Composition*, 1926. Oil on canvas, 113 × 97 cm. Stedelijk Museum, Amsterdam.

168 VICTOR SERVRANCKX. *Exaltation of Mechanicism, Opus 47*, 1923. Oil on canvas, 113 × 211 cm. Musées Royaux des Beaux-Arts de Belgique, Brussels. Photo P. Bijtebier, Brussels.

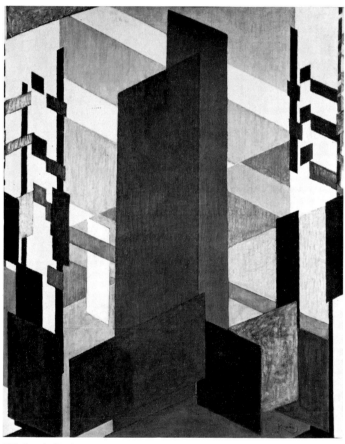

152 Frank Kupka

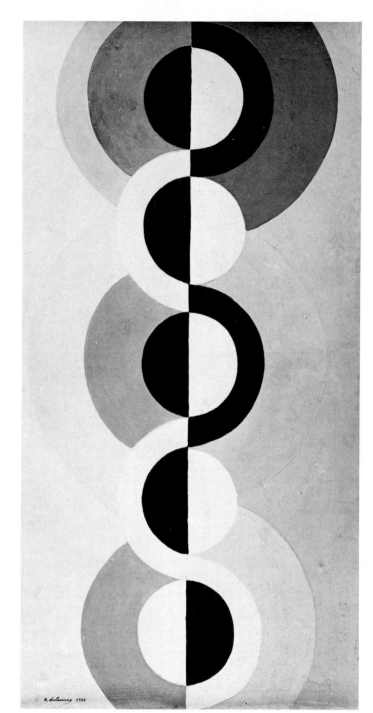

153 Robert Delaunay

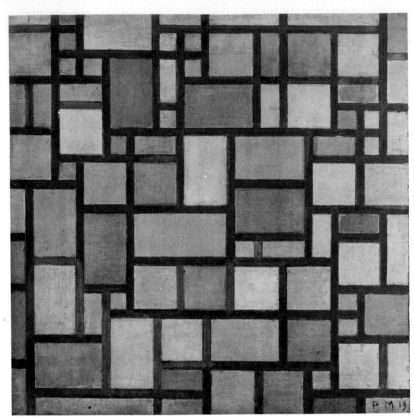

154 Piet Mondrian

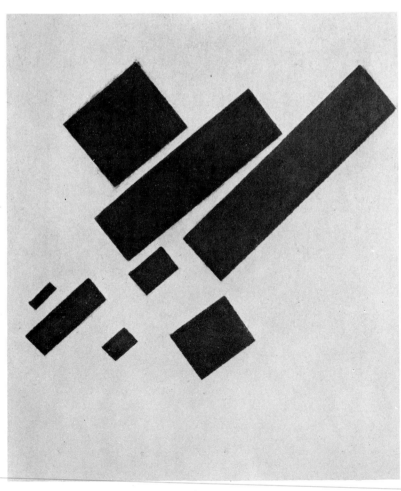

155 Casimir Malevitch

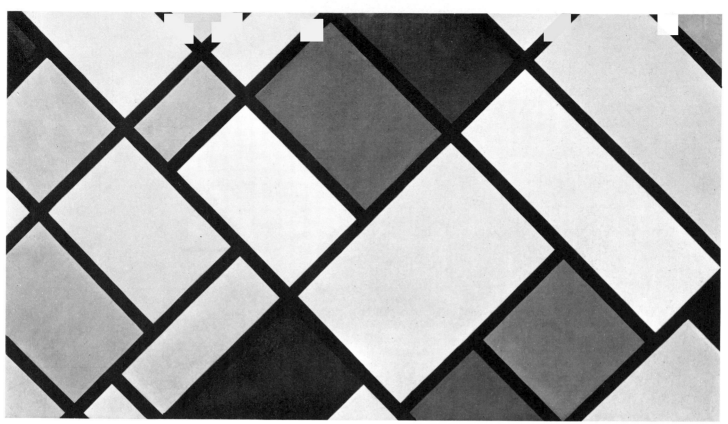

156 Theo Van Doesburg

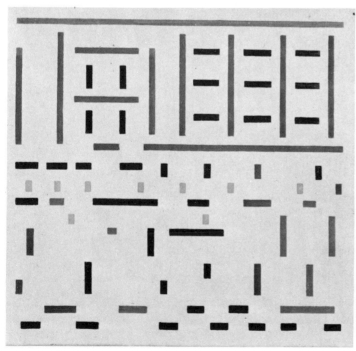

157 Bert, Van der Leck

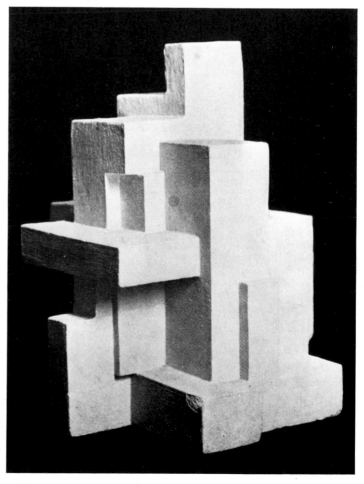

158 Georges Vantongerloo

159 César Domela

160 El Lissitzky

161 Friedrich Vordemberge-Gildewart

162 Wassily Kandinsky

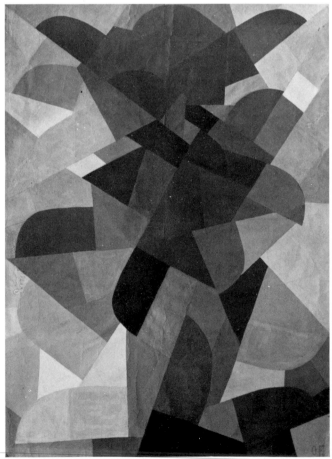

164 Otto Freundlich

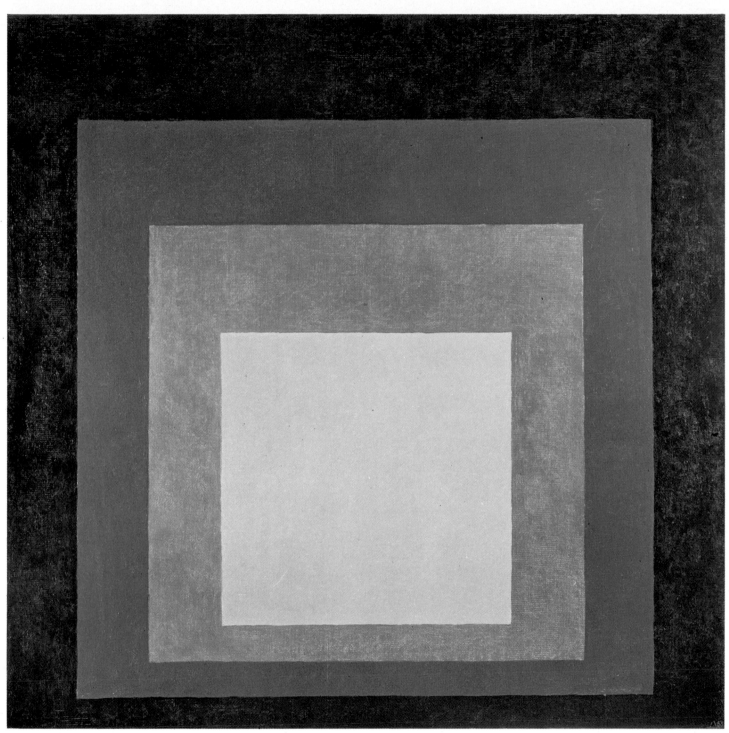

165 Josef Albers

166 Willi Baumeister

167 Fernand Léger

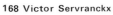
168 Victor Servranckx

each other, evoking a visual effect corresponding to the musical concept of a chord.

In this painting he also succeeded in realizing his intention of creating 'a kind of pictorial geometry of ideas, the only thing that remains possible'. The fact that colour plays such an important part in this geometry derives precisely from the very great influence which Seurat, through his theories and disciples, exercised on the members of the Section d'Or.

For Robert Delaunay, the other forerunner of geometrical abstraction, originating from the Section d'Or, colour is the very essence of painting. In 1912, therefore, he was working on the solution which obsessed him. The painting from 1912, *Disc*, in which a circle is divided into concentric rings that are divided in turn by a quartering of the circle into different coloured sections, shows the realization of his ideas: the surface of the circle is brought into movement through the colour, the rings rotate, and the whole happening, although in a narrowly circumscribed area, appears, in fact, to proceed in time. Here is the basis of all Delaunay's later work, which – after a representational interlude – returns again in the years after 1930 to the dynamic play of geometrical forms of his works of 1912. And it is remarkable to observe, even in his representational stage – which begins with the *Cardiff Team* of 1912-13 and the *Homage to Blériot* of 1914, and perhaps reaches its climax in the *Portuguese Still-lifes* of 1916 – that he has not abandoned the formal language of colour contrasts and circle segments, but that, during this period, he linked with a representational content, i.e. that he integrated it with fragments from observable reality.

Perhaps even more strongly than Kupka, Robert Delaunay – together with his wife, Sonia Delaunay-Terk – was inspired by the principles of music. For the action in his early abstract works – the *Disc* of 1912 and the related *Circular Forms* – as well as in the *Rhythms* from his later abstract period, shows many analogies with the language of music. Delaunay pays particular regard to the fact that his paintings not only take place on the flat surface of the canvas, but create another dimension – that of time. This time factor also plays a part in the representational works of his middle period, and gives these works a musical accent.

It is especially in the late works, however, in the *Rhythms without End* [153], inspired by the same elements as the early *Disc*, i.e. circle segments and rings, that this musical element is given the predominant voice.

Thus the element of music can be clearly recognized in two of the pioneer masters of geometrical abstraction. It can not only be recognized, but even traced back to the principles of a theory of harmony propounded by Seurat as a reaction against an impressionism that had entrusted itself, too willingly and too passively, to the charm and beautiful appearance of optical observation. Seurat, and with him his immediate and later disciples, needed a methodology, a Cartesian system, to give the formal language a structure, a skeleton. This was the origin of his harmonic theory, which was to serve in turn as the basis for the first attempts to give visual form to a geometrical abstraction.

The second source – besides musical inspiration, which derived from Seurat – was mathematical in nature. Geometrical abstraction, as it developed in the years around 1913 in Russia, and in 1917 in the Netherlands, derived from cubism. And cubism, in its turn, achieved in its own way the strict geometrical propositions of Cézanne, basing itself on his motto of 'thinking with the eyes'. Cubism was, from the beginning, an attempt at spatial definition and formal organization, and both Malevich in Russia and Mondrian in the Netherlands and Paris passed through this school of extreme formal discipline.

On the one hand, cubism meant for both these pioneers a first step away from objects – which was, at the same time, a step towards abstraction, towards non-representational art, or, as Malevich expressed it in still more sweeping terms, towards the 'objectless world'. One can see clearly, on the first cubist canvases of both masters, how the object loses its importance and how its forms play a part only in the general composition of the painting, in the 'pictorial score'. This appears very clearly, for example, from the two versions of Mondrian's *Still-life with Ginger Jar* of 1911 and 1912, where, in the first version, the things still bear the character of object, while, in the second version, the forms of glasses, saucepans, etc., have become simply accents of line and colour in the

rhythmic flow of a pictorial composition. What, for example, was a white table-napkin in the first version (in the left foreground), on which a knife was placed diagonally, has become in the second version an area of white with a diagonal linear accent. In this way, the characteristics of objects are transposed into formal values, and the first step is taken along the path towards abstraction, even in the original, literal sense of the word: the values of form and colour have been abstracted from the objects themselves. And with Malevich and his Russian friends, as with Mondrian, we see this process grow with the years and dominate the work of the painters, until, at a given moment, there is a breakthrough, the essence of which is that the artist completely abandons the given object from which his abstraction derived and starts working on his own authority with the vocabulary and syntax that he had mastered during his cubist, abstracting period. This break can be clearly seen, both with Malevich and Mondrian. With Malevich, his famous black square on a white ground was painted in the same year as his cubist paintings of 1913, and with Mondrian, the first paintings with coloured squares from 1917 stand beside his great cubist composition of the same year, which is still inspired by the *Pier and Ocean* theme of 1915.

But the cubist adventure of Malevich [155] and Mondrian [154] not only smoothed the way to abstraction; it was also the basis for the exclusive use of a strictly geometrical formal language. In Malevich's work the transition from a conventional use of language to this new geometrical language occurred somewhat more slowly and gradually. His first cubist works translate the forms of things rather in the manner of Fernand Léger, in a system of interpenetrating cones and cylinders. Later, he employs a construction in the picture plane, making greater use of flat surfaces. In all this work Cézanne's proposition is still recognizable: 'To relate nature to the cylinder, the sphere, the cone, putting everything into perspective.' With Mondrian the transition to cubism took place suddenly, under the overwhelming impression of the work of Picasso and Braque at an exhibition in Amsterdam in the autumn of 1911, and he carried this new conviction to its logical conclusion by at once moving to Paris to learn the new lan-

guage. In the short period from the beginning of 1912 to the summer of 1914, when he returned to the Netherlands, we accordingly see a marked simplification of his formal language. He begins, gradually, to eliminate curves and even diagonals in order to arrive at a disciplined scheme of horizontal and vertical lines, which will reach a climax in his paintings of the years 1915 to 1917.

Not until 1917 – that is, after the series of paintings in which Mondrian carried cubism far beyond its original frontiers – was there formed, through the meeting and co-operation of Theo van Doesburg [156], Piet Mondrian, Bart van der Leck [157] and Vilmos Huszár, the De Stijl group. The collective oeuvre of this group, produced the first series of works which link as a matter of principle the language of geometrical form with that of abstraction. Mondrian's monumental works from 1914 to 1917 are all still based on a theme – generally that of *Pier and Ocean* – so that they still recognizably belong, through their strict centripetal composition and the clear predominance of form over colour, to cubism, although they have moved so far from the starting-point, from the actual object which inspired the composition, that many critics are inclined to date the beginning of geometrical abstraction from these works. Nevertheless, this proposition cannot be maintained, for it is only with the appearance of colour and centrifugal composition, in the work of Mondrian, Van Doesburg and Van der Leck, that abstraction and geometrical language appear.

In his first article in the periodical *De Stijl*, which is a kind of declaration of principles, Mondrian [S. 39] comments upon this change. In short and pregnant sentences he not only characterizes the origin of geometrical abstraction – at least in the Netherlands – but also describes the language to which *De Stijl* intentionally limited itself, and makes clear the aims of this new art. The vocabulary which the masters of De Stijl, each in his own way, had succeeded in mastering, through an increasingly radical shift away from the object, is in fact the elements of the pictorial language itself. These elements are: the straight line in perpendicular opposition – i.e. the horizontal and the vertical – to which are added the three primary colours – red, yellow and blue – supplemented by the triad of the primary non-colours, white, grey

and black. With this extremely limited arsenal, the masters of De Stijl set out to achieve something which was for them the aim and task of all painting: something which can only now, in the twentieth century, be expressed with adequate means. This was to make universal harmony visible, and to place clearly before the eyes of the spectator the laws governing man and nature. A representation, any actual object, can only confuse this bold aim. Only abstraction, only limitation to the elements of painting, can realize it completely. Thus the masters of De Stijl were searching for the laws which stood in the same relationship to the rich and varied forms of visible reality as did the theme to its musical variations. And this theme could be found only in the elements of the pictorial language itself, which acted at the same time as a brake to any development of the artist's individual feeling. Since it was a question here of a cosmic, universal problem, the artist's subjectivism, his individual approach, was of no worth.

Thus the various volumes of *De Stijl* reflect the ideas of the artists about their work, and the aims which they had in view. In the work of Mondrian and Van Doesburg, and also in that of Van der Leck, at least up to a certain point in his development, the growth of this geometrical abstraction can be clearly traced. The first works in this manner – the compositions in line and colour of 1917 – still have difficulty in freeing themselves from the cubist composition scheme. The compositions with colour planes which follow are the first true realization of a new and sovereign idea: that of the balancing of colour planes of differing specific gravity. And then appears, in 1918, the first work that lays the foundation for the imminent development of neoplasticism. In this, Mondrian links the framework of straight lines with the colour planes by continuing the sections of line until they cross. In this way he not only creates a unity of line and colour, but also succeeds in making the colour planes and the white background – which is now no longer background, but a part of the actual picture plane – into a continuous whole. And in these years it is not only Mondrian who practises these experiments with a new language. Van Doesburg and Van der Leck join with him in close association,

so that it is sometimes as difficult, even for the expert, to distinguish between works of Mondrian and Van Doesburg dating from 1918, as with Braque and Picasso in 1911 or 1912.

Certainly, the principle of mathematics forms a point of departure in these works. The elements with which the De Stijl masters worked were mathematically determined. The straight line, the right angle and the three primary colours (i.e. the angles of an equilateral triangle inscribed in the colour circle) were the whole of their vocabulary. But not until 1919 did they first apply the mathematical method in their work. Mondrian's 'chessboard' paintings [154], and the diamond-shaped canvases of the same year, have as their basis the modular division of the picture plane, and only the grouping of the colours (in the case of the chessboard paintings) and the strong, dark grey lines (in the diamond-shaped canvases) show a deviation from this mathematical scheme. It is a deviation, however, that is based upon the scheme itself and interacts with it. Just as in music – and here we encounter again the other pole of Flaubert's prophecy – measure and rhythm act in mutual opposition, so here there is a mathematical framework against which the various deviations clearly and palpably emerge. And this preference for a mathematical approach to painting is almost a necessity, if one regards the visual arts as did the masters of De Stijl: as an expression of a view of the world, of laws, which must be harmonious and therefore also articulated in measurable relationships. It is here, in the concept of harmony, that the principles of mathematics and music meet.

Here, then, in a single sentence, is the principle of geometrical abstraction: the artist leaves behind him capricious Nature, and the arbitrary visual forms of creation, and penetrates to the very core of that creation, which – in the conception of Antiquity as in that of twentieth-century physics – is constructed on a mathematical basis, and becomes visible in the richness of the world of forms only in a veiled and clouded way. In order to penetrate to the structure and essence of reality, the artist must look beyond the appearances of reality in order to discover lasting reality, the true distinctions and relationships. And these relationships can be described only in terms of dimensions, numbers and weights, so that they belong to the

realm of mathematics. In the earlier volumes of *De Stijl* there are two quotations which very clearly define this mathematical approach to a view of the world: the first from St Augustine, *Number is everything in art* (*De Stijl*, III, p. 25 *bis*), the second, still more explicit, from Proverbs, *Omnia in mesura et numere et pondere disposuisti* (*De Stijl*, IV, p. 89).

It is characteristic of De Stijl's view of the world that it sought the basis of creation in the harmony of relationships, the interplay of numbers and dimensions. In the early years of the group Mondrian was the pioneer of this principle, and from his experiments Georges Vantongerloo developed his abstract sculptures [158], just as the architects of the group were also inspired by this principle. Later, after the realization of his revised principles in architecture, especially in the interior decoration of the Aubette in Strasbourg (1928), Theo van Doesburg consciously applied the principle of the mathematical method in his last paintings. His *Arithmetical Composition*, in which squares diminish in size from bottom right to top left according to the law of mathematical progression, is a proof of the significance which the leader of the De Stijl group still attached to mathematics, to the principles of dimension and number in his final period.

It was Van Doesburg, moreover, who, through his influence and activity, spread geometrical abstraction, first in Europe and later beyond. The first phase of this expansion was at the beginning of the 1920s, when he brought about a revolution in the ideas and programme of the Bauhaus. This institution, which was founded in 1919 as a modern version of the medieval craftsmen's guild and had as its aim a collective unity of artistic creation (*Gesamtkunstwerk*), manifestly fell at the beginning of the 1920s under the spell of Theo van Doesburg's personality, and his strict, clearly formulated principles. He was the central figure around whom the progressive young artists in Germany grouped themselves, those who saw in abstraction the most adequate expression of a modern view of the world.

Another influential figure was El Lissitzky [160], who had been formed in the school of the Russian avant-garde, and whose abstractions – which he called Prouns – in no way denied their derivation from Malevich and his Suprematism. But in those years the art of the Russian avant-garde had come into contact with geometrical design in another way. The young sculptors Pevsner and Gabo [170] had made the system of geometrical forms the basis of their works, which took as a point of departure new materials and structures, and approached the frontiers of abstraction through the principle of their construction, which was technical and structural in character and did not follow organic laws. Lissitzky's work owes to these innovations the strongly constructive approach of its formal language, while he remains linked with the work of Malevich through the feeling of weightlessness, of immaterial lightness, that always characterizes his geometrical constructions. Lissitzky joined De Stijl during the years when the influence of Theo van Doesburg had brought about a reorientation of the Bauhaus. From 1922, the purity of the De Stijl principles, their immanent puritanism, began to exert an influence, through the Bauhaus, over Germany.

Two artists, in particular, fell deeply under the influence of these principles in 1924. The first of these was Friedrich Vordemberge-Gildewart [161], born in Osnabrück, who came into contact with Van Doesburg through Kurt Schwitters, and subsequently not only worked in a consistently abstract manner (which he had done since the beginning of his career), but also developed geometrical abstraction, the strict discipline and limitation of vocabulary, in his own way. His compositions with lines and colour planes do not share the grave bearing of Mondrian's and Van Doesburg's works, in which the broad black lines and the strong colour planes together form simple, majestic chords, comparable with the splendid sounds of the old Dutch psalm melodies. By contrast, his canvases have a great subtlety; they become a field of tension in which thin, taut lines and bright colours engage in a lively interplay. In comparison with the powerful fugues of the Dutch masters, his canvases often appear as *divertimenti*, as light and entertaining chamber music, for they are indeed constructed according to the same kind of laws, the same strict harmonic theory. It is the 'mobility' of these works which makes them important for the future.

The other figure who was drawn into the De Stijl group at that time was the Dutchman Cesar

Domela Nieuwenhuis [159], then living in Berlin. His early work, done in Switzerland, was completely dominated by geometrical principles, although these were then still applied to objects from observable reality. But soon after his contact with Van Doesburg and Mondrian he abandoned these representational elements and based his work entirely on the geometrical language developed by the masters of De Stijl. Domela at first followed in the footsteps of the older masters, but quite soon he added a new element, which would in its turn be important for the future – the third dimension and the quality of new materials. His relief constructions, in which sheets of perspex, metal strips, and sometimes punched tin, contrast with each other in different planes, introduced a new element into the domain of geometrical abstraction, i.e. actual space, the contrast of mass and void – something which is perhaps comparable with the opposition of primary colour to primary non-colour, as employed by the masters of De Stijl, or with the contrast of sound and silence in music.

Domela's enrichment of geometrical abstraction was another facet that was to reveal its full potentialities only in later years. Numerous spatial constructions, built up on a plane parallel to the wall, such as the reliefs of Joost Baljeu, with their strong rhythmical suggestions, derive from these first experiments of Domela's. At the same time, through the exploitation of the contrast of materials, he added something else to this form of art that would be comparable to the timbre, the sound colour, of musical instruments. Just as the sound of the clarinet combines in a unique way with the cello, so was Domela able to contrast and bring into relationship the surface of perspex with the structure of various kinds of wood.

Geometrical abstraction, principally inspired by Van Doesburg, was to have its centre of diffusion in the Bauhaus. Certainly, the importance of this diffusion hardly appeared at the time; it became apparent only later – long after the closing of the Bauhaus by Hitler's lackeys. Numerous young artists from the Bauhaus circle – among them Werner Graeff, Peter Roehl, Ladislas Kassák – looked up with admiration to Theo van Doesburg and honoured him as their master. Austerity and increasing dominance of geometrical forms are also found in the work of Kandinsky, the great pioneer of abstract painting. This austerity reached a climax in about 1927 [162], when the canvases were constructed almost entirely of geometrical elements – circles, circle segments, triangles, rectangles, squares, etc. It is likely that this austerity derives from the strict grammatical analysis of painting that Kandinsky undertook and recorded during those years in his book *Von Punkt zu Linie und Fläche*. But this search for the grammar of painting only became possible through the emphasis that the masters of De Stijl had placed upon syntax, upon the correspondence of painting with a structurally constructed language. And it was precisely in his investigation during those years that Kandinsky attempted to analyse the elements of this language for their objective value, to determine their specific gravity and also their interrelationships. In those years – even more than in the period from 1910 to 1912, when he wrote his book *Uber das Geistige in der Kunst* – Kandinsky was seeking to propound a harmonic theory, a 'figured bass' for painting.

The other important artist who was already much influenced by the new trend was Josef Albers [S. 42]. In 1923 he became an instructor at the Bauhaus, and already at this early date – he was then thirty-five years old – he was one of the most consistent champions of the strict geometrical language, which excludes any representational allusion. His later work, especially after the closing of the Bauhaus, is almost exclusively devoted to the theme of the square [165]. This concentration on a single theme enables the wealth of possibilities of geometrical abstraction to be revealed, and Albers shows a tremendous subtlety not only in respect of the relationships of the squares, which he sometimes places concentrically one inside the other, sometimes with a slight divergence, but also in respect of the colour nuances and colour contrasts with which he sets off one square against another. In the clarity and simplicity of Albers's design and coloration there is contained a large part of the development which has occurred in recent years, and which leads from geometrical abstraction to recent developments, such as Hard Edge. Albers is one of the most important links in this chain, whose existence needs to be emphasized, particularly at the present time, where such new

tendencies are often presented as completely new inventions without any prehistory.

The Bauhaus was certainly one of the most important centres where geometrical abstraction was developed, but there were also other sources which ran parallel with the inspiration of De Stijl and were partly related to it. They were also descended in part from cubism, and in part inspired by Dada, the group formed in Zurich in 1916, which was again connected with Theo van Doesburg's De Stijl by the fact that Hans Arp and Hans Richter, who both belonged to the original circle of Dada, were also members of De Stijl. Moreover, Van Doesburg's close friendship with Kurt Schwitters – the leader of Dada in Hanover – formed another link in the chain.

The early works of Hans Arp – who was, in fact, a member of De Stijl only as a poet – and those of his wife, Sophie Taeuber-Arp [163], show clearly the characteristics of geometrical abstraction. In a certain sense, these works also derive from a tradition which began with cubism, for the large geometrical rectangles, placed beside each other, are also reminiscent of the collage technique in which a few early examples were executed. The effect of others is based upon a surprising application of textile techniques; but in neither case are the works so created purely decorative or simply a pleasing arrangement of the surface. On the contrary: here, too, an artist has tried to combine the simple elements of the pictorial language into an emotional communication, which rises above the fortuitous and capricious subjectivity of the individual to the level of that general validity which the masters of De Stijl denoted with the word 'universal'. And only later, especially after 1930, did Arp, with his completely three-dimensional sculptures, find a similar universality through organic, non-geometrical forms, so that his work from that time turned in another direction, that of a warm and flowing sensuality, instead of the quiet and sometimes dream-like order which he had achieved in his early works.

Order – that is what characterizes those masters of geometrical abstraction who, in one way or another, are descended from cubism. Auguste Herbin [169, S. 43] is one of the most powerful and consistent figures among them. He was trained in the cubist discipline, and he had dis-

covered the intensity of colour in a still-earlier Fauve phase; he let both these experiences gradually come to fruition. In his early work abstract periods alternate with representational ones until, in 1927, he finally decided in favour of abstraction, an abstraction based increasingly on a strictly geometrical formal language. Herbin's paintings are also connected with cubism, through their rejection of any spatial illusion, any effect of depth. If, nevertheless, a feeling of space is generated by these canvases, it is the result of the suggestivity of the colours which evoke through their contrasts tensions and harmonies, a feeling that cannot remain limited to the picture plane, but radiates from it. It is a feeling which – so to speak – surrounds and overwhelms the spectator in the same way as a particular kind of music: music which is constructed on a strong mathematical basis – like the *Art of Fugue*, or the *Well-Tempered Clavier*.

It was in about the same year, 1926, that the work of one of the great masters of cubism, Fernand Léger [167], began to fall within the definition of geometrical abstraction. Although it was for only a relatively short period, the change was nevertheless decisive. Certainly, for many years, since his first cubist works, his paintings had given evidence of a strong feeling for geometrical forms, because he was conscious of the predominance of geometry in our contemporary environment. He realized that this drive towards geometrical structure must also leave its impression on the fine arts if they were to be an adequate expression of contemporary man. Although he knew that abstraction could not always determine his own work [S. 44] he could nevertheless see that its coming was unavoidable.

Fernand Léger was certainly not the only artist in those years who, from a feeling of inner necessity and artistic purity, sought in geometrical abstraction the way back to the origins of pictorial language. And it was always the same considerations that compelled artists to take this step: the realization of the importance of the flat surface, the attempt to co-operate with architecture, the elementary value of colour. Thus in geometrical abstraction in the mid-1920s everywhere there was a strong tendency towards mural painting. Besides Léger's works, there were the tightly confined mural compositions of Willi Baumeister

[166] (although these were sometimes only small paintings on a prepared, wall-like ground), and the powerful canvases of the Belgians Victor Servranckx [168], Jozef Peeters and Karel Maes, whose technical inspiration and metallic clarity were in marked contrast to the Flemish expressionism of the same period. The mid-1920s were, in fact, strongly influenced by the machine aesthetic, the idea that the machine can produce a perfection of which no human hand is capable – and that, in this way, it can help man to arrive at a purer concept of reality and its laws.

The great champion and pioneer of this view of the world and society was Laszlo Moholy-Nagy [263], who, from 1922 to 1928, contributed greatly to the reorientation of the Bauhaus by his insistence upon the kinship of the artist with the explorer, researcher and inventor. The art of those years tried to realize an interpenetration of art and science that would lead to an integration of the polarity of the human approach to reality.

All this optimism, this attempt to create a better world, taking as its example the harmony realized in art, was brought to nothing in the early 1930s by the rise of Nazism in Germany. The utopian character that was so clearly implicit in the philosophy of De Stijl, and in Malevich's Suprematism, proved to be farther from reality than the artists had hoped, and the realization of their dream of the future seemed to be possible only in a later phase of humanity. The Bauhaus, which was at that time perhaps the strongest centre of the new philosophy, was closed as one of the first acts of the Nazis when they came to power, and then began – as a remarkable irony of fate – the spread of the ideas of this group all over the world, but especially to Britain and the United States. Numerous artists who had worked in Germany, and not only Germans, settled elsewhere, especially in America, where they introduced the principles and grammar of geometrical abstraction.

Nevertheless, Paris remained the centre of the movement during the 1930s. The two groups which were formed at that time – Cercle et Carré, led by Michel Seuphor, and Abstraction-Création, where a large number of artists discovered each other – both had a defensive, polemical character and were conscious that they were fighting for more than aesthetic ideals. Although the groups were not bound by a common political ideology – on the contrary, they were a meeting place for the most extreme political opposites – they were linked by a common philosophy, by a vision of the future of man and society and the role to be played in it by art. There was general agreement that the visual arts should not express the chance, individual aspects of life, but should interpret the universal currents of humanity, those which were not limited by arbitrary circumstances. Theo van Doesburg formulated this conviction – which ran so directly counter to the new nationalism and the idolization of blood and soil – in his *Manifeste de l'art concret*.

Artists from many countries participated in the creation of this concrete art, of which geometrical abstraction constituted not the whole, but certainly a predominant part. Kandinsky and Pevsner were from Russia, Moholy from Hungary, Van Doesburg, Domela and Mondrian from the Netherlands, Otto Freundlich [164] and Vordemberge-Gildewart from Germany, Henryk Stazewski and Ladislas Strzeminski from Poland; while France itself was represented by numerous artists, among them Herbin and Arp.

The British element seemed to be hardly represented in this international concert. It was Naum Gabo who took the ideas of Abstraction-Création to England. In 1937, he published, together with Leslie Martin and Ben Nicholson [171, S. 46], the review *Circle, International Survey of Constructive Art*, which contained contributions by Mondrian, among others. At that time the painter Ben Nicholson and the sculptress Barbara Hepworth were beginning to break away from an art that was still tied to observation, and to create works which took as a starting-point only the vocabulary defined by Van Doesburg in his manifesto of concrete art. The arrival in England of Mondrian – who left Paris in 1938 immediately after the Munich crisis and was hospitably received by the *Circle* group – strengthened this influence on British artists. Only from this time is it really possible to speak of abstract art in England in the sense that it was understood on the Continent.

The same thing happened, two years later, in the United States. There, too, one could hardly speak of an abstract art until about 1940, and certainly not of geometrical abstraction. In the years after

1940 New York became the same kind of refuge for persecuted artists that Paris had been in the years after 1933, following the Nazi seizure of power in Germany.

Mondrian arrived there in 1940, driven from London by the German bombers whose arrival above Paris he had foreseen in 1938. And it is thrilling to see how the contact with the modern metropolis *par excellence* renewed and rejuvenated his work. From the very beginning of De Stijl the metropolis had been a source of inspiration for these painters. It was precisely the triumph of human order over the vagaries of nature which so excited them in the image of the city. Initially, however, the masters of De Stijl still regarded the city as an architectural order; an example is Mondrian's painting *Place de la Concorde*, begun in 1938 and completed in 1943. But after his contact with New York, Mondrian became aware of the dynamic rhythm in this order, which now becomes pulsating and full of movement, but no less obedient to laws and no less geometrical.

Broadway Boogie Woogie – the painting that links the idea of modern, geometrical architecture with a dance and, so also, with the idea of music and movement – was, for all who knew and revered Mondrian's art, a surprise and a revelation. For, in this painting, the harmony which Mondrian and his friends had always sought is not only present, but is achieved through the process of looking. The spectator's experience here is not a fact, but an event. And in his *Victory Boogie Woogie* [174] – the painting which expressed the victory over tyranny, and which remained unfinished at Mondrian's death in 1944 – the colour planes jump about in a staccato rhythm, which prefigures a new and lighter world and, at the same time, proclaims a new potential for painting.

In Mondrian's last works, as in Robert Delaunay's *Rhythms without End* of 1934 [153], the foundation was laid for the development of geometrical abstraction after the Second World War, both in Europe and America. For the element of movement, which – through developments in daily life and the way of looking at the world – came to receive increasing emphasis, already dominates these paintings. Delaunay's painting, through its strong colours, acquires a particular impetus; it is in fact pure rhythm, pure motion. Similarly,

Plates 169-188

169 AUGUSTE HERBIN. *Being Born*, 1958. Oil on canvas, 100 × 81 cm. Private collection, Brussels.

170 NAUM GABO. *Linear construction*. Nylon threads and plastic, 91 × 52 × 49 cm. Stedelijk Museum, Amsterdam.

171 BEN NICHOLSON. *Painting*, 1938. Oil on canvas, 70 × 90 cm. Private collection.

172 FRITZ GLARNER. *Relational Painting, Tondo No. 20*, 1951/54. Oil on masonite. Private collection.

173 JEAN GORIN. *Composition No. 4 with Recessed Line*. 1931. Oil on wood, 67 × 67 cm. Private collection.

174 PIET MONDRIAN. *Victory Boogie Woogie*, 1943-44. Oil and collage on canvas, 126 × 126 cm. Collection Mr and Mrs Burton Tremaine, Meriden, Conn.

175 RICHARD MORTENSEN. *South East*, 1956. Oil on canvas, 162 × 130 cm. Galerie Denise René, Paris.

176 OLLE BAERTLING. *Composition*, 1955. Galerie Denise René, Paris. Photo Lennart Olson, Enskede.

177 JEAN DEWASNE. *The Little Trophy*, 1952. Oil on canvas, 75 × 31 cm. Private collection.

178 GASTON BERTRAND. *Florence*, 1956. Oil on canvas, 65 × 81 cm. Musées Communaux de Verviers.

179 JO DELAHAUT. *Pomegranate*, 1952. Oil on canvas, 196 × 152 cm. Private collection.

180 LUC PEIRE. *Graphie XXXXV*, 1965. Oil on canvas, 58 × 185 cm. Property of the artist.

181 VICTOR PASMORE. *Relief Construction in Black and White*, 1945-55. Oil on wood and perspex, 132 × 68.5 cm. Marlborough Fine Art Ltd., London.

182 BERTO LARDERA. *Between Two Worlds No. III*, 1959-60. Iron and steel, height 3.50 metres. Lurup estate, Hamburg.

183 ROBERT JACOBSEN. *Problem of Movement*, 1954. Iron, 38 × 50 × 25 cm. Louisiana, Humlebaek, Denmark. Photo Schnakenburg, Copenhagen.

184 ANDRÉ VOLTEN. *Project for the Utrecht Fair*, 1962. Marble. Stedelijk Museum, Amsterdam.

185 MORICE LIPSI. *Horizontal Sculpture II*, 1956. Stone, 34 × 60 × 22 cm. Property of the Artist. Photo Y. Hervochon, Paris.

186 RICHARD LIPPOLD. *Primordial figure*, 1947. Brass and copper wire, height 247 cm. Whitney Museum of American Art, New York.

187 TOMÁS MALDONADO. *U–I–54*, 1954. Oil on canvas, 100 × 100 cm. Property of the artist.

188 RICHARD P. LOHSE. *Progression of Six Identical Groups*, 1952/65. Oil on canvas, 120 × 120 cm. Galerie Denise René, Paris. Photo Roelli, Zurich.

169 Auguste Herbin

170 Naum Gabo

171 Ben Nicholson

172 Fritz Glarner

173 Jean Gorin

174 Piet Mondrian

184

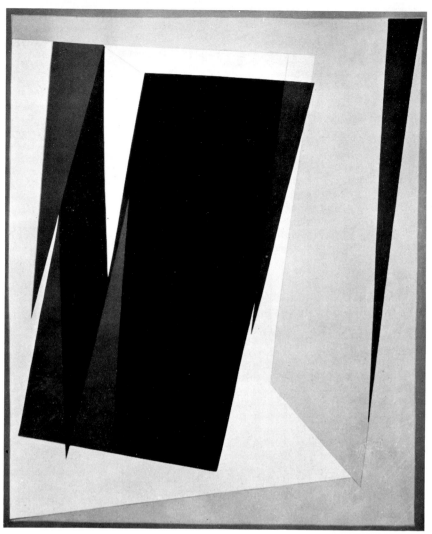

175 Richard Mortensen

176 Olle Baertling

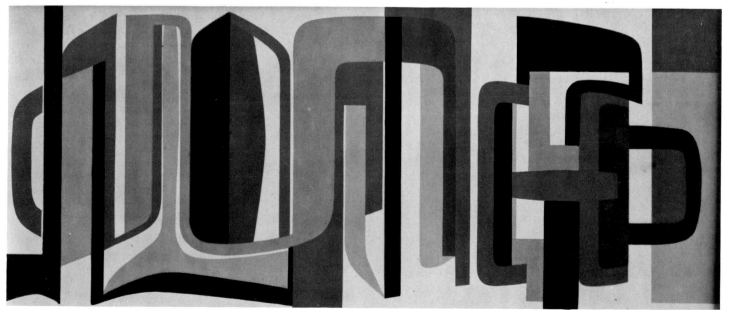

177 Jean Dewasne

178 Gaston Bertrand

179 Jo Delahaut

180 Luc Peire

181 Victor Pasmore

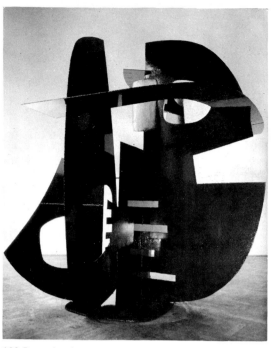

182 Berto Lardera

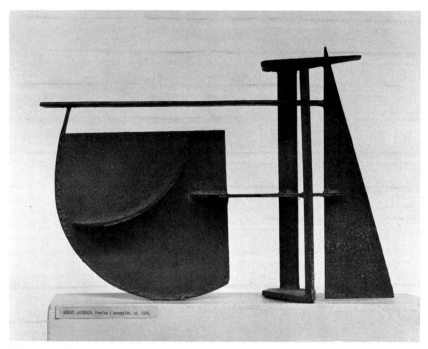

183 Robert Jacobsen

186 Richard Lippold

184 André Volten

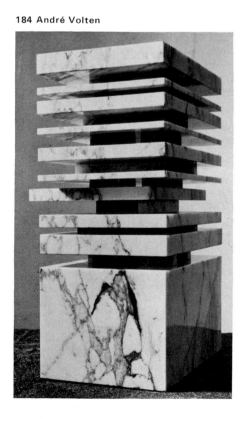

185 Morice Lipsi

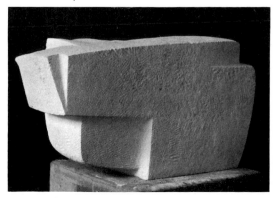

187 Tomas Maldonado

188 Richard P. Lohse

188

Mondrian's late canvases no longer set off a system of black lines against a series of coloured planes, but let the colour carry the line; they are consciously inspired by the dance rhythm of contemporary popular music. It is indeed these works that fulfil Flaubert's prophecy that art will hold the mean between mathematics and music.

Mondrian's work, like that of the other masters of De Stijl, is to a high degree utopian in character. His canvases, in which harmony becomes visible through the mutual abolition of contrasts, might serve as an model for the abolition of tragedy and show humanity the way to a lighter and better future. Robert Delaunay's paintings, too, like those of Le Corbusier, Léger and many kindred spirits, are overflowing with optimism, with confidence in the light that will break through the darkness and illumine the world. This light will be first and foremost human reason, which has the power to penetrate to the harmony of creation, to the laws which govern the whole organization of the world and of humanity itself. Mondrian's *Victory Boogie Woogie* [174], which was painted over a year before the defeat of Nazism, is a clear example of this utopian attitude of mind.

After 1945, a climate seemed to have been created in which the new art could flourish. Man would be able to build out of the chaos a new and meaningful world, to realize the ideas conceived previously, and to create a paradise on earth. It was especially the artists inspired by Mondrian who took this feeling as their starting-point. They included Fritz Glarner [172] who tried to capture precisely the harmony of Mondrian's rectangular canvases in that other perfect form, the circle; Jean Gorin [173], who made a similar attempt, and succeeded in including space as well; Charmion van Weigand, who had been a pupil of Mondrian himself in New York; Marlow Moss, who wanted to re-create the austerity of Mondrian's works in ascetic, almost colourless reliefs, or in contrasts of planes against another material indicating the line; and many other artists, including the American, Burgoyne Diller, and several South Americans and Italians. It seemed a language had been found that knew no frontiers and could interpret the twentieth-century spirit, with its clarity and scientific method. This was also the spirit of the Bauhaus – and among the old masters of this source of

the new art, Josef Albers [165; S. 42] consciously took up the thread again in the United States and, in his series *Homage to the Square*, left a brilliant monument to a way of thought and feeling that should serve as an example for the future.

It seemed Paris would become the centre of geometrical abstraction again. The Galerie Denise René, established in 1945 with the help of a group of artists, was its focus. Léon Degand, critic, philosopher and idealist, its passionate and sharp-witted defender, and the Salon des Réalités Nouvelles its annual forum. Artists from many countries took part in this constructive activity – the Dane Richard Mortensen [175], who had only a short time previously played an important part in the turbulent Danish expressionist movement, adapted himself to the strict discipline of the geometrical language without losing any of his vitality. Olle Baertling [176, S. 48] came from Sweden to strengthen the group. Michel Seuphor, known hitherto principally as a poet and essayist, developed his talent for the plastic arts. Other founder members included Vasarely and Jean Dewasne [177, S. 47]. In the years after the Liberation a persuasive power radiated from this centre, which went far beyond the frontiers of France. In Belgium, Gaston Bertrand [178], Jo Delahaut [179] and Luc Peire [180] were gripped by it, as was in England, no less a figure than Victor Pasmore [181].

Sculptors were involved as well. The Italian, Berto Lardera [182], worked in Paris and created from the combination of flat, geometrical metal shapes a new, open sculpture, in which space was formed during the contemplative process. In Switzerland, Ansbacher created large sculptures from stone surfaces carved stereometrically to reveal the laws of the underlying forces. The Dane Robert Jacobsen [183] followed in his sculpture a similar path to that taken by Mortensen in painting. His austere metal structures derive their form from economy, from omission. Morice Lipsi [185] who placed the accent on volumes, on the fulness of geometrical surfaces; while in America, Naum Gabo, one of the old masters of geometrical abstraction, together with Richard Lippold [186], dissolved forms in a transparent play of lines of force, which themselves express the laws of form. In the Netherlands, André Volten [184] developed

an art of great purity and austerity from the rhythmical combination of identical elements.

There were also women working in the group. Among them were the Frenchwoman, Marcelle Cahn, who made subtle reliefs, Gisela Andersen, who achieved a high degree of musicality in the variation of colour planes, Mary Vieira, who constructed her disciplined and supple sculptures from standardized but mobile elements, and the Dutchwoman, Sedje Hemon, who began as a musician and has begun to translate her visual works back into music.

But the times were not favourable to this clear and disciplined way of thought. In place of the order which most of these artists had visualized, instead of paradise, there reappeared chaos, menace, tragedy. And the immediate consequence for the visual arts was – as it had been after 1815 – the rise of a wave of romanticism, a spring-tide of subjectivism and unchained passion which submerged everything.

Very few artists held their ground and continued to believe in the power of an objective, supra-individual principle. Chief among these was the group of artists, reared in the spirit of the Bauhaus, who, from about 1949, worked for a continuation of the Bauhaus world in the plans for the Hochschule für Gestaltung in Ulm. Max Bill [209, 210, S. 49] was their spiritual leader; Friedrich Vordemberge-Gildewart was soon associated with them; and the Argentine painter Tomás Maldonado [187] worked in the same spirit. In nearby Switzerland, Richard P. Lohse [188, S. 50] consistently pursued the realization of the constructivist ideas which had been accepted in the past. And what was it that all these artists had taken as their guiding principle and had brought them again, across national frontiers, into agreement with artists like Vasarely and Nicolas Schöffer in Paris, who were posing similar questions?

In 1949, Max Bill formulated this problem in a paper called *La Pensée mathématique est l'art de notre temps*. It seems to me that in referring to 'mathematical *thought*' he put the accent in exactly the right place. For today, in this form of art which has since developed in so passionate a manner, it is not a question of the use of mathematical forms, but of a mathematical method.

Bill visualized this method in such sculpture as *Endless Ribbon* and in paintings like *Field with Eight Groups* [209], where the colour values are distributed on a single plane according to a serial motif, resulting in a strict order deriving from an idea. Lohse worked in a similar manner, as in his *Progression of Six Identical Groups* [188]. The same serial principle, based on a theme and its modification, is found in Vasarely's work, as well as in Schöffer's light sculptures. It is with the aid of this principle that modern man orders and dominates reality, in science, technology, the conquest of space and nature. In the work of these artists, this mode of thought has become susceptible to emotional experience; for giving these principles visible form has transferred them from the sphere of abstract thought to the domain of sensual experience.

These works remained for many years inaccessible and unrecognized. No one looked at them. All the critics had such terms as 'cerebral' or 'rational' to hand as a counter and a condemnation. And yet these were the forerunners of an art which is now beginning to make headway to find so much response (not least in its applications in everyday life), because it is in many respects in sympathy with the spirit of today. It is, therefore, perhaps not so great a coincidence that these works began to find a wider response in 1962, the year of the Cuba crisis, when reason was again allowed to triumph over the emotional and affective approach to events.

The scarlet thread which runs through the history I have tried to summarize here is not the use of geometrical forms, nor simply the absence of a reference to a piece of observed reality. What this art does render visible and observable however, is a way of regarding, ordering and understanding the world and so of controlling it. It expresses the need for objectivity, and for transmissibility; a discovery can no longer be allowed to be dependent upon the chance situation of the discoverer. It is, to put it in very old words, the need for validity and durability which led Spinoza to write his *Ethica more geometrico demonstrata*, and whose truth is demonstrated by an identical principle in the visual arts, and hence the philosophy, of our age.

Vasarely: the Artist within Contemporary Life

FRANCINE C. LEGRAND

The development of modern art leads us to consider a work of art from two aspects: first, the stages in the progress of its creation, its origin and direction, all of which enable us to see the work as it is woven through the fabric of its time; then, the work of art as an island, isolated from all except the observer. Its presence becomes perceptible as a vibration at the heart of immobility and silence. A great work of art must satisfy us in both these areas.

Vasarely [189-202, S. 51] is generally called the inventor of Op art. Aside from the fact that any statement of this kind immediately arouses arguments about priority, the phenomenon of crystallization is unquestionably more important for artistic evolution than that of invention as such. In any case, if Vasarely were merely the inventor of Op art, he would, in my opinion, be of little interest. His fundamental contribution resides in the fact that he has rethought the problems of plastic creation in terms of the future as he conceives it, and by so doing, he accepts the risks of exhausting his powers in the service of what may prove to be an illusion. Vasarely has rejected certain outdated notions in an effort to impose an ensemble of diverse relationships – between the work of art and the public, and the work of art and the artist. Standing confidently upon the threshold of a new era, Vasarely prefers to devote himself to experiments with a new, widely diffused language, rather than confine himself to the secure production of paintings of rarified appeal for the exclusive consumption of a few aesthetes. He is involved in demonstrating that art must be conceived as integral to the community. In place of respect for the unique creation, an object of pleasure and a symbol of privilege, Vasarely is concerned with a quality inherent in the conception of a work of art, a quality residing at that level where 'a flash of joyous certainty' is transferred to a combination of forms and colours which cannot be lost when the object is reproduced, which continues to characterize the work whatever the scale and material, and is indeed intensified through certain controlled techniques of diffusion. In place of the solitary genius of Romantic art, or of the artist as 'star' promoted by publicity, Vasarely would substitute a team of explorers with close links to contemporary life, equipped with all its resources, in active collaboration with researchers in other disciplines.

Vasarely is clearly not the first to have chosen this direction. He has joined the company of those pioneers whom he frequently invokes: Kandinsky, Malevich, Mondrian. Benefiting from the experiments of certain precursors has enabled him to extend his field of investigation and to affirm his moral role. Vasarely's oeuvre reflects the image of a coherent progression whose creative phases are ordered in terms of an inexorable evolution, worked out in the artist's mind long in advance, rather than resulting from groping, random efforts.

If, however, one of the major characteristics of Vasarely's personality is will, the other is imagination, which gives his work its impressive warmth, its rich diversity – an imagination which makes his art a reservoir of forms, ideas and dreams.

FORMATION OF THE ARTIST

In 1928-29 Vasarely studied in Budapest with Alexander Bortnyik, whose teaching was strongly influenced by the Bauhaus. His theories rejected the hierarchy of values which subordinated the applied

to the liberal arts, and, beginning with the problem of organized production, attempted to bridge the gap between art and technique. Bortnyik's teachings extolled a modern concept of beauty, in a ringing affirmation of function as a condition of harmony. This programme, at once more theoretical and more concrete than that of traditional art schools, gave Vasarely an early awareness of his own abilities.

Bortnyik later summed up his method of plastic composition: 'Our point of departure was the square as schema, which we then subdivided into varying planes or surfaces. The essential thing is that the form should always create an impression of planes, not of volumes.... The object of all exercises is to train the eye to perceive equilibrium and harmonies of variable rhythms.[1] His colour theories were based upon those of Oswald, who, by adding green to the three primary colours, had four basic colours and eight principal ones[2] upon which black and white acted as intensity factors. The colour spectrum contained twenty-four divisions: the eight pure colours, and these same colours with the addition of black and white. The amount of black may be increased in geometric progression, giving an exact scale of decreasing values.

Moholy-Nagy, another Hungarian artist and teacher, strongly influenced the circle around Bortnyik. According to Vasarely, it was during the winter of 1928 or spring of 1929 that Moholy-Nagy gave a series of lectures in Budapest. From 1921 on, Moholy had been involved with rearch into the properties of transparence and refraction, utilizing transparent screens of different shapes, placed one behind another. In 1922, to demonstrate his stand against the art object as unique example, Moholy ordered by telephone five paintings on enamelled porcelain, to be executed according to a pre-established grid.[3]

At the time, it seemed as though Vasarely's natural virtuosity was its own defence against the rigour of his training. The spirit of the Bauhaus, however, was to triumph at a later date. The Bauhaus exercises in the analysis of textures – probably done in Budapest as well as Dessau – must have confirmed a brilliant, even intoxicating facility for trompe-l'œil rendering. Nor did Vasarely in any way dilute the ambiguity, the meta-physical play, characteristic of trompe-l'œil – even at the risk of appearing suspect in a milieu devoted to functionalism and favouring economy of means.

THE GRAPHIC PERIOD

Before joining the Bauhaus, Vasarely had worked in advertising. In 1930, when he moved to Paris, it was in this field of work that he planned to make a career. Painting seemed to him a bourgeois form of expression, with no future.

For the next ten years, with the object of preparing a training course, he became engrossed in countless experiments, establishing a systematic repertory of the resources offered by graphic art, forcing himself to persevere with the dual tasks of analysis and synthesis. From these experiments, Vasarely was later to draw his own plastic language.

Around 1935, two motifs appear in Vasarely's work which he was to continue to favour for many years; stripes and chequer patterns. His zebras and tigers placed head to foot are, sometimes, studies in movement, at other times, studies in lines of variable thickness, or again, studies of wavy lines and displaced parallels. These studies may contain unconscious references to the art of the Steppes, although, according to Vasarely, their inspiration derives from Picasso and the latter's studies of complementary profiles. The chequerboards use harlequins as their pretext or else are disposed in accordion patterns with chess-pieces added in the form of cut-outs. The superposition of fields allies these studies to certain paintings of Kandinsky's Bauhaus period of 1927. We can already see, in the chains of distorted squares which disrupt the picture plane, the disturbing performances of the kinetic period that was to come.

Another series of key works, the studies of transparent cubes, contain the same motif repeated six times, thus applying the rules of axonometric perspective as taught by Bortnyik. By a subterranean course, these studies were to lead to the full maturity of the Crystal series.

Other experiments followed: automatism and accidental art. Surrealism was then in its second period. No longer the aurora borealis it had been in 1922-30, when it shook the foundations of

creativity, the movement still retained sufficient influence to sway new departures in art. Several painters, subsequently abstract, hesitated before jettisoning those elements which surrealism had contributed to their art. In Germany, abstract art found little resistance in the wake of the Bauhaus. In Paris, however, these cross-currents were closely interwoven. Thus, during Vasarely's first exhibition at the Galerie Denise René it was Jacques Prévert who composed for the catalogue a curious tribute entitled 'Imaginoires'.[4]

The character of some of Vasarely's studies, as well as his circle of friends, caused a number of critics to place him among the surrealists. He was called the 'Prince of *trompe-l'œil*', a title he might well have kept. A bizarre spirit hovers over these prints, whose influence lingered, even at the height of Vasarely's kinetic period. Vasarely had made a discovery of which he only later became fully conscious, and which he defined as 'the emergence of a mysterious space within the picture plane'. The origins of this ambiguous space, of this other dimension, were to be demonstrated some six years later when the artist analysed and utilized it with almost diabolical intelligence and precision.

FIRST MORPHOLOGICAL SERIES

At the age of thirty-seven, Vasarely realized that painting was the most rewarding field for experiment. For two years, he had lingered on the periphery of surrealism and post-cubism. Like most of his contemporaries, he reached abstract art by means of successive schematizations which absorb the original motif; but in addition he developed other and highly revealing modes of approaching the abstract. Imaginary architecture, for example, with its cast shadows, would be transformed into an abstract composition simply by eliminating the substance of the forms and leaving the shadows, obliging us to read the space in an altogether different way. Elsewhere, he used the explosion of an image – his self-portrait in a broken mirror – and upon this rupture of conventional order he superimposed a formal reorganization, animated by an unexpected disconnection, often in the form of asymmetry, at times imperceptible, but sufficient to jolt the spectator's vision.

Frequently Vasarely held himself back at the threshold of a new direction of whose course he was not yet certain. Later he would return to this point of departure, gather together all the needed elements of information, and carry them through to their ultimate consequences. Each group of his works has a double origin: one remote, a sort of intermittent meditation upon plastic elements, the other proximate, provided by actual experience. There is thus a dual process, at once cerebral and affective, and from this, it follows that Vasarely's works are doubly charged; they belong to that level of creativity at which profound resonance is fused to dazzling technique. This explains why the paintings grouped under the series titles *Births*, *Belle-Isle*, *Crystal*, *Crystal-Gordes*, *Denfert-Rochereau*, *Gordes via Denfert*, *Births*, *Galaxies*, *Radio Sources*, etc., do not correspond to rigidly defined periods, but are rather interrelated morphological families.

The earliest schema, and one which, in the course of its evolution, has cut across many others, was entitled by Vasarely, in 1963, *Births (Les Naissances)* [190], because of its long gestation period. It is formed by a network of parallel lines whose irregular undulations sculpt a form which seems gently to ruffle the surface of the picture plane. A superposition of childhood memories, incorporating tactile sensations, and direct observation, rendered significant by an expanding field of knowledge, this schema is infused with the magic of anamorphosis.

The morphological series *Belle-Isle* [191] is the result of Vasarely's contact with nature. Studies of landscape done at Belle-Isle in 1947 brought to light ovoid forms resembling pebbles. Occasionally, the stones themselves are imprisoned in a relief. Vasarely obliges his mineral components, irregular and singular, to group themselves into a defined order. These elementary motifs immediately assume the meaning of archetypes, since it appears that nature repeats them in variable substances and graduated dimensions, from microcosm to macrocosm. A constellation of pebbles on the beach evokes the whirling movement of water, which in turn is echoed by cloud formations. However, Vasarely was soon to abandon this theme, feeling that it was too charged with figurative references. Later, as soon as he felt

liberated from the object, in 1953-54, he took it up again in compositions whose ample breadth expresses the plenitude of what Vasarely calls 'oceanic emotion', the ocean felt as a vast genetic force which maintains the constant mutation of the cosmos.

The *Crystal* series [194] pushes intellectual speculation still further than does the *Belle-Isle* group. This undoubtedly explains why Vasarely, who harbours no sentimentality towards the past, prefers *Crystal*. The point of departure for *Crystal* is the prism, axonometric and transparent. He need only bind together, by means of colour, the forms of the different facets of the prism to be confronted by a multitude of possibilities. From these studies emerges one of the laws of the Vasarelian universe: within and without are not distinct but continous. Vasarely then returned to his youthful studies of transparency, of which the first was a tracing of a female bather, the immersed portion of her body drawn on the reverse of the paper. The superposition of paintings on cellophane engendered a new and complex plastic vocabulary. In 1948, as he began to experiment with film projection, he became aware of its possibilities for composition in space, extended over several planes, 'vibrating matter replacing solid matter'. He began these experiments at Gordes, where, using a parabolic reflector, he projected a ray of sunlight through a screen on to a long white wall.

Gordes, an almost deserted Provençal hamlet perched on a rock, was visited in 1938 by André Lhote, and was adopted in 1948 by several painters of the younger abstract generation, including Vasarely, Dewasne, Deyrolle and Schneider. Gordes was the second source for the *Crystal* series. Once again, Vasarely's art was enriched by a meditation upon natural forms. *Combat*, in the issue of 7 September 1949, published one of the key drawings of this period, inspired by the panorama of houses flanking the hill. Hereafter, the splendid crest of the Lubéron, the angles of the Cistercian architecture of Sénanque silhouetted against the sun, were all to be captured within a transparent prism.

Unexpectedly, this schema encountered another. The origin of the morphological series *Denfert-Rochereau* [193] is to be found in the fine cracks

Plates 189-202

189 VICTOR VASARELY. *'Photographism' with Dancer*, 1951. After pen and ink drawings.

190 VICTOR VASARELY. *Ebi nor*, 1956. 130 × 195 cm.

191 VICTOR VASARELY. *Belle-Isle*, 1947.

192 VICTOR VASARELY. *Sauzon*, 1950-52. Oil on canvas, 130 × 97 cm.

193 VICTOR VASARELY. *Drawing from Denfert Period*, 1938-61. Incised drawing. Galerie Le Point Cardinal, Paris. Photo J. Hyde, Paris.

194 VICTOR VASARELY. *Orgovan*. Oil on canvas, 120 × 100 cm. Private collection, Brussels.

195 VICTOR VASARELY. *Tolna*, 1953-58. Oil on canvas, 97 × 130 cm.

196 VICTOR VASARELY. *Pamir*, 1950. Oil on canvas, 120 × 100 cm.

197 VICTOR VASARELY. *Sorata-T*, 1952. Triptych of engraved plates, 200 × 450 cm.

198 VICTOR VASARELY. *Eridan*, 1957. Oil on canvas, 162 × 130 cm. Private collection, Brussels.

199 VICTOR VASARELY. *Progressive Plastic Units*, 1963. Oil on canvas, 195 × 130 cm.

200 VICTOR VASARELY. *Alom*, 1966. Oil on canvas, 170 × 170 cm.

201 VICTOR VASARELY. *CTA 104 E*, 1965. Oil on canvas, 160 × 160 cm.

202 VICTOR VASARELY. *Spatial Development in Units*, 1964. Metal, 160 × 70 × 70 cm. Multiple.

189 Victor Vasarely

190 Victor Vasarely

191 Victor Vasarely

192 Victor Vasarely

193 Victor Vasarely

194 Victor Vasarely

195 Victor Vasarely

196 Victor Vasarely

197 Victor Vasarely

198 Victor Vasarely

200 Victor Vasarely

201 Victor Vasarely

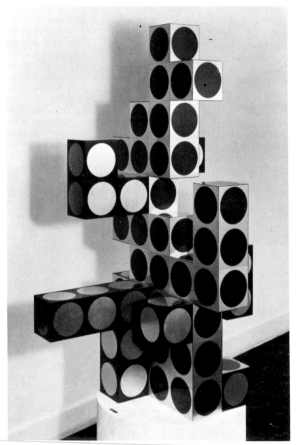

202 Victor Vasarely

observed by Vasarely on the tiled walls of a Métro station. The evolution of this group of forms leads from simple outline, whose purity thrusts through space and opens upon it, towards enclosed forms soldered to one another like honeycombs. Several years later, the landscape of Gordes was to appear within this network, but, this time, strictly confined to the picture plane. When the ellipsoid forms of the *Belle-Isle* series [192] reappear, a fusion of still different schemata takes place, a fusion through which the homogeneity of the world is expressed in the form of several works of consummate perfection.

The first Vasarelian language, pure composition, had now been developed [196]. It was characterized by a special sort of simplicity unique to this artist: a simplicity more apparent than real. Consistently avoiding the known and predictable, this language is based upon asymmetry as a principle of living harmony, introducing rhythm into the composition. Now the form-colour union assumes its most subtle, as well as most sumptuous accents. Two blacks are placed together, one velvety, with brown highlights and warm depths, the other hard and metallic. Two reds merge to delight us by their dual magnificence. The whites are bluish or faintly pink. A blue, competing with a juxtaposed black, appears studded with stars. Vasarely has spoken of a secret control, never embodied in a precise idea, but always stopping short at the level of emotion, of sensation, and operating as a balance of extreme sensibility.

FROM PLASTIC UNIT TO KINETIC ART

The analysis of the mysterious laws of pure composition led Vasarely to the realization that form can be affirmed only in terms of precise qualities of colour, and that, conversely, colour possesses this quality only once it has been defined by specific form. It is at this moment that the scales balance. 'Line (drawing, outline) is a fiction which does not belong to one but to two colour-forms at the same time. It does not engender colour-forms, but is a product of their encounter.'[5] From this point on, Vasarely turns away from the notion of a major form outlined against a background or dominating other secondary forms. He works in such a way that the shape of one form gives birth to the second, of exactly the same nature.

This has led him to define the plastic unit, the union of two complementary elements (form + ground), by the equation $2 = 1$. He bases this creative approach upon the full acceptance of a metaphysical principle which he had long since grasped intuitively: 'the eternal duality of all things finally acknowledged as indivisible'. Mondrian had already acknowledged that the space separating two forms might also assume the appearance of a form, which makes obvious the fundamental unity of form and space. Kupka had also begun to experiment with pure composition, but could not bring himself to abandon the decisive stimulus of an edifice seen in axonometric perspective. At this stage of Vasarely's evolution the experiments of Malevich in which the picture plane becomes part of the atmosphere, reacting to exterior light phenomena, seemed far more significant. On this subject, Vasarely observes that, within any plastic unit, one colour advances as the other recedes; the picture plane is thus quickened by a sense of contradictory space, giving the 'illusion of movement and duration'.[6] When the dominant direction is oblique, the illusion becomes one of movement in one direction only. One square, placed obliquely and squeezed into a lozenge, seems to pivot upon a central axis, thus achieving three-dimensional space. The pivoting black square of *Homage to Malevich* (1935-58) is in this respect a key work.

Vasarely also departs from neo-plasticism and axonometric perspective by systematizing his earlier experiments in the reversibility of colours, and by exploiting them in terms of the expression of movement. Not only do his favoured chequer patterns and stripes reappear, but all the experiments, all his dispersed explorations, assume a meaning, whether these be the collages called *Transparences*, paintings on cellophane, studies of transparent screens extended in depth, works in depth on plexiglass tiles separated by space, or refracting boxes. These in turn give birth to complete works based upon the following principles: the reading of a work which tends to decipher one form as positive and the other negative may be executed in reverse; the balance and precision of the composition make the values of the components of the plastic unit interchangeable; the positive values may be translated negatively;

the two terms of the unit may be repeated through inversion; viewed in this way, they may be multiplied and extended as well. The results of these theories were to emerge in 1955, when the exhibition 'Le Mouvement' took place at the Galerie Denise René. Vasarely exhibited a triptych composed of engraved tiles, *Sorata-T* [197], done in 1952 for Caracas.

Pushing the principle of reversibility to its extreme consequences, Vasarely now renounced colour in favour of black and white, the embodiment of positive-negative in its purest state. With these resources, which we tend to think of as meagre, he continued through the following years to produce variations astounding in their richness and magical effects. Juggling, he reaches those summits of virtuosity where the rarified air acts as a filter. The contradictory interpretations suggested capture the vision as in a net, turning it from left to right, upside down, backwards and forwards, as insecurity overwhelms the observer's mind. 'Nothing he paints leaves the soul in peace', said the critic Alain Bosquet. [7]

New morphological series followed: one of the most beautiful, *Mirror Images*, the result of studies of transparent screens, is so entitled because most of the compositions exist in two versions, one the negative of the other. But this name also reveals their hidden analogy to those labyrinths of mirrors in which form is repeated and dislocated. Our gaze pursues the secret of this false mobility; we are convinced we have seized it, only to be brought face to face with an unforeseen detour, which causes the form to shoot off in another direction. A spatial phenomenon is born, only to vanish in turn, swallowed up by visual traps which are, at the same time, conceptual, perhaps an implication of that same metaphysical doubt which produced the anamorphoses of the sixteenth and seventeenth centuries. [8]

Another group of works, completed at about the same time, in 1956, seems to be grafted on to the universe of pure physics. It translates a corpuscular tendency, an explosion of forms, into swarming groups of tiny elements, differing only slightly from one another: circles, squares and their derivatives. These elements are no longer ordered in a classical hierarchy of primary and secondary forms, a hierarchy which still holds sway over one school of abstract art. Nor are they grouped in accordance with the quasi-biological genesis subscribed to by a number of tachists and lyrical abstractionists, in which one form engenders another, which, in turn, may oppose the first. All of equal importance, these elements are governed by a structure, that is, by an ensemble of multiple relationships which give them significance. Their reduction to a limited number of simple types is accompanied, paradoxically, by virtuoso performances in terms of visual effect. Action and reaction interpenetrate and reverberate in different directions [198]. The composition escapes the confines of the canvas, as the latter becomes an expanding field of operation by means of what Henri van Lier has defined as 'transparency without depth'. Its provisional frontiers are assaulted by a dynamism which comes both from within and without. The surface vibrates, and even the surrounding air, galvanized by contact with the canvas, seems to propagate its waves. Incapable of focusing on one point of the canvas, the eye and mind undergo the explosive release of simultaneous visual combinations, contradictory and in a state of perpetual transformation. Thus, these two senses participate in the functioning of the work, as a sort of unity in a state of becoming, perpetually unmaking and remaking itself.

Excitement gives way to serenity in the morphological series *Galaxies*, dominated by the harmonious balance of circular or square forms which sometimes correspond to the two extremities of the canvas. When the field refers to space, the painting seems to coagulate the smaller elements, restricting their suggested movements within an orbit which seems to express a gravitational principle, subject to cyclical order.

THE FINAL CHOICE

Vasarely has made up his mind. The substance of the work he intends to create is now intellectually complete. This work expresses the philosophy of the 'plastic unit', which he has defined in terms indicating how much his thought is dominated by science. The parallelism he finds between the evolution of his own art and the discoveries of science has convinced him that he stands in the trajectory of the most advanced contemporary thinking. He feels that plastic creation – not only

his own, but also of all those working in the same direction – is closely linked to a consciousness of the new atomic age.

For Vasarely, the major breakthrough of the last few years is the advent, thanks to technical resources, of colour as an element in architecture. He envisions the city of the future as a solar city, within whose confines the form-colour plastic unit, an organic cell perfectly adapted to its surroundings, and forming the urban fabric itself, will be multidimensional and polyvalent. It will cover columns, form walls, be spread on the ground, be projected in sequence into space like a film (the slide has become to painting what the record is to music); or again, reduced to the proportions of a domestic icon, this unit will both stimulate and reflect the tonicity of modern life. Any aesthetic contribution of this order, however, will only assume its full meaning 'in a context which supposes a profound economic and social evolution', these two factors exercising in turn an ethical influence.

This fundamental vision, of a visual creativity capable of integration into a society prepared for it, entails the adoption of techniques for diffusion and multiplication. The masterpiece is no longer a unique object, but a work whose power resides in its potential for multiplication, presupposing a total gift to the community. It is up to the artist to organize his experiments in terms of these requirements, and to develop his creative norms in such a way as to facilitate industrial production. This is the lodestar which has guided Vasarely's principal activity for nearly fifteen years. He feels that the basic elements are now established – a plastic alphabet sufficiently supple for others to utilize in turn, and sufficiently rich to accommodate that quality of language, the music unique to his own art.

PERMUTATIONAL AND PROGRAMMED ART

With great perseverance and exceptional sense of organization, Vasarely has explored the possibilities of the plastic unit through what he terms 'permutable binary structures'. Taking his inspiration from the ceramic murals executed for Caracas, he transposed his elements on to squares of faience which could be assembled in different ways, thus making possible several monumental compositions. However, the register of expression was limited and the material cold. It was at this point that Vasarely thought of using metal; after several trials, he adopted, as industrial prototype, a small plaque (11 cm or $4\frac{1}{4}$ inches square) bearing a circle within a square, a broken circle, another square, a lozenge, or a section of square. With these assembled elements he conceived several types of *Spatial Developments* [202]. The polished surface of the metal, its degree of dullness or shine, brings to these works a great richness of colour values, as well as a quality of nobility, enabling them to occupy space with the same authority as stone.

For the development of prefabricated elements in concrete, enamel, glass, polyester, he creates other modules, always relying upon the same elementary geometric forms and based upon the plastic unit.

Engaged in a constant struggle against the 'myth of the unique object', Vasarely transposed his morphological series into widely diverse materials – silkscreened with impeccable technical skill – profound works of art on glass, tile, aluminium grilles or plates, interference networks of colour on plexiglass, tapestry, graphics printed on metal in limited editions like engravings. The preparation of each of these multiples, and their putative function, suppose a readjustment of the basic elements in terms of their structural relationship. Once again, the artist's mysterious control intervenes in these creative manipulations; his scales are those of one who weighs the infinitesimal, sensitive even to imponderables.

Besides working out practical problems, Vasarely continues to invent his art. Here, too, he breaks down the work into a series of systematic operations. The most simple method will also prove the most fertile, as it favours all the resources of programmation leading to a radically new position for the creative imagination. Using as model small gouaches, which have been scrutinized and envisioned at length in different versions, Vasarely's assistants execute monumental collages with an alphabet of formal elements prepared mechanically beforehand. Vasarely admits readily that such combinations could be executed later on by a computer. Henceforth he has elaborated a code

representing colours and forms by numbers. The composition which serves as matrix is generally so subtle that the spectator senses the rhythm and tonalities of expression without apprehending the key. He will still only barely grasp it when this same work is transposed, according to the rules of programmation – either in other colours with the same forms, or in the same colours with variations in the form and so forth. The rhythm behaves differently according to the colour register: an allegretto, whose elements suggest a feeling of gaiety, seeming to express a spring-like mood, or translate joyous heartbeats, can be transformed into an andante – solemn, grave, even melancholic.

NEW MORPHOLOGICAL SERIES

This system could not be further removed from the cult of the 'master's touch'. It also abolishes the highly personalized character of the relationship between spectator and object, ending their aristocratic dialogue. But the radiance of the work of art – and this is the Vasarelian miracle – is in no way diminished. The strict application of theory entails no impoverishment or desiccation. On the contrary, Vasarely's creativity was never more dazzling, never more direct than when imprisoned within this rigid mould. Multiple repeatability does not create monotony, but a sense of dynamic profusion. The results convince us that this cerebral concept of the plastic has been justified at the core of the work by the purest source of poetic sensitivity.

In 1962, to escape from the obsessive duality of black and white, Vasarely impetuously returned to colour. No longer in quest of precious tonalities and studied harmonies, he uses bright reds, greens and blues to infuse his geometry with a special kind of naiveté. At the Musée des Arts Décoratifs in 1963, circles and squares, asymmetrical in form and in increasing size, dominate the walls. This crescendo of 'progressive plastic units' reinforces the fanfare of polychromy. The return to the rhythms of his youth summons forth images of folk-dances: skirts unfolding like petals, swirling movements, flying ribbons. But as he reaches into the collective patrimony of central Europe, Vasarely also touches upon certain aspects of modern mass culture: the five-and-ten-cent store, its shelves piled high with the most varied items, all mass produced.

Vasarely gives us an indication of the resonance of these polychrome units which make up a very simple and universal vocabulary when he speaks of the possible future of 'a new planetary folk-lore'.

In contrast, the series *Radio-Sources* [201] marks a return to illusionism. The elements present a scale of light intensity so skilfully distributed that the work at times seems illuminated by a light placed behind the canvas; at other times the observer looks in vain for the projector which seems to sweep the surface. Squares and circles no longer ripple and change shape through anamorphosis; these elements are still present but dematerialized. The eye appears to perceive the displacement of a luminous wake and follows it in fascination. The emission of light vibrations, interrupted, then repeated, has replaced black and white kinetics. These works seem less intended to be contemplated at length; the eye should scan them at intervals, each time following the trajectory of brilliant light which moves over them.

Here one could speak of 'sweeping eye vision', a mode of seeing well adapted to contemporary attitudes and related to the effects obtained by Julio Le Parc in his light-continuum studies – effects which in this case, however, are in no way illusory.

A group of works on silver or gold background now re-states the old pictorial problems of chiaroscuro and transition from light to shadow in modern terms: these are alternate appearance and disappearance, with their overtones of magical prolongation.

Still another series continues the reds, greens and blues of 'planetary folklore', modulating them in such a way that the distance is the same between each degree of tonal intensity of a colour as between the various colour scales, with corresponding values.

But this is merely a question of measurements. The essential point is what Vasarely makes of these: the air of gaiety, feeling of freshness and sense of plenitude produced by his balance of modulations. One may be an enthusiastic advocate of his theories of programmation or their violent critic; but all arguments dissolve in confrontation with his art.

'EACH INDIVIDUAL IS AN END AND A BEGINNING'

Vasarely responds to the dominant tendencies of his time like an antenna. He has grasped the orientation of modern life with the most exceptional lucidity – an ever-active lucidity – thanks to which he has been able to posit certain solutions for the future.

As he had hoped, his work is a springboard, as well as a turntable. Vasarely's pre-kinetic abstract period had no lasting influence, in spite of the imprint which it left upon the work of a whole series of his contemporaries. For in fact, although this period created a great perfection of style, this style had come to an end, and Vasarely felt compelled to break with it. The younger generation needed examples rather than models, and the direction chosen by Vasarely provided the former. Even though the line of experimental artists continues unbroken from the Bauhaus on, Vasarely's discoveries assure him a major role. The impact of his work, the militant character of his personality, as well as his success in the art world, all encouraged a breakthrough in the realm of plastic discovery. Further, the assimilation of a new scale of techniques and materials accentuated the thrust towards what Vasarely has called 'an ineluctable mutation'. The traditional definition of the artist has all but given way before the concept, only vaguely defined as yet, which unites the function of creator with that of technician and researcher.

From now on, the romantic flame of discovery and originality must be replaced within a redefined context. Perhaps when we speak of originality, we must now see it as circumscribed, and calculated on the basis of probability, until it becomes verified by biological evidence. Seen in these terms, to be original is what is least probable. The different expressions of visual language become vessels of communication: modern life is permeable to the propositions of 'plasticians', art becomes more and more open to the demands of the life which conditions and, at times, contaminates it. Fashion, television, publicity, industry – all seize upon any idea capable of being translated into plastic terms, introducing them immediately into the consumer cycle. Because of the increasing speed of information, as well as its growing volume, we are witnessing in the artistic domain, as in all others, a depersonalization of invention.

How can we still partition those areas open to 'plasticians', stage-managers or commissioners of our aesthetic pleasures into private preserves, separated from one another by a no-man's-land? The goal of the artist can no longer be the creation of a perfect object which contains his own destiny, but must be his participation in a sequence of plastic events which form one continually growing object within our consciousness and sensibility.

In this perspective, the leaven or core of Vasarely's work does not lie in the adoption of one form of kinetic theory over another – a relevant classification has been done by Frank Popper[9] – but in obsession with movement in all its consequences and correspondences, as much in art as in our knowledge of the world. And never have the the two realms been so closely related. It is in this sense that Vasarely stands at one of the crossroads of the great contemporary adventure.

Many lines of force in Vasarely's work have been and still are subjects of reflection which have considerably changed the course of artistic evolution in general. These include questions of the primacy given to the relationship between the terms of a visual proposition; the multiplicity of schemas contained within this proposition,[10] the destruction of closed form, resulting from polyvalent elements and, simultaneously, from their restricted typology in proportion to their performance; continuity between perception and emotion (a phenomenon of which William Seitz has observed that we no longer distinguish between those effects of optical images located in the mind and eye),[11] or finally, of the sense of instability which is, in Vasarely's art, the point of departure for an urgent appeal for participation, or rather, an appeal for our commitment. Critics and partisans of his work all place their studies in relation to evidence provided by the artist. Divergence of points of view or reversals of position make their mark in precisely the measure in which every dialogue implies both an element of reserve, as well as the stimulus to formulate arguments of one's own. These various positions bear witness to the constant and necessary changes which modify the way in which we see our own period and our reaction towards it.

Today, the principal springs of creation seem to be, for one, the notion of environment or surround-

ings, as directed towards a physical and psychic exploitation of space, without the social motivation dominant in Vasarely's theory of the polychrome city, and for another, the aesthetic and psychology of the spectacle-play, with its active audience participation. This double orientation emanates directly from the principle of the transformable work of art. Further, the idea of team-work, now widely accepted, if only for the moment, implies a process of comparison and constant exchange. All of these tendencies underline the new thrust of the creative imagination as exemplified in Vasarely's work, and with it, the radical transformation of behaviour and attitude towards everything touching upon the activity of art.

1 Vasarely has contacted his former teacher, still in Budapest; and Bortnyik's methods are now fairly fully known as a result.

2 Yellow, orange, red, violet, ultramarine, steel-blue, glaucous green, grass-green. Compare Ludwig Hirschfeld-Mack's Bauhaus exercises on the properties of black and white added to colours, in which a chain of identical shapes was carried through a regular sequence of gradations of colour.

3 LASZLO MOHOLY-NAGY, *The New Vision: Abstract of an Artist*, New York 1947, p. 79: 'It was like playing chess by correspondence.' See also p. 245 of this book.

4 A portmanteau word made up of *image, magie, noire* and *imaginaire*.

5 See the statements quoted in Roger Bordier, 'Vasarely ou un certain ordre de conséquences', *Art d'aujourd'hui*, v, 1, February 1954, pp. 24-25.

6 VASARELY, *Notes pour un manifeste*, published on the occasion of the exhibition 'Le Mouvement', Galerie Denise René, Paris 1955. See also Vasarely, in *Aspects*, January 1955.

7 ALAIN BOSQUET, in *Galerie des arts*, Paris June 1966.

8 JURGIS BALTRUSAITIS, in his *Anamorphoses ou perspectives curieuses*, refers to the numerous experiments with optical illusions carried out by sixteenth- and seventeenth-century artists; the resulting effects were known as 'paradoxical perspectives'. According to Baltrusaitis, they sprang from a deep-seated idea which also haunted Descartes, a sort of metaphysical suspicion. They 'made uncertainty certain and therefore belonged to a network of evidence on the necessity of revising accepted conventions and values. ... Scientific experiments, trick images in popular prints, theatrical transformation scenes and dual-image paintings existed side by side in the same context, that of a philosophical obsession with illusion. Anamorphosis, when linked with these investigations, takes on a added significance.' The idea of the deceptiveness of appearances links up with that of the vanity of earthly life.

9 FRANK POPPER, *Kinetic Art*, London 1966.

10 The simultaneous existence of polyvalent schemas, between which the author is unable to choose, is one of the basic features of the *nouveau roman*.

11 WILLIAM SEITZ, *The Responsive Eye*, The Museum of Modern Art, New York 1965.

Plates 203-219

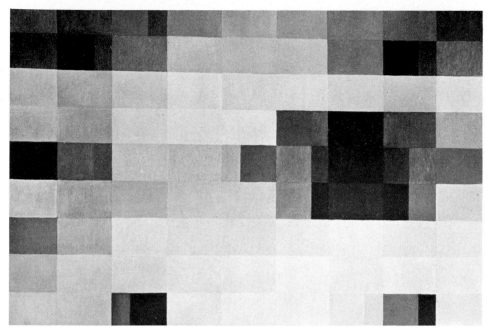

203 Johannes Itten

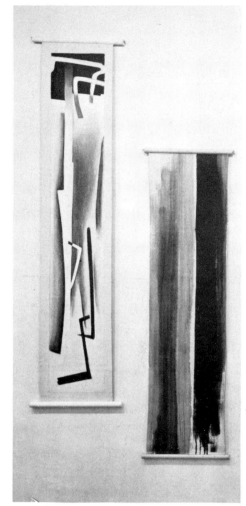

204 Hans Richter

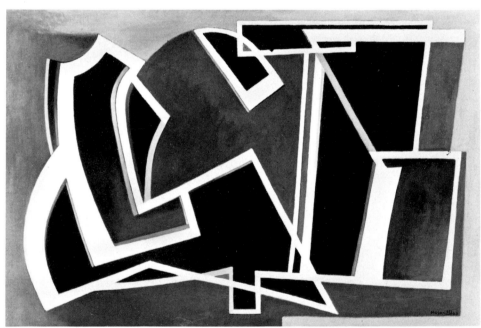

205 Alberto Magnelli

209

206 Antonio Calderara

208 Karl Gerstner

207 Ballocco

209 Max Bill

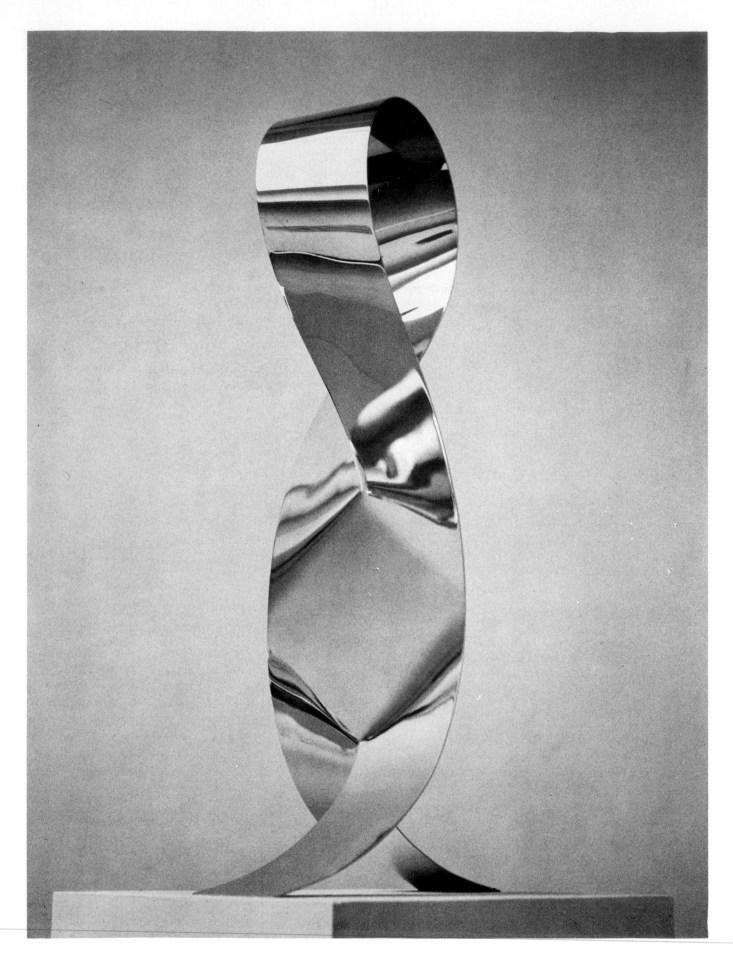

211 Rupprecht Geiger

212 Otto Piene

◀ 210 Max Bill

213 Wojciech Fangor

213

214 Leon Polk Smith

215 Alexander Lieberman

216 Francesco Lo Savio

217 Kenneth Noland

215

218 Raimer Jochims

219 Jef Verheyen

Colour Kinevisuality

UMBRO APOLLONIO

The art of colour and latent motion (Op art), which I have called kinevisual, has its source in the technical spirit of the age, but it does not indulge in positivistic and mechanical technique. If it did, it would justify the evaluation of art in terms of skill of craftsmanship. On the contrary, the correspondence between subject and expression, material and technique, forces all the parts of the creative process to contribute simultaneously to a predetermined end, and any incongruity irreparably alters the image. Interaction and homogeneity are traditional and still valid standards for aesthetic appraisal. This appraisal is not arrived at by way of physical laws, for different reactions are produced in different individuals – although these days with the help of statistics it is possible to work out the frequency of particular responses to given stimuli. Aesthetic quality emerges from experiments which produce the most unpredictable and varied results. In fact, research in the field of pigments and in the related field of optical perception clarifies the path from the optical datum to the psychic and imaginative datum. It is well known that visual reactions are not only physiological and biochemical, arising purely from the retina, but equally psychological, that is, generated within the observer's own mind; it is only from the conjunction of these two factors that cognitive experience occurs.

In the modern period the colour-light problem was faced by the impressionists and divisionists, but still in a representational context, though sublimated and poeticized. There is no need at this stage to retrace the steps which led from this sort of experiment to modern visual research; it may be useful, however, to give a brief resumé. The first valid propositions can be attributed to painters born between 1870 and 1900: Balla, Kupka, Mondrian, Malevich, Picabia, all of whom are acknowledged to have played important parts in defining the properties of colour. Balla's *Iridescent Interpenetrations* of 1912 give rise to an effect of vibratory movements; Mondrian's colour planes relate to one another without reference to specific forms; they only create a balance of proportion and tone, such as Piero and Vermeer achieved in their time. Malevich, too, uses only a few elementary forms. Purism traces its origins to these examples. It is at present enjoying one of its revivals, and has made a major contribution to kinevisual research. Balla's luminous mobility is reflected in paintings by Larionov and Goncharova, founders in 1913 of luminism *(luchizm);* there is a further elaboration of these ideas in the work of Delaunay, who produced, among other things, an essay on light, published in 1912. Thus two directions for exploration were offered up – one involving a revolt against the convention of formal and colour harmonies on a geometrical canvas, the other concerning itself with a greater fragmentation and excitement of movement, as in the work of Van Doesburg and Herbin.

Four painters who exerted a considerable influence on the twentieth century were all born in 1888: Josef Albers, Johannes Itten, Alberto Magnelli, Hans Richter. Very few artists have achieved such indisputably poetic results with such simple means as Albers. He, too, creates no forms, but much more along the lines of Mondrian and Malevich than of Balla or Delaunay, he establishes such space-colour relations on the basic design that he sets in motion elongations of perspective, resonant cavities, harmonic echoes of incredible complexity and variability for so limited a construc-

tional surface. The degree of transcendance he achieved in his *Homage to the Square* series, modulating it with exquisite colour tonalities, has no equal in the work of others, not even in the paintings executed with great finesse by Antonio Calderara (b. 1903) [206]. Itten [203], when compared with Albers, appears much more speculative and theoretical; but he has produced some extremely important works, employing middle tonalities and sensitive modulations with an astonishing dynamism. Hans Richter, on the other hand, goes back to rendering movement rather expressionistically: a succession of his pictures are so formulated that they can be grouped with those that assimilate motor activity into the pictorial context, setting up an insistent rhythm. Magnelli's intolerance of the static shows itself in the prevalence of shapes imposed like emblems on a limitless field, and by colour inflexions that eliminate even the possibility of a passive state.

Magnelli [205] is one of the major painters of pictorial geometrics. Among the followers of the same line of development are Wladislaw Strzeminski (1893-1952), Henryk Berlewi (b. 1894), Marcelle Cahn (b. 1895), Pavel Mansourov (b. 1896), Mario Soldati (1896-1953), Otto Josef Carlsund (1897-1948), Mauro Reggiani (b. 1897), Jean Gorin (b. 1899) [173], Fritz Glarner (b. 1899) [172], and Friedrich Vordemberge-Gildewart (1899-1962) [161]. These were contemporaries of the adherents of neo-plastic purism, among whom are Mario Radice (b. 1900), Cesar Domela (b. 1900) [159], Manlio Rho (1901-1957), Michel Seuphor (b. 1901), Luigi Veronesi (b. 1908), Richard Mortensen (b. 1909) [175]. Richard Paul Lohse (b. 1902) [188] follows principles much closer to Itten's system of organizational design on the basis of scrupulous calculation. Mario Ballocco (b. 1913), with his colour progressions, contributes to the same development. Hugo Demarco (b. 1932) attempts something similar [271]. Often what is best in these painters is the symmetrical ordering of the compositional fragments, and Karl Gerstner (b. 1930), who alternates between picture-making, object-construction and designing [208], amalgamates these diverse activities so naturally and effectively that the calculations are entirely absorbed into the end product.

In terms of a colour configuration achieved by way of direct experimentation with pigment, the most outstanding achievement is that of Max Bill (b. 1908) [209, 210, S. 49]. He is active as an architect and industrial designer as well as a painter and sculptor, and the quality of his work and the scale of the problems he tackles places him on a level with masters such as Mondrian, Albers or Malevich. Max Bill has not limited his research to one field only; he is convinced that the artistic vocation, involving human life in its totality, must apply itself to all creative techniques. It is really extraordinary how such a wide range of activities are welded together into a homogeneous whole, an authentic *Weltanschauung*. In the field of painting Max Bill, having renounced any compromise in the way of psychology or symbolism, has applied himself to the formulation of images working on the level of colour perception; these produce a reaction which is almost normative in its objectives; the works can be interpreted as the plan for a universal harmony.

In 1955 Max Bill completed a few paintings which depicted a nucleus and an astonishing halo bursting out of it. The resemblance to these of some paintings by his contemporary Rupprecht Geiger (b. 1908) [211], and by the younger Wojciech Fangor (b. 1922) [213], is obvious. This is not to belittle their contribution, which is certainly not unimportant: the active concordance between colour and colour, between formal profile and its dissolution, between the central corpus and its extensive reflection, are all elements which act simultaneously and point forward, with all the brilliance they encompass, to a dynamic fusion. At one time, too, Otto Piene (b. 1928) [212], twenty years younger than Bill and Geiger, tried out colour compositions using brilliant reflections on middle tones. The effect he obtained is reminiscent of massed clouds, whereas Geiger always tends to synchronize elements of form and colour.

The generations now begin to interact on each other with greater frequency and show respect, in quite distinct ways, for the utilization of colour to illustrate a principle of instability. Vasarely (b. 1908) is the leading figure among those concerned mainly with Op art structured on a figurative base. Other contributors to this volume have dealt very fully with his work; it is enough here

to point out that he is a complex personality whose work is of interest to, and affects, the whole field of expressive dynamics, from the assured resolutions of Herbin [169, S. 43] to the linear-optics experiments of Mansourov.

We have now come to a more evident contemporaneity, in which the two tendencies mentioned above: purist 'formalism' and organic 'simultaneism', alternate in different forms and with different qualities. Barnett Newman (1905-70) [235, S. 55], one of the greatest painters of the last quarter-century, would almost certainly have refused to be included in any constructivist or formalist group, because he declared his dislike of all geometric perfection; for some he would undoubtedly seem to be sort of expressionist. He works the canvas into flat planes, sharply divided from each other; but the overall rigour of this process, while severe and incisive, involves no recourse to deductive orders of a dogmatic nature. Newman binds himself to a uniform intensity, where contrast, measured by the degree of sensibility (however potential) of the areas, outlines, colours, generates an emotive spatiality without limits. In this sense he can be set alongside Leon Polk Smith (b. 1906) [214, 237], as both artists contain the movement within colour zones, and separate these more or less by straight lines, which function as axial guidelines as well; Alexander Liberman (b. 1912) [215] appears, in comparison, considerably more schematic, and Olle Baertling (b. 1911) [176, S. 48] more fragmentary and deductive. Jean Dewasne (b. 1921) [177, S. 47], more in line with Mortensen [175] and Magnelli, fortifies the composition with a greater articulation of the forms; quite often the colour has a certain naturalism. In many cases, where there is a problem in the total composition, it is the forms, emblems almost raised on a flat background, that take the leading role. No real internal movement or true structure is evident. A certain aggressiveness comes into play, enhanced by the breaking and chipping of the outlines, and dependent too on a plan of an expressionistic character, in the sense that the linear web pattern is given free rein.

An impeccable connection between field and colour is also found in the work of Ellsworth Kelly (b. 1923) [251]. A coincidence of multiple reciprocal reference points gives his pictures a mobility tempered to a moderate rhythm, with no straining or concessions to rhetoric. Some of his monochrome surfaces, isolated and contrasted, which stimulate a shift in attention from one to the other and thus bring about a movement of connection, spring from the same inventive matrix as do analogous experiments carried out by Yves Klein (1928-62) and Piero Manzoni (1933-63) [149], both of whom died in their early thirties. Here the starting-point is precisely the active availability of the colour, which is in general spread out, compact, primary. The movement takes place, not by coercion from form to form, but through the transitions between two or more immobile zones with different colour properties; almost a transference from place to place, so that the consonance is accomplished in the mind, which recalls the point left after the point arrived at, and has continuous access to the whole composition at once.

A purist emancipation, in which the directional energy of form is allied to the colour factor, has been achieved by Kenneth Noland (b. 1924) [253, S. 59]: here the apexes of a triangle, for example, not only provoke a thrust in a given direction, but cause it to become a complex signal through the multi-coloured stripes of which the triangular sector is composed. This constitutes a vitalized basic diagram whose energy level is extended towards infinity. It does not lead, however, to any perspectival development; Frank Stella (b. 1936) [247, S. 58), on the other hand, uses centrally-focused perspectives in which the point of convergence of the lines resulting from his open vision of the cube is a final, ultimate limit. Stella approaches and actually reaches his destination; Noland, on the contrary, could get lost on the way, because there is nothing blocking his path. Hector Garcia Miranda (b. 1930) works on not too dissimilar presuppositions: he experiments with the motor effect produced by, for example, superimposing a triangle of a different colour on a square or a lozenge. And it would not be at all incongruous to relate Al Held (b. 1928) [252] to this purist attitude, for his penetrating and carefully balanced connections.

With regard to the monochromic tendency – which is used with authoritative perspicacity by Lucio Fontana (b. 1899) [139-45, S. 35], and,

more recently, by Enrico Castellani (b. 1930) [147] and Agostino Bonalumi (b. 1935) [150] – – contemporary kinevisuality includes some examples of a sensitive version which recalls in a way the limpid and refined simplicity of Ben Nicholson (b. 1894) [171, S. 46]. In the geometric relief of his paintings certain basic formal data of empirical nature are reconciled; there is no regression involved, but rather a freeing of them in terms of absolute values. Ad Reinhardt [236], born twenty years later, evades all reflection of ordinary reality and articulates his composition on a geometric grid which the painting operation transmutes into repetitive delicate transitions. Something analogous occurs in the work of Riccardo Guarneri (b. 1933) [220], born twenty years later still. Thus, at intervals over half a century, certain fundamental resolutions spectacularly reassert themselves. And the same is true of the current which has elected colour as the exclusive substance of vision, from Albers to Rothko. Reimer Jochims (b. 1935) [218; S. 52] mobilizes his painting through the use not of more or less frequent vibrations, but of diffuse pulsation. The colour organism is pervaded with light and breathes with natural regularity: it refers to a temporal space-time which exists without ever coming to a halt, and in the gradual and reciprocal rotation from darker to lighter zone an internal heartbeat persists. Thus two contemporary movements run concurrently: one relying on the substance *per se*, and the other on the progression of fluid light. The painting of Jef Verheyen (b. 1932) [219] proceeds from the intensity of his colour perception, and reveals a severe discipline; the relationship between perception and reality is so profound that it constitutes in itself the significance of the painting, and hence its value. There is also in the work of Jules Olitski (b. 1922) [45] a certain delicate but open-ended diffusion of light which shows great sensitivity in the formation of clouds of luminous colour.

In comparison with such a profound concordance of image and means, the dynamics of Richard Anuszkiewicz (b. 1930) [221] or of Larry Poons (b. 1937) [243] seem to turn simpler and more common modes of awareness to account; similarly, the optical agitations of Benjamin Cunningham (b. 1904) or Jeffrey Steele (b. 1931) [223] or Peter

Plates 220-234

220 RICCARDO GUARNERI. *Simultaneous Rectangle*, 1965. Oil on canvas, 95 × 100 cm. Private collection.

221 RICHARD ANUSZKIEWICZ. *Heat*, 1968. Acrylic on canvas, 213 × 213 cm. Courtesy Sidney Janis Gallery, New York. Photo G. Clements, New York.

222 PETER SEDGLEY. *Manifestation*, 1964. Emulsion on cardboard, 100.3 × 100.3 cm. Calouste Gulbenkian Foundation, Lisbon.

223 JEFFREY STEELE. *Ilmatar*, 1967. Oil on canvas, 91.5 × 137 cm. The Arts Council, London. (Erratum: for Jefry read Jeffrey, p. 222.)

224 BRIDGET RILEY. *Current*, 1964. Emulsion on cardboard, 148 × 149 cm. The Museum of Modern Art, New York. Phillip C. Johnson Fund.

225 GÜNTHER FRÜHTRUNK. *Vibration*, 1967. Acrylic on canvas, 97 × 104 cm. Galerie Der Spiegel, Cologne.

226 MARIO NIGRO. *From 'Total Space'*, 1954. Private collection. Photo Ferruzzi, Venice.

227 PIERO DORAZIO. *In the Long Run*, 1965. Oil on canvas, 170 × 220 cm. Marlborough Galleria d'Arte, Rome.

228 PIERO DORAZIO. *Untitled*, 1963. Oil on canvas, 40 × 50 cm. Marlborough Galleria d'Arte, Rome.

229 ALMIR MAVIGNIER. *Vibrations on White-Pink*, 1962. Private collection. Photo Giacomelli, Venice.

230 PAOLO PATELLI. *Painting*. Private collection.

231 GUIDO MOLINARI. *Violet Mutation*, 1964. Private collection. Photo Ferruzzi, Venice.

232 GEORG KARL PFAHLER. *Accmet*, 1964. Oil on canvas, 144 × 115 cm. Galerie Müller, Stuttgart. Photo G. Binanzer, Stuttgart.

233 ANTHONY CARO. *The Window*, 1966/67. Painted steel, 215 × 320 × 391 cm. Collection S.M. Caro. Photo courtesy Kasmin Ltd. London. (Erratum: for Antoni read Anthony, p. 228.)

234 ANTHONY CARO. *Sculpture XXII*, 1967. Pacific-grey steel, 25 × 80 × 68.5 cm. Private collection. Photo courtesy Kasmin Ltd. London. (Erratum: for Antoni read Anthony, p. 228.)

220 Ricardo Guarneri

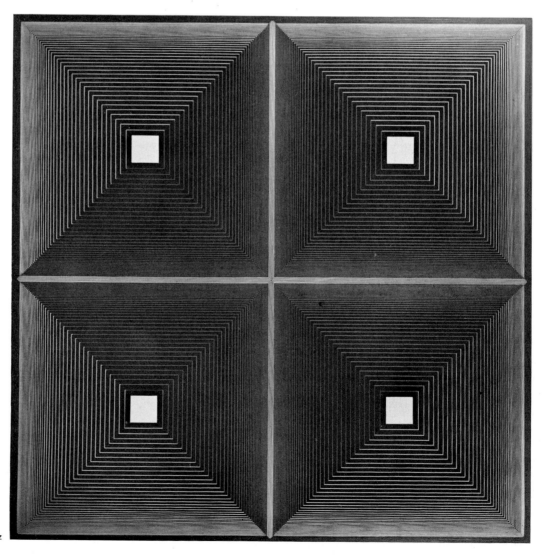

221 Richard Anuszkiewicz

221

222 Peter Sedgley

223 Jefry Steele

222

224 Bridget Riley

225 Günther Frühtrunk

226 Mario Nigro

227 Piero Dorazio

228 Piero Dorazio

229 Almir Mavignier

230 Paolo Patelli

231 Guido Molinari

232 Georg Karl Pfahler

227

233 Antoni Caro

234 Antoni Caro

Sedgley (b. 1930) [222] represent only expedients of an illusory character, while the research into total space of Mario Nigro (b. 1917) [226] is based on the displacement of perforated planes. The process perfected by Bridget Riley (b. 1931) [224], which converts retinal perception into aesthetic behaviour, and, using only black and white, is raised to a level of vibrant intensity, has greater fullness and acuity.

Günter Frühtrunk (b. 1923) [225], another major figure, constructs on a structural base; spatial mutation occurs via the attraction and synergism of curves and intersections. The surface divided in this way into steady articulations depicts a sort of elusive relief, which also appears in the works of Yaacov Agam (b. 1928) [268-70, 275-6, S. 63], in which the sequences give rise to morphological metamorphoses by moving closer in and further away.

The interaction of colour, vivid and resonant, has a powerful effect in the work of Morris Louis (1912-62) [254]. The variegated stripes, in close conjunction or separated or reduced to an isolated group on the surface, are always placed in unstable equilibrium, and emit a glow which brings their setting to life in an illusion of alternating movement. This is not brought about through optical-perceptual shifts, as is usual in paintings which work on a visual level, but depends on the strength of the action of the colour potential, the energy content of the colours and their mutual attraction. The dynamics of the whole kinevisual movement are very often twofold, not so much because there is first a peculiarly physical impression followed immediately by a complementary psychological one, as because the effects run simultaneously on two vectors and the motion becomes transferred: precisely this happens in Louis's work, the eye runs over the single stripes in an orthogonal or diagonal direction, according to their position, and passes from one stripe to the other horizontally.

In Piero Dorazio (b. 1927) [227-28, S. 53], on the contrary, the movement is brought about in depth: on the surface it is vibratory, because the texture is continuous, or at any rate made up of a network. Until 1961, or a little later, his paintings on a minute network base move rhythmically to a regular beat; but they also force the gaze to go right into the network, beyond the plane of the canvas towards that distant point from which the molecular interlacement of signs radiates. Now, his painting is created by superimpositions and by intersecting strips that are often as wide as bars; and the most accentuated transparencies, always aimed towards brilliancy of intersection, still induce the gaze to penetrate beyond the canvas and plunge deeper, right down to where the light becomes a pure white, or at least very pale. For a long time Dorazio's problem has been one of quantity: a quantity of minimal signs or coloured lines crowded together, or, more recently, a reduced quantity of broad coloured lines in strict spatial relationships with each other. Thus from a rapid, almost snaredrum-like beat they work up to a slow tempo, a crystal-clear percussion. But his is not, despite this, a painting of signs or gestures – a certain gestural propensity can be seen rather in Morris Louis – as much as a painting of splendour: an absolute presence within a wholly occupied frame, extending without obstructions into infinity.

Movement achieved using micro-structures serially repeated, according to exact calculations of perception, is found again in Almir Mavignier (b. 1925) [229]. In such a case, however, the function of colour is not determinant but co-operative; in fact Mavignier often works in black and white or in just two colours. Yet there is another characteristic which is accentuated in his works: the relief, or rather the play of shadows cast by it. The composition is accomplished by dabbing spots of colour on the surface of the canvas, which go to make up small clots whose projection above the plane of the canvas casts a veil of shadow over the picture; a sense of dynamism is achieved through this process too, and not only through the alignments and distances between corpuscle and corpuscle.

At this point, I am assailed by a suspicion that I may have opened up the scope of this investigation too broadly, almost reverting to the old criterion by which all non-figurative work, regardless of its stylistic character, was grouped under the heading abstract art. So one might ask if those paintings which are commonly included in the 'hard-edge' grouping, and which to a certain extent can be considered a development based on concretist

presuppositions, really do have anything to do with what I have called colour kinevisuality. There is no doubt of it: in these an effect of motion, however vestigial, can be recognized, and colour retains its activating role. Yet the operative effect, the invitation which the painting extends to the viewer, is still of a contemplative character, not necessarily involving an active use of perceptual effects; this is true notwithstanding the ambiguity, the ambivalence, the polycausality inherent in the work itself.

It is essential in a survey like this, if one is to give an idea of the extent of the tendency in question, to take account of geographical regions less favoured with publicity in the art world as a whole. One hears, for example, of a fairly lively movement in Canada, whose most interesting members include Jean Goguen, Claude Tousignant, Jean-Paul Mousseau, Guido Molinari [231], whose work follows the postulates laid down by the 'Plasticism' group (which in 1955 issued a manifesto against tachism). For a long time, unfortunately, I have heard nothing of a concretist Cuban painter who once exhibited in Italy – Luis Martínez Pedro – and in Cuba the concretist group was anything but negligible. I should also have liked to say something about certain Dutch painters, such as Dan van Severen, J. C. G. van der Heyden, or Jos Manders. And why not mention Victor Pasmore, who is certainly a front-ranking artist? Or Gaston Bertrand, Genevieve Claisse, Joel Stein? One artist who must take his place here is Yorrit Tornquist, who in his constructions makes use of colour in its pure and elementary sense to discover the workings of light. Temporal or else rhythmic dimensions, of precise aesthetic objectivity, then emerge from this asymmetry. That the relativity of the values of the individual elements in the context depends on the point of view of the spectator, becomes unquestionably explicit in his work.

These notes should be considered an attempt to outline an aesthetic problem which is anything but simple or of minor importance: on the contrary, there are so many artists who are either sympathetic to or practising this movement that one may wonder if this will prove to be the style of the age. If that should come about, another question will have to be asked: which group in the crowded complex is that of greatest authority? Certain tendencies are too obvious to need discussion; but others, to which today we give more weight, could fall back into second place. Thus my suspension of final judgment can surely be forgiven, as can, I think, the inevitable gaps in exposition.

Diversity in Unity: Recent Geometricizing Styles in America

LUCY R. LIPPARD

In the late 1940s and early 1950s, the prevailing American attitude toward geometry in art was expressed by Mark Rothko, who urged the rejection of 'memory, history and geometry', and by Willem de Kooning, who called geometric shapes 'not necessarily clear', and 'a form of uncertainty'. 'Geometry was against art', he continued, and, prophetically, in view of the current minimal art: 'The end of a painting in this kind of geometric painting would be almost the graph for a possible painting – like a blueprint.'

Yet when Sidney Tillim wrote, accurately enough, in 1959, on the eve of a geometric or 'post-geometric' revival, that 'in the last decade, geometric painting in the US has been almost totally eclipsed by the ascendancy of abstract expressionism', he might have stressed the 'almost'. For in 1950, in the heart of the abstract expressionist enclave, there already existed the seeds of a new attitude toward geometric art. It was expressed by two men, one speaking from the traditionally classical point of view, the other from a more personal and romantic stance. The first was Ad Reinhardt [236, S. 54], who had returned to geometry after developing a painterly departure from cubism: 'An emphasis on geometry is an emphasis on the "known", on order and knowledge.' The second was Barnett Newman [235, S. 55]: 'Geometry *can* be organic. Straight lines do exist in nature.... A straight line is an organic thing that can contain feeling.' He criticized Mondrian's overclassical approach because 'the geometry (perfection) swallowed up his metaphysics (his exaltation)'.

During the late 1950s, Ad Reinhardt's iconoclastic writings and his 'identical', 'black' paintings predicted aspects of the most extremely rejective art of the 1960s, the rigorous conceptualism of structure-makers like Donald Judd, Robert Morris, Sol LeWitt or Carl André, of painters like Frank Stella or Jo Baer. Newman's grand and practically unmarked surfaces and his statements are also applicable to Stella and to such painters as Larry Poons or Agnes Martin, and sculptors like Tony Smith or Ronald Bladen. Reinhardt provided a prototype for the new art; Newman was a broad formal influence. Neither artist can be discussed fruitfully in the context of general trends, yet each seems now to belong to the 1960s rather than to the 1950s. Between their by now wholly divergent attitudes lies the area in which the 'minimal' paintings and structures operate, a result of what Tillim called 'a collision of the classic urge for order and the romantic urge for expression'.

Given the great diversity of geometricizing styles today, even a name-studded survey of the artists involved, to say nothing of any analysis of their work, would be beyond the scope of this essay.

The sources alone are confusing to the point of chaos. Rejective abstraction has so broad a base as to include in uneasy alliance surrealist automatism and biomorphism, abstract expressionist attitude and scale, De Stijl unity, suprematist austerity, constructivist impersonalism, Dada iconoclasm, Bauhaus design, as well as found objects, crystallography, engineering textbooks, advertising, and modern living *in toto*. At the same time, it posits a general determination to go beyond cubism, to present an art without reference to outside events, mythopoetic or personal content; it is equally

determined to avoid the academic sterility that has been the perennial fate of geometric styles.

I shall, therefore, limit myself here to a skeletal version of the new art's historical origins, and even neglect the better-known older figures (Josef Albers, Barnett Newman, Ad Reinhardt, Mark Rothko in particular), though their contributions continue to be of importance, as well as case-histories of individual artists since then.

It seems more important at this point to continue with a series of generalized conjectures and digressions on issues raised by the new styles than to provide still another survey, with all the shortcomings inherent in the genre.

In the 1950s, only isolated figures were working with any originality in geometric idioms (notably Albers, Diller, Davis, Newman, Reinhardt, Kelly, and, to a lesser extent, Rothko; also Leon Polk Smith, Myron Stout, Al Jensen, Ludwig Sander and others). Geometric art was associated with Europe, with tradition, and American art was engaged in establishing its independence and its maturity.

This process levelled off by the mid-1950s, and by 1958 the strains of reaction were discernible.

They took the form of a rejective impetus which did not initially discard the hard-won freedoms of abstract expressionism so much as it narrowed them down, clarified, objectified, simplified what had become an over-refinement of gesture, individualism, paint quality, surface texture and pattern.

As this impetus crystallized into a stringent formalism, it became obvious that a broad range of styles and possibilities was emerging. By 1967, the art that can be called geometric in one sense or another had become the prevailing style. Much of it looks geometric but actually is not, and much of it does not look geometric, as we usually understand the term, but is based on advanced mathematical ideas that expand the classical vocabulary of conventional geometry beyond recognition. Newman called his work 'post-geometric' because of its lack of precision and hierarchical composition, while Reinhardt's paintings, rising from neo-plasticist abstraction, might be called 'post-geometric' because they drain geometry of all but a single visual clarity, making it an armature rather than a system.

Around 1960, critical attention turned to those so-called abstract expressionists whose styles contained little or no 'expressionism'. H. H. Arnason called them Abstract Imagists, but in fact the main significance of Pollock's, Newman's, Rothko's and Reinhardt's styles was their renunciation of imagery, their shift of emphasis to a purity and breadth of sensation that stressed colour, light, space, scale, with an intensity that came to be called 'presence'. Newman's immense colour fields were not 'composed' but simply divided, and were aimed at immediate perceptual and emotional experience. Pollock's great webs of line [1-5, S. 1] can now be seen not so much as violent emotional outpourings, but as tranquil, even lyrical surfaces implying infinite expansion into space. The all-over principle they developed, the imageless plane, is now recognized as one of the most fertile formal devices in twentieth-century art, directly or indirectly engendering such diverse results as Kelly's big curved forms pushing at the framing edges, Agnes Martin's [238] grid continuum (which acts, like Monet's light or Mondrian's broken grid, to veil and destroy the plane), Larry Poons's [243] swirling colour discs within an indecipherable space lattice, and the modular structures of Judd, LeWitt, André or Smithson. The all-over principle is combined with the light-colour-space sensations introduced by Rothko and Newman, and with Reinhardt's theoretical rejections, to produce the rigorous but faintly atmospheric surfaces of Robert Mangold's [242], Robert Irwin's and William Pettet's almost monotonal paintings.

There seems little doubt that the most important intermediary step, as far as the most radical rejective styles are concerned, was Frank Stella's [247, S. 58] development of the shaped two-dimensional canvas along the sparest lines. The effect on his peers of his pin-striped paintings (first black, then eventually aluminium, copper, metallic purple, green and other colours) should not be underestimated.

Beginning with simple notches from the corners, they were cut more and more extremely away from the solid rectangle until they assumed shapes independent of the traditional format, cut-out at the centre, zig-zagging across the wall; most important, the striped surfaces were figured to

follow the framing edges exactly (a concept perhaps suggested by Newman's use of the stripe, remarked by Clement Greenberg, and expanded into an elaborate theory of 'deductive structure' by Michael Fried). Denying all but plane or shape, Stella seemed to have re-defined the limits of painting; as Robert Rosenblum has put it, he showed 'the bones rather than the flesh of painting', and it was a shocking experience for a good many observers.

Stella's advocation of symmetry, repetition, an anti-seductive, anti-pictorial, anti-picturesque painting, seemed to fulfill Reinhardt's prediction, as laid out in his 1957 'Twelve Rules for the New Academy' (no texture, no accidents or automatism, no brushwork or calligraphy, no sketching or drawing, no forms, no design). The most important proposal was a steadfast non-relationalism, a rejection of the design, or composition, at the heart of all painting until then. 'The balance factor isn't important,' said Stella. 'We're not trying to jockey everything around.' Non-relationalism is the single factor that separates the American geometric artists from their near-counterparts in Europe, as well as in the part. Although the structural idioms can be set squarely in the line of historical development, now that they have happened, their sources are mostly to be found in recent American painting, rather than in any sculpture or any historical movement. Parallels exist between the new art and art of the past, but as Donald Judd has asserted, 'A lot of things look alike, but they're not necessarily very much alike.'

Judd, as an artist and as a critic, has been one of the most articulate and original thinkers connected with the new art. His statements are extreme, but they are seconded by a good many of his colleagues.

The other important figure for mention is Robert Morris [240; S. 57], whose complex intellectualism has been applied to Duchampian reliefs and to the mixed media area of Dance-Happenings, or Theatre Events, as well as to his boxy, single gestalt-oriented structures. Judd, Morris, Sol LeWitt [248] and Carl André, all significantly different, both in their art and their ideas, were the first 'Primary Structurists' to exhibit, in 1964 and 1965, and they, with Dan Flavin [239], who began

his iconic light structures around 1963, have provided the core of the new art's aesthetic.

In painting, as well as in sculpture, the non-relational concept is best served by neutral or modular elements repeated broadly enough so that they do not become mere pattern, and do not obliterate the colour-field effects. Stripes, dots, chevrons, bands, or monotonal surfaces do not call attention to themselves but integrate the whole, as do progressively arranged shaped canvases or sculptural elements. Jo Baer, Agnes Martin, Larry Poons, Gene Davis, Robert Mangold, Robert Ryman, Paul Mogenson, David Lee, Peter Gourfain, Brice Marden and numerous others employ such non-relational means to an end which, rather than defeating painting, seems to hold it more tightly to its own identity.

The work of these artists, as well as the hard-edge painters (that term was coined by Jules Langsner for a group eventually called the 'Abstract Classicists') has been considered simply another manifestation of the ancient classic ideal. Yet the idealization, harmony, balance of shapes, proportional relationships of the past are for the most part renounced in favour of the inseparable colour-space or shape-volume unit. Robert Morris, for instance, says sculpture must have its own literal space and 'create strong gestalt sensations' which 'offer a maximum resistance to perceptual separation' into parts. He asserts that such a wholeness, which cannot be seen but can be sensed all at once, is opposed to the cubist effect of simultaneous vision, and that his simple polyhedra cannot be seen within a cubist framework. Like the large majority of his colleagues, he has never been attracted to or particularly interested in a Bauhaus type of purism. Judd has put it bluntly: 'I consider the Bauhaus too long ago to think about, and I never thought about it much'; he intends to avoid the aesthetically exhausted 'effect of order and equality that traditional European painting had.... They lined up with a philosophy – rationalism – that is pretty much discredited now as a way of finding out what the world's like.'

Though Judd, and others, particularly Robert Smithson, are knowledgeable in the field of crystallography, and propose a philosophical basis for their work that shares that science's interest in a coexistence of order and disorder within an

apparently ordered structure, they have little in common with very similar ideas explored some time earlier by the Swiss, Max Bill. Less theoretically sophisticated than their European counterparts, the Americans seem to stress the object as object in a more direct, though perhaps more naive manner. Rejection of the past is not half so conscious as acceptance of the present and anticipation of the future, though without any *Brave New World* impedimenta. The structurists' insistent conceptualism and a barely perceptible aura of optimism are generally typical of geometric art in the twentieth century. Perhaps the most striking divergence from the geometric tradition is rejective art's absolute reflection of the sensibility of the 1960s, though the hopes of pining down such an elusive factor are faint. The immense popularity of Marshall McLuhan's writings, especially his dictum 'the medium is the message', is not insignificant. Current ideas are moulded by men like McLuhan, Wittgenstein, Robbe-Grillet, Buckminster Fuller, Norman O. Brown, John Cage, Maurice Merleau-Ponty, Jorge Luis Borges, to mention a few often-invoked names.

As American art became more aggressive in its rejection of the past and its defiance of any sort of interpretation, the artists spoke of exacting *commitment* from the spectator, rather than of entertaining their audience. Barbara Rose has suggested that the artist, 'acknowledging that the sensibilities are jaded and the attention span short, has decided to capitalize on just that'. While the hostility of the new art has been exaggerated, as has its intention to 'bore', it does seem notable that the timelessness and obdurate stasis of much new work are conceived in an era of great speed and change. Reinhardt has even offered the possibility that he is painting the last paintings anyone can paint. Nevertheless, the new art, by absorbing Johns's, Warhol's, Stella's, Newman's, Duchamp's premises as well as Reinhardt's, has made it clear that the 'impersonal' is as human and as infinitely variable as the autobiographical or the figurative humanizing schools. Art is, like it or not, personal. Or, as Lawrence Alloway has put it, the 'status of order as human proposals rather than as the echo of fundamental principles, is part of the legacy of the 1903-15 generation. ... A system is as human

Plates 235-249

235 BARNETT NEWMAN. *Abraham*, 1949. Oil on canvas. 213 × 90 cm. Betty Parsons Gallery, New York. Photo O. Baker, New York.

236 AD REINHARDT. *Abstract Painting, Blue*, 1951. Oil on canvas, 126 × 51 cm. Private collection.

237 LEON POLK SMITH. *White-black Correspondence*, 1966. 173 × 152 cm. Private collection. Photo G. Clements. New York.

238 AGNES MARTIN. *Play*, 1966. Acrylic on canvas, 183 × 183 cm. Collection Albert Landry, J. L. Hudson Gallery, Detroit. Photo O. E. Nelson, New York.

239 DAN FLAVIN. *Primary Pictures Series*, 1966. Fluorescent tubes, 122 × 213 cm. Courtesy Nicholas Wilder Gallery, Los Angeles. (Erratum: for Don read Dan, p. 239.)

240 ROBERT MORRIS. *Untitled*, 1966. Fibreglass with light. 91 × 122 × 229 cm. Collection The Whitney Museum of American Art, New York. Photo R. Burckhardt.

241 DONALD JUDD. *Untitled*, 1967. Galvanized iron. 37 × 190 × 65 cm. Leo Castelli Gallery, New York.

242 ROBERT MANGOLD. *Grey surface with Curved Diagonal*, 1966. Oil on masonite, 244 × 244 cm. Collection Philip Johnson, New York. Photo R. Burckhardt.

243 LARRY POONS. *Knoxville*, 1966. Acrylic on canvas, 300 × 400 cm. Collection Mrs. Christophe Thurman.

244 JO BAER. *Vertical Flanking: Small (Blue)*, 1966-67. Oil on canvas, 100 × 152 cm. Photo E. Pollitzer, New York.

245 CHARLES HINMAN. *Downward View to Left and Right*, 1964. Acrylic on canvas, 212 × 212 cm. Richard Feigen Gallery, New York. Photo E. Pollitzer, New York.

246 LEO VALLEDOR. *Prophecy*, 1965. Collection Park Place Gallery, New York. Photo J. A. Ferrari, Brooklyn.

247 FRANK STELLA. *Valparaiso Flesh* (sketch), 1964. Height 194 cm. Collection Leo Castelli Gallery, New York.

248 SOL LEWITT. *Untitled*. White-painted wood, 457 × 457 cm. Private collection. Photo J. D. Schiff, New York.

249 CARL ANDRÉ. *Exhibition*, *1966*. Tibor de Nagy Gallery, New York. Photo W. Russell, New York.

235 Barnet Newman

236 Ad Reinhardt

237 Leon Polk Smith

238 Agnes Martin

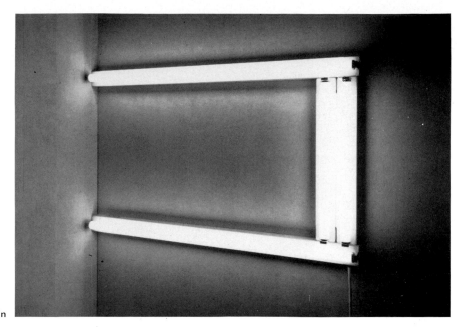

239 Don Flavin

240 Robert Morris

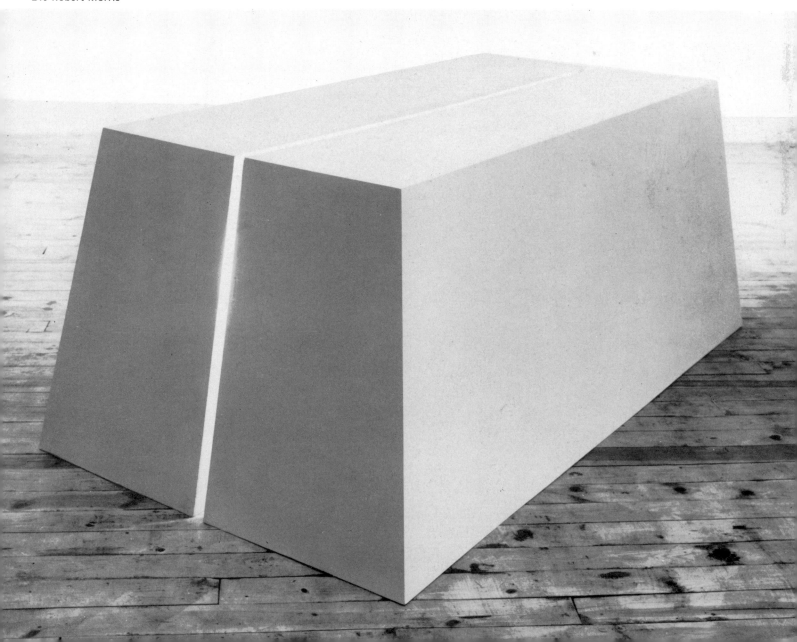

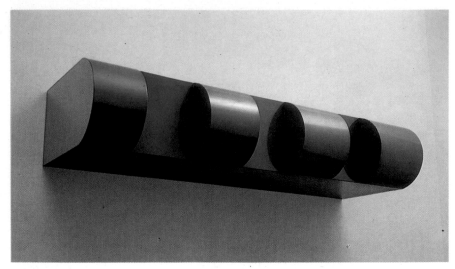

241 Donald Judd

242 Robert Mangold

243 Larry Poons

244 Jo Baer

245 Charles Hinman

246 Leo Valledor

247 Frank Stella

248 Sol LeWitt

249 Carl André

as a splash of paint, more so when the splash gets routinized.'

The concept of the open, limitless, saturated colour-field, most developed by Newman, and that of large flat areas of close-valued colour that evoke another kind of perceptual stumulus, as developed by Albers and Reinhardt, have had a wide influence on the geometric styles, especially the brief and rather vague phenomenon known as 'hard-edge' painting. The name, as Allan Kaprow has noted, 'suggests some of the blunt truth these paintings wish to convey', and Clement Greenberg has rightly pointed out that hard-edge painting 'won its hardness from the softness of painterly abstraction'. It represents the intermediate step between the heroic period of the New York School and the recent minimal styles, if seen from an evolutionary point of view, and shared with Pop art, not only a heyday, but a similar ambivalence toward its predecessors. Hard-edge painting differs from the equally flat and hygienic handling of traditional geometric art (the Arp, Herbin, Delaunay, Vasarely strain) in several basic ways: it usually consists of a single emblematic image, dominating the canvas rather than played against other parts, and with a scale far greater than earlier idioms. Above all, the image is usually not 'geometric' but a crisply contoured free form which seems geometric because of its decisive precision. (Thus, Albers is not strictly speaking a 'hard-edge painter' though he was influential; even more so were Matisse's late *découpages*, shown at the Museum of Modern Art in 1960.) The hard-edge ground is no longer 'background'; the figure is not so much on the ground as of the ground, sharing with it not only the surface but the surface action. This is furthered by strong, brilliant decorative primary colours, often complementary and close-valued, or by the restriction to black and white.

Leon Polk Smith [237] was working in this manner early in the 1950s; he, Myron Stout, Jack Youngerman, Sven Lukin, Robert Huot, Larry Zox, Will Insley, Ralph Humphrey, Doug Ohlson and Darby Bannard (though the latter's concern is with a different and complex colour experimentation) are among the still numerous exponents of these or related devices today. The most recent variation on a hard-edge style is a perverse,

incongruous illusionism in which the eye is shunted back and forth between rapidly directional shapes that contradict each other, their shaped format, their colour, or their linear configurations. Frank Stella now works in a related manner, as do Neil Williams, Charles Hinman [245], Leo Valledor [246], Ed Ruda and Ron Davis [259]. Certain sculptors (Peter Forakis, Forrest Myers, Charles Ginnever) are attempting similar effects in three dimensions, at times following the lead of the late David Smith's imposing semaphores [250], but even Smith found the reconciliation of colour and form in three-dimensions an extraordinarily difficult task. 'Hard-edge sculpture' is a redundant term, and the polychromed geometricizing sculpture related to hard-edge painting is impossibly diverse to discuss here, though the names of Tom Doyle, David Weinrib, Robert Murray, George Sugarman, Lyman Kipp, Michael Todd should be put on the record for the quality of their work.

The four most prominent hard-edge painters who come to mind are Al Held, Ellsworth Kelly, Kenneth Noland and Morris Louis, and except for the two last named, they have little in common. Held is almost unique in his retention of the intuitive roughness of the New York School, presented in huge scale, bold colour and a raw yet simple image. His controlled dynamism influenced, but now has little to do with, the much drier and more scientifically inclined Park Place Gallery painters, whose preoccupation with ambiguous spatial effects and colour is more related to the short-lived Op art movement.

Kelly [251], whose work around 1962 epitomized the hard-edge idiom to many, comes from a different tradition, having lived in Paris from 1948 to 1954 and evolved there a geometric style after exposure to Vasarely and other Europeans. Yet the rows of modular panels, each a different colour, made first in Paris and restated periodically since then, now seem most prophetic.

As Albers calls his proportionately centred *Homage to the square* series the 'dish' in which he 'serves his colour interactions', so Kelly considers the panels merely neutral containers for his own vibrant colour. In the 'hard-edge' work, a single, immense image often overflowed its framing edges

and crowded the colour-ground into small areas that forced reconsideration of the figure-ground relationship (at least this ambiguity was remarked by admirers; Kelly had no such intentions). His occasional sculpture prefigures the 'new English sculpture' in its extreme planar thinness and contour.

Noland [253, S. 59] and Louis [254] were the founders of the 'Washington Colour School', and early exponents of the repeated non-relational motif (concentric circles, chevrons, and bands in Noland's case, veils, bands, stripes in Louis's). They used the device less for formal innovation or variety than to support a very intense saturated colour, stained into the canvas and thus totally identified with the surface, a technique adapted from Pollock and Helen Frankenthaler [42] (in whose work it is employed toward a softer, flowing effect, as it was by the early Morris Louis).

Gradually hardening both edges and concept, Louis and Noland, and, in some paintings around 1962-63, Jules Olitski [45], achieved a powerfully substantial style which at best achieves Newman's passionately heightened chromatic grandeur. Paul Feeley, Tom Downing and Gene Davis have employed similar effects, and the latter's tautly striped canvases in erratic, pungent hues are related to music, as are the underlying structures of the most important younger colour painter, Larry Poons [243]. Poons's discs and ovals on solid fields give the impression of disorder despite his serially regulated schemas, but it is a disorder characterized, paradoxically, by clarity and wholeness in the best structural genre.

As responsible as most painters for the rise of hard-edge and colour painting was the critic Clement Greenberg, who proposes a Marxist interpretation of modernist painting in terms of a dialectical necessity to evolve and conform to painting's essential nature – that of the flat, two-dimensional, rectangular surface. It was Greenberg who brought the triumvirate of Newman, Rothko and Clyfford Still back to attention, and Greenberg who, during his investigation of possible directions for a 'Post Painterly Abstraction', influenced an entire younger generation (in New York and California and in England and Canada) to emulate the principles of 'openness and clarity'

he cited as characteristic of the rising style. He also nominated Noland and Louis as heirs apparent to Pollock and Newman, acting as midwife to their development, introducing them to Frankenthaler's work, and keeping an eye on their painting until it was ready for public consumption. His sensitivity to the artists' needs and ideas is exceptional, though since around 1963 he has expressed increasing dissatisfaction with the extreme direction in which openness and clarity were leading the younger generation; his sympathy with and comprehension of 'minimal' art is minimal indeed, and his partisan criticism has, interestingly enough, been replaced with writings by several of the most conceptually oriented minimal artists themselves.

The Greenbergian formalist and evolutionary criticism has been particularly appropriate to the manner in which the artists themselves see their task. The new styles have been called 'self-critical', and are dependent on the old in the sense that 'Modernism uses art to call attention to art' (Greenberg). While some of the Pop artists made 'art about art', many abstractionists were painting about painting in a more general sense, insisting upon certain 'problems' as yet unsolved or unexhausted by their predecessors. Dedication to continual advance is apparent in many younger artists' espousal of the cult of the difficult (at times mistaken for the cult of novelty), their habit of demanding more and more of their art and their ideas. The furious speed with which styles and trends replace each other in the American art world has its basis less in commercialism than in the artists' determination to avoid an 'easy art', though commercialism is too often a by-product. There is, in fact, a search for ever more rigorous standards with which to offset the instant acceptance of a buying public. *Épater le bourgeois* is no longer so necessary as to outrun the eager appreciators.

Though Andy Warhol's assembly-line art, his adaptation of Duchamp's mechanical Bride to the electric age, eventually reached a new pinnacle of acceptance, conceptually it was of great importance to the developments mentioned above. Pop art in general has been important to abstract art, and its antecedents can be found in the formalist as well as in the anti-formalist strain. Roy Lichten-

stein, for instance, with his diagrams and reductions, can be seen as a disguised formalist who disdains restriction to a single camp. Warhol's and Oldenburg's introduction of new media and subject matter have had an obvious effect on the 'funky' or 'eccentric' branches of a structural art (Frank Viner, Eva Hesse, Bruce Nauman), and there has been for some time a growing group of geometricizing abstract painters and sculptors who lean a little more to Pop acerbity and the 'professional con' game than most, notably Richard Artschwager [256], Billy Al Bengston, and Nicholas Krushenick. A distinct rapport with the exaggeration (amounting at times to Mannerism) of Pop art, and with its exuberance, harshness and arrogance, is reflected in the streamlined shapes, the colours (pale, insipid, acid and garish), surfaces (vinyls, enamels, day-glo paint, formica, plexiglass) and textures (metallic, pearlescent, fluorescent), and all the flagrantly artificial effects not found in previous abstraction. Neon, cloth and rubber are now accepted as perfectly workable sculptural media.

Los Angeles is the second centre of a hedonistically precise style, of which Larry Bell's translucent mirror cubes [258] and John McCracken's glowing monochromatic planks and boxes [257] are typical. Ron Davis [259] has fused a strong formalist awareness of advanced painting's possibilities with an atypically idiosyncratic approach in his careening perspective renditions of fibreglass box-like shapes that boast a peculiar richness and density despite their wholly geometric foundations. Clark Murray, Craig Kauffman and occasional Californians John Chamberlain, Richard van Buren and David Novros have departed from similar fusions.

Donald Judd [241, S. 56] is perhaps the major example of an artist who has exploited the new media and materials and colours without in turn being exploited by them. Within his assertive but detached frameworks, serial, modular and factual, aggressive but beautiful colour has recently taken on added importance, acting both as armour against the spectator's personal associations and as invitation to a perceptual experience. Both Judd's and Davis's work illustrates the offhand acceptance of, but lack of reliance on, technique and precision that is often neglected in

discussions of rejective art. The Southern Californian 'finish fetish' was less widespread than might be thought, and it was hard-edge painting and the earlier geometric sculpture, rather than structures and minimal painting, that subscribed to any sort of technological perfection as end over means.

This is not to say that there has been any return to the autobiographical painterliness of abstract expressionism, but artists whose work is as 'clean' as Stella's, Bladen's or Poons's, allow and sometimes seem to encourage accidental imperfections – not, they hasten to point out, to stress the 'hand of the artist', but to relegate technical perfection to its proper role in the creative process; that role is minor. The kind of impersonality some of these painters are after has more to do with Matisse's methods when making the *découpages*, in which he 'drew with scissors', guaranteeing himself (whether intentionally or not) a certain degree of detachment. Painters like Ron Davis, Robert Ryman [255] or Brice Marden (and Johns before them in a figurative context) can continue to employ a visible brushstroke, and paint that keeps its identity as paint while discarding the emotional clichés of action painting as well as the refinements of a lyrical impressionism. Ryman's mottled all-white paintings on sheet steel, flat against the wall, have greyish areas that evoke nothing but paint, and the plane is painted plane alone, not object, not framed picture.

Much of the new art is, therefore, anti-mechanical. The procedure of sending the sculptures out to be executed by professional craftsmen is not, as some would have it, in homage to industry or in protest against 'humanism', though this is not always an unwelcome by-product. It is, on the contrary, a matter of working against the temptation to become too involved in craft rather than concept.

In the 1930s, Moholy-Nagy painted three pictures by telephone. His wife has explained this: 'He had to prove to himself the supra-individualism of the constructivist concept, the existence of objective visual values, independent of the artist's inspiration and his specific *peinture*. He dictated his painting to the foreman of a sign factory, using a colour chart and an order blank of graph paper to specify the location of form elements and

their exact hue. The transmitted sketch was executed in three different sizes to demonstrate through modifications of density and space relationships the importance of structure and its emotional impact.'

Such a gesture was, therefore, ideological; today's frequent fabrication is practical. In 1950, Alexander Liberman also had paintings executed by others, yet today no American painter, no matter how 'impersonal', has done so to my knowledge. Stella has said he would, but since his execution is, despite himself, very much his own, it would surprise me if he went through with it. Josef Albers, of Moholy's generation, has pointed out that he based work on *Die Reihung*, or the serial concept of the row, over forty years ago, and that this concept, related to and arising from the machine line of identical products, 'led to a new aesthetic experience emphasizing a belief in human ability, providing new insight into human experience'. He saw the ability to repeat without variation as a positive advance; for the machine, after all, is an accomplishment of man.

It has often been contended, rightly, that the new structural art has its origins in both maintreams of modern art – that of Duchamp's readymade and that of Albers' Row. It is interesting to add that both these mainstreams, anti-formal and formal, devolve to a considerable extent from the twentieth-century machine mystique, now altered and continued in the electronic age of which Marshall McLuhan is an appropriate recorder. As the anthropologist Edmund Carpenter has put it, 'Electricity is not just another machine; it is antimachine. It makes machines obsolete. It is more organic than anything. It unites everyone.' The artists who now send their work out to be constructed avoid allusions to machine forms as assiduously as they avoid allusions to anything else outside the object; the process of manufacture, by artist or artisan, is forced into anonymity.

Analogies have also been made between 'primary structure' or monotonal painting and architecture. There are individual cases that bear out such a comparison, at least in background. Tony Smith [262], an isolated figure whose structures were chronologically the first, but were seen by no one, was an architect until 1960, and Robert Grosvenor [261], who has said that he wants his work thought of not as large sculpture but as 'ideas which operate in the space between floor and ceiling', studied naval architecture. Robert Morris, when asked about the origins of his steadfastly antipictorial objects, replied that an early one was inspired by the pyramids of Zoser. And John McCracken relates his work to 'architectural monuments of the past: Stonehenge, Egyptian pyramids and various other structures... but it has nothing to do with the past itself. It's a matter of finding those particular forms which seem expressive of a kind of very high level of human consciousness.' The connection with architecture is, therefore, of the most general kind, based on a common anonymity and public scale, broad, undetailed surfaces and logical sequences of form. Yet none of the new sculpture attempts to envelop the spectator, though some of it, namely LeWitt's modular frameworks and André's styrofoam bars and low firebricks, envelops space in a provocative manner. The environmental aspect has been largely disregarded in favour of placement and scale in relation to the viewer. The idea is not to surround but to isolate and confront.

The 'real' or literal space occupied by the structures is intended to provide new spatial experiences in relation to the work and the way it fills a particular (though not predetermined) public space, not to evoke other images or experiences.

The most controversial fact about the new art is generally its pronounced, even exaggerated conceptualism, its desire for visual inertia and cerebral vitality (though this, like all the other statements here, does not apply to all the work – especially not to Ronald Bladen's) [260]. Sol LeWitt [248] likes the idea that a blind man could enjoy his art; its finite conclusion of a logical, self-generating scheme is as important to him as the way it looks. Carl André had a show in New York in which flat rectangles of white bricks made a numerically established pattern on the floor; a year later the same rectangles made up his Los Angeles show, but this time the floor was covered by bricks and the rectangular pattern was empty space, or floor. Peter Young works from a system of binary numbers, and an increasingly broad interest in science and mathematics (re-visualized rather than illustrated) is evident

lately. Most of the artists are extremely leery of dependence upon science as such, or of imitating elementary design exercises. Yet many of them perceive, like Bertrand Russell, 'the aesthetic pleasure to be derived from an elegant piece of mathematical reasoning', and find it can be successfully applied to visual concerns if sufficiently disguised. As Tony Magar has put it, 'When I read math books I find myself reinterpreting things.'

This is, of course, nothing new. From the Middle Ages to the cubists' *Section d'Or*, the order inherent in mathematical solutions has attracted artists. Nor is it new in America. In 1950 the short-lived periodical *trans/formation* stressed 'arts, communication, environment', and affirmed that 'art, science, technology are interacting components of the *total human enterprise*'. From such approaches a good deal of value and a good deal of artificial synthesizing has resulted. One can hardly say that geometry, for instance, is good or bad for art.

It can be a useful tool, however, and the conceptual bent of current art provokes natural affinities with the empirical method. For the methods and the approach, rather than the forms or appearances of scientific models, fascinate most of today's younger artists. Perhaps the two most popular disciplines are topology and crystallography, both relatively new sciences and both offering an element of freedom not found in traditional Euclidian geometry. As the metallurgist Cyril Stanley Smith has observed: 'There is a close analogy between a work of art which suggests an interplay of dimensions, and the real internal structure of a piece of metal or rock which results in physical interactions between the atoms and electrons composing it.' In crystals the 'plane of disorder' coexists with the structural order of the polyhedra. Thus concepts germane to both maintreams of modern art are incorporated – order from the traditional geometrical strains, disorder and the acceptance of the 'laws of chance' from the Dada-surrealist strains.

Topology had been explored for some time by Max Bill before most Americans were aware of its possibilities, and Bill's influence on the Park Place group has resulted in similar experiments in one-surface and continuous volume forms. Yet the fantastic propensity for distortion, and for free, unique forms and effects had been neglected, and the concepts were usually illustrated rather than absorbed into a new aesthetic. The possibilities of topology are just beginning to be explored. Charles Hinman [245] has for some time demonstrated an area of 'rubber sheet geometry' in his shaped canvases, which set out from the basic idea that a shape can be both itself and its apparent opposite, or innumerable other potential shapes, both rectilinear and biomorphic. Tony Smith [262, S. 61], whose massive black structures are conceived as parts of a continuous space lattice suggested by crystal structures, also utilizes a topological continuity in the radical changes that transform his work as the viewer moves around them. Smith's projected inflatable sculpture will utilize still more specifically the topological capacity for transformation. He relates it to surrealism (which, like topology, has been called a 'state of mind'), to the writings of James Joyce, and to psychoanalysis.

Thus, topology is attractive to the artist not for fixed systems, like older geometry, but for its extreme flexibility and power of formal suggestion. Topology seems to transcend geometry. Steven Barr has written: 'A topologist is interested in those properties of a thing that, while they are in a sense geometrical, are the most permanent – the ones that will survive distortion and stretching.' Both topology and crystallography are characterized by that anti-dualism, that fusion of romantic and classical motives, which marks the new art. A topological form is geometric but looks organic; crystals are organic but look geometric. Thus Fritz Glarner's protest against the very term 'geometric abstraction', because art is by nature intuitive, and Burgoyne Diller's preference for the term 'organic form' instead of 'geometric form' (since 'the latter suggests measurement') have given way to Donald Judd's non-committal words: 'The main virtue of geometric shapes is that they aren't organic, as all art otherwise is. A form that isn't either geometric or organic would be a great discovery.' No longer associated with classical, impersonal or universal art alone, geometry in its broadest sense, and the geometric idioms, are showing themselves adaptable to any persuasion, perhaps taking their place, with physics, as this century's most glamorous

science, like natural history in the nineteenth century.

In any case, the great diversity of intent among the unifying, geometricizing artists indicates that within the self-imposed restrictions and rejections of the new art lie as many possibilities for divergence from a norm as in any other art.

Plates 250-262

250 DAVID SMITH. *Zig VIII I/15-64*. 1964. Painted steel, 255.9 × 222.2 cm. Marlborough-Gerson Gallery, New York.

251 ELLSWORTH KELLY. *Red–Blue–Green–Yellow*. 1965. 218 × 135 × 218 cm. Sidney Janis Gallery, New York. Photo G. Clements, New York.

252 AL HELD. *Blue Moon meets Green Marine*, 1965. Acrylic on paper on masonite, 67 × 48 cm. André Emmerich Gallery, New York. Photo R. Burckhardt.

253 KENNETH NOLAND. *Saturday Night*, 1965. Acrylic on canvas, 218 × 218 cm. Private collection. Photo Courtesy André Emmerich Gallery, New York.

254 MORRIS LOUIS. *Sky Gamut*, 1961. Acrylic on canvas. 230 × 143 cm. Private collection. Photo courtesy André Emmerich Gallery, New York.

255 ROBERT RYMAN. *Standard*, 1967. Oil on steel, 122 × 122 cm. Bianchini Gallery, New York.

256 RICHARD ARTSCHWAGER. *Untitled*, 1966. Formica on wood, 150 × 47 × 78 cm. Leo Castelli Gallery, New York, Photo R. Burckhardt.

257 JOHN MCCRACKEN. *Blue Board*, 1966. Plywood, fibreglass and lacquer, 213 × 117 × 1.3 cm. Collection R. Mayer, Chicago.

258 LARRY BELL. *Exhibition of Cubes*, 1967. Galerie Sonnabend, Paris. Photo A. Morain, Paris.

259 RON DAVIS. *Six Ninths, Yellow*. Plastic, fibreglass and wood, 182 × 333 cm. Nicholas Wilder Gallery, Los Angeles. Photo Fran J. Thomas, Los Angeles.

260 RONALD BLADEN. *Untitled*, 1966. Wood (for execution in metal), 245 × 245 × 490 cm. Courtesy Fischbach Gallery, New York.

261 ROBERT GROSVENOR. *Transoxiana*, 1965. Wood, polyester and steel, 320 × 945 × 91.5 cm. Park Place Gallery, New York. Photo R. Burckhardt.

262 TONY SMITH. *The Snake is Out*, 1962-66. Wood, 457 × 732 × 457 cm. Courtesy Fischbach Gallery, New York.

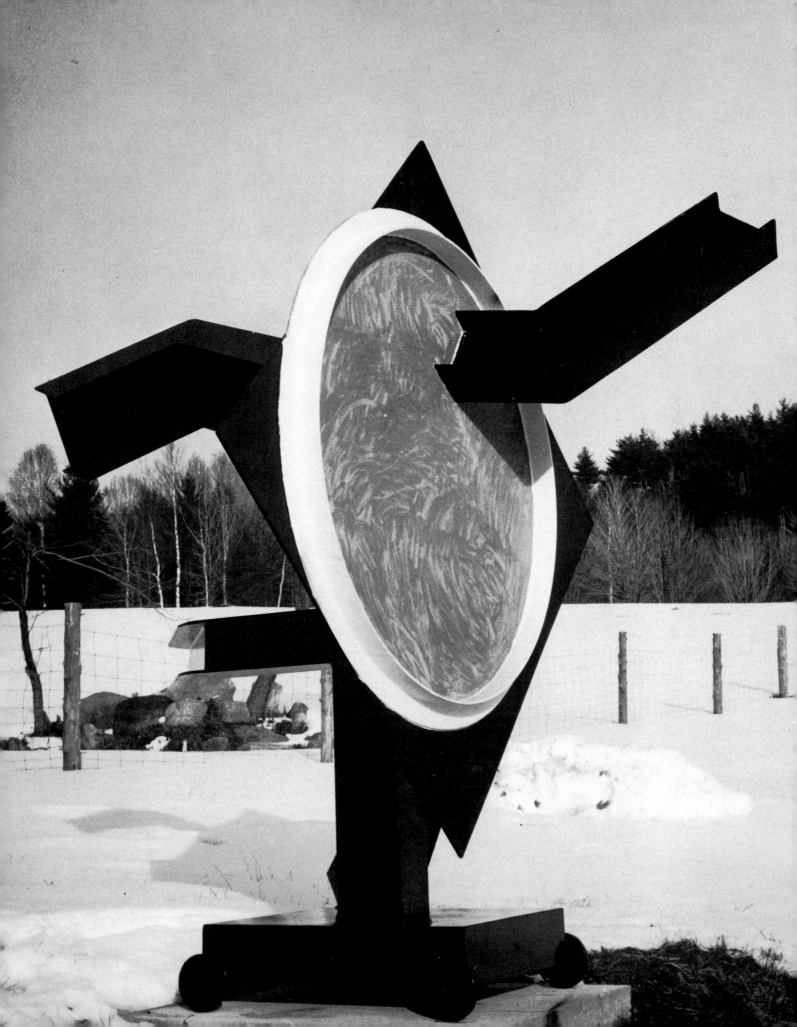

251 Ellsworth Kelly

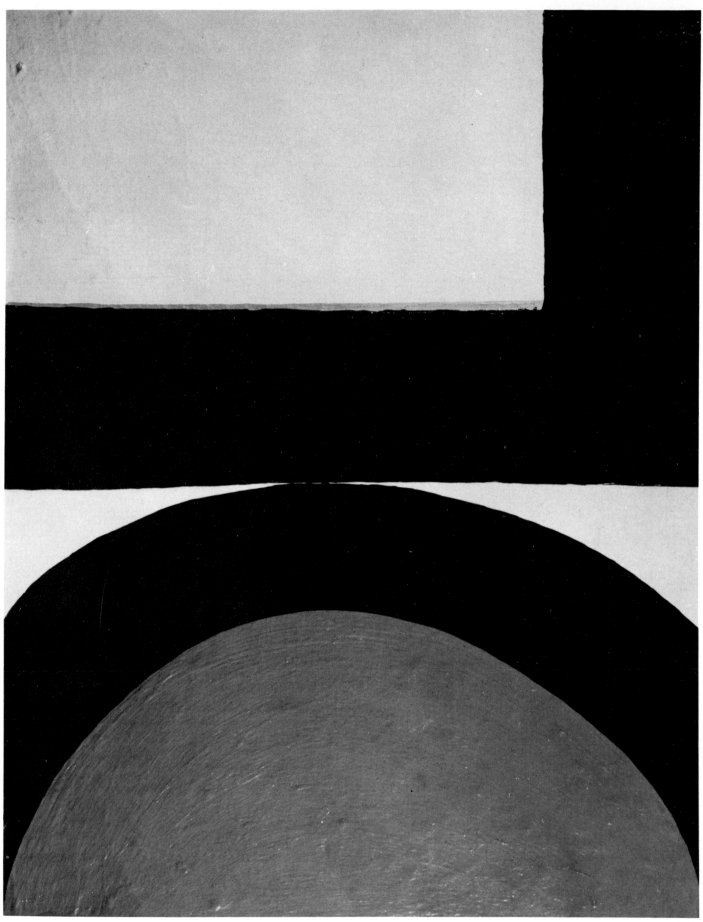

252 Al Held

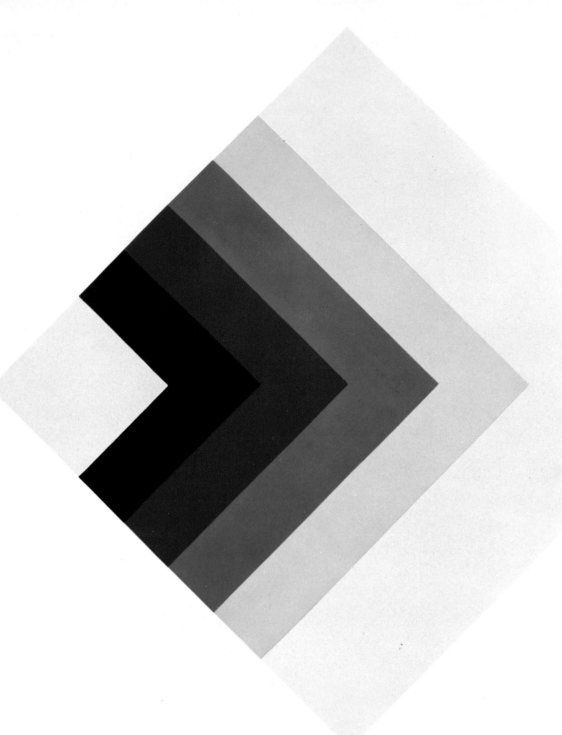

253 Kenneth Noland

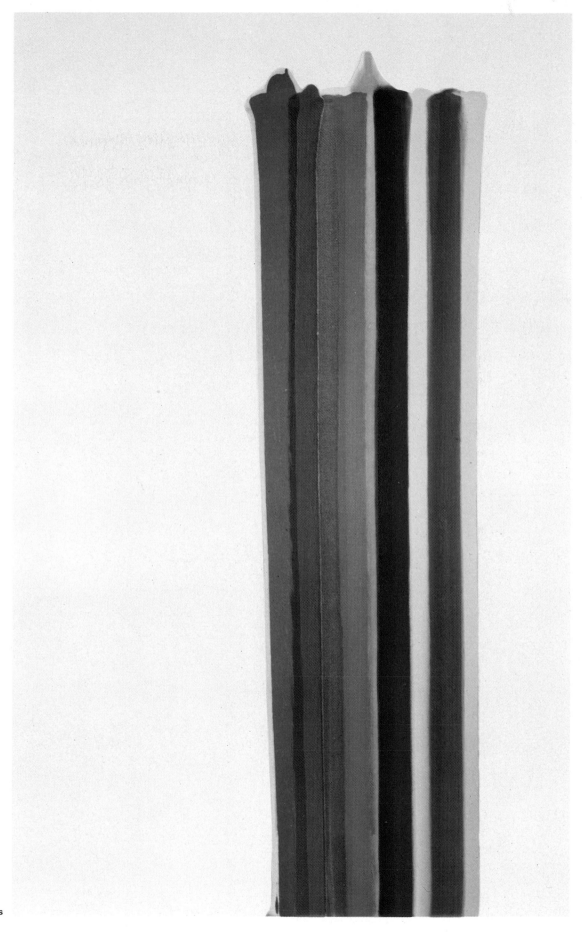

254 Morris Louis

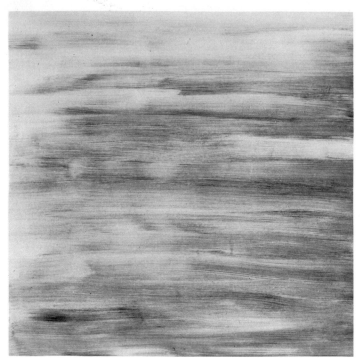

255 Robert Ryman

257 John McCracken

256 Richard Artschwager

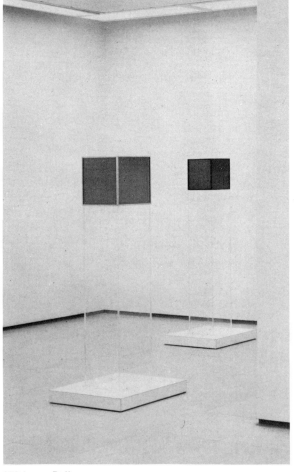

258 Larry Bell

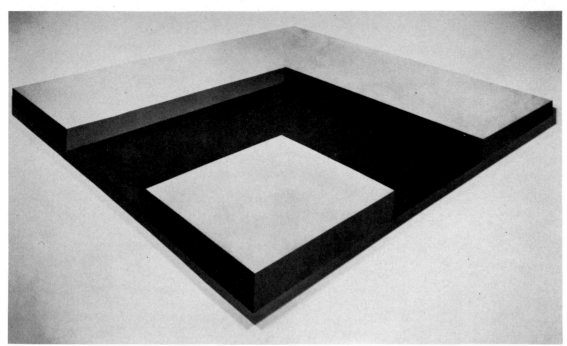

259 Ron Davis

260 Ronald Bladen

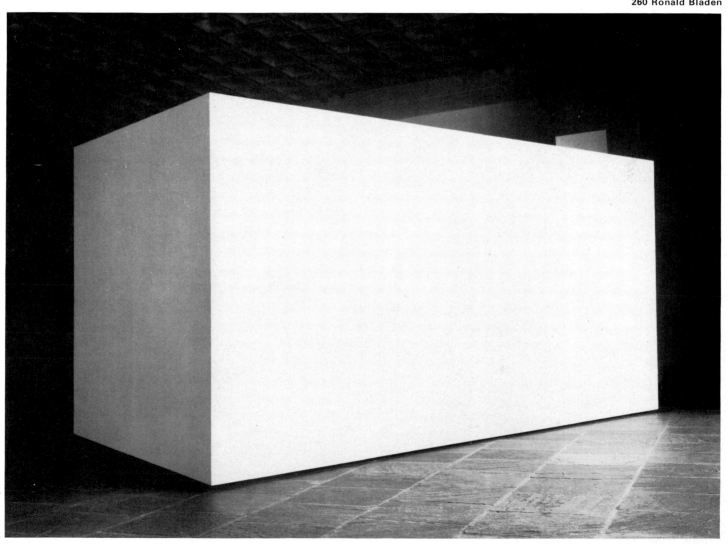

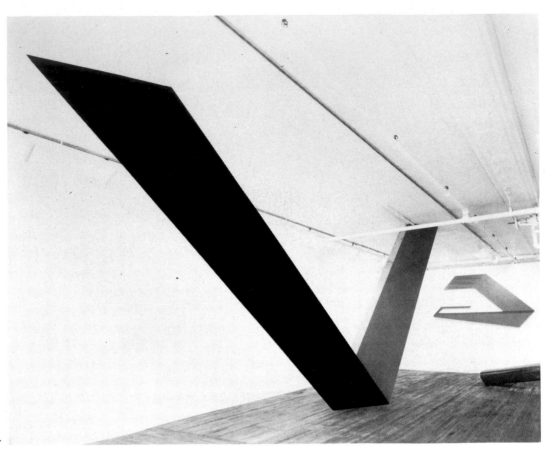

261 Robert Grosvenor

262 Tony Smith

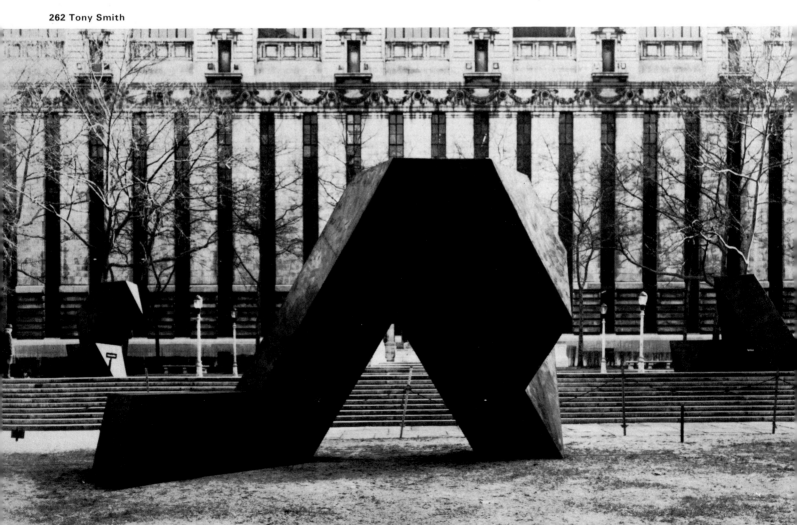

Time – Light – Motion

OTO BIHALJI-MERIN

Movement underlies all growth.
PAUL KLEE, 1920

Light is the primary condition for all visibility. Light is the sphere of colour. Light is the vital element of man and image.
OTTO PIENE, 1964

Perception, a continuum born of space and time at the speed of light, transcends the visual definition of the world represented in the classic arts. The dynamic art of our time seeks to project a realm distinct from the spatial concepts formed by our sense organs; as well as the three traditional dimensions there is now a fourth, the dimension of time. Major trends in modern art are concerned with movement and light as new creative elements. Artificial light and movement, self-expressed rather than represented, light as actual radiation rather than optical illusion – these accord with the neo-realistic mode of response that has erupted in the second half of the twentieth century, as do real objects mounted into a work of art in place of their images.

Movement and light as creative elements in art are intimately linked to the space-time concepts of modern science. Einstein's theory of relativity has affected not only the world of physics but the world of art as well. Minkovsky's non-Euclidian approach, in which 'space and time join hands to form the world' holds the mathematical foundations for the four-dimensional concept of space. Atomic physics has been joined by the science of electronically guided machines, cybernetics.

The time-space art of light and motion looks forward to the creation and interpretation of a reality complex for which no model as yet exists, and for which the mind of man is scarcely prepared. There is no such thing as time in the objective sense. What we call time is in fact a coordinate in the four-dimensional continuum. Neither magic nor traditional art can capture the time-space dimension. It can be visualized only in movement.

Nor is there any such thing as motion in the absolute sense. Movement is unity of space and time – it is always relative to a point in space which is itself in motion, or which only seems to be at rest.

It is true that even in times past artists have tried to represent movement, as the displacement of a body, arrested at a single instant in time; but movement itself could never be represented, only suggested. It is entirely probable that Degas and Toulouse-Lautrec, in addition to studying horses at the racetrack, were familiar with the experimental photographs of Eadweard Muybridge and Etienne Jules Marey, which analysed the movements of galloping horses and running men in sequential shots.

The first Futurist Manifesto, published in the Paris *Le Figaro* in 1909, asserted that a trotting horse had not four legs but twenty. In keeping with this formula Giacomo Balla painted his *Dog on a Leash*. Gino Severini's *Dancer with Tambourine* and Luigi Russolo's *Dynamismo* reflect the experience of speed, of tumbling, of movement, are an effort to express temporal duration in space.

Unlike the futurists, Marcel Duchamp was not idealizing the dynamism of the machine in his *Nude descending a Staircase*, painted in 1912. He was rather showing the objectification and alienation of man in a mechanized world. A year later he mounted a bicycle wheel on a stool, creating the first Readymade and the first Mobile, and at the same time introducing the concept of 'Anti-art'. In terms of style Duchamp's kinetic object, the whirling wheel, was the Dadaist answer to the weird, inhuman motion of a mechanized civil-

ization. Lifting objects from their context and turning them into non-functional engines, the artist was combining elements of humour, horror, emptiness and negation.

Detachment from the world of appearances was recognizable in the cubist works of Picasso and Braque – the dissection of physical reality into constructs of geometrical facets beneath whose surfaces lay hidden impulses of power and movement. Picasso's *Girl playing the Violin* (1910), *Accordion Player* (1911) and *Guitar Player* (1911-12), like Braque's *Portuguese Woman* (1911) and *Man with Guitar* (1914), were marked with the dynamism that had also inspired the futurists.

In Russia the analytical trends of cubism blended with the kinetic notions of futurism. Natalya Goncharova painted her *Bicycle Rider* (1912-13), David Burliuk his *Woodchopper* (1912), Kazimir Malevich his *Scissors-grinder* (1912). In Malevich's picture the relation to the visible world already slackens. What preoccupied the artist was not the scissors-grinder himself but the problem of rhythm and movement. The dominant element is the inclusion of the time motif – the serial structure of motion phases, multiplication of the hand at work, the spinning wheel. Malevich reached the limits of the possible. He abandoned all objectivism and landed on the shores of Suprematism, of non-objective painting. The picture that epitomizes this dematerialized vision, a flat white surface, represented his final step towards non-form, towards liberation from traditional concepts, towards the white square of light, the archetype of all begining.

Malevich, Tatlin, Rodzhenko and Lissitzky worked towards encompassing the space-time dimension within the media of art. In 1924 Lissitzky wrote of the necessity for overcoming earth-bound gravitation, to the end of creating hovering bodies in motion: 'Every form is the frozen snapshot of a process. Hence a work of art marks a temporary halt on the way rather than a rigid goal.' Tatlin's design for a steel construction with orbiting spatial elements, *Monument to the Third International* (1920), was conceived as a synthesis of architecture and moving sculpture.

Antoine Pevsner and Naum Gabo [S. 62], in their Realist Manifesto published in 1920, formulated the theoretical foundations for kinetic art: 'We cast off the age-old error of art, dating back to Egypt, that only static rhythms can be the elements of art. We proclaim that kinetic rhythms are the basic forms of our time as we see it, the major elements of art.'

METAMORPHOSES OF LIGHT

Colour and light have always been the elements underlying the metamorphosis and the spiritualization of painting. The indwelling shimmer of the gold ground in Byzantine mosaics and icons symbolized the all-embracing unreality of space. The stained-glass windows of Gothic cathedrals, transparent compositions in diaphanous hues, were pervaded with luminous and supernatural tension. It was Leonardo da Vinci who saw that even shadows held colour. Bellini and Giorgione translated the gleaming light of magic Venice into atmospheric colour. The universe of Tintoretto was staged colour, dramatized light. Caravaggio, Velázquez and Rubens used light, natural and man-made, to look deep into the nature of life. Through the chiaroscuro of his pigments Rembrandt perceived the solitude of the individual in the infinity of time-space. Vermeer filtered his light to create a cleansed world of propinquity and colour. The solemn gloom of Georges de la Tour sublimated light into a synthesis of existence and eternity.

From the Renaissance to expressionism, light was forever in the service of the object. Whatever was represented in art was revealed in the illumination from a light source beyond the picture. Impressionist painting, for the first time in the history of art, no longer represented things as such but things reflected and captured in the passing moment. Thingness and recognition are downgraded or relinquished in favour of dynamics and sensory stimulation. The fragmentary has become essential – the hint, the preciousness of colour, the structure of the *matière*.

To the emotional fervour of expressionism, analytical cubism opposed the chill vision of geometrical form. Physical reality is dissected and arranged in tectonic facets. Inspired by telescope and X-ray, artists peered into a world of form to which there was as yet no catalogue. The struggle to force light to come to terms with the physical world, begun by Picasso and Braque, was carried

forward by Robert Delaunay, who called light the sole reality. Orphic Cubism elevated light to the level of representation in its own right, orchestrating it through colours which had become translucent.

Light in abstract art is the light of colour, the emanation of matter. In Mondrian, brightness becomes an element of a puritan spiritual catharsis. Kandinsky's brush takes the soaring light of the spheres to the outermost limits of absolute painting, dematerializing it in the process. To Willi Baumeister light and colour evoke space and time. The chromatic discs of E. W. Nay [93], orchestrated like a choir of voices, become rhythmic ornaments of light and colour.

The painters of the nineteenth century discovered the floating movements of natural light, unmixed in hue, as well as of coloured shadows. In the second half of the twentieth century an avant-garde is once again turning from natural to artificial light. They employ electromagnetic vibrations and frequencies, each of which corresponds to a colour in the spectrum. Although light on its own, it is not colour radiation as such but rather electronically programmed and guided artificial light.

SYNTHESIS OF LIGHT AND MOTION

The motion picture began to develop before the turn of the century. Primitive at first, it was nevertheless in accord with the spirit of the age. Image and motion are blended in it in a way that permits the optical projection of the time dimension as a creative element. The invention of light-engendered serial images that could form moving photography, the possibility of cross-cutting alternative lines of action, the use of slow motion and accelerated motion cinematography: these exerted a profound influence on twentieth-century art.

There had been attempts to express movement, colour and sound in terms of light even before the invention of the film. The magic lantern, invented in 1646 by Athanasius Kircher, was a device of the *ars magna lucis et umbrae*. The Jesuit Bertrand Castel presented a synthesis of music and coloured light in 1734 with his *clavecin oculaire*. In 1895 A. W. Rimington, London professor of fine arts, demonstrated a coloured-light music inspired by Turner's paintings. There were other pioneers

and precursors of a new art of light: at the turn of the century the experiments of Thomas Wilfred that were to have an influence on later developments; the Prometheus Symphony by Alexander Scriabin, performed in Carnegie Hall, New York, in 1914, with an accompaniment of coloured light shapes projected by the composer; the 'optophonic' concert given in Moscow in 1919 by the abstract painter W. Baronov-Rossiné with the help of a device that projected colour rhythms synchronized with the music. They may be compared with Leonardo's designs for flying machines, inspired in conception but beyond proper execution, because the science and above all the technology were not yet available.

During the 1920s a number of artists were concerned with translating cinematic light rhythms into the language of painting. Panel and scroll were developed into sequential temporal rhythms by Vikking Eggeling in his *Horizontal-Vertical Mass* and by Hans Richter [204] in his film *Präludium*. Richter showed me his scrolls in his Locarno studio in 1964. After forty years, during which they have inspired numerous pictures-in-motion, they still kindle the same impulse – to arrest time and let it run backwards.

During this same art phase Man Ray constructed a collage he called *Object for Destruction*. At a Dada exhibition in Paris in 1957 a young man who fancied the moving eye was following him fired a gun at it and destroyed it. Man Ray made a new version of his early work, now calling it *Indestructible Object*. To me this metronome with the eye moving on its pendulum seems a symbolic rejection of central perspective, pointing to the time continuum that can be grasped in visual terms by movement and light alone.

In the past light and darkness were easily distinguished. Light meant the brightness of day that issued from the sun's cosmic force. Dark meant the absence of sunlight: night. This rhythm of light and dark inherent in nature has long since disappeared in the great cities of man, who has created artificial light. This improvised symphony, this interplay of functional illumination – neon lights, signals, flashing advertising signs – cried out to be deliberately coordinated by the artist, using the technology of light to programme it as a projection of his creative will.

Systematic experimentation was conducted after the First World War at the Bauhaus in Weimar. Around 1923 a group composed of Ludwig Hirschfeld-Mack, Josef Hartwig and Kurt Schwerdtfeger worked on putting together what they called 'reflector cinema', actually a further development of the experimental work begun by Wilfred. The light-bearing figurines for the *Triadisches Ballett* took form at the same time in Oskar Schlemmer's Bauhaus studio. Moholy-Nagy's project for a 'total theatre' of spatial music and optical motion belongs to this same circle. These projects concerned with light reached the point of impinging on scientific investigation.

Frank Popper, for many years a close observer of the development of lumino-dynamic art, has subjected it to theoretical analysis, and his knowledge has exerted a considerable influence. He stresses the importance of science in kinetic art, of borrowing the modalities of cinematography: projector, screen, sequential programming.

Moholy-Nagy with his light-space modulator was followed and outdistanced by Nicolas Schöffer [273, 274, S. 64] with his dynamo-spatial and lumino-plastic constructions. Photoelectric cells, computers and microphones are synchronized to create novel spectacles hitherto unknown.

PASSIVE AND ACTIVE MOVEMENT

Joseph Albers [165, S. 42], in comprehensive cyclical experiments, studied the interactions of complementary colours by placing square within square to produce dazzle effects. Max Bill [209, 210, S. 49] used colour as an inexhaustible source of powerfully creative optics. Johannes Itten [203] viewed colour, rhythmically organized, as the basic stuff of the spirit.

The art of Vasarely [189-202, S. 51], the 'Raphael of kinetic drawing', has already become all but classic. It is a psychological art that triggers sensations of movement in the beholder, whose eye is set oscillating by Vasarely's multidimensional condensations of visible space, his studies in movement with their movable, superimposed transparent panels, his sculptures employing linear grids. These may be properly described as works embodying passive movement.

Art based on compass and grid requires intellectual discipline, technical precision and visual mobility.

Plates 263-279

263 LASZLO MOHOLY-NAGY. *Light Space Modulator*, 1923-30. Steel, height 151 cm., base 69 × 69 cm. Busch-Reisinger Museum, Harvard University, Cambridge, Mass. Gift of Mrs Sibyl Moholy-Nagy.

264 GETULIO ALVIANI. *Surface with vibratile texture*, 1962. Aluminium, 70 × 70 cm. Property of the artist.

265 GIOVANNI ANTONIO COSTA. *Visual Dynamic, No. 21*, 1963. 85 × 85 cm. Galerie Denise René, Paris.

266 IVAN PICELJ. *Itta*, 1966. 89.5 × 89.5 cm. Photo B. Balic, Zagreb.

267 WALTER LEBLANC. *Mobilo-static Torsion*, 1965. Property of the artist.

268 YAACOV AGAM. *New Year*, 1967. Oil on relief in aluminium, 45 × 54 cm. Private collection. Photo Hammel, Paris.

269 YAACOV AGAM. 3 views of *New Year*.

270 Yaacov Agam's studio. Photo A. Morain, Paris.

271 HUGO DEMARCO. *Continual Movement*, 1966. 84 × 84 × 23 cm. Private collection. Photo J. Masson, Paris.

272 CARLOS CRUZ-DIEZ. *Physichromy No. 177*, 1965. Wood and plastic, 22 × 43 cm. Galerie Denise René, Paris.

273 NICOLAS SCHÖFFER. *Expansive Lumino-dynamic*. Galerie Denise René, Paris.

274 NICOLAS SCHÖFFER. *Microtime 10*, 1964, 95 × 53 cm. Galerie Denise René, Paris. Photo Y. Hervochon, Paris.

275 and 276 YAACOV AGAM. *Rhythmical Space: Let There be Light!* 1962. Modulation of light by sound. Architect: Pierre Faucheux. Photo H. Gloaguen.

277 PIOTR KOWALSKI. *Pyramid*, 1967. Steel and fluorescent green plexiglass. Éditions Claude Givaudon, Paris. Photo Pierre Joly - Véra Cardot, Paris.

278 LILIANE LIJN. *Liquid Reflections (Saturnian)* I, 1966. Plexiglass, water and steel. Private collection.

279 JÉSUS-RAPHAËL SOTO. *Spiral*, 1955. Private collection. Photo A. Morain, Paris.

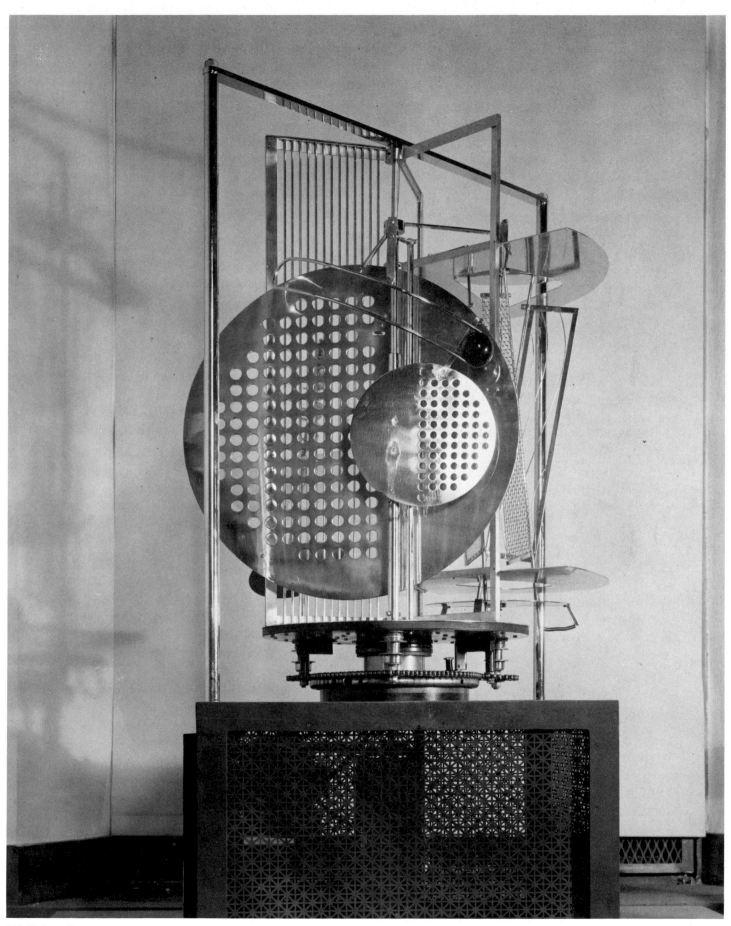

263 Moholy-Nagy

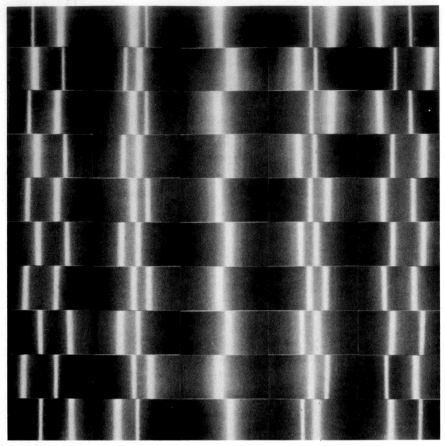

264 Getulio Alviani

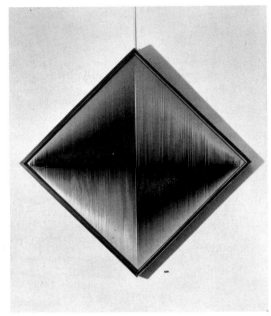

265 Giovanni Antonio Costa

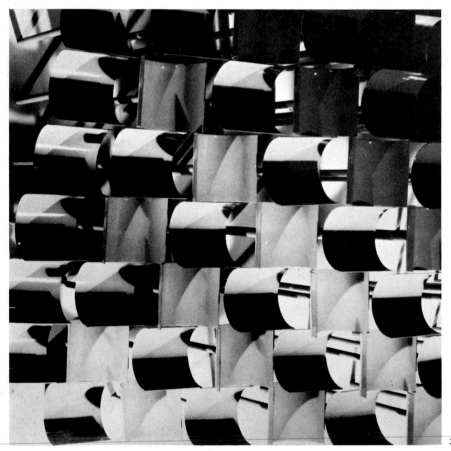

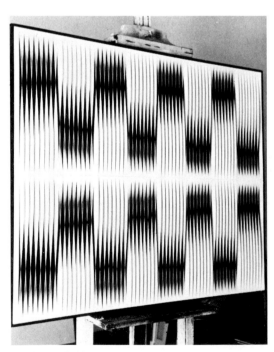

267 Walter Leblanc

266 Ivan Picelj **268-270** Yaacov Agam ▶

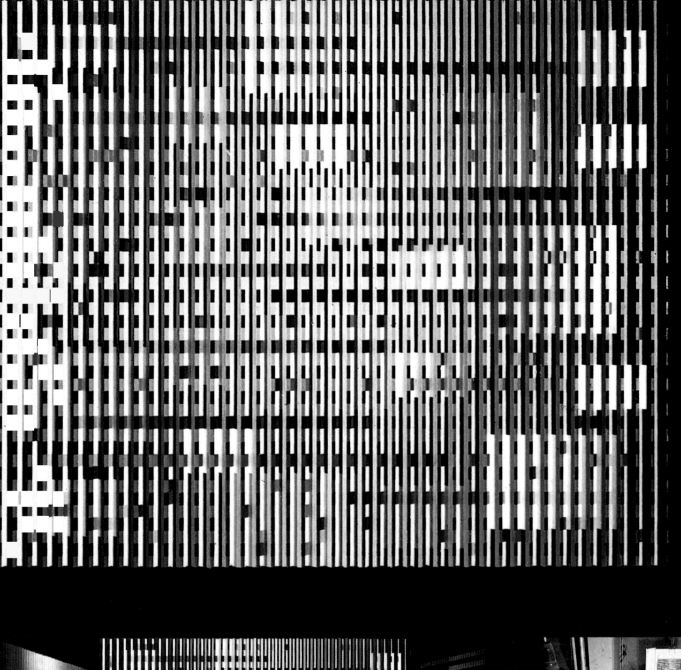

271 Hugo Demarco

272 Carlos Cruz Diez

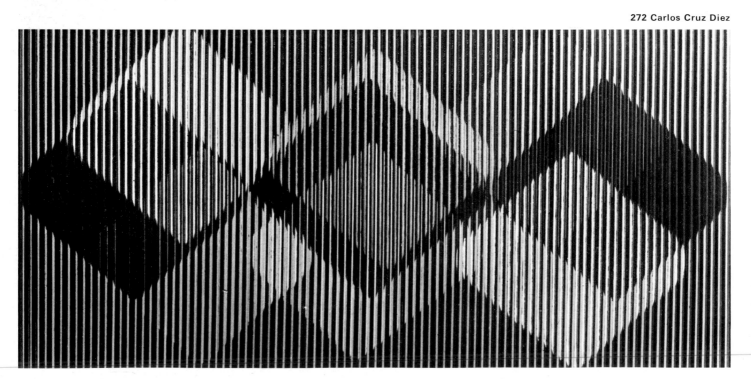

273 Nicolas Schöffer

274 Nicolas Schöffer

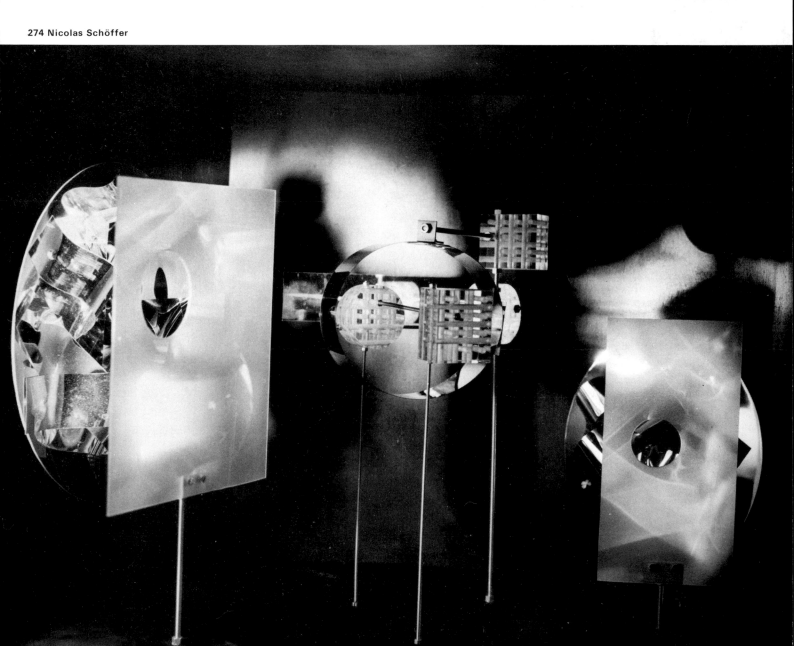

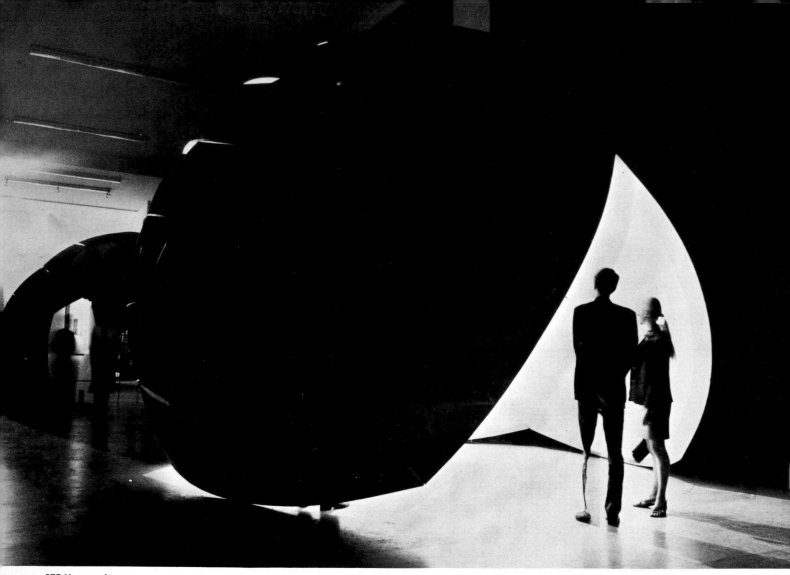

275 Yaacov Agam

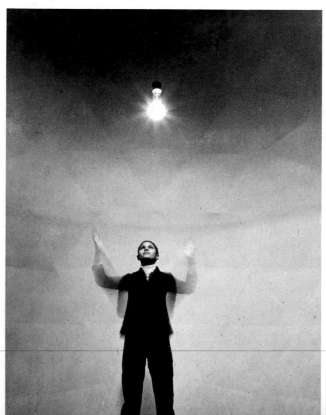

276 Yaacov Agam

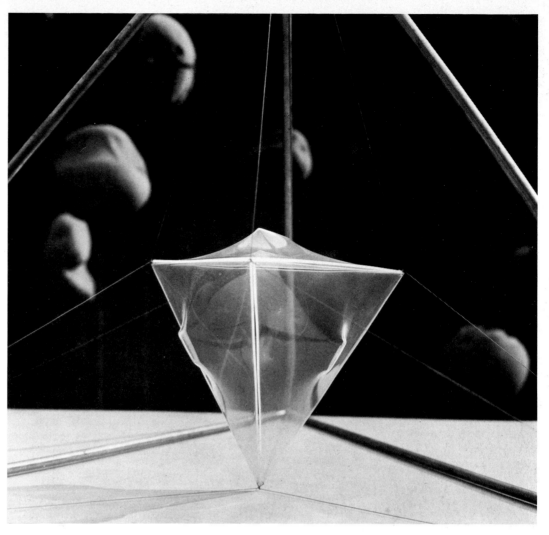

277 Piotr Kowalski

278 Lilian Lyn

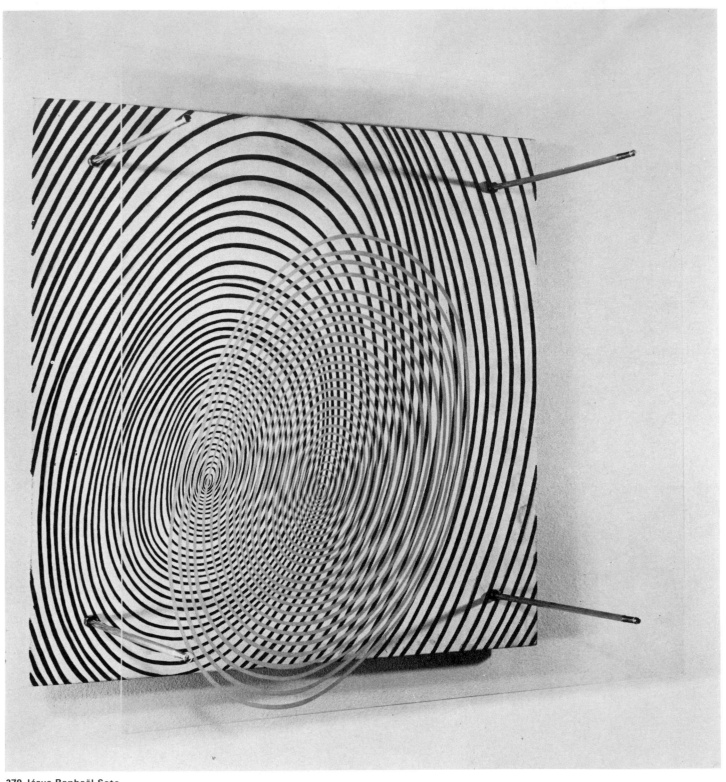

279 Jésus Raphaël Soto

In the chill world of rational imagination, linear systems and condensations and resolutions of suggested pseudo-geometrical zones give the impression of non-functional statistics somehow appropriate to the spirit of modern urban culture. In the mid-1920s Henryk Berlewi had already anticipated certain developments with his experiments with *Mechano-Faktur*. Op art circles cultivated movement as a psycho-physiological reaction to systems of lines and grids – Richard Anuszkiewicz [221], Larry Poons [243], Miroslav Sutej, Bridget Riley [224], not to mention the mechano-kinetic pendulum drawings of Zoran Radović, an electronics engineer.

Also to be counted as passive kinetic art are the works of Getulio Alviani [264], constructed of thin aluminium elements in contrary orientation, giving ever new variants of light reflection from different aspects. Toni Costa [265] creates aleatory constructs based on the principles of light interference. The architectonic structures of Ivan Picelj [266], made of ribbons of metal, change their basic pattern with the eye's angle of incidence. The unifying laws underlying all these figurations contain both the disquiet and the harmony of a new aesthetics.

Yaacov Agam [268-70, 275, 276, S. 63] was among the first to create rhythmical pictures beneath a lattice that rings changes on the underlying fugue theme as the viewing eye moves.

The stationary metal reliefs which Carlos Cruz-Diez [272, S. 65] calls *Physichromie* change colour and form as the observer actuates a switch – squares, metal strips, ornamental forms shine in carefully attuned transparent and vibrant light that slowly dies away.

Hugo Demarco's intricate reflecting units [271] show spatial structures and geometrical forms in vibration, multiplied by polished aluminium surfaces that create changing impressions. 'Every movement,' says the artist, 'the slightest shift of eye, may serve to intensify the basic theme or to neutralize it or put it together another way.'

Sergio de Camargo's *Surface Double Structure* becomes a focus of light and shadow forms, a wall demonstrating a stimulating multiplicity of identities as well as their resolution into white, by means of changes in the light source. 'Light shines white from the illuminated sides of the bodies, a white that is entirely new and without parallel in nature as it gleams from the picture. Taking shape by their immanent light, these bodies have their own plastic power, independent of reality' (Christian Wolters).

Kinetic art is spreading. The work of Mortensen, Steele [223], Dorazio [227, 228, S. 53], Cunningham, Mavignier [229], Wilding, Flondor-Strainu [304], and Yvaral can be no more than mentioned. Most of the kinetic impressions here discussed issue from moving light sources or arise in the stimulated retina as assimilated movement from moiré and lattice patterns. But the resistless dynamic of our days has not spared the calculated art of passive motion. Even Vasarely has now motorized the harmonious lineaments of his grids. The room devoted to Vasarely in the Paris 'Lumière et Mouvement' show of 1967 made it possible to trace his transition from passive to active movement. The almost imperceptibly animated drawings brighten or darken as light or shadow brushes over the black and white bands. At times forms overlap or pass one another, circles glide across a white square, as though a dusky hand caressed the patterns, reminding me of the squares and lines in school notebooks, of mathematical graphs. Small curtains are opened or drawn. The gentle flutter almost suggests that these serried rows live and breathe, that a living heart beats behind the machinery of this synthetic world.

PLAYGROUND AND STAGE

Some artists within the framework of the aesthetic categories projected by light and movement have insisted on using the new media to continue traditional pictorial and sculptural art; but development did not halt – it burst through these limitations. Film and television technicians were drawn in to lend their skills at rhythm and visualization. Nicolas Schöffer [273, 274, S. 64] is among the pioneers of these new methods. In 1948 he designed dynamo-spatial constructions meant to pervade the very fabric of cities and change their face. Urban space is the ambiance of his objects, streets and squares, to be floodlighted with changing colours and forms from a lumino-dynamic tower, to be stirred by rhythmical musical sequences. His cybernetic tower sculpture erected in Liège

in 1961 radiates light, form, colour and sound values in ever-new variations.

For the exhibition 'L'Objet', held at the Musée des Arts Décoratifs in Paris in 1962, Schöffer built a light wall on wich interchangeable radiant cells created luminous patterns in colour.

In 1959 György Kepes, Professor of Visual Design at the Massachusetts Institute of Technology, who has spent many years working on the creative uses of light in art, buit a light wall for the KLM offices in New York. From behind metal plates with sixty thousand perforations, programmed light radiates luminous colour patterns suggesting a journey into interstellar space.

Le Corbusier was concerned with integrating the art forms of time-space with sculptural architecture, and to this end he built the Philips pavilion at the Brussels World Fair of 1958. The *Poème Électronique* performed in it combined space, light, sound and colour.

A room in the 1967 'Lumière et Mouvement' show was devoted to Schöffer – a treasury of scientific fable, rational magic, the black art of precision optics – teleluminoscopes of flashing metal, whirling radiant discs, ominous television screens, huge glittering fluorescent projectors that cast shadows. The main attraction was a world of flamingo-pink, sea-green, electric-yellow shadow play seemingly borrowed from Broadway – the mirror tent. The walls of this reflecting pyramid multiply the spectator a hundredfold – a thousand Buddhas, a thousand faces, reminiscent of Andy Warhol's Pop art Mona Lisa proliferation which he calls *Thirty Are Better than One*.

Hegel called the pyramids of Egypt 'death crystals of perfection divined'; and in the same way Nicolas Schöffer's mirror pyramid represents the dream architecture of utopia, plyground and stage. It recalls the infinite reflections of Baroque mirror cabinets; but Schöffer replaces the autistic barriers of that elegant society with the spectacle of today's mechanized mass world.

Does this characterization of Op and kinetic art as both playful and spectacular, this involvement of the spectator in what is taking place, imply a denigration of the function and dignity of art? Or are we here dealing with a radical turn towards new forms of action in which art and play are fused? 'Perhaps we must choose', as Sartre put

Plates 280-296

280 ALEXANDER CALDER. *Mobile*, 1960. Iron, 195 × 180 × 180 cm. Donation Ny Carlsberg Fondet, Louisiana, Humlebaek, Denmark.

281 GEORGE RICKEY. *Homage to Bernini*, 1958. Kinetic sculpture, steel, height 168 cm. The Museum of Modern Art, New York.

282 JEAN TINGUELY. *Meta-mechanism*, 1953-55. Photo W. Ramsbott, Cologne.

283 JEAN TINGUELY. *Pop, Hop and Op & Co*, 1965. Painted steel, toys, feathers, etc., with motor, height 110 cm. length 209 cm. Property of the artist. Photo Hickey & Robertson, Houston.

284 HARRY KRAMER. *Obelisk*, 1964. Loeb Gallery, New York.

285 VASSILAKIS TAKIS. *Signal*, 1966. Steel. Property of the artist.

286 HERMAN GOEPFERT. *Optophonium*, 1960. Photo K. Meier-Ude. Frankfurt.

287 POL BURY. *2270 white dots*, 1965. Wood and nylon. Galerie Maeght, Paris. Photo C. Gaspari, Paris.

288 GÜNTHER UECKER. *Untitled*. Painted wood and nails, 87 × 87 cm. Galerie Denise René, Paris. Photo A. Morain, Paris.

289 HEINZ MACK. *Five angel's wings*. 1965. Aluminium on wood under plexiglass. 200 × 103 cm. Wallraf-Richartz Museum, Cologne. Collection Peter Ludwig, Cologne. Photo Schmitz-Fabri, Rodenkirchen.

290 HORACIO GARCÍA ROSSI. *Luminous Box*, 1963. Galerie Denise René, Paris.

291 ANGEL DUARTE. *(Equipo 57') Composition*.

292 FRANÇOIS MORELLET. *Wire with Undulating Movement*, 1965. 200 cm. Galerie Denise René, Paris.

293 JULIO LE PARC. *Continual Light*, 1967. 100 × 100 cm.

294 GREGORIO VARDANEGA. *Electronic Relief*, 1967. 120 × 120 cm. Galerie Denise René, Paris. Photo A. Morain, Paris.

295 MARTHA BOTO. *Optical Movement*, 1966. Animated box, 50 × 50 × 20 cm. Galerie Denise René, Paris. (Erratum: for Maria read Martha, p. 278.)

296 GERHARD VON GRAEVENITZ. *Large Glowing Mural*, 1966. 300 × 700 cm. Kunsthalle, Nuremberg.

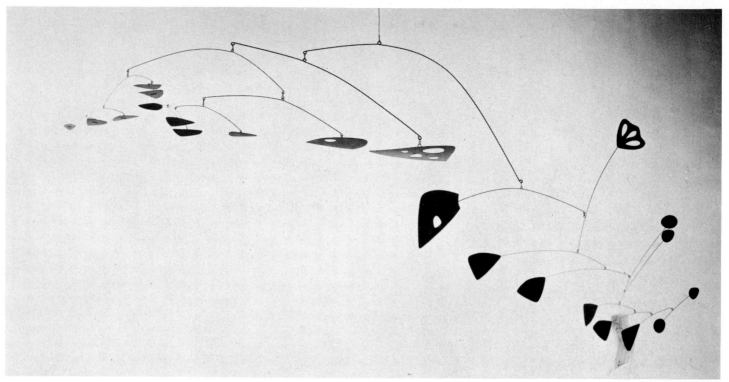

280 Alexander Calder

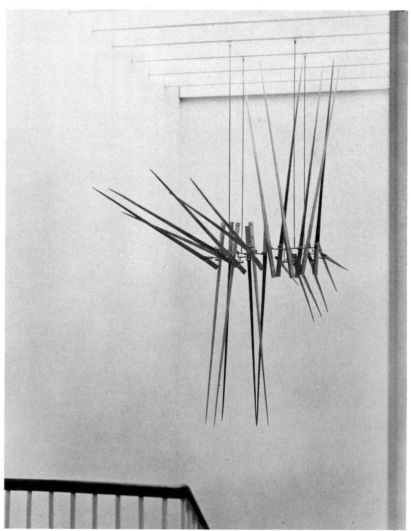

281 George Rickey

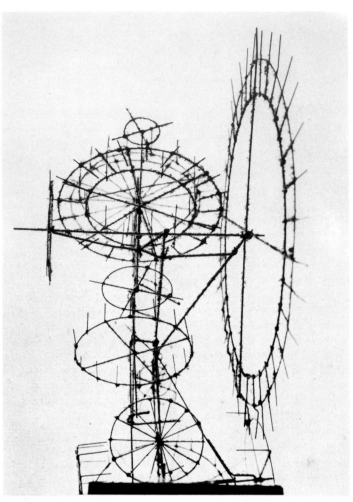

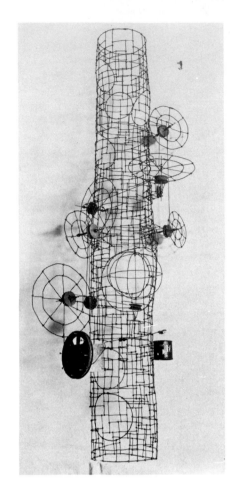

282 Jean Tinguely

283 Jean Tinguely

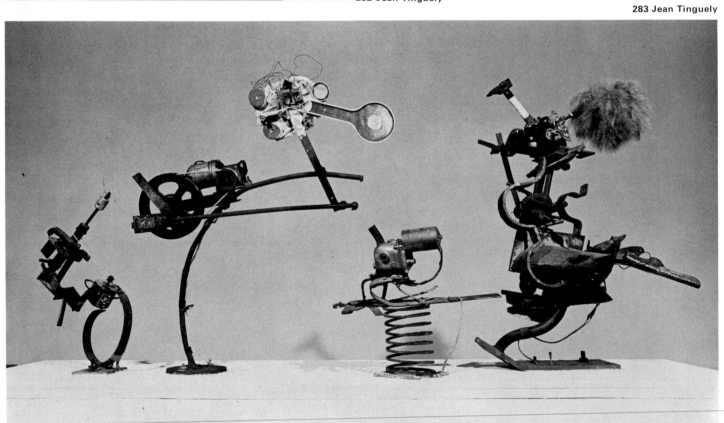

286 Herman Goepfert

285 Vassilakis Takis

287 Pol Bury

288 Günther Uecker

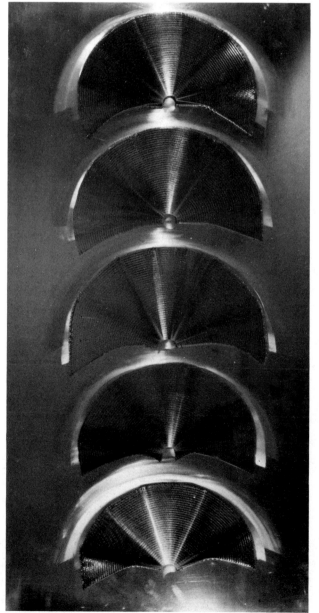

289 Heinz Mack

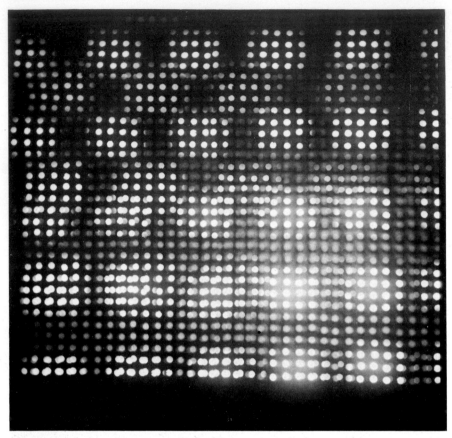

290 Garcia Rossi

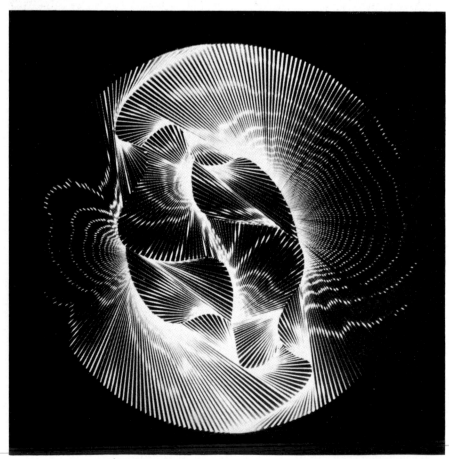

291 Angel Duarte

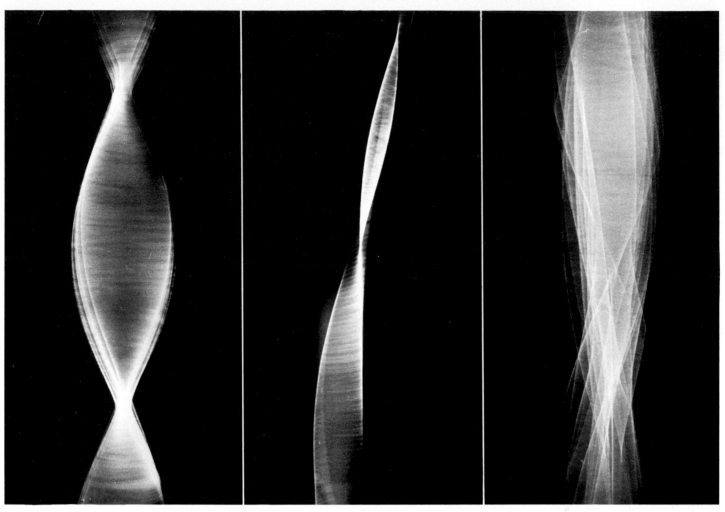

292 François Morellet

293 Julio Le Parc

294 Gregorio Vardanega

295 Maria Boto

296 Gerhard von Graevenitz

it, 'between being nothing and playing at what we are.' Is there indeed less luminosity and movement in literally motorized and electrified works of art than in a cathedral painted by Claude Monet?

The magical, allegorical, playful mirror world that has found a new home in Op and kinetic art may have its origins in man's first optical experience as he perceived himself in the reflection from a mirror-smooth pond. An image wrought by the refraction of light rays lasts but an instant, while art lends permanence to the passing show; yet even light and movement, it seems to me, are not merely aesthetic categories of art. However primitive their technical realizations may seem to be, measured against space technology, they do afford new media for projecting and interpreting space and time.

The theoretical and experimental character of these art forms is rooted in the conviction of those who employ them that the traditional activities of art come last in the order of priorities. Many artists are preoccupied with the problem of getting away from the picture and the sculpture as isolated works, of integrating the art object with the total architectural setting, of creating an environment in which artist and spectator collaborate.

Bernard Lassus's *Light Refractors* and animated chromatic rhythms transform a wall, with the help of programmed artificial light, into a leaf-green, autumn-brown shadowy sphere of breathing growth. The viewer's spheres of awareness and response are affected by tactile and visual scales. The themes are modulated between light and darkness, the chromatic materiality of the space set at nought. Toying with the bright round disc offers the viewer a living challenge. He casts a triple-coloured shadow – saffron yellow, cosmic blue, apricot – or a blend of the intersecting shadow lights. The pseudo-mirror opens up spaces that were optically closed, dissolving the spatial cube – a magical mirror as in Faust's witches' kitchen, yet no more than a base screen once the light fades.

Yaacov Agam's extinction of space is an earlier effort to lead the viewer from dark corridors into an environment of the picture become space. Addressing a mass audience, he is perhaps the inventor of this game between artist and spectator. The only ones immune to the game so far are the museum guards, who, rather than encouraging the visitors to touch the exhibits, insist on keeping them at a distance.

Pierre Faucheux, architect of the Paris 'Lumière et Mouvement' show (1967), built two hemispherical rooms for Agam [268-270, 275, 276, S. 63], reminiscent of Buckminster Fuller's geodesic domes. At the centre of one of them, *Painting with Light-Rhythm*, revolves a stroboscopically lighted object impelled by magnetic forces. In the other, *Rhythmical Space: Let There be Light!*, a lamp lights when the visitor utters a cry. This audio-visual light echo not only harks back to the Creator's command but evokes the existential terror of secret-police grillings by night.

Among the originators and creators of such light-motion devices are Jean Tinguely [282, 283, S. 67], Julio Le Parc and several artist collectives, especially GRAV of Paris, still to be discussed. Spectator participation is a principle common to all of them, realized in various ways. Piotr Kowalski [277, S. 68] uses electricity to render his *Sisyphus Games* manipulable. Small balls within a large glass globe are made to glow with the help of rubber gloves. Lifted into the electrical field, they shine red and blue, only to fade as they sink back to the bottom.

Anna Maria Gatti creates ornaments from greyish-green triangles that cast shadows. Their transparent geometrical intersections are animated when the viewer shifts the light source.

The planetary poetry of Liliane Lijn [278] uses the vitreous surfaces of circular mirror lakes on which move crystal balls, seeking and losing one another in a transparent world of infra-rays and photons. Grown-ups find themselves playing with these balls, like children with marbles.

Armando Durante's 'visualization' of sound, based on television technology, and Hermann Goepfert's 'optophonium' [286, S. 69], combine the sphere of sound with light and movement. Goepfert's musical light objects, using programmed light impulses synchronized with a sound tape to elicit music, cast silvery-cool shadow configurations.

Hans Walter Müller employs perforated panels of glass and metal to project chromatically animated

Pop collage lattices with inserted lettering in various directions. The light wall moves towards the viewer who is able to control the various sensory stimuli by switches. It engulfs him in kaleidoscopic sequences and emblematic symbols. The word 'genesis' floats through the air. Müller's *Machine M* recalls Fernand Léger's film *Ballet mécanique*, in which all the characters and devices are represented as rhythmically animated objects.

DADA AFTERMATH AND KINETIC PERSPECTIVES

Jean Tinguely's self-destructive phase – his spectacular machines that dismantle and annihilate themselves, his *Studies of the End of This World* – seems to me a form of kinetic existentialism. These works belong with Beckett's *Endgame*. They have something of the spirit of *Pierrot le Fou*, whom the director of that film, Jean-Luc Godard, blows up with dynamite.

With his 'drawing machines', Tinguely has introduced a theatrical form of automatism into sculpture. Yards of paper tape are inscribed with jerky signs and unexpected rhythms by mobile metal arms. His *Metamatic 17* and other drawing machines are post-Dada creators of the absurd, of chance and playful irony. From his early meta-mechanical sculptures to his ballplaying toys, animated by wheels, clutches and motors, he is first and last the engineer of the anti-machine. Xenakis remains a creator of kinetic Pop, and Vasarely, despite his motorized lattice symphonies, of Op; but Tinguely's work will always carry the odour of Dada.

The late Dadaist anarchoid thoughts of Harry Kramer [284, S. 70] lead into an environment of technically autonomous automatisms. He regards as utopian any and every effort to regard light-and-motion objects as expressions of a new cosmic sense of space and time. The machines and automats of art are kin to the vending machines of everyday life. Their home is with the electric refrigerator, the air-conditioner, the television set: a chair, a wash-basin, a water-closet, hybrids reminiscent of Marcel Duchamp, wire cages with blinking bulbs, dripping water, turning screws that have neither use nor purpose.

Pol Bury's *Soft Punctuations* [287, S. 71] in black and white show light tendrils in infinitely slow motion, not unlike the growth of moss. They awaken a sense of ambivalence between meditation and headlong rush. The unexpected and adventitious in these breathing mechanical objects conveys a burlesque humour and poetic melancholy.

The animated philosophical fluxes of Constantin Xenakis are Dada futurism with tragic accents, images deformed in a mirror composed of horizontal and vertical surfaces. The observer becomes part of the object which, like him, is caught up in a process of constant movement and change, a synthetic landscape of twining moss and pink sea-roses, gently drifting in a silvery reflecting sea. Takis [285], the romanticist of the anti-machine, dreams of the liberation from gravity. He extends the antennae of the age of science into deep space. A white ball orbits about the radiant power of an electromagnet. Under the spell of science and technology, anti-sculptures with built-in electromagnets are to serve a new form of meditation.

INDIVIDUAL CREATION AND TEAMWORK

The extinction of the natural background, the transformation of the visual world under the impact of science and technology, have had a crucial effect on art, uprooting it from the soil of nature. At this level the artist approaches the engineer and comes closer to the technician than he does to his fellow artists of the past.

Objects – kinetic art works – can no longer be regarded in the light of self-contained compositions in the classical sense. Physical concentration within a clear-cut space – the framed picture, for example – is regarded as obsolete. The new objects open out into space, their forms change and move. Their themes arouse no mythological associations, indeed have but rarely any inherent connection with the real appearance of visible nature.

What preoccupies the artist is motion as the aesthetic transformation of mass into energy, the programming of light and movement and, lastly, the question of individual work *versus* teamwork. In the 'scoring' of a light-and-movement ensemble, the artist's individual hand gives way to an anonymous technical perfection. Mass production, which results at times from group work, lessens the significance of uniqueness. The artist designs the work, and experts execute it and produce it

for mass consumption. The gulf between inventor and spectator narrows: the spectator can inject himself into the process by mechanical or electrical means. He becomes actively and emotionally involved in the experiment.

In many places groups of artists have formed whose members carry out their studies together, or who inform each other of their results as scientists do. These artist groupings are often limited in time and by theme; yet their work and proliferation is characteristic of our time.

Gruppo T, formed in 1959 (G. Anceschi, D. Boriani, C. Colombo, G. de Vecchi and G. Varisco), pursues the common aim of creating a reality under the aspects of change and perception 'Continuous and non-continuous movement we find important not because they are to render images visible in endless repetition, but for the purpose of indicating sequences of individual phases in the process of constant transformation.' The M.I.D. group, formed in Milan in 1964 (A. Barese, A. Grassi, G. Laminarca and A. Marangoni), immersed itself in the study of stroboscopic motion and programmed light. The Paduan Gruppo N (A. Biasi, E. Chiggio, A. Costa, E. Landi and M. Massironi) won first prize at the San Marino Biennale in 1964. This group has interested itself in light interference and dynamo-optical effects.

In Córdoba, Grupo Espacio, concerned with light and kinetics, split up and gave rise to Equipo 57 (A. Duarte [291], J. Serrano, A. Ibarola, J. Cuenca and J. Duarte). Inspired by Pevsner and Vasarely, this group delved into the creative possibilities of chromatic structural tension effects. The Yugoslav group Exat 51 developed into the collective Nova Tendencija (I. Picelj. A. Srnec and V. Rihter, exhibiting jointly with V. Bakić, U. Šutej, A. Dobrović and Kalman Novak), which is concerned with the study of visual perception, systems of even and uneven rhythms and reflex effects of a structural character.

The Dvizdjenje (Movement) group, formed in 1962 in Moscow (L. V. Nusberg, V. Akulinin, B. Diodorov, V. P. Galkin, F. A. Infanté, A. Krivchikov, G. I. Lopakov, R. Sapgiry-Sanevskaja, V. V. Stepanov and V. Skerbakov) is developing the principles established by Lissitzky, Gabo and Mondrian. Media and expressive forms are to represent, not objects in motion, but motion itself. Only movement endures, not things. In New York an anonymous collective has formed under the name of Usco, composed of poets, film people, painters, sculptors and engineers. 'We are all one, beating the tribal drum of our electronic environment.' This group is concerned with exploring electronically guided light radiation and reflected projection in art.

To the German Zero group [146, S. 36], art means a form of meditation and concentration. Zero seeks to create a zone of quiet and of new beginning. Heinz Mack's [289] light cubes, light reliefs and mechanical colour toys of industrial glass and polished metal are harmonic reflections of space. Günther Uecker's [288] gleaming nail thickets, white structures of reflecting light, have a certain relation to African nail fetishes. His objects and BaKongo ritual figures demonstrate a kinship between modern and archaic notions of form: man takes possession of things and beings by entering into them. Otto Piene [212] created the *Light Ballet* as a continuum of motion, to which he added smoke, light graphics, circular figurations derived from fire by guided chance. With their fusion of circle and light as the basic forms that have survived all the vicissitudes of history, they offer points of contact with ancient sun worship and with the use of light in modern painting.

GRAV (Groupe de Recherche d'Art Visuel) [72], formed in Paris in 1960 and sponsored for some years by the Galerie Denise René, has had considerable influence and met with a strong response. The element common to its members' work, although developed and interpreted along different lines, is the visualization of light: primitive geometrical forms in mobile assemblages, ornamentation at several levels, simultaneous differential speed rhythms of individual configurations within the total composition.

Labyrinth, exhibited at the Biennale de la Jeunesse in Paris in 1963, suggests the group's underlying aim of fascinating the observer, of including him in the game, of leading him down tortuous, uncertain and often unknown pathways to a hidden optical nuclear space. The large hall devoted to the GRAV in the 1967 'Lumière et Mouvement' show was once again dominated by the labyrinthine ambiance of dark corridors and trick stairways

with missing steps and padded impact areas, to activate the visitor. Under the assault of light flashing on and off, youthful visitors run an obstacle race, hopping and slipping as though they were fleeing a storm under a moonless sky. One is reminded of Egyptian and Cretan labyrinth cults, and perhaps even of Kurt Schwitters's *Merzbau*.

François Morellet's [292] light crosses shed their macabre stellar radiance, cast their moving shadows. Francisco Sobrino's glass globes move with the observer, shine and fade in transparent reflections and transformations. Horacio García Rossi [290] makes his moving action paintings glow. Joël Stein's reflecting aluminium panels turn into a kaleidoscopic mirror world in which things and men become ornamental hybrids. Yvaral's verticals, his rhomboid aluminium lamps hanging from the ceiling, turn and reflect light and shadow figurations.

Julio Le Parc [293] immersed himself in the unlimited abundance of basic forms and light combinations, in the form of black and white symbols, static or rotating. Here are sequential surfaces of changing structure, representing a diversity in the perception of time and movement. Le Parc says that in creating his objects he must be aware not merely of the combinations that are immediately possible, but also of those that are much more remote. He must, in other words, have at his disposal a kind of catalogue that includes every part and every aspect, allowing him to include in any work in hand a suggestion of every possible form it might take. The criterion of his art is the universality of its formula. Le Parc's objects radiate a new trans-human beauty. Extremely simple movements of aluminium strips, rising and falling vibrations that correspond to respiration: these reflect a silvery light and misty bands of gentle music. Occasional spectral flashes brighten the delicate greys of many nuances against a satin-white ground. The prize awarded to Le Parc at the Venice Biennale in 1966 not only signified recognition of his creative work but emphasized the importance of light and kinetics in the development of modern art.

The collective work of artist groups may indeed be highly characteristic of our age of advanced technology, capable of fostering its social aspects, but most artists continue to work individually. Side by side with Le Parc and his friends in GRAV (which includes a strong South American contingent), individual artists also work outside the groups. J.R. Soto [279, S. 66] creates delicate, calligraphic, geometrical wire curtains which move imperceptibly and set up exquisite moiré patterns. In explanation of the chromatic kinetic objects he creates, Gregorio Vardanega [294] has said: 'Transparency of colour, luminosity of colour, colour space, the sound range of light, light refraction, light projection, light scattering, the radiation of light from solid, fluid or gaseous materials – these are elements in the limitless abundance of possibilities for a new aesthetics, the aesthetics of light, the aesthetics of luminous colour, movement, natural or programmed.'

Martha Boto's cyclical études [295] display transformations of lines and planes, luminous graphisms created with the help of projection and multiplying mirror boxes, lights that drift like snowflakes, whirling fluorescent bouquets.

The creative elements of Gerhard von Graevenitz's objects [296] are dredged up from darkness and light into a monumental pictorial order that brings the world of microstructure to visual awareness with the help of statistical methods. His playful crystalline compositions resemble a universe in which everything moves by harmonious laws while appearing at the same time to remain motionless. Small metal plates turn, silver against white, programmed and at once unpredictable, animated reflections with rainbow effects and a calming sense of composure.

Siegfried Albrecht's progression was stimulated by Goethe's colour theory and modern science. His chromatic permutations of form are based on the polarity of light and shadow, the interplay of complementary colour modulations – drifting shadowy shapes in misty grey, pale red, orange and icy blue, like electromechanically animated X-ray pictures of unknown landscapes, metamorphoses of circle and triad.

Martha Hoepffner [298] dreams up models of aesthetic and scientific symbiosis. Rhythmically combining transparent colourless plastics and flooding them with polarized light, she creates chiaroscuro modulations of double-refringence, with progressive transformations of systems of form and

complementary colour. Manipulating these discs, the viewer conjures up what was previously invisible, playing a game in which radiant light forms become the image and semblance of the simultaneity of movement and light.

In creative approach Nino Calos [300] shows a kinship with Martha Hoepffner. Light gently migrates behind a glass wall panel, like embroidery in white and colour, delicate tints glowing like stained-glass windows.

John Healey's dynamic light compositions in cosmic blue, flamingo pink, heliotrope and nacre are inspired by cloud formations. Abraham Palatnik's kinechromatic devices create coloured light and shadow compositions that constantly change, gently rising and falling like the breath of nature, whirling, trickling, gliding.

One of the pioneers of moving light projected on ground-glass screens is the American Frank Malina [299, S. 74], who introduced light elements into his pictorial compositions in 1954, basing himself on space research. His *Lumidynes* and *Reflectodynes* use thermally activated cyclical light effects. Imaginative forms glow on a dark screen, delicate light figures flash past into a gentle counterpoint. There is a suggestion of natural forms, of familiar landscapes we know we have never seen. Rounded shapes in agate-bronze, smalt-coloured eddies, shell-pink and bamboo-yellow pulsations, curvaceous billowing patterns, come to life as sequences in time. In the stained-glass windows of the Gothic age the colouring depends on the movement of the sun, but here cosmic programming has given way to the technology of man.

Artists concerned with the new expressive media of light and motion are growing in number. Their art is universal and supranational. Bruno Munari's experiments with polarized light and Enzo Mari's with space and programmed light have influenced the coordination of the new trends in Italy. Lily Greenham uses programmed motion of classic elements of geometric ornamental form [301] to modify the patterns, tints and dimensions of light. Karl Gerstner's ingenious optical toys represent light variations on mathematical themes. The radiant reticulations of animated lines created by Nam June Paik of Korea resemble electronic calligraphy written in light.

The monumental curved signs that the Greek-American light-sculptress Chryssa builds up from neon tubes are lit according to a programme which rhythmically accentuates their manifold Baroque forms through clashes of colour. Her sculptures are light variations on a theme; they occupy a middle ground between neon advertising signs and cosmic symbolism.

Neon tubes are used by Dan Flavin [239] to evoke a new consciousness of space: set-pieces in the spirit of the American Minimalist landscape, with an intellectualized, purist structure.

The light sculptures of Alexander Srnec, inspired by motion pictures, are based on an ingenious musical synthesis: a mobile coloured light pattern is projected on to dynamic sculptural forms.

In his object *Light Variable*, Kalman Novak of Yugoslavia has created a type of colour composition which the viewer can manipulate and alter. Milan Dobeš [302] of Czechoslovakia, with the help of negative mirrors and optical lenses, creates an environment of light refractions colour reflexes. Christian Megert [303] of Switzerland, in his mirror pictures, *Space Without End and Limit*, opens up image-engendering vistas of unexplored landscapes. The revolving hemispheres of Gyula Kosice of Hungary articulate light and motion by the aid of the archetypal power of water.

In the water level of the sacred spring at the Temple of Demeter at Patrae, visitors thought they could perceive the shape of the future. Just so, in the artificial springs and programmed cascades of their objects the rational magicians of kinetic and optical art perceive the shape of things to come.

SCIENTIFIC CONCEPT AND INTUITION IN ART

The aesthetics of Op and kinetic art are a reflection of the spirit of our age. Ever since Impressionism the desire to liberate art from its classic parameters has been rising. Action painting was only a belated abstract expression of the instinctive striving for movement in art. Even the artists of the new figurations have taken over the sense of speed and technical animation into their imagery.

The elements that stir the eye and awareness of the viewer are not merely rhythm and movement as such, but the swift alternation of night and day, of fulminating colour and catacombic gloom. The special character of the art of movement and light lies in its return to the locus of first origins,

the darkness of the cave. Within its shadowy depths now shimmer the luminographic mysteries of modern experimentation.

Some of the phenomena we have examined in this sphere of luminous art may appear to be a kind of positivism of art, the naturalistic application of light in its creative capacity as raw material. Is all this glowing and flickering still art? And if it is indeed art, does this not imply a loss of psychical depth, of creative power, bartered for the cold demythologized world of the computer?

It seems clear that the fruits of science in our time are ahead even of the imagination of artists. Will their work now enter even more deeply into the sphere of science, completely blending with it? Or will this art, under the impulses from science, become an altogether new art of mankind?

The art of light, viewed as a kind of cybernetic Mannerism, may well do no more than serve the entertainment needs of *homo ludens*, man the player of games. Its intricate computer-guided automation may become the spectacular mechanical folklore of the twentieth century. But in my view it may also reflect the realities of the world, in its light and sound rhythms, its harmonies of form and proportion.

Unless all the signs deceive, mankind – despite severe upheavals and relapses – stands at the end of an era of *Weltangst*, of fear of the daemons of civilization, of fascination by the absurd, of temptation to self-destruction. We are witnesses to a process in which the system of time-space coordinates is being radically changed, to an effort of rendering visible the untrodden worlds between earth and cosmos.

The impact of light, emerging anew in the art of our time in a way quite different from the age of Impressionism, has assimilated the deadly aspects of cosmic radiation. Light is not merely what is visible as light; it can remain dark and invisible, hidden from view. Traversing the vast reaches from sun to earth, it is all darkness until it reaches the limits of the atmosphere. Only when light impinges on dense and continous matter does it turn to visible brightness. So too the kinetic luminence of art – in which darkness, in the form of its *alter ego*, is contained and mastered – can flourish only through the substance of man's creativity.

Plates 297-304

297 JOACHIM ALBRECHT. *Polar Route*, 1967. Metallized paint on aluminium, 73 × 145 cm. Property of the artist.

298 MARTHA HOEPFFNER. *Luminous object with chromatic variations no. 6* (with motor), 1966. Transparent synthetic material and polarized light, 39 × 39 × 17 cm. Property of the artist.

299 FRANK MALINA. *Stairways to the Stars III*, 1965. Wood and plexiglass, 101 × 250 × 14 cm.

300 NINO CALOS. *Lumino-kinetic Mural Panel (Luminous Mobile 236)*, 1968. 220 × 120 × 18 cm. Photo A. Morain, Paris.

301 LILY GREENHAM. *Triangles. Diamonds and Squares in Movement*, 1966. Wood and coloured bulbs. 100 × 100 × 50 cm. Photo R. David.

302 MILAN DOBEŠ. *Pulsating Rhythm.*

303 CHRISTIAN MEGERT. *Luminous box; play of mirrors*, 1968. Mirrors, 65 × 65 cm.

304 FLONDOR-STRAINU. *Aerial Mobile Mirage*, 1968. Striated glass and drawing in India ink on P.A.L., 190 × 190 × 59 cm. Private collection.

297 Joachim Albrecht

298 Martha Hoepffner

299 Frank Malina

300 Nino Calos

301 Lily Greenham

302 Dobeš

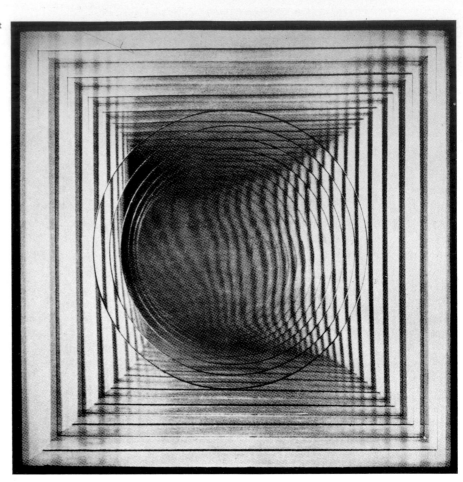

303 Christian Megert

304 Flondor-Strainu

Artists' Statements

37 Paul Cézanne

Allow me to repeat what I was saying to you here; treat nature in terms of the cylinder, the sphere and the cone, all put in perspective, so that each side of an object, of a plane, moves towards a central point. Lines parallel to the horizon give the breadth – call it a section of nature or, if you prefer, of the spectacle which the *Pater omnipotens aeterne deus* lays out before our eyes. Lines perpendicular to the horizon give the depth....

From, *Cézanne, Correspondance*, B. Grasset, Paris, 1937. Extract from a letter to Émile Bernard.

38 Georges Seurat

AESTHETICS

Art is harmony. Harmony is the analogy between opposites, the analogy between like things, in value, colour and line, considered in terms of the dominant, and under the influence of a lighting in cheerful, calm or sad combinations.

The opposites are:

For *value*, that which is more luminous (lighter) and that which is darker.

For colour, the complementaries, i.e., a certain red contrasted with its complementary, etc. (red – green, orange – blue, yellow – violet).

For line, those which make a right angle.

Cheerfulness, in terms of *value*, means a luminous dominant tone; in terms of *colour*, a warm dominant tone; in terms of *line*, lines above the horizontal.

Calm, in terms of *value*, means equilibrium between dark and light; in terms of colour, equilibrium between warm and cold; in terms of *line*, the horizontal.

Sadness, in terms of *value*, means a dark dominant tone; in terms of colour, a cold dominant tone; in terms of line, downward movements.

TECHNIQUE

Given the phenomena of the duration of the light impression on the retina, synthesis is an inescapable consequence. The means of expression is the optical mixing of values and colours (both local colours and those of the light source: sun, paraffin lamp, gaslight, etc.), i.e. the optical mixing of lights and their reactions (shadows) in accordance with the laws of contrast in the graduation of illumination.

The frame is coloured in that harmony which contrasts with the values, colours and lines of the paintings.

'Letter to Maurice Beaubourg', 28 August 1890, printed in *The Neo-Impressionists*, ed. Jean Sutter, London and Greenwich, Conn., 1970.

39 Piet Mondrian

The truly modern artist *consciously* perceives the abstractness of the emotion of beauty: he *consciously* recognizes aesthetic emotion as cosmic, universal. This conscious recognition results in an abstract creation, directs him toward the purely universal.

That is why the new art cannot be manifested as (naturalistic) concrete representation, which – even where universal vision is present – always points more or less to the particular, or in any case conceals the universal within it.

The new plastic cannot be cloaked by what is characteristic of the particular, natural form and colour, but must be expressed by the abstraction of form and colour – by means of the straight line and determinate primary colour.

These universal plastic means were discovered in modern painting by the process of consistent abstraction of form and colour: once these were discovered there emerged, almost of its own accord, *an exact plastic of pure relationship*, the essential of all emotion of plastic beauty.

De Stijl, vol. I, No. 1, 1917.

40 De Stijl, First Manifesto

There is an old and new consciousness of the age. The old is connected with the individual. The new is connected with the universal. The struggle of the individual against the universal is revealing itself in the World War as well as in the art of the present day.

The war is destroying the old world with its contents: the dominance of the individual in every field.

The new art has brought forward what the new consciousness of the time contains: balance between the universal and the individual.

De Stijl, vol. I, No. 2.

41 De Stijl

The truly modern – *i.e.*, conscious – artist has a double vocation; in the first place, to produce the purely plastic work of art, in the second place to prepare the public's mind for this purely plastic art.

From *De Stijl*, vol. I, no. 1, 1917.

42 Josef Albers

The origin of art:
The discrepancy between physical fact and psychic effect

The content of art:
Visual formulation of our reaction to life

The measure of art:
The ratio of effort to effect

The aim of art:
Revelation and evocation of vision

ON MY WORK
When I paint and construct
I try to develop visual articulation

I do not think then – about abstraction
and just as little – about expression

I do not look for isms
and not at momentary fashion

I see
that art essentially is purpose
and seeing (schauen)
that form demands
multiple presentation
manifold performance

I do not see
That forced individualism
or forced exaltation
are the source
of convincing formulation
of lasting meaning

In my own work
I am content to compete
with myself
and to search with simple palette
and with simple colour
for manifold instrumentation

So I dare further variants.

From the catalogue 'Josef Albers: Homage to the square', Museum of Modern Art, New York 1965

43 Auguste Herbin

The study of those problems posed by the evolution of painting takes on, with respect to form and colour, a scientific character, but of a science which must not be confused with psycho-mathematical science. It concerns a knowledge, as precise as possible, of the limits and of the means proper to non-figurative, non-objective painting. To the physical scientist, who is objective and a materialist, non-objective painting is incomprehensible. But if he is sensitive to the beauty which a non-objective painting may present, he will discover the principle of that beauty; he will understand and justify the

reasons for his aesthetic satisfaction: and that forms the object of another science. Considering that art can only be itself, the non-objective artist has nothing to do with such concepts of colour and form as mathematical science can teach him. What the artist should be familiar with is a colour and a form closely related to each other, closely related to art, within the limits proper to the personality of the creator, within the limits proper to painting. The artist should arrive at his own science. What is most important of all is the creative activity, and the living and beautiful work of art which should be its result.
To seek for tradition is to seek for death. One must combat, untiringly, everything which may retard the awakening and the development of our creative faculties.

From *L'art non figurative non objectif*, Lydia Conti, Paris 1949.

44 Fernand Léger

The abstract? A total liberation; a necessity for contemporary art. One starts again from zero. This however, is not an absolute creation; it is not an end in itself, simply a means of disintoxication and a departure in search of new conquests: a way of perfecting oneself. Purism does not appeal to me: such a thing, such a closed world, is too meagre for my liking, but nevertheless this had to be – that one should go to the absolute extreme. Pure colour applied in a dynamic way can burst open a wall. Pure colour is a formidable raw material, as indispensable to life as water and fire.

From the catalogue 'Fernand Léger', Musée des arts décoratifs, Paris 1956.

45 Theo van Doesburg

If the means of expression are liberated from all particularity, they will be in harmony with the very purpose of art, which is: to achieve a universal language.... We are inaugurating the period of pure painting, by constructing the *spirit* form: the period of concretization of the creative spirit. Concrete painting, not abstract, because nothing is more concrete, more real, than a line, a colour, or a surface.

From *Manifeste de l'art concret*, Paris 1930.

46 Ben Nicholson

Many people believe that one artistic movement must necessarily exclude all others, but I do not see why many separate forms should not exist side by side: alongside abstract art there is room for a literary, surrealistic art, or for an art more firmly based on figuration. But since abstract art is a means of pictorial and sculptural expression which works in a liberated and concentrated way, it has a special effectiveness of its own.
In art a square and a circle are nothing in themselves; they come to life only through the instinctive use the artist makes of them in setting out to express a poetic idea.
I believe that abstract art is not a limited mode of expression understood by only a few, but a powerful, unlimited and universal language.

From 'Bemerkungen über abstrakte Kunst', in *Katalog Nr. 4*, Kestner-Gesellschaft, Hanover 1966-67.

47 Jean Dewasne

The artist's task is to raise the materials in which he works to expressive power. But that alone would not suffice, if, at the same time and in parallel, he did not build up the structural logic which emerges from a natural flowering of the aforesaid materials. The latter should engender the structure proper to itself, in such a way as to achieve a self-evident quality. The structure derives directly from conditions which allow the material to function with a maximum of intensity.
The constructive schemas have as much part in the aesthetic emotion and in the human expression as have the various visible plastic elements, immediate and personalized.
What I have just defined in this way is the new synthetic and dialectic conception of 'abstract' art, which is objective art in the form in which it is beginning to be developed at the present time. And this in opposition to the analytical and static concept of the first abstract art.
The work of art is, first and foremost, a means of uniting mankind. We are far, therefore, from the work of art in which the painter has poured out his complexes, his sores and secret ills. The picture becomes,

above all, an authoritative construction, elaborated with all that is permanent, sound and elevating in the artist himself; the most lucid, the most intimately associated with the work, the efforts, the creations of all the men of his time. The artist is all the more closely united with nature in that he no longer contents himself with its superficial appearance, but associates himself with all that man has discovered in it and with all of man's progress in exploiting and understanding it.

The artist ceases to be a pariah or an eccentric, and becomes a balanced, social constituent of a humanity with prodigious possibilities.

From 'Réflexions sur l'art "abstrait"', *Quadrum*, No. 7, Brussels 1959.

48 Olle Baertling

The open form lays open unknown problems – only in the unknown is there true creation.

Teddy Brunius, 'Baertling discovers Open Form', Galerie Rose Fried, New York 1965.

49 Max Bill

art is neither a substitute for nature nor a substitute for individuality nor a substitute for spontaneity, and where it does present itself as a substitute it is only art if it gives order and form to this substitute. because it can bring order, art moves closer to the laws of structure.

art can only exist if and because individual expression and personal invention subordinate themselves to the ordering principle of the structure and derive new regularities and new creative possibilities from this ordering principle.

From 'struktur als kunst? kunst als struktur?', in Kepes, *Struktur in Kunst und Wissenschaft*, La Connaissance, Brussels 1967.

50 Richard P. Lohse

Colour is increasingly assuming the function of form, which is to create rhythmical bases by differentiation.
The number of colours is no longer enough. Colour creates form. Form is anonymous.

Pictural elements are united in themes. Themes assume the function of individual elements.
Similar themes unite to form a whole which is similar to its parts.
Anonymous form engenders infinity and the absolute. The method is the picture itself.

From 'Standard, Modul, Serie: Neue Probleme und Aufgaben der Malerei', in Kepes, *Modul, Proportion, Symmetrie, Rhythmus*, La Connaissance, Brussels 1968.

51 Victor Vasarely

AT PRESENT, WE ARE MOVING TOWARDS THE TOTAL ABANDONMENT OF ROUTINE, TOWARDS THE INTEGRATION OF SCULPTURE AND THE CONQUEST OF DIMENSIONS SUPERIOR TO THE PLANE.
FORM AND COLOUR ARE ONE. Form can only exist once it is signalized by a quality of colour. Colour is only a quality once it has been delimited by form. The line (drawing, contour) is a fiction which belongs not to one but to two colour-forms at the same time. It does not generate colour-forms; it results from their encounter. TWO COLOUR-FORMS INEVITABLY CONTRASTED CONSTITUTE THE PLASTIC UNIT, HENCE THE UNIT OF CREATION: THE ETERNAL DUALITY OF ALL THINGS, FINALLY ACCEPTED AS INSEPARABLES.
UNITY is the abstract essence of the BEAUTIFUL, the first form of sensibility.
TO COORDINATE IS TO CREATE SOMETHING NEW AND TO RE-CREATE ALL ART OF THE PAST.
Since the entities of past art alone are intelligible, as it is not granted to everyone to study contemporary art deeply, IN PLACE OF ITS 'COMPREHENSION' WE ADVOCATE ITS 'PRESENCE'. SENSIBILITY BEING A FACULTY PROPER TO HUMANS, OUR MESSAGE WILL REACH THE COMMON MORTAL BY THE NATURAL ROUTE OF HIS EMOTIVE SENSIBILITY. The art of tomorrow will be a 'common treasury' or it will not be.
It is painful, but unavoidable, to abandon old values in order to ensure possession of new ones. Our condition has changed; our ethic, our aesthetic must change in its turn. If the notion of a work of plastic art up till now has been embodied in a craftsmanlike approach and in the myth of the 'unique piece', it will·be found today in THE CON-

CEPT OF A POSSIBILITY OF RE-CREATION, OF MULTIPLICATION AND OF EXPANSION.
The future reserves a joy for us in the new plastic beauty, mobile and emotive.

From *Le Mouvement, notes pour un manifeste*, Galerie Denise René, Paris 1955.

The polychrome city – also and in particular polychrome in respect of the diversity of its structural materials and surface treatments – appears to me as a perfect synthesis; the fundamental principle of the conjunction of the arts reunites all the plastic arts in the 'complete function'. Of this, the polychrome city propounds precisely the most coherent application, at that point in history where we find ourselves, after the revolutions of Mondrian and Malevich. To us, there is something satisfying in the fact that the harmonic principle should be rendered eminently necessary by the end of the historic evolution. But it must be added to this that the polychrome city realizes the only architectonic synthesis of such character as to associate a real psychic dimension to the plastic value of a physical space, thus installing this space-form-colour in the universal consciousness.
Comparable with the syntheses of past ages, the polychrome city, today's synthesis, is in fact a concrete construction capable of essential extension; it manifests a psychic dimension of the physical together with its adjustment to the immediate social structure.
I have defined 'plastic unity' by the two constant/contrasts, in the simple dialectic formula: $1 = 2, 2 = 1$. When I say black and white (always convertible into contrasted colour-forms), I am opting for a view of the world in which 'good and evil', 'beautiful and ugly', 'physical and psychological' are inseparable opposites/complementaries, two sides of the same medal. Black and white, therefore the better to convey the message, the better to diffuse it, to inform, to give, black and white, yes and no. Black and white, dot and line. It is the work of plastic art recreatable at a distance, or multipliable by someone else. Black and white. It is a binary language for the constitution of a bank of plastic art in an electronic brain. It is an immense prospect of static, equitable sharing-out of art as a 'common treasury'. It is the indestructibility of the art thought, and the perenniality of the work in its orig-

inal form. The masterpiece is no longer the concentration of all the qualities into *one* final object, but the creation of a *point-of-departure prototype*, having specific qualities, perfectible in progressive numbers.

From *La forme-couleur intégrée dans la cité par la technique des revêtements muraux*, published by the artist, 1959.

52 Reimer Jochims

The reality of the picture is the picture of reality. I am not looking for a new style, but for a new way of seeing. The simplification no longer has to take place on the actual canvas, but during the act of sight. The new way of seeing is not a new pair of glasses, but a new way of SEEING.

From *das kunstwerk*, 10-12, XVII, April-June 1965.

53 Piero Dorazio

I do not try to instruct the viewer on the function of colour but rather to continue my own education as to its possibilities. Combining the elements of painting in my own way, certain images result. I then see to what extent these come near to what I already know, or had hoped to know. I am sure that what I discover to-day the viewer will see to-morrow.

A work of art is not made to be consumed. 'Consumption', a term borrowed from economics, cannot indicate for art the destination of automobiles or detergents. By the way it is made, a work of art abstracts certain human values and experiences, expressing them in a visual form. The viewer then gives to what he sees a personal meaning concerning his relationship with himself and with the world. Thus a work of art does not play a passive role, that of being consumed, but on the contrary plays a constantly active and activating one, since it stimulates the awareness and the ambitions of the onlooker.

I don't believe in the current myth of originality. On the contrary, I am convinced that in accepting the achievements of others we increase the value of our own. The work of the artist gives a visible physiognomy to civilization, while the work of the scientist makes it concrete and productive.

From the catalogue 'Piero Dorazio', Marlborough-Gerson Gallery, New York 1965.

54 Ad Reinhardt

I am just making the last painting which anyone can make.

Art is always dead, and a 'living' art is a deception.
A modern painter's worst enemy is the picture maker who somehow creates in people the illusion that one need not know anything about art or art history to understand it. But looking isn't as simple as it looks.

Limits in art are not limits
No limits in art are limits.
Less in art is not less.
More in art is not more.
Too little in art is not too little.
Too much in art is not too much.

From the catalogue 'Ad Reinhardt', Jewish Museum, New York 1967.

Fine art can only be defined as exclusive, negative, absolute and timeless. It is not practical, useful, related, applicable or subservient to anything else. Fine art has its own thoughts, its own history and tradition, its own reason, its own discipline. It has its own 'integrity'....
Fine art is not 'a means of making a living' or 'a way of living a life'. Art that is a matter of life and death cannot be fine or free art. An artist who dedicates his life to art, burdens his art with his life, and his life with his art. 'Art is Art, and Life is Life'.
The 'tradition' of art is art 'out of time', art made fine, art emptied and purified of all other-than-art meanings, and a museum of fine art should exclude everything but fine art. The art tradition stands as the antique-present model of what has been achieved and what does not need to be achieved again. Tradition shows the artist what not to do. 'Reason' in art shows what art is not.... 'The way to know is to forget'.
The first and absolute standard of fine art, and painting, which is the highest and freest art, is the purity of it. The more uses, relations and 'additions' a painting has, the less pure it is....
The less an artist thinks in non-artistic terms and the less he exploits the easy, common skills, the more of an artist he is. 'The less an artist obtrudes himself in his painting, the purer and clearer his aims', the less exposed a painting is to a chance public, the better. 'Less is more.'
The Six Traditions to be studied are: (1) the pure icon, (2) pure perspective, pure line and pure brushwork, (3) the pure landscape, (4) the pure portrait, (5) the pure still-life, (6) pure form, pure colour and pure monochrome. 'Study ten thousand paintings and walk ten thousand miles'. 'Externally keep yourself away from all relationships, and internally, have no hankerings in your heart.' 'The pure old men of old slept without dreams and waked without anxiety.'
The Six General Canons or the Six Noes to be memorized are: (1) No Realism or Existentialism. 'When the vulgar and the commonplace dominate, the spirit subsides.' (2) No Impressionism. 'The artist should once and forever emancipate himself from the bondage of appearance.' 'The eye is a menace to clear sight.' (3) No Expressionism or Surrealism. 'The laying bare of oneself', autobiographically or socially, 'is obscene.' (4) No Fauvism, primitivism or brute art. 'Art begins with the getting rid of nature.' (5) No Constructivism, sculpture, plasticism or graphic arts. No collage, paste, paper, sand or string. 'Sculpture is a very mechanical exercise causing much perspiration, which mingling with grit, turns into mud.' (6) No 'trompe-l'œil,' interior decoration or architecture. The ordinary qualities and common sensitivities of these activities lie outside free and intellectual art.

From 'Twelve Rules for the New Academy', *Art News*, May 1957.

55 Barnett Newman

I am always referred to in relation to my colour. Yet I know that if I have made a contribution, it is primarily in my drawing. The impressionists changed the way of seeing the world through their kind of drawing; the cubists saw the world anew in their drawing, and I hope that I have contributed a new way of seeing through drawing. Instead of using outlines, instead of making shapes or setting off spaces, my drawings declare the space. Instead of working with the remnants of space, I work with the whole space.
It is full of meaning, but the meaning must

come from the seeing, not from the talking. I feel, however, that one of its implications is its assertion of freedom, its denial of dogmatic principles, its repudiation of all dogmatic life. Almost 15 years ago Harold Rosenberg challenged me to explain what one of my paintings could possibly mean to the world. My answer was that if he and others could read it properly it would mean the end of all state capitalism and totalitarianism. That answer still goes.

From an interview with Dorothy Seckler in *Art in America*, vol. 50, no. 2, Summer 1962, pp. 83, 86-87.

56 Donald Judd

One of the most important things in any art is its degree of generality and specificity and another is how each of these occurs. The extent and the occurrence have to be credible. I'd like my work to be somewhat more specific than art has been and also specific and general in a different way. This is also probably the intention of a few other artists. Although I admire the work of some of the older artists, I can't altogether believe its generality. Earlier art is less credible. Of course, finally, I only believe in my own work. It is necessary to make general statements, but it is impossible and not even desirable to believe most generalizations. No one has the knowledge to form a comprehensive group of reliable generalizations. It is silly to have opinions about many things you're supposed to have opinions on. About others, where it seems necessary, the necessity and the opinion are mostly guess. Some of my generalizations and much of the specificity are assertions of my own interests and those that have settled in the public domain.

From *Art in America*, October-November 1965.

57 Robert Morris

The ideas of industrial production have not, until quite recently, differed from the Neolithic notions of forming – the difference has been largely a matter of increased efficiency. The basic notions are repetition and division of labour: standardization and specialization. Probably the terms will be-

come obsolete with a thoroughgoing automation of production involving a high degree of feedback adjustments.

In grasping and using the nature of made things the new three-dimensional art has broken the tedious ring of 'artiness' circumscribing each new phase of art since the Renaissance. It is still art. Anything that is used as art must be defined as art.

Simplicity of shape does not necessarily equate with simplicity of experience.

From the catalogue 'Robert Morris', Galerie Sonnabend, Paris 1968.

58 Frank Stella

What happened, at least for me, is that when I first started painting I would see Pollock, de Kooning, and the one thing they all had that I didn't have was an art school background. They were brought up on drawing with the brush. They got away from the smaller brushes and, in an attempt to free themselves, they got involved in commercial paint and house-painting brushes. Still it was basically drawing with paint, which has characterized almost all twentieth-century painting. The way my own painting was going, drawing was less and less necessary. It was the one thing I wasn't going to do. I wasn't going to draw with the brush.

My painting is based on the fact that only what can be seen there *is* there. It really is an object. Any painting is an object and anyone who gets involved enough in this finally has to face up to the objectness of whatever it is that he's doing. He is making a thing. All that should be taken for granted. If the painting were lean enough, accurate enough or right enough, you would just be able to look at it. All I want anyone to get out of my paintings, and all I ever get out of them, is the fact that you can see the whole idea without any confusion.... What you see is what you see.

From 'Notes on Sculpture', in *Artforum*, February 1966, October 1966, Summer 1967.

59 Kenneth Noland

Imagine yourself looking across a street at a crowd pedestrians [sic]. Suddenly one of

them glances your way, like that quality of connection I'd like those colours to have – but abstractly...

The thing is colour, the thing in painting is to find a way to get colour down, to float it without bogging the painting down in surrealism, cubism or systems of structure...

Structure is an element profoundly to be respected, but too open an engagement with it leaves one in the back waters of what are basically cubist concerns. For the best colour painting, structure is nowhere evident, or nowhere self-declaring...

No graphs; no system; no modules. No shaped canvases. Above all, no *thingness*, no *objectness*. The thing is to get that colour down on the thinnest conceivable surface, a surface sliced into the air as if by razor. It's all colour and surface, that's all.

From 'The thing in painting is colour'. *The New York Times*, 25 August 1968.

60 Carl André

The course of development
sculpture as form
sculpture as structure
sculpture as place

Up to a certain time I was cutting into things. Then I realized that the thing I was cutting was the cut. Rather than cut into the material, I now use the material as the 'cut in space'.

My work is atheistic, materialistic and communistic. It's atheistic because it's without transcendent form, without spiritual or intellectual quality. Materialistic because it's made out of its own materials without pretension to other materials. And communistic because the form is equally accessible to all men.

Actually my ideal piece of sculpture is a road.

From *Artforum*, October 1966.

61 Tony Smith

I'm interested in the inscrutability and the mysteriousness of the thing.

More and more I've become interested in pneumatic structures. In these, all of the material is in tension. But it is the character

of the form which appeals to me the biomorphic forms which result from this construction have a dream-like quality for me, at least like what is said to be a fairly common type of American dream.

I don't think of them as sculptures but as presences of a sort.

I'm not aware of how light and shadow falls on my pieces. I'm just aware of the basic form. I'm interested in the thing, not in the effects – pyramids are only geometry, not an effect.

From *Artforum*, vol. V, no. 1, December 1966.

62 Naum Gabo and Antoine Pevsner

We are liberating ourselves from millennial error inherited from Egyptian art, which saw in static rhythms the only elements of plastic art. We claim that kinetic rhythms are the essential forms of our perception of real time.

From *Manifeste réaliste*, Moscow 1920.

63 Yaacov Agam

From my very first experiments, it has always been my intention to create a work of art existing beyond the visible, getting away from the image, which could only be grasped in stages, with the awareness that what one had there was but the appearance of a partial and dynamic revelation, and not the finalized perpetuation of an existing thing. My aim is to show the visible as possibility in a state of perpetual becoming. To create the light through the word – the most intimate of ambitions, man's most secret one, and the one which allows him to regain his divine state.

'Let there be light', said God, and there was light. The power of the Word, speech creating light; how one is inspired to emulate this feat of God, who with a word brought forth light!

From the catalogue 'Lumière et Mouvement', Musée d'art moderne de la ville de Paris, 1967.

64 Nicolas Schöffer

Definition of spatiodynamism
The essential aim of spatiodynamism is the constructive and dynamic integration of space in the work of art. Effectively, a tiny fragment of space contains very powerful possibilities in the field of energy. Its exclusion by hermetic volumes has for long deprived sculpture of possibilities of development as much in the field of formal solutions as on the plane of the dynamic growth of the work.

Spatiodynamism corresponds to the most immediate aspiration of man, which is towards the physical and theoretical conquest of space, from the infinitely great to the infinitely small, with ever increasing dynamic means, but also deriving new dynamic forces from his conquests. Spatiodynamism has elicited the same efforts on the aesthetic and plastic plane.

It is also the symbol of all these aspirations, and could be the common denominator of all these bold experiments, multiple in aspect but serving the same end: man's arrow-straight progress towards the domination of the elements which surround him.

From a lecture given at the Sorbonne, Paris, on 19 June 1954, and published in *Nicolas Schöffer*, Éditions du Griffon, Neuchâtel 1963.

Definition of luminodynamism

Luminodynamism is the exploitation of a surface or of a fraction of space of any size, in which are developed plastic and dynamic elements, coloured or not, by real or optical movements combined with artificial or natural light-sources.

Produced on a surface, this development provokes an increase of luminosity in relation to its environment; produced in space, the light, dynamized by mixing, penetrates and traverses the spatiodynamic sculpture in movement, augmenting its luminosity, but also producing on every surface or space, opaque or translucent, placed in the *double field* created by the action of the sculpture and of the mixed sources of light, visual developments that are rhythmic and extremely varied.

From *Nicolas Schöffer*, Éditions du Griffon, Neuchâtel 1963.

65 Carlos Cruz-Diez

My Physichromies claim to 'express' no more than the display of a few conditions of colour. They propose a 'climate' due to the changing condition of the colour, which is more or less physiological, sometimes voluptuous, even erotic, and touches the primary senses. The Physichromies seek to make directly the brute fact of colour.

From the catalogue 'Lumière et Mouvement', Musée d'art moderne de la ville de Paris, 1967.

66 Jésus-Raphaël Soto

In every moment of our behaviour we observe the existence of relationships. We astonish ourselves with the laws of chance, without realizing that we are merely becoming aware of realities previously undreamt of. The elements are submerged in the work like fish in water; all these directions, speeds, accidents, positions, are controlled by an environmental whole upon which they depend and which conditions their variants. Their power is measured by the number of their revelations. This state, conscious or not, of the contemporary artist, has given to the art of our time its surprising wealth of possibilities.

In the past, the artist felt himself as it were an external witness of the world, the harmonies of which he recomposed in his own way – from outside – in creating relations of forms and colours on the canvas. In our time we, on the contrary, feel ourselves in the world like the fish in the water; we are no longer observers, but component parts of reality. Man is no longer here and the world there. He is in the thick of it, and it is this involvement that I want to make felt with my enveloping works. It is not a case of sending people mad, of stunning them with optical effects. It is a case of making them understand that we are bathed in the trinity of space-time-matter.

From the catalogue 'Lumière et Mouvement', Musée de l'art moderne de la ville de Paris, 1967.

67 Jean Tinguely

The only stable thing is movement, everywhere and always.

What is definitive is the provisional. There is nothing surer than that which is not sure. The wheel: that's all.

Moreover, all that is strong is never stable, but is always speed and movement.
The greatest stability is instability.
Teeth, which are hard, break, while the tongue which is soft endures.

From the catalogue 'Lumière et Mouvement', Musée de l'art moderne de la ville de Paris, 1967.

68　　　　　Piotr Kowalski

If the work should (socially?) (now) explode (circulate), this 'popularization' of Art ('... made by all. Not by one'. Never ceases to hum in our ears) will (finally) take away from the 'artist' his (last) aristocratic privilege of taste (choice?).
This (definitive?) step to be taken (now) is a shifting of decisions towards the (transmissible) level of 'manufacture' (transformation of the material according to method A), and the object (the work) is to be made by the same process (technique) which secretes (currently) all the other human extensions.

From the catalogue 'Lumière et Mouvement', Musée de l'art moderne de la ville de Paris, 1967.

69　　　　Hermann Goepfert

It is not necessary to stress the fact that light is the prerequisite of all visual art. But here light is not being regarded as a means of illuminating visual objects, nor as thematic content; it is, rather, a material for plastic expression instead of colour considered as pigment, or wood and stone considered as physical bodies. Yet light is only one aspect of the new material. In addition to light there is sound and the magnetic field. In short, everything in nature which emits waves, all energetic material.
To create environments out of luminous objects is the dream of us all.

From *Kleine Egoist Künstler-Monographie 3*, ed. Adam Seide, Frankfurt am Main.

70　　　　　Harry Kramer

What can we do with a world that can be mathematically formulated, but can no longer be concretely experienced? In the hands of physicists objects and processes lose all stability and contour, and become a mere tremor of electrons whose quiverings scarcely touch our retinas. We stand in front of a heap of discarded sensory symbols which have to be given up in favour of mathematical ones. We have nothing to offer, for we can give form neither to nothingness nor to boredom. Attempts to express the vacuum by empty pedestals, white canvases, or blank pages are too thin – even as intellectual jokes. All we can do is make our brain into a concave lens that focuses the entire phantastic process into images.

From the catalogue 'Automobile Skulpturen', Cologne 1961.

The *Mouvement pur* culminated with Duchamp and Calder. Their pupils and followers have flooded their surroundings with thousands of ridiculous things. Anyone who fancies himself as an artist simply sticks champagne corks and little bits of enamel on the ends of wires and dangles the thing from the ceiling. Radar, Fu-Mess, and interplanetary flight then get presented as an excuse for these anaemic concoctions. To believe that creative art is being trailed along by technology is an oversimplification. When Tatlin was working on his plans for the memorial to the third Internationale, they were still shooting at each other with pistols out of tired bi-planes. The 'Mouvement' is a real art form, a hybrid form which incorporates elements of painting, sculpture, and of pure spectacle. It entertains, it is something to be watched. The *Mouvement pur* is only one aspect of mechanical art. Almost before they are born, new inventions are adopted by propaganda and exploited to death.

From the catalogue 'Harry Kramer', Biel Municipal Gallery, 1962.

Spectacular automata and kinetic sculpture are the urban forms of art. They are aggressive, real and corrupted. The effort to interpret them through meditation, through spirituality or as utopias takes no account of the effect they provoke on the spectator. Kinetic art has accepted the ends and the means of publicity. To present kinetic art as a game, as tinkering or as experimentation arouses wild fury among the sculptors, who work desperately hard. I know of no artistic discipline in which the work is harder, the concept more serious and the achievement more firmly willed.

From the catalogue *Lumière et Mouvement*, Musée de l'Art Moderne de la ville de Paris, 1967.

71　　　　　　Pol Bury

At the time when white holes served me as animated motifs, I had the idea of replacing the white paint by artificial light. This had certain advantages: it is easier to see in the dark, and it gives the holes an indefinite edge, uncertain and mobile.
Since then, I have lost interest in white holes and I have reached the point (perhaps for some time to come) of considering light (artificial) as a means of seeing better rather than as an object of contemplation.

From the catalogue *Lumière et Mouvement*, Musée de l'Art Moderne de la ville de Paris, 1967.

Between the immobile and mobility, a certain slow movement leads to the discovery of a field of 'actions' in which the eye can no longer register the trajectory of an object.
Through the slowness of movement, the trajectories escape being 'programmed'; they are related to a real or fictitious freedom, to a freedom which acts for itself and for its own pleasure.
Speed limits space, slowness multiplies it. This freedom we also see in the contrary force which the ball opposes to its own motion; an opposition which would not have us forget what a battle it has to wage against weights. Weight.
Two balls on the scale of slowness; earth, air, fire and water are those that bear the weight of their measure.

From 'Temps dilaté', in *Strates*, no. 3, Éditions Christian Dotremont, Brussels 1964.

Science, every day, makes discoveries: the laser already permits of the impalpable real. We can begin to rave. The magnet, the motor and the neon are only a small beginning.

From *Le petit commencement*, Éditions du Daily-Bul, La Louvière.

72 Groupe de Recherche d'Art Visuel (GRAV)

For this Group, the introduction of light is neither an advance nor an end in itself. Its use varies according to the situations presented: variations, progressions, reflections, transformations of structures, projections, revolving lights, neons, all have been used separately in isolated situations (luminous boxes, grids, or neons, for example) or integrated in mazes or halls.

This Group is not concerned to create a work having light as its subject, nor to produce a super stage-performance, but, through provocation, through the modification of the conditions of environment, by visual aggression, by a direct appeal to active participation, by playing a game, or by creating an unexpected situation, to exert a direct influence on the public's behaviour and to replace the work of art or the theatrical performance with a situation in evolution inviting the spectator's participation.

From *Manifeste du Groupe de Recherche d'Art Visuel* (GRAV), in the catalogue 'Lumière et Mouvement', Musée de l'art moderne de la ville de Paris, 1967.

We are particularly interested in the proliferation of works which permit of varied situations, whether they engender a strong visual excitement, or demand a move on the part of the spectator, or contain in themselves a principle of transformation, or whether they call for active participation from the spectator. To the extent that this proliferation allows the calling in question – even diffidently – of the normal relations between art and the spectator, we are its supporters. But this is only a first stage. The second might be, for example, to produce, no longer only the works, but ensembles which would play the part of social incitement, at the same time as liberating the spectator from the obsession with possession. These 'multipliable' ensembles could take the form of centres of activation, games rooms, which would be set up and used according to the place and the character of the spectators. From then on, participation would become collective and temporary. The public could express its needs otherwise than through possession and individual enjoyment.

From *Manifeste du Groupe de Recherche d'Art Visuel* (GRAV), in the catalogue 'Le Parc', Galerie Denise René, Paris 1966.

73 Julio Le Parc

For my interest does not run to creating, let us say, a sort of theatrical performance with the sole end of variation *ad infinitum*, nor to repeating temporary sequences previously programmed. I am trying to go deeply into an aspect of reality which is highly attractive: the condition of instability. To grasp it in its intrinsic nature, one must treat it with the most dematerialized elements possible.

From the catalogue 'Lumière et Mouvement', Musée d'art moderne de la ville de Paris, 1967.

74 Frank Malina

Kinetic art is not one of the stages in the quest for style or mannerist fantasy; it is in itself a new art added to those of painting and sculpture. It has obvious affinities, in its intentions, with traditional painting and sculpture. I think that the artist, like the fish in the sea, cannot escape from the world in which he lives. The artist's eye does not enable him to create something out of nothing, like a god; the artist reflects and transposes, for the eye and the brain of his contemporaries, certain selected aspects of the universe of man and of nature his senses enable him to perceive.

From the catalogue 'Lumière et Mouvement', Musée d'art moderne de la ville de Paris, 1967.

INDEX